EXAMINING VELAZQUEZ

GRIDLEY McKIM-SMITH
GRETA ANDERSEN-BERGDOLL
RICHARD NEWMAN
with technical photography by Andrew Davidhazy

YALE UNIVERSITY PRESS : NEW HAVEN AND LONDON

Publication of this book has been aided by a grant from the
Program for Cultural Cooperation Between Spain's Ministry of
Culture and United States' Universities.

Designed by Sally Harris
and set in Bulmer type by Huron Valley Graphics, Ann Arbor, Mich.
Printed in the United States of America by
Murray Printing Co., Westford, Mass.

Library of Congress Cataloging-in-Publication Data

McKim-Smith, Gridley, 1943–
Examining Velázquez / by Gridley McKim-Smith, Greta Andersen
-Bergdoll, Richard Newman ; with technical photography by Andrew
Davidhazy.
p. cm.
Bibliography: p.
Includes index.
ISBN 0–300–03615–9 (alk. paper)
1. Velázquez, Diego, 1599–1660—Criticism and interpretation.
2. Painting, Spanish—Expertising. 3. Painting, Modern—17th–18th
centuries—Spain—Expertising. I. Andersen-Bergdoll, Greta, 1944–
II. Newman, Richard, 1951– . III. Davidhazy, Andrew. IV. Title.
ND813.V4M35 1988 .
759.6—dc19 87–31872

10 9 8 7 6 5 4 3 2

CONTENTS

CONTENTS

ACKNOWLEDGMENTS

We have incurred many debts of gratitude on both sides of the Atlantic, and we will express our thanks, first jointly and then separately, to those who have contributed to the investigation.

Mr. and Mrs. Richard B. Kaufmann, Mrs. Hazel McKinley, Mr. and Mrs. Moise S. Steeg, Jr., and various private foundations in Louisiana provided the generous contributions that made our travel and research in Spain possible.

In 1980, José Manuel Pita Andrade, then director of the Prado Museum, gave permission for our investigation there and kindly made the facilities of the museum available. Alfonso E. Pérez Sánchez, the Prado's present director, made the specific arrangements for the physical examination of the paintings. Our indebtedness to him, however, extends far beyond our gratitude for his practical assistance. Through his major and abundant contributions to the literature on the art of Spain, he set exacting standards and provided firm foundations for our work. We hope he realizes, as we do, that without his advice and example this investigation could not have been carried out. Particular thanks are expressed in the notes to individuals on the Prado's staff who helped our team in specific instances, but here we would like to recognize the general support we received from Rocío Arnáez, Carlos Manso, Manuela Mena, and Pedro Sobrino. José María Cabrera offered his equipment, and he and María del Carmen Garrido kindly shared their extensive knowledge of Spanish materials. Research done with Garrido, whom we thank especially, will be published by the Prado.

In the United States, Seymour Slive, then director of the Fogg Museum, provided support in the crucial early phase of the project's planning. Arthur Beale, then director of the Center for Conservation and Technical Studies of the Harvard University Art Museums, not only contributed equipment but also showed a gracious spirit when faced with the unforeseen events that can attend the shipment of scientific instruments. James E. Marron of Eastman Kodak Company provided advice on the infrared photography. Judy Metro and Judith Calvert of Yale Press have been unfailingly patient and encouraging during the production of the manuscript.

Each of us would like to express gratitude individually to those who helped us separately.

Gridley McKim-Smith: Research on chapters 1, 2, and 3 was made possible by a fellowship from the American Council of Learned Societies. An earlier grant from the American Philosophical Society enabled me to create a useful archive of photographs of Velázquez's paintings. William Walker of the Thomas J. Watson Library of the Metropolitan Museum provided space for the conservation-related research. And

grants from the Madge Miller Research Fund of Bryn Mawr College made secretarial services available.

Svetlana Alpers, Jonathan Brown, David Cast, R. D. Harley, Dale Kinney, Irving Lavin, Steven Z. Levine, Joyce Plesters, David Rosand, and Zahira Véliz have read sections of these chapters and have made insightful comments. Many years ago, Elisabeth Jones, then of the Fogg Museum Conservation Department, first called my attention to color changes in aging paint. John Brealey of the Metropolitan Museum revived my interest in the issue and reminded me of its importance. Special thanks are due to the students at Bryn Mawr and Haverford colleges, whose enduring skepticism made writing chapter 3 more challenging.

Other colleagues helped in various ways, and I would like to express my gratitude collectively to Gary Bayer, Marcus B. Burke, Mary Campo, Marcia B. Hall, William B. Jordan, Duncan T. Kinkead, Agnes Mongan, Steven N. Orso, Carole Roberti, Umberto Ródríguez-Camilloni, Eleanor Sayre, Suzanne Stratton, Ron Todd, and Mercedes Zabala.

The generous support of my late brother, John McKim, was crucial and unforgettable. Finally a debt too great for words is owed to my husband, Frank Smith, whose love and loyalty have made this possible.

Greta Andersen-Bergdoll: I would like to thank John Brealey, who taught me to look at paintings. I am also grateful for the advice and support of Karen Davidson and Christy Cunningham.

Richard Newman: Most of the analytical work was carried out at the Center for Conservation and Technical Studies, Harvard University Art Museums; in part, this was made possible by a grant from the Andrew W. Mellon Foundation. The scanning electron microscope work was carried out at the Center for Astrophysics, Smithsonian Institution/Harvard University, Cambridge, Massachusetts; I thank Karen Motylewski and John A. Wood for allowing us to use this instrument. Microprobe analyses were carried out in the Department of Earth and Planetary Sciences, Harvard University.

I particularly thank María del Carmen Garrido of the Prado Museum, who shared the results of her unpublished research on the materials used by sixteenth- and seventeenth-century Spanish painters other than Velázquez. Additional research, carried out in 1983–86 on the *Forge of Vulcan* and *Las Meninas* by Garrido, McKim-Smith, and Newman, is not discussed here but is being published by the Prado Museum.

Andrew Davidhazy: Many thanks are due to H. Lou Gibson (formerly of Eastman Kodak Company), author of numerous articles and publications on infrared photography, for the helpful advice and encouragement he gave me prior to undertaking this project.

Thanks are also due to Martin Scott, Senior Biomedical Imaging Specialist at Eastman Kodak, for his recommendation and enthusiastic endorsement of the photographic value of the work to be done in this project.

INTRODUCTION

This book is the result of a collaboration between an art historian, a conservator, a conservation scientist, and an instrumental photographer. It presents a series of chapters that are loosely linked by one thin thread: issues raised by the examination of six paintings by Diego Velázquez in the Prado Museum. Beyond that preliminary unity, each chapter deals with a different subject: some discuss chemistry, some theory, and still others bear some resemblance to examination reports. As in the case of all mixed breeds, the only way to comprehend the appearance is to review the ancestry.

Examining Velázquez is the product of the first technical investigation of paintings by that artist in the Prado since 1960–61, when the museum organized an exhibition to coincide with the tricentennial of Velázquez's death. At that time, research was carried out by the National Gallery of Sweden, and radiographs were made of selected paintings.[1] In 1980 we consulted many of these radiographs, and to them we added a radiograph of the *Forge of Vulcan*,[2] a file of infrared photographs, examinations with the infrared vidicon, and analyses of pigments. We examined *Philip IV Standing*, the *Bust of Philip IV*, the *Forge of Vulcan*, the *Surrender of Breda*, the *Portrait of a Dwarf* (*El Primo Don Diego de Acedo*), and *Las Meninas;* we took pigment samples from the *Coronation of the Virgin*, but did not examine it further. We have confined our discussion here to these paintings. Between 1983 and 1986, María del Carmen Garrido, McKim-Smith, and Newman regathered examination data on these six paintings and examined twenty-odd more canvases by Velázquez. Garrido went on to examine still more of the master's paintings in 1987. The data from all these examinations are preserved in the museum's files and are being published by the Prado.

Each collaborator contributed something different to the text of *Examining Velázquez:* the historical and theoretical discussions (chapters 1–3), as well as appendixes I and II, were written by McKim-Smith; notes on the individual paintings were written by McKim-Smith and Andersen-Bergdoll (chapter 4); the chemical analyses of pigments were made by Newman (chapter 5 and appendix III); drawings of pentimenti were made by Andersen-Bergdoll; and the infrared photographs were taken by Davidhazy.

In the end, the book possesses a title that is somewhat misleading. A more accurate designation, at least for the first three chapters, might have been *Observations on Spanish Painting that Were Suggested by Examining Velázquez.* Although all the chapters discuss questions that arose from examining paintings by Velázquez, the first

three are frequently not about Velázquez at all. Instead they are about issues that his paintings raise and share with many other pictures of the period. We chose the title *Examining Velázquez,* therefore, because it was conveniently short and deliberately vague.

When we began working with the Velázquezes in 1980, we did not have a laboratory at our disposal within the museum. We worked in the galleries while they were being rehung after one phase of the museum's ongoing renovation program. The work required the delicate balancing of schedules on the part of the Prado's personnel and our team. Even so, sampling often had to be done while the pictures hung on the gallery wall. Most of the paintings were covered with grime and old varnish, which complicated both sampling and examination with the naked eye. These conditions dictated that we proceed with caution and that we not attempt to address certain questions. Our limitation to six canvases provided another significant restraint: a selection of six Velázquezes from an oeuvre of over one hundred produces a sample so small that the validity of generalizations is questionable. The examination of additional, securely attributed paintings carried out by Garrido and by us has not revealed new materials or techniques, but even these paintings studied later provide a total of less than one-third of Velázquez's production. Therefore where general comments are offered, they are put forth as tentative suggestions and guidelines for future research, not as conclusions.

In the first three chapters, McKim-Smith has proceeded on the assumption that conservation technology, like the computer, is a solution looking for a problem. Elsewhere in art historical literature, technical examination is often used to investigate a date or an attribution. By design, we chose paintings whose authorship was secure and for which controversies of date were not of overwhelming importance. Freedom from concern with the date or attribution of a painting invited a reassesment of the uses of technical data by art historians. And then the stimulus to seek new perspectives provided a welcome opportunity to address a problem that has plagued the Velázquez literature for the past half century.

Velázquez's work is visual, but what we say about it must be verbal. Of course, this is true of any painting. But the problem has been especially acute in regard to Velázquez because he created a style whose eerie verisimilitude defies the writer's ability to provide a surrogate in words for Velázquez's brushstrokes in paint. In fact, Velázquez's imagery provides the viewer with an experience so overwhelmingly sensory that until well into the twentieth century art historians made the mistake of claiming that Velázquez possessed a sensitive eye but no brain—that he painted what he saw so unthinkingly that he produced canvases without iconography, without history, without social comment or context. Fortunately, this early imbalance in favor of formalism has been corrected in recent decades. But the welcome advances in understanding Velázquez's narrative content and in appreciating his erudition have necessarily been made at the expense of attention to the forms that create the paintings.

As a result, discussion of Velázquez's color, composition, brushwork, and so forth,

remains today at the primitive stage it had reached early in this century. When a comment on Velazquez's forms ventures beyond simple aestheticism, it usually still remains confined to an analysis of stylistic development or a rehearsal of form as an illustration of content. Technical examination forces a return of attention to the visual object. Simultaneously, it demands that the object be seen in new ways. X-radiographs and infrared photographs reveal hidden forms, cross sections uncover concealed structures, and pigment analyses force the viewer to pay attention to color. All this new information challenges the art historian to construct new critical structures, to find new ways to perceive and describe the physical qualities of a painting. By attempting to identify the historical and theoretical questions that might be brought to bear on the discussion of Velázquez's brushwork, technique, and color, we suggest that technical information can extend the parameters of the historical cognition of Velázquez's paintings.

In chapter 1, the results of the chemical analysis were used to make a comparison of Velázquez's actual pigments with the theoretical prescriptions made by seventeenth-century writers. The discrepancies between pigments advised and pigments used suggested that even the raw materials of painting were not innocent of meaning to the painters who used and discussed them. This discovery then led to a consideration not only of the genealogy of pigments, but also of the genealogy of Velázquez's techniques. His brushwork was perceived in his time as Venetian, and he was frequently mentioned as Titian's special heir. As in the case of the pigments, descriptions of Velázquez's techniques were influenced by unspoken ambitions, one of which was to establish the legitimate descent of Spanish painting from the Venetian tradition. This emphasis in Spanish discourse upon the Venetian ancestry of Spanish painting suggested another topic.

In chapter 2, all the technical data in combination (radiographs, infrared photographs, cross sections, and analysis of pigments) were used to juxtapose Velázquez's technique with the technique of the Venetian school to which he was said to have claimed passionate allegiance. Since writers in the seventeenth century were possessed of a desire to link Spanish painting to the Venetian school, it was irresistible to try to put their claims of a resemblance to a modern test. Thus the results of the examinations of the Velázquezes are compared with published examinations of works by Titian and Tintoretto. In terms of working method, materials, and layering of paints, for example, there are undeniable similarities between the Venetians and Velázquez. Yet often those resemblances are no more characteristic of a Velázquez than of works by many other baroque painters. As a result, chapter 2 became not only a comparison of Velázquez with the Venetians, but also an experiment in the application of scientific data to the complicated issue of a historical relationship.

In chapter 3, analysis of pigments made us painfully aware of the spontaneous changes suffered by Velázquez's original colors over the last three centuries—which then raised the challenge of discussing color at all. No doubt some colors possess iconographic meaning, but our concern here is to develop a way of discussing the

elusive problem of hue when it is not used to symbolize a verbal concept. In chapter 3 it becomes apparent that two kinds of critical reconstruction are necessary if color is to be reintegrated into art historical discourse. First, the importance of color in the seventeenth century must be researched and acknowledged. Second, once acknowledgment has taken place, a way of discussing color must be found that permits recognition of this importance without simply sliding back into the bellelettristic habit of the *ekphrasis*. We suggest that chemical analysis of pigments may help when it is used to address the historical, in addition to the aesthetic, dimension of color. For example, identification of pigments can assist in reconstructing a seventeenth-century viewer's reaction to a given painting. In centuries before the advent of modern synthetic paint, differences in pigment choices produced differences in color, and some colors were more costly and therefore more beautiful in the viewers' eyes. Thus analysis of pigments may help to research the relative importance of paintings in their own time, for costly materials may indicate that a particular image was either very sacred or very public.

In many ways these first three chapters are neither scientific nor historical. Instead they present theoretical speculations and pursue avenues of inquiry that were suggested by the scientific or historical material.

Chapter 4 provides miscellaneous observations on the paintings, often made in response to discussions published earlier in the Velázquez literature. Most of the chapter is a collection of what a Spaniard would call *precisiones* about the paintings examined.

In chapter 5, descriptions of the pigments used by Velázquez are based on the research carried out for this book and previously published information, and how these pigments compare with those used by other seventeenth-century painters is discussed. The "stratigraphy" of Velázquez's paintings (the composition and colors of the ground layers and the overlying paint layers) as revealed by cross sections of the paint film is also discussed.

Approaches to the separate chapters have varied according to author. In spite of the divisions of primary responsibility laid out above, we have all exchanged information, edited each other's drafts, and generally influenced each other. Where biases show themselves, they might be apportioned as follows: Statements implying faith in the validity of empiricism as an interpretive strategy should be credited to Newman and Davidhazy, whereas sections betraying an interest in what we all came to call "the transcendental Velázquez" are the voices of McKim-Smith and Andersen-Bergdoll.

<div align="right">

Gridley McKim-Smith, Art Historian
Greta Andersen-Bergdoll, Conservator
Richard Newman, Conservation Scientist
Andrew Davidhazy, Professor of Photographic Technology

</div>

1

WRITING AND PAINTING IN THE AGE OF VELAZQUEZ

*T*he relationship between the written word and the painted picture has always posed tantalizing questions. Until recently Spanish baroque art theory[1] had been less closely studied than art theory in Italy or the Netherlands, and there are aspects of Spanish writings that still receive little attention: the practical instructions laid down by theorists for physically making a painting and the recorded remarks about physical qualities such as brushwork and finish. Until now these instructions and remarks have been accepted, uncritically, as valid documents of Spanish picture making. Although they have a significant degree of validity, they also, in our opinion, sometimes reflect literary conventions and social concerns as much as actual practice.

Of particular interest are some comments on what seventeenth-century Spanish theorists said about paints and painting techniques, as well as the discrepancies between what these theorists said and what Velázquez actually did. These comments take the reader back to Pliny and Vitruvius, but they also recall the unstated functions of treatises on "practice" within Velázquez's time. That is to say, there were at least two important but hitherto unnoticed characteristics of discourse on practice. First, treatises were supposed to be compendia of past practice as much as reportage of present procedures. Second, even the raw materials of picture making could be manipulated to serve purposes other than mere instructions, as when pigments were presented as ammunition in the dispute over the status of painting.

These discrepancies might be described as covert agendas and overt disputes, which raise a more general question about seventeenth-century Spanish art theory: what was the baroque viewer's reaction to technique? Recorded remarks about Velázquez's technique, like recorded descriptions of materials in the treatises, were grounded in complex associations and long traditions. Needless to say, these associations and traditions conditioned the seventeenth-century viewer's understanding of the picture he saw, for they provided him with his categories of perception—what was worth noticing and what wasn't. As has long been remarked in Italian art theory,[2] fixed tropes tend to become diffused over an entire society. Ultimately, poets, playwrights, preachers, lawyers, and theorists form the habit of expressing themselves in terms of a given convention. Once conventionalized, a particular concept can transcend its original

significance to become a small but recurrent obsession. The freely brushed smear or blob of paint, called a *borrón* or *mancha*, eventually became just such a miniature mania in Spanish thought. At first blush all this fuss over a few centimeters of paint seems unnecessary, but to the seventeenth-century viewer, a *borrón* triggered a complex series of crucial associations. For all that these associations were labyrinthine, they did lead, almost inevitably, to a larger obsession: Venice. To understand the *borrón* is to understand the significance of the Venetian tradition for the Spanish viewer. And in turn, to understand the Venetian tradition is to understand a fundamental element in the Spaniard's conception of his own national achievement.

Free brushwork, of course, was one day to flower into a major and passionate ideology among eighteenth-century Rubenists and nineteenth-century Impressionists. Reconstructing the early context of the *borrón* in one seventeenth-century nation does not lead to startling changes in the interpretation of any given baroque painting, but it may help to orient the modern onlooker as to the early connotations of a passage of paint.

THE GENEALOGY OF PIGMENTS

Relating theory to practice is notoriously difficult. First of all, one has problems of vocabulary. What exactly did the treatises mean when they said, for example, *colorido*, or when they described a mancha? Did the Spanish words mean exactly what *colorito* and *macchia* had meant in Italian theory?[23] And even if the terms were synonymous, how can one be sure of exactly how either word related to real paintings, since a word is not a brushstroke?

In order to formulate an answer to this problem, we focused first on pigment names rather than on more abstract words. We found that if we compared what treatise writers said about Spanish pigments with what artists did, we could also compare the words to the paintings fairly precisely. A pigment is a colored substance that can be suspended in a medium, such as oil. Sometimes pigments are no more than pieces of earth, as, for example, red ochre. Or they can be rare and costly substances, such as lapis lazuli, which makes up ultramarine. Among the advantages of using pigments for a test case is the fact that the meaning of pigment names can be pinned down with a precision not possible with more abstract words. Pigments have definite chemical and physical properties, and most of them are best handled in certain ways. Regardless of the word used for red lake, which is an organic color obtained from an insect or plant, it would be impossible to confuse a description of how to prepare and use red lake with a description of how to prepare and use vermilion, which is an inorganic compound of mercuric sulphide. In a few cases, authors do not give sufficient information to identify a pigment with certainty, but most of the Spanish pigment names can be defined satisfactorily (see Appendix I: Glossary). Thus the theoretical vocabulary can be fixed.

With regard to practice, the pigments in a painting can be analyzed and again, with

only a few exceptions, identified. In the case of Velázquez's paintings, the analyses were carried out by Newman (see chapter 5); he took samples from seven paintings by Velázquez in the Prado,[4] and he identified the pigments by means of polarizing microscopy, X-ray diffraction, and a scanning electron microscope or electron beam microprobe with an attached energy-dispersive X-ray spectrometer.

Thanks to the arguments of deconstruction and poststructuralism, we are mindful of the philosophical dangers of the word *objectivity* and of the ideological charge it carries. But for our purposes, it must be said that objectivity has been a useful fiction, for the analyses have permitted comparison of what the treatises said with what Velázquez did, with occasionally surprising results.

In the past, little scientific testing of pigments in Spanish baroque paintings has been published.[5] In 1978 Hidalgo Brinquis contributed a useful study of Pacheco's pigments in his paintings for the Casa de Pilatos in Seville.[6] More recently, analyses have been carried out at the Gabinete de Documentación Técnica in the Prado Museum,[7] the Doerner Institut in Munich,[8] the National Gallery in Washington,[9] and the Cleveland Museum of Art.[10] Though analysis of Spanish pigments is still in its infancy, so far no data have surfaced to contradict what we found in the Velázquezes we tested.[11]

The paintings sampled were the two early portraits of *Philip IV* from the 1620s (figs. 1, 7); the *Forge of Vulcan* from 1630 (fig. 14); the *Surrender of Breda* of 1634–35 (fig. 23); the *Portrait of a Dwarf* (*El Primo Don Diego de Acedo*) from the late 1630s or early 1640s (fig. 34); and *Las Meninas* from around 1656 (fig. 42), that is to say, about four years before Velázquez's death in 1660. Because it had the best purples, Newman also took samples of that color only from the *Coronation of the Virgin* (fig. 40), painted before 1644.[12] We wished to include a painting that could be firmly dated to the 1640s, and we chose *Don Diego* to represent that decade. Recently Brown's documentary research suggests that *Don Diego de Acedo* may belong to the late 1630s.[13] In any event, the Prado's collection does not include a painting that can be placed in the 1640s for reasons other than style. Velázquez's second trip to Italy in 1649–51 also was not represented. In spite of the span of about forty years in the paintings sampled, Velázquez's "colors," as they were called in his day, varied little from painting to painting, even for those executed when he was in Rome. Although it is tempting to assume that this consistency means that the pigments we obtained are characteristic of all Velázquez paintings, it would be more prudent to change that assumption to a hypothesis. After all, Velázquez was rather flexible in other elements of his approach to making a picture.[14]

Now to turn to the question: Did the writers describe Velázquez's pigments accurately? Treatise writers do not mention any pigment as being used specifically by Velázquez, so we had to compare his pigments as tested with the writers' general advice on pigments for oils. Unfortunately, there seems to be no clear answer to the question. The discrepancies between what the writers said and what Velázquez did, between theory and practice, nonetheless shed light upon two problems: the relation

of Spanish baroque theory to art theories of the more distant past,[15] and the Spanish struggle to have painting recognized as a liberal art.

Among treatises written in seventeenth-century Spain, it makes sense to concentrate upon two books published in Velázquez's lifetime by people he knew: Vicencio Carducho's *Diálogos de la pintura,* published in 1633, and especially Francisco Pacheco's *Arte de la pintura,* published in 1649. Pacheco was Velázquez's teacher and father-in-law, and, as will be seen later, his remarks sometimes have special validity for Velázquez's materials. In addition to Carducho and Pacheco, it is occasionally useful to compare Palomino's *Museo pictórico y escala óptica,* finished during the first decade of the eighteenth century and published from 1715–24. Palomino had access to information on Velázquez through the painter's assistant, Juan de Alfaro, and that information has generally been proven accurate by later research.

For Spanish and European treatises in general, it has long been recognized that the theoretical sections—the justifications of painting as a liberal art—were in part reworkings of literary conventions and in part responses to social issues. But it has been supposed that when Carducho or Pacheco got down to describing how to grind their colors, heat their oils, and trim their brushes, they were providing on-the-spot reportage of actual practice. This high validity has been expected particularly of Pacheco, who usually is scrupulously correct on biographical matters.

Comparison of Velázquez's pigments with the pigments recommended by Pacheco and Carducho suggests that our faith in these writers is sometimes well founded. But it also suggests that our perceptions of the treatises as practical manuals of seventeenth-century Spanish art need to be refined. Pacheco lists fourteen of Velázquez's fifteen pigments: lead white, red ochre, vermilion, red lake, yellow lake, lead-tin yellow, yellow ochre, azurite, smalt, ultramarine, carbon black, bone black, umber, and Van Dyck brown.[16] This last pigment we have only tentatively identified in one of the paintings we examined. He lists the fifteenth, green earth, for fresco and tempera only. He recommends six more not used by Velázquez: orpiment, indigo, malachite, red lead, hematite, and verdigris. Of these, it should be noted that hematite can be considered as a pure form of red ochre. Carducho lists all pigments used by Velázquez, plus seven more: orpiment, indigo, malachite, red lead, hematite, *verdacho,* and *tierra negra.*[17]

Certainly Velázquez followed Pacheco's instructions in many cases, such as giving a canvas a ground of red ochre mixed with white lead. Such a ground was to be applied with a knife. Application with a knife of a ground containing lead white probably accounts for the series of arcs, which otherwise are inexplicable, that appear in radiographs of paintings like the *Forge of Vulcan* (fig. 15) and the *Surrender of Breda* (fig. 26).

Yet in other aspects of his technique, Velázquez differs considerably from his master, as when he paints the *Surrender of Breda* on a nearly white ground, like an Impressionist painting (colorpl. 4F). It would be naive to expect Velázquez to have used all the pigments mentioned by either writer or to follow their directives to the

letter, and some deviation from their texts would not necessarily be significant. In this case, however, it bears examining. Some of the pigments not used by Velázquez, like orpiment, are described by the writers as important. For example, Pacheco's discussion of orpiment is the longest among his descriptions of yellows, twice as long as the discussion of lead-tin yellow, which Velázquez used frequently.[18]

Similarly, in her comparison of Pacheco's *Arte de la pintura* with Pacheco's own pigments for tempera, Hidalgo Brinquis discovered that the writer/painter used far fewer pigments than he advised.[19] Most of the colors Velázquez fails to use are described as fundamental by both Pacheco and Carducho: indigo, malachite, orpiment, and red lead are discussed as though they were frequently used in Spain. From tests on paintings by Murillo, Antolínez, and Zurbarán,[20] it seems that Velázquez was not alone in avoiding those substances, as well as the hematite mentioned by Pacheco and the *verdacho* and *terra negra* mentioned by Carducho.

It is worth repeating here that our sample of Spanish paintings is small, and future analyses possibly will reveal instances of indigo, malachite, orpiment, or red lead used as colors. But one is tempted to predict that these pigments will not be found with frequency. One wonders why the writers persisted in mentioning unpopular colors. Three possible reasons come to mind. First, these pigments may have received emphasis because of their costliness and inherent value. Second, they may have been problematic to handle and have invited a show of mastery from the author who could claim to solve their problems on paper. In reality, neither of these two explanations is entirely valid, but they are too obvious to be dismissed without discussion. Third, and most likely, the missing pigments may have been mentioned because they were traditional ingredients in ancient painting and in Italian painting and had customarily been listed in earlier literature.

With regard to the inherent fineness of certain pigments, it is true that lists of other equipment were somewhat slanted to emphasize items of value, which were appropriate to the liberal art of painting. In the poems of Pacheco's elder colleague Pablo de Céspedes, the handles of the artists' brushes are carved of ivory and ebony, the bristles taken from the "sylvan vair" and the wild boar. Of course these materials must have been used occasionally, but it would be unusual to find a poem exalting brushes made of a common wood or the bristles of a barnyard pig. From antiquity there had been a homely tradition of conditioning pigments in urine, dung, saliva, or garlic. In fact, in the Middle Ages, Theophilus reported that an especially choice additive was the urine of a boy with red hair.[21] Of the Spanish writers, only Pacheco advises such ingredients as garlic and scraps of mutton or bile from cows. Carducho is more concerned with fixing a vocabulary in Castilian for major ingredients like the colors themselves, and he does not pause to discuss lesser items. Although literary ambitions may have encouraged writers to indulge in lofty descriptions of the ingredients of painting, it is doubtful that the fineness of pigments was ever a single cause for their emphasis. A persuasive piece of evidence against intrinsic value is supplied by the Spanish resurrection of the *paragone* or *parangón,* that old debate from Italy on

painting versus sculpture.[22] As Carducho put it, the sculptor, "declares the value of the material with which he works . . . [such as] the Minerva of gold and ivory by Phidias . . . " To this the painter can reply that "he will boast of the slight value of his material, for it is a scrap of linen and some pieces of earth, and a few oils, the glory [being] his intellectual, learned activity, which itself is sufficient to give such great value to his works."[23]

In Palomino's *Museo Pictórico* one feels that Spanish treatises have come of age, for the contradictions contained in earlier writings are reconciled within a coherent system. On the inherent fineness of materials, Palomino pronounces: "[the handles of brushes are] sometimes of ebony, or brasil, but these last two are only for princes, and gentlemen, or very fastidious persons, who glory in trying to achieve the most beautiful of all the trappings of painting."[24] In spite of Palomino's appreciation for refined equipment, he is careful to insist that "that tint, which may best give the desired effect, that one will be the most legitimate and the truest, though it be made of the dust of the road."[25]

The second possible reason for an emphasis on little-used pigments is that some are trickier to use, and thus require longer exposition. Orpiment was forever fascinating because it was poison, arsenic trisulphide, and had to be handled with care. Yet some difficult pigments, such as indigo and malachite, are not discussed at length, and thus the intractability of a color could not have been the only reason for dwelling upon it.

The third and best explanation for discrepancies between the treatises and the canvases is probably that the treatises had mixed purposes. As is well known, the battle over the inclusion of painting among the liberal arts was joined in Italy in the fifteenth century, and in Italy the struggle had turned in favor of the painters during the sixteenth century. In Spain, however, that battle did not begin until the seventeenth century, when it was fought with an obsessiveness that threatened to turn even the most neutral literature into a polemic. In fact, most of the treatises on the art of painting are thinly veiled arguments intended to raise the status of painters from artisans to artists.[26]

Carducho and Pacheco both had been influenced by the earlier belief in the importance of theory, which was summarized by Gutiérrez de los Ríos in his *Noticia general,* published in 1600. Gutiérrez attempted a general aesthetic philosophy designed to fit not only the visual arts, but also music, mathematics, rhetoric, equitation, the military arts, and so forth. Gutiérrez repeated earlier thinking in declaring that an activity became an art when it bore a meaningful relation to theory, to a system of rules and concepts. Art required "reason, rules and study," and it should be "a compilation, and gathering of precepts, and proven rules, that lead in orderly fashion toward some good and worthy use."[27] And theory was derived from a study of history and tradition. For example, Gutiérrez repeated the time-honored concept that talking is not an art, but rhetoric is,[28] because rhetoric is organized within a system of historical tenets.

Both Carducho and Pacheco turn to the tactic of establishing the theoretical pedigree of painting, and that includes the pedigree of the ingredients, or pigments. We discover that Apelles used red and yellow ochres,[29] Michelangelo painted with ultramarine,[30] Apollo preferred indigo,[31] and God used smalt.[32] Of the unused colors, Pliny and Vitruvius had discussed orpiment, indigo, malachite, and black earth;[33] Pliny had also referred to red lead and hematite.[34] Italian authors from Cennino to Vasari carried on the description of these pigments. Pacheco made an effort to associate the Greco-Roman pigments with the Spanish: *silaciis Attico* was the Spanish *ocre;*[35] *sinopide Pontica* was *almagra;*[36] *sandier* was *azarcón.*[37] Other writers did the same, as when Felipe de Guevara remarked on Vitruvius's *creta verde,* saying that "one can believe this to be the green earth (*verde tierra*), which they use in our present time."[38] Apart from the dispute over painting as a liberal art, writers of the seventeenth century felt an extravagant admiration for antiquity; within the dispute, the ancient pigments had to be emphasized to confer legitimacy upon contemporary practice. Significantly, when Pacheco first submitted his *El arte de la pintura* in 1641, he called it *The Antiquities and Grandeurs of Painting,* and in the final edition of 1649, volume one still bore that title.

Carducho's section on the "Practice of Art" has been considered an important document of the Spanish painter's materials. Although Carducho does list many of Velázquez's pigments, internal evidence indicates that his chapter is a pastiche of Spanish pigments combined with Italian pigments taken from Vasari and Lomazzo. Carducho never forgot that he had been born in Italy. He left Florence at the age of eight or nine, and spent his remaining fifty-odd years in Spain.[39] As the frontispiece to his *Diálogos* betrays, he attached more importance to his Florentine credentials than to his years as painter to the Spanish king. Carducho's list of colors introduces several Italian pigment names into Spanish, admittedly an easy thing to do between Romance languages, but he often gives Italianate spellings to words that are by 1633 rightfully Iberian. It seems that Carducho's motive in discussing pigments was to expand the Spaniards' horizons and not to limit himself to describing their provincial practices alone.

Like Carducho, Pacheco sought to achieve more than an account of contemporary practice in Spain, and to read his section on colors as an instructional manual is probably to misread his intention. *El arte de la pintura* is an anthology, drawing upon Pliny, Cennino, and Vasari, along with the unpublished writings of Pablo de Céspedes. In other words, the form of the treatises imitated the precept that should govern the art itself, which was that it should be "a compilation, and gathering of precepts and proven rules." It is difficult to separate paraphrase from original statement, and it would be unwise to make too much of the Spaniards' borrowings from sources as fundamental as Vasari and Cennino. Nevertheless, the recognition of those borrowings allows the modern reader to make better sense of some chapters that otherwise appear illogical or oddly organized. Sometimes the structuring of a chapter betrays the debt, as when Pacheco gives instructions for painting on canvases. In

Vasari, instructions for preparing canvases are immediately followed by instructions for painting on stones.[40] As a consequence, Pacheco interrupts his instructions for preparing canvases to introduce a lesson on painting on stones. Once the advice for stones has been registered, he goes back to discussing canvases and picks up where he left off with a list of pigments for those prepared canvases.[41] Similarly one wonders whether the second part of book three, chapter four, on painting in encaustic, would be there at all if it were not for the fact that Pliny had dedicated several pages to that procedure.[42]

Pacheco's and Carducho's debt to earlier literature is heavy, and that debt remains the best explanation for the discrepancies between the theoretical lists and Velázquez's pigments. In fact, the discrepancies make good sense if we assume that the practice sections of the Spanish books were intended as encyclopedias of pigment lore rather than up-to-date reports on contemporary Spanish colors. With an eye to conferring a noble inheritance upon recent practice, certain pigments became canonical in the artist's published palette, and ritual mention of them was required to meet standards of erudition and completeness, as well as to claim the legitimate descent of Spanish painting from an authorized tradition. All the prescribed but unused pigments are colors that figure prominently in earlier treatises: indigo, malachite, orpiment, red lead, and hematite date from the writings of Pliny and Vitruvius; *verdacho* and *terra negra* from Cennino, Vasari, and Lomazzo.

The considerable originality of Pacheco, however, demands that his relationship to traditional literature be clarified. In spite of his debt to Pliny, Vitruvius, Cennino, and Vasari, his observations are frequently new and daring. Even though he may make the required obeisance to a traditional pigment on one page, he has the nerve to criticize it on the next, as when he dismisses that revered item, ultramarine, with an offhand, "it is not used in Spain, nor do painters know how to use it."[43] Velázquez uses it, of course, and Pacheco appears oblivious to the fact that two pages later he himself will advise glazing lesser blues with it.[44] In any event, once Pacheco has put Cennino's "illustrious, beautiful and most perfect beyond all colors"[45] in its place, he then devotes his longest description of a single pigment to azurite.[46] In this section, he provides information on innovative techniques that appear to be drawn from his immediate experience. Likewise, the thoroughness of his instructions for red lake indicates extensive first-hand knowledge of it.[47] Pacheco was aware that Pliny had placed indigo among the precious pigments, but here again his opinions are his own: although he advises its use in oil, in tempera he relegates that expensive import to *"obras de menos consideración."*[48] The fact that Pacheco did borrow heavily from earlier treatises does not diminish his enormous contribution to our knowledge of grinding, mixing, and spreading colors. Even with these references to earlier literature, much of his advice is so meticulous that it provides fresh details. In his affection for craft, Pacheco is the Spanish Cennino, and he deserves his spot on the reference shelf.

But to use Pacheco as a reliable reference work, one still needs a way to separate

older customs from current practices. Until a better strategy is devised, we suggest paying attention to Pacheco's grammar. The least elegant of the writers, Pacheco left a seemingly senseless series of changes of person. For example, he speaks of orpiment in the third person: "*Some* use *jalde* or orpiment for the fine yellows in oil,"[49] but he goes on to describe a pigment like lead-tin yellow in the first person: "*I* use lead-tin yellow (fortunately) that leaves behind the color of the best orpiment in brightness and beauty, surpassing it in safety."[50] As noted in the glossary, a couple of Pacheco's pigment names are difficult to translate. But if our translations are correct, then, with the exception of verdigris, all the pigments mentioned by Pacheco in the first person are also found in Velázquez's paintings.[51] And even verdigris may one day be found in Velázquez's palette, since it was a common baroque pigment and is found in the paintings of other Spanish painters.[52] Velázquez used only one color not in Pacheco's first-person list: green earth. Even with his flat-footed prose, Pacheco managed to pass along the accumulated wisdom of the ages, as well as making his own living practice clear without setting it apart too noticeably from tradition. His first-person entries were still in use, whereas third-person ones were traditional, but no longer in use.

The insistence upon the pedigree of a pigment probably explains the short shrift given chalk, a frequent adulterant in Spanish practice, but a substance whose anteced-ents lay more in northern Europe than in the Mediterranean. Pacheco mentions chalk only in passing.[53] Carducho never mentions it at all. Small quantities of chalk are found in most of Velázquez's paints, and they have been identified also in the works of Zurbarán and Murillo.[54] A cheaper variety of lead white, called *lootwit*, contained chalk and was used in Holland in the seventeenth century. If something like *lootwit* was available to Velázquez in Spain, it might explain the frequency of chalk in his paints, although his paint does not contain as much chalk as *lootwit*.

The connection between Spanish and Netherlandish materials has received little study, but from chemical analysis one suspects that in reality the Spaniards wrote *a lo italiano* but painted *a lo flamenco*.[55] In general Velázquez's pigments are closer to those of Rembrandt than to those described by Carducho, Pacheco, and Italian treatise writers. The significance of this resemblance to northern pigments will remain uncertain until more data on the pigments used by Italian baroque painters are published. Nonetheless, it is worth pointing out that research on the works in the Mauritshuis by Rembrandt revealed that his palette, like Velázquez's, included lead white, red ochre, vermilion, red lake, lead-tin yellow, yellow ochre, azurite, smalt, carbon black, bone black, umber, Van Dyck brown, and green earth. Rembrandt also used chalk as an additive.[56] Although ultramarine has not been identified with frequency in Rembrandt's works, it was found in the *Resurrection of Lazarus,* now in Los Angeles.[57] Rembrandt uses malachite in his *Andromeda,* now in the Maurit-shuis,[58] but he does not use orpiment, indigo, or red lead. Except for the presence of malachite and the absence of yellow lake, Rembrandt's pigments are identical to Velázquez's.[59]

In fact, investigations carried out by the staff of the Doerner Institut have indicated that in a group of European paintings, most of which were Netherlandish, no orpiment, malachite, or red lead was found in paintings executed between 1600 and 1700; indigo was not found with frequency before 1650.[60] Rubens, however, seems to have transcended his nationality in many ways, by using a much more varied and Italianate palette than his Flemish, Dutch, or Spanish colleagues.[61] He does resemble Velázquez in his avoidance of orpiment, his use of chalk, and his substitution of a white ground or imprimatura for the colored one sanctioned by Italian tradition.[62]

The information on the pigments can be summarized as follows. It seems that Velázquez worked with a more restricted palette than his Italianate authors would lead us to believe. In view of this discrepancy between their writings and his paintings, one must assume that the so-called "practice" sections of Carducho and Pacheco were, at least in part, theory. Without a doubt one motive for claiming Pliny's or Vitruvius's pigments for Spanish painters was to exalt the status of the art of painting in Spain. But that motive, however valid, need not be claimed as a universal determinant behind the discussion of obsolete materials. The Spanish writers not only consciously echoed Pliny and Vitruvius, but also revealed their extensive familiarity with Horace, Quintilian, and Cicero. Pacheco read and wrote Latin, and he also must have known the sixteenth-century books on rhetoric and poetics that were available in Spain.[63] Rhetoric was securely established as a liberal art and poetry as a noble calling, and Spanish books on rhetoric and poetry, like books on painting, commonly refer to the prestigious precedent of ancient authors to praise and justify contemporary Spanish writings. The review of the Greco-Roman statements, in other words, was a convention so pervasive in writings on any subject that to some extent it simply became an activity in its own right. For all that it could be adapted to the real struggle to raise painting to a liberal art, that struggle was hardly the only reason for the emphasis upon the genealogy of materials.

In concentrating on why the writers included unused pigments in their lists, we have ignored the question of why Velázquez and his contemporaries avoided those same colors. As we noted earlier, pigments for oil paints changed all over Europe at the end of the sixteenth century or at the beginning of the seventeenth. The reasons for this change are as yet unknown, but it is worth pointing out that Palomino, writing some forty years after Velázquez's death, lists a series of colors that he says should be "exiled from the artist's palette" because they are bothersome to use or can change color. Prominent among these banished pigments are malachite, orpiment, and red lead. He has misgivings about indigo, too.[64] Palomino's blacklist does not serve as the perfect apologia for Velázquez's palette, however, for Palomino also wants to eliminate azurite, one of Velázquez's favorite colors. Overall, though, his list describes Velázquez's pigments remarkably accurately.

It is proverbial that the activity of one generation is rarely recorded until the following generation, and one is inevitably reminded of the truism about theory lagging behind practice, but the assumption that the relation of theory to practice is

so straightforward that it can be reduced to, in this case, theory's following practice does not do justice to the complexity of the relationship between writing and painting in the seventeenth century. Quite possibly theory does "follow" practice provided that one supposes that the function of theory, by definition, is either to precede or to follow real activity; such a simplistic assumption naturally leads to an elementary conclusion. Yet if the theory-follows-practice or practice-follows-theory presumptions can be set aside for a moment, a rather more complicated picture emerges. In their sections on practice Pacheco and Carducho do not limit themselves to prescribing or describing. Their aims are more intricate. For one thing, they seek to create a sober context in which painting can be properly valued; such a context seems intended to parallel the real activity of painting as much as to influence or chronicle it. Converting a canvas into something which can be discussed in philosophical terms is an ambition too spacious to be encapsulated by a neat formula. The urge to immortalize current pictures by linking them to precedent is similarly complex, for it is involved with the past, the present, and the future all at once. Even in the more narrative sections of the treatises, the writers desire simultaneously to describe past practice, to chronicle selected present activity, and to pass along helpful hints to the future practitioner. This complexity of the theory-to-practice relationship persists in the theorists' treatment of elements other than pigments, as will be noted in the section below.

THE GENEALOGY OF PERCEPTION

In view of the unexpected theoretical bias of the descriptions of ingredients, it seems a good idea to consider the few early remarks on technique, too. In our opinion, the early comments on Velázquez's facture also have their own history, and they should be placed securely in this context, rather than simply taken at face value.

By way of introduction, we note that several of the canvases we studied are covered with layers of discolored varnish, and only the *Coronation of the Virgin* and *Las Meninas* have been cleaned recently, although not in time for our examinations in 1980.[65] Until all the paintings can be cleaned, our observations about the seven Velázquez paintings remain hypothetical; nevertheless, they are based on a closer look at the works than had been available to anyone in recent memory.

In his pigments, Velázquez introduced no new chemical substances, using nothing for which the writers did not already have a word. In his techniques, however, he was an innovative artist painting at a moment in which novelties were being tried all over Europe. The greatest discrepancy between his practice and the writers' theories is that many of his inventions are ignored altogether by the writers. Some of his unmentioned techniques are so individualistic as to be peculiar within Spanish painting of the seventeenth century, and their very peculiarity may have discouraged theoretical discourse.

Eccentricity, of course, could not have been the sole reason for ignoring Velázquez's more unusual painterly habits. Some procedures may not have been

mentioned simply because they were unknown to anyone but the artist himself. In spite of this commonsensical caveat, in general it seems that there is a consistent pattern governing which techniques are noticed and which are ignored, and certainly viewers got close enough to see the ones they decided to talk about. The thinness of Velázquez's paint, which is sometimes almost the consistency of wash, is not discussed by the writers of his time, though it was an outstanding element in several famous paintings. Just as Palomino gives accurate information on the lack of certain pigments, he alone mentions a thinner paint, but not in connection with Velázquez. Palomino recommends mixing one part oil and three parts turpentine varnish, describing the technique of using a liquid paint as "easy, because the paint spreads more softly, and masterful, because it can be worked more freely . . . and one may highlight, and build up as much as one likes, with the paint remaining juicy and lustrous . . . "[66] This passage is reminiscent of Velázquez's painting style, but the artist cited is Luca Giordano. For all that Palomino says that Luca had said to the king that *Las Meninas* was "la Teología de la Pintura,"[67] Palomino does not oblige us further by saying that Luca's thin paints were in any way related to Velázquez's thin paints.

A second element that went unremarked was Velázquez's freedom in varying the color of his grounds. Like the *Rokeby Venus* in London (fig. 55),[68] the *Surrender of Breda* was not painted on the red or gray ground commonly found in Spanish baroque paintings and recommended by most treatises. Instead the sky was painted on a nearly white ground, without any colored imprimatura at all. The white ground helps explain the painting's luminosity and the brilliance of its colors.

Another unusual technique not discussed in the treatises is Velázquez's addition of lumps, perhaps palette scrapings, to otherwise liquid paints. Palette scrapings are likely to make their way into paint even when the artist does not want them there, but in the *Surrender of Breda* (fig. 23) and the *Portrait of a Dwarf* (fig. 34), these lumps seem too frequent to be accidental. Velázquez's use of this technique, however, seems to obey no consistent principle. In the *Surrender of Breda*, for example, one large protrusion stands about one-quarter inch off the surface of the canvas even after lining; it seems to increase the three-dimensionality of the rough stone that establishes the foreground. Yet, in other paintings Velázquez concentrated many lumps in one decorative area, such as the jacket of the dwarf, whose black garment is sprinkled with shining studs of raised paint that catch the light to produce a glittering effect.

Other eccentric effects in Velázquez's paintings deserve mention, such as the little strokes of chalk drawn on top of, not beneath, the oil paint in the chestnut hair of Venus in the *Rokeby Venus* (fig. 56).[69] Another peculiarity is found in the liquid and luminous edge of the robe of God the Father in the *Coronation of the Virgin*, where Velázquez let a broad drip of red lake slide along until it stopped, the end of the broad drip cupping like a Morris Louis *avant la lettre*. A similar effect is achieved in marking the horse's right front leg in the *Surrender of Breda*, where the diluted paint was placed at the top of the marking and also allowed to run down.

Since these oddities of the painter's craft are nowhere mentioned by writers, Velázquez's techniques, like his pigments, must have been discussed within a preconceived framework, and this meant that a substance of dubious ancestry, such as chalk, was scarcely discussed at all, in spite of the fact that Velázquez used it extensively. Similarly, the silence about Velázquez's innovations in technique suggests that their eccentricity rendered them irrelevant—that they had no utility within the vocabulary of contemporary controversy and that, indeed, there may have been no vocabulary of any kind to guide perception or discussion. As Gutiérrez de los Ríos had pointed out in his seminal treatise of 1600, artistic validity was assured by an action's meaningful relation to rules. Once it went beyond the bounds of the rules, Velázquez's technique could not conveniently be discussed within the idiom of Spanish artistic theory.

The procedure of making pentimenti was one technique that had already been converted into a theoretical concept in the sixteenth century with the development of the Italianate rubric of *colore* or *colorito*.[70] During the first half of the seventeenth century, however, poets and theorists usually confined their remarks on pentimenti to those made by Titian. Pacheco, for example, notes that Titian revised as he painted, and the early Spanish references to the Venetian painter probably reflect the fact that his controversial techniques were widely publicized. Furthermore, Titian was a significant enough figure for Spaniards for almost any of his recorded activities to have become discussable. So even though pentimenti were mentioned in treatises during Velázquez's lifetime—indeed, in the 1660s a poem dedicated to Velázquez makes casual mention of his retouchings[71]—it is not until later in the century that revising is discussed with frequency and ease.

All Velázquezes studied by us have revisions or pentimenti[72] (figs. 2–5, 9–12, 15–20, 26–32, 35–38, 46–48). Nevertheless, one possible reason for deemphasizing pentimenti in Spanish treatises was that they posed a theoretical threat to the advancement of the status of painting. In spite of the precedent of Titian and the conceptualization of colorito, these corrections posed a dilemma for Pacheco and other Spanish writers in the first half of the century. The concept of drawing or *dibujo*, absorbed from Italian theory, was established as the intellectual foundation upon which painting's claim to being a liberal art partly rested. In both Italian and Spanish theory, drawing meant both a physical sketch on paper and the overall design of a painting, and, as Pacheco understood it, the concept required that the artist make a series of preparatory drawings in which all details were worked out before painting in oils began. Because dibujo (also called *diseño*) demanded mental activity, it testified that painting was an intellectual endeavor. And in Italy *disegno* had been successfully used as a weapon for advancing the status of painting, so the Spaniards' interest in translating this success into local terms is understandable.

The concept of dibujo, then, amounted to a prohibition against revision of the painted work; oil, nevertheless, is a medium that is particularly amenable to alteration, to "repenting" of a form and covering it over with something new. By the time

that Pacheco was insisting upon dibujo, strict allegiance to that central Italian concept was already becoming a thing of the past in Spanish practice. Thus Pacheco found himself in the uneasy position of claiming dibujo as a contemporary practice when in reality Spanish painters were already more interested in *color,* the naturalistic tradition that sixteenth-century Italian theorists had perceived as the polar opposite of disegno. There is a good deal of lip service to resolving every detail on paper, but even Pacheco bends his rules to accommodate a particular historical precedent: Titian.

Titian's influence upon the style, technique, and thinking of seventeenth-century Spanish painters deserves its own detailed study. Pérez Sánchez has provided a magisterial introduction to the topic in general, and here it is possible to touch upon it only as it regards Velázquez and his technique.[73] As the Prado's great collection of Titians attests, he was a favorite painter of the Hapsburg monarchs, and the fact that Charles V had conferred nobility upon him was enough to make him a painter of mythic achievement in the eyes of Spanish theorists. Taking famous advantage of the oil medium, Titian did make corrections on many canvases, a practice noted by Pacheco and others, and doubtless observed in the paintings themselves by Velázquez, who was in constant contact with the royal collection. Velázquez surely knew, for example, the *Entombment* by Titian, for it was brought to Spain for Philip II (figs. 68, 69). In this painting, the right hand of Mary Magdalen was once higher, and Titian covered it over thinly and repainted it in its present position.

Treatise writers were fond of comparing Velázquez and Titian as masterful colleagues. For example, Pacheco says of a portrait by Velázquez that it was "painted in the manner of the great Titian, and (if it is permissible to say so) not inferior to his heads."[74] Of course, it could be said that Titian is the ultimate source of all technical tours-de-force in European oil painting, but standardized references to Titian in Spanish writings in particular became such a commonplace that one must conclude that his work was more than a mere model for style. His oeuvre came to represent a point of view. His style was seen ultimately as the symbol of an ideological system representing a mishmash of associations about *colorido,* free brushwork, social recognition, and, ultimately, the privileged descent of Spanish painting from Venetian painting.

Surely one motivation for comparing Velázquez and Titian was the occasional resemblance, at least to the naked eye, of their canvases. Yet the writers' emphasis upon this relationship, and even Velázquez's own mention of Titian's name during his second trip to Italy, no doubt reflected a philosophical stance as well as a concrete influence. For all that Titian may have been a source of inspiration, deference to his name was de rigueur in painters trained in the Spanish school of theory. Titian was cited over and over as the greatest colorist, the finest portraitist, the inventor of free brushwork, the recipient of a grant of nobility. If one peruses biographies of Spanish artists, including Velázquez's, it seems that every third

painter painted "heads in the manner of the great Titian," or made paintings that were "*muy parecidos al gran Ticiano.*" No other painter, Spanish or foreign, is so often cited as a yardstick for achievement in Spanish painting of the seventeenth century.[75] Yet as is noted in chapter 2, Velázquez's actual technique is often closer to that of Tintoretto, though that less prestigious painter attracted less notice from the theorists.

BORRONES AND MANCHAS

In this evaluation of Velázquez's painterly innovations, however, some refinement is still needed. Many aspects of his facture went unremarked in his lifetime and even the flagrant making of pentimenti was noted only elliptically, but, by contrast, one technique was associated with Velázquez at least twice during his life and once again by Palomino in the early eighteenth century: his *borrones* or loosely-stroked slashes of paint (figs. 24, 43, 44, and colorpls. 1A, 1B, 3A). As we shall show, however, the verbal remarks on Velázquez's visual tricks are neither fresh nor original. Instead, their discussion represents a recycling of ideas that had been around for quite some time.

The Spaniard Vargas had reported that Titian's brushes were "as big as a birch broom"; although publication of his remarks had to wait until the nineteenth century, shop rumors may have circulated in Spain.[76] Such rumors find expression in a statement by Fray Jerónimo de San José that Titian "invented that other [method] so strange and forceful, of painting with strokes of a huge brush."[77] Such reports resonate in Palomino's statement that Velázquez "painted with long brushes, and with the spirited manner of the great Titian."[78] As in the case of the pigments, Palomino's statements, which may be true of Velázquez, may have contained, in addition, an element of ritual, a citation of Titian's past activity to legitimate Velázquez's current practice. Nothing is more difficult than evaluating comments that are motivated by a desire for propaganda but that also may be true. After all, long brushes might have allowed Velázquez to stand back from his painting, the better to convey the image as seen from a distance. In any event, here Titian may play for Velázquez the role that Pliny or Vasari played for his pigments: both a genuine influence and a theoretical justification. And if Velázquez's technical relation to Titian, like the relation of his pigments to those of earlier artists and writers, had an undeniable thread of continuity, it seems that the treatise writers made that thread a lifeline, securely binding Spanish painting to a more glorious past.

In noting the free brushwork of Velázquez's paintings, writers compared his spontaneity with precedent, as when Palomino says that Velázquez painted "with the spirited manner of the great Titian." Vasari had said of Titian's brushstrokes that "they cannot be looked at close up—but from a distance they appear perfect."[79] Palomino says of Velázquez's brushwork that it "could not be understood close up, and from a

distance it is a miracle."[80] Palomino's statement was thus a rephrasing of a traditional observation. But Vasari's remark was itself a refurbished trope, a convention that derived ultimately from Horace's famous passage comparing poetry to painting. Thanks to Horace, the concept of proximity versus distance was to provide a favorite category of perception for viewers in Velázquez's time.

In the *Ars Poetica*, Horace had not only mentioned painting, but he had also gone on to talk about how a painting looked: "a poem is like a painting; one pleases you more, the closer you stand; and another, the farther away."[81] The consideration of the spectator's distance from a painting was well absorbed into European literature, and thus it is hardly surprising that Vasari should say of Titian's brushstrokes that "they cannot be looked at up close—but from a distance they appear perfect." As will be seen below, the nearness/farness habit of perception crops up obsessively throughout Spanish literature of the Golden Age.

Perhaps because the purpose of observations about the viewer's distance was as much to rehearse a rhetorical convention as to describe a living reality, the discussion of brushwork is carried on through an underdeveloped vocabulary. As Baxandall has pointed out, the classical ancestry of European art criticism led writers to think in binary contrasts almost from the beginning of humanistic discourse.[82] So brushwork in the seventeenth century in Spain was presented in terms of a polarity: one could either *unir* one's strokes, blending them in smoothly polished surfaces, or one could *manchar*, painting with splotches and visibly separate strokes, or *borrones*. The argument over manchas and borrones itself became an independent controversy, the miniature mania mentioned at the first of this chapter. Once again, Titian served as the justification for *manchando*, and for a Spaniard, Venetian painting came to be seen as synonymous with free brushwork.[83]

In order to understand the seventeenth-century ideas associated with them, one must place references to Velázquez's borrones and manchas in their contemporary context in poems, sermons, popular sayings, and treatises. And ultimately these references must be understood within the debate about *dibujo* versus *colorido*. Although the terms of that debate originally were borrowed from the *disegno* versus *colore* confrontation in Italy, they were eventually transformed into Spanish concepts with Spanish connotations. As one follows this transformation chronologically, it becomes all but impossible to separate borrones and manchas from the issue of the viewer's nearness to or farness from the painting. Nor is it easy to disentangle these components from the general discussion of naturalism, colorido, and Titian. Instead of struggling to isolate each element, it seems better to leave these threads in their interwoven (and sometimes tangled) state and to try instead to sketch the development of the whole web of ideas.

In 1629 a stanza attributed to Quevedo in his *silva* to the paintbrush, *Al Pincel*, not only celebrated Velázquez's manchas, but specifically called them *manchas distantes*, implying that the viewer's distance from them was of interest.[84]

> Y por ti el gran Velázquez ha podido,
> diestro, cuanto ingenioso,
> ansí animar lo hermoso,
> ansí dar a lo mórbido sentido
> con las manchas distantes;
> que son verdad en él, no semejantes.[85]

[By means of thee (the brush), the great Velázquez has been able (being as skillful as he is clever), thus to give life to the beautiful and thus to give sensation to the soft, with the distant blobs which are truth itself and not resemblances.]

A second reference to Velázquez's brushwork occurs in 1646 in Juan Francisco Andrés Uztarroz's *Obelisco histórico*, when Uztarroz remarks that

> the beauty consists in a few well-worked brushstrokes, not because a few do not require labor, but so that the execution may seem free, effortless and not affected . . . Diego Velázquez uses this very elegant manner, for with his subtle skill he shows how much Art, expression and rapid execution can do in a few brushstrokes.[86]

Uztarroz's comments read like a compendium of commonplaces. For all that his oblique references to *sprezzatura* and *facilità* remind the reader that those qualities are associated with free brushwork, what is most interesting is his approval of Velázquez's *pocos golpes*, which from the context can be assumed to have been free *borrones*. Obviously the admiration of the poet who wrote the silva, or the admiration of Uztarroz, did not come out of the tenets of the theorists like Pacheco, who claimed to favor disegno over colore. To understand better the eventual Spanish acceptance of borrones and manchas, and the reservations that qualify that acceptance, it is necessary to look at early references to the borrón and to review its development from its first mention until the 1670s, when Jusepe Martínez's *Discursos practicables* made it clear that the metamorphosis of the early concept, along with its coloristic associations, was complete.

From Accident to Artifice

In many references made during the seventeenth century, the words borrón and mancha had comparable meanings. In spite of their rough equivalence, in the realm of connotation a borrón had certain nuances of its own. The verb *borrar* meant to erase, cancel, or remove, and the original meaning of borrón in painting may have been a slash, blob, or splotch that covered something up, presumably in a messy or provisional way. From early on the borrón was associated with a preliminary stage of a written passage, and to this day a *borrador* is a rough draft. As was pointed out by Socrate in his early research on the term, Nebrija's *Vocabularió* of 1492 lists borrón as derived from *borra*, coarse wool, and borrar, to erase; the link with *borrón de escriptura* or inkblot is also noted.[87] Early in the history of the word, the borrón seems to have been linked with negative qualities. In Covarrubias's dictionary of 1611, the

physical blot has already acquired the moral sense of a stain upon one's honor: a borrón is the "ink drop that falls on what is written, and by allusion the bad deed that darkens whatever there may be in a man that is best."[88] In the early picaresque novel, *Lazarillo de Tormes*, the negative sense of a moral blemish appears again. In part two, chapter eight, which describes "How Lázaro brought a lawsuit against his wife," Lázaro recounts that his friends "were advising me, as one so dear to them, to remove the borrón from my honor by returning to fetch her."[89]

In 1615 Fray Juan de Santa María characterized El Greco's borrones as *crueles*,[90] an uncomplimentary adjective that Pacheco was to repeat in his *Arte de la pintura*, finished in 1638.[91] Although the connection was not explicitly stated, probably the ancient requirement that art be deliberate influenced the early reception of the borrón. Inkblots are not done on purpose, and preliminary sketches do not exhibit the fully conscious control that is part of true art. "That which is done by chance is not art," says Pacheco in another context, adding, with his usual scrupulousness, that this rule was laid down by Aristotle and by Seneca.[92] The antique dictum was to be maintained throughout the seventeenth century, but the borrón was to be redefined so that it could be vindicated, not condemned, by the Aristotelian standard. As a result of some subtle refinement in the use of the word, the negative associations seem gradually de-emphasized; as the years went by, both borrón and mancha were used increasingly to describe admired forms. Nevertheless from time to time there were still viewers who had reservations, and whenever a freely-brushed area of paint was to be criticized, borrón, not mancha, was likely to be brought into play, as if to intimate impending disapproval.

The borrón's negative tinge made it exquisitely effective in Lope de Vega's *La Corona merecida* in 1603. In this *comedia*, which deals with the wrongful passion of King Alfonso for a married woman, Doña Sol, the monarch has unjustly imprisoned the virtuous lady's husband. King Alfonso will free him if Doña Sol will grant her favors. Desperate to free her spouse, she agrees to the king's summons but she closets herself first with, significantly, a lighted candelabra or torch. When she does arrive at the king's apartments, she begins to disrobe while he watches. She approaches him and lifts her sleeves, suddenly revealing hideously burned and lacerated flesh, at which point the horrified monarch cries out:

> ¡ Quedo, quedo no me hagas
> más asco, falsa belleza!
> Quita esos paños sangrientos
> que el estómago me mueben.
> . . .
> O pared negra y borrada
> con telas de oro cubierta!
> ¡ O dulce imaginación
> con el suçeso siniestro!
> ¡ O, ymagen de pintor diestro
> que de cerca es un borrón![93]

[Stop! Stop! Don't make me more nauseated, false beauty! Get rid of those bloody draperies which turn my stomach. O black and *borrada* wall, covered with cloths of gold! O sweet hiding of the sinister event! O image by the skillful painter, that up close is a *borrón*!]

When seen clothed and from a distance, Doña Sol is lovely. From up close, and when revealed in reality, her flesh is a borrón. For all that the close view is disgusting, Lope's description of it is tempered by admiration for the artist who can contrive so triumphant an illusion: "O image by the skillful painter, that from up close is a *borrón*!" A certain distance from Doña Sol, as from the borrón, is a prerequisite for successful deception of the eye, and the relationship between the viewer's distance and the new style of painting is repeated by other writers again and again in poems, plays, sermons, and treatises on art.

In 1600–05, Padre Sigüenza demonstrates the still-ambivalent attitude toward the newly painterly brushstroke. Speaking of Federico Zuccaro's *Adoration of the Magi* in the Escorial, he remarks, "because he had tried so hard to give the paintings an illusion of three-dimensionality from a distance, they would not be so agreeable when seen from up close."[94] Similarly, when Sigüenza speaks of Navarrete el Mudo, a Spanish painter famed for having studied with Titian, he prefers Navarrete's smooth, pre-Italian style:

> In these four paintings, it seems to me that Juan Fernández (Navarrete) followed his own inclination and let himself be guided by his innate genius, which consists of his working very beautifully and with a very smooth finish, so that the work could meet the eyes and be enjoyed however close they wanted to come, a particular taste of Spaniards in painting. It seemed to him that this was not the way of those with daring or what he had seen in Italy . . . and thus in the rest of the paintings he did not finish them so highly and he put more effort into giving whatever he did three-dimensionality and force, imitating more the manner of Titian.[95]

In 1633 Carducho is another useful witness to the use of borrones, and he alerts us to the fact that borrones are acquiring new associations. There are good borrones and bad borrones. In spite of his leanings towards dibujo, he accords the borrón a legitimate place within certain kinds of paintings, provided that strict criteria are met. At the same time, he reveals the connections between borrones, nearness/farness, and Titian. Not surprisingly, the full passage comes under the chapter on different styles of painting, beneath the subheadings of *pintura perfilada* and *pintura de borrón:*

> afterwards he did admirable things with borrones, and after that the entire Venetian School painted in this very bizarre and daring way, and with such license, that some paintings are barely recognizable from up close, although if one moves back an appropriate distance, one discovers through an agreeable view the artfulness of the painter; and if this deception is done with prudence, and with measured, luminous and colored perspective, and is colored so that one achieves by this means what one seeks, it is not less admirable, but rather much more admirable than that other polished and finished manner.[96]

Carducho concedes, as Italian writers before him had done, that such coloristic handling is suitable in a given situation: when paintings are to be seen from a distance.[97]

In spite of the fact that Carducho allows coloristic practices a limited utility, he does his share of theoretical vacillating. He looks back to the doctrine of Florentine *disegno* as supreme over Venetian *colore*, saying, "Understand that drawing . . . is the perfection of Art . . . "[98] Still following the Central Italian doctrine, he describes *color* or colorido as insubstantial decoration for good drawing, useful merely as a vehicle for naturalism and communication of emotion or *afectos*, and, repeating this idea, for making a painting meaningful to a distant viewer.[99]

Already in Carducho the basic Italianate pairings and associations are set forth. *Dibujo/colorido, perfiles/borrones,* and *cerca/lejos* were all linked polarities, and each pair expressed an issue that eventually involved the other pairs. Thus dibujo, perfiles, and cerca all shared a theoretical fraternity, as did colorido, borrones, and lejos.

Pacheco, like his colleague Carducho, claims primary allegiance to drawing, saying that it is "the life and soul" of painting.[100] Of the early Spanish writers, Pacheco is most aware of his predicament in claiming dibujo as superior, while regarding Titian, with his colorido, as the supreme artist. In book two, chapter eleven, he states his dilemma frankly in the form of a reply to three defenses of borrones. The first argument which Pacheco feels he must refute is that "most of the painters [that is, those who make borrones] do the opposite of what I approve, and whatever is used by so many . . . has the force of law."[101] Pacheco's reply is simple: "What is used by the most is not the best." Then he summarizes the second argument as, "painting with borrones, made to be seen from far away . . . has more force and three-dimensionality than the finished and soft."[102] Here Pacheco concedes that borrones save time, but he declares that there is no evidence that borrones carry better or have more three-dimensionality than a smoothly finished painting, because "he who works at it can give his painting all the force he may want, as one sees in the paintings of Leonardo da Vinci, of Raphael of Urbino, which are very highly finished."[103]

Pacheco's third argument is most telling: he reviews the case of Titian and, in effect, redefines "finish" to allow the grand master his place. He begins by confessing that "they also resort to another very strong argument, which seems impossible to discredit, with the example of Titian . . . since when a painting is not finished, they have a saying, calling it *'borrones de Ticiano.'* "[104] (figs. 70, 71). Pacheco's reply to this last custom shows him at his most uncomfortable. First he defends Titian by saying that "unfinished" can refer either to facture or to composition. Thus a painting with borrones can still be finished if it lacks nothing essential. "This part Titian had," Pacheco rationalizes, "as such a great artificer, and his borrones are not taken the way they sound, for it would be better to say brushstrokes placed in the appropriate place, with great dexterity."[105] But having given Titian this rather clumsy reprieve, Pacheco cannot resist one last dig: "And be advised that his best and most esteemed paintings (which I have seen in the Pardo and the Escorial) are the most finished. . . ."[106]

Pacheco was well aware that the issue of nearness versus farness was grounded in antiquity. As if further to support his misgivings about borrones, at the end of this chapter in which he argues for and against this issue, he quotes Horace's *Ut pictura poesis* passage. Modern classicists have pointed out that Horace's dictum can be interpreted as favoring either proximity or distance, and thus either smooth or rough finish. But to Pacheco the lines admitted but one reading: according to Pacheco, Horace's conclusion was

> that there are poems that are for far away, to be heard in passing, and not studied; and others, which grow in value when examined closely, because they possess in themselves a great many good things to consider; so that painting done for up close, because its parts tolerate a greater test, is here more praised by the poet, and is compared quite accurately to good poetry.[107]

In the midst of these ambivalent remarks on the borrón, an important refinement has been taking form. This refinement, which began with Carducho's discussion, involves the belief that borrones could be done badly or well. A competent borrón then becomes a concept in itself. And corresponding to the painter's good or bad judgment is the viewer's judgment, which is equally fine or faulty. As the following passage from Carducho points out, the sensitive connoisseur will appreciate the well-done blob or smear, and only the ignorant will criticize it:

> and when a painting is made by this approach, to the person who is ignorant about Art, and inexperienced, it will seem that the contours and proportions are full of encumbrances, and confused muscles, and the colorido full or borrones, and badly placed and strident colors, with no proportion or art; and thus when these paintings and their effects are contemplated, will not the connoisseur recognize that the paintings that are done with this learned artifice deserve greater estimation than the others, which are made with only common rules?[108]

The careful insistence upon the connoisseur's sensitivity keeps up until late in the century, as an anecdote from Martínez in the 1670s makes clear. The tale itself is a commonplace. In Martínez's use of it, it concerns a painter commissioned to execute a picture for an important chapel. When the painting is finished, the artist takes it to the chapel, but does not install it. The patron arrives, glances rapidly at the painting, and says to the painter: "Sir, I did not expect from your hands work so crude, and unfinished, for it is all borrones. Try to give it the perfection that I expected." The painter replies that the work was indeed unfinished, and that it will not be completed until it is in place. The painter then installs the work, waits for a month before allowing anyone to see it, and invites the patron to return. The patron, here cast as the fool, "was amazed that the painter had improved the picture so much in so short a time: the disciples of the master had a good laugh, knowing that he had not retouched anything at all."[109]

Paintings made with this *docto artificio* are superior, not inferior. Even the seeming

carelessness of such brushwork is masterfully calculated to rival nature's brush, as Lope points out:

> A tí que con descuido artificioso
> Produziste más arboles y flores
> Que estudiosa de esmaltes y colores
> La Aurora en la más fértil primavera.[110]

[To thee who with artful carelessness, created more trees and flowers than Aurora, who was wise in the ways of enameling and colors, in the most fertile spring.]

As these comments made from 1603 on point out, eventually the exquisite borrón was perceived as a mark of distinction in the eyes of the *conocedores* of the court. In fact, now on a deeply serious level, a fine borrón was so highly regarded that its author could be still greater than Lope's *pintor diestro:* he could be likened to *Deus pictor,* the creator of the world, for a painting, the poet and priest Paravicino says, is like the world. It must be seen in the right light to be understood, just as the world must be seen in the light of Christ's teachings. In a sermon delivered in the Royal Chapel of Madrid in the presence of Philip IV and published in 1638, he explained:

> Because when speaking of the world, which according to the pen of the apostle [II Corinthians:7] is no more than a painting. *Praeterit figura huius mundi.* To be the light of the world is not just to be the light so that it may be seen, but the light so that it may be contemplated, and with which it may be judged. For in a painting, those who possess this learning know that it is important to see the painting in its right light, not just to judge it, but even to see it. For if a panel by Titian is not contemplated in its light, it is no more than a conflict of borrones [*una batalla de borrones*], and brushstrokes of badly shaded red colors. And seen in the light for which it was painted, it is an admirable and daring blend of colors, a spirited painting, which even in terms of the verdict of the eyes, puts truth on trial. *Ego sum lux mundi,* as Jesus Christ says of this painting of the world.[111]

Not surprisingly for a sermon preached for that devoted collector of paintings Philip IV, the argument is that the enlightened Christian, like the enlightened connoisseur, must see the world or the painting in its intended illumination. A learned contemplator, be it of Titian or of theology, knows how to look to true advantage.

Returning to the passage attributed to Quevedo quoted at the beginning of the discussion of borrones, the silva on Velázquez represents a more individualized tribute:

> y por ti el gran Velázquez ha podido,
> diestro, cuanto ingenioso,
> ansí animar lo hermoso,
> ansí dar a lo mórbido sentido
> con las manchas distantes,
> que son verdad en él, no semejantes.[112]

22

[By means of thee (the brush), the great Velázquez has been able (being as skillful as he is clever), thus to give life to the beautiful and thus to give sensation to the soft, with the distant blobs which are truth itself and not resemblances.)

The passage also makes it clear that Velázquez goes beyond mere resemblance, which is the usual goal of colorido, creating manchas that reflect a higher truth, being *verdad en el*. Another criterion for a good borrón is also brought into play: a good mancha or borrón is not only lifelike in its effect, but also it is economical. The execution must be summary, but the painter's negligence must be merely illusory, the camouflage for brushstrokes placed with precision and optical efficiency. The differentiation in quality from borrón to borrón is pointed out yet again if we return to Uztarroz's passage on Velázquez, quoted at the beginning of this discussion of borrones:

> the beauty consists in a *few* well-worked brushstrokes, not because a *few* do not require labor, but so that the execution may seem effortless and not affected . . . Diego Velázquez uses this very elegant manner, for with his subtle skill he shows how much Art, expression and rapid execution can do in a *few* brushstrokes [italics added].[113]

To sum up the history of the reception of borrones in Spain: originally connoting condemnation, the borrón underwent a decided change in meaning between the late sixteenth and early seventeenth centuries. As its acceptance found voice in treatises, plays, poems, and sermons, some fine differentiations began to be noted. Appreciation of the borrón was reserved to the discriminating connoisseur, and borrones required a special mode of viewing. In addition to seeing the borrón from the proper distance and in the correct light, the viewer needed learning, experience, and sensitivity to decipher the painted code. To the initiate, the successfully decoded message carried a sense of heightened reality, a revelation—as is clear from Paravicino's sermon—of profound near-divine truth. Such enhanced validity required skill on the part of the painter whose brushwork was to achieve it. The staccato strokes had to be few in number, brushed in quickly and seemingly without effort, and placed "in the appropriate place, with great skill." If all these exacting criteria could be met, the resulting painting could claim *verdad*, not mere verisimilitude (cf. colorpls. 1A, 1B, 3A).

The good borrón was no longer provisional or accidental. It combined the necessary Aristotelian deliberate intent with the artist's *ingenio* and *destreza*, his talent and skill. Spaniards, with their concern that their pictures meet traditional criteria for fine art, ultimately legitimized the new brushwork by means of old standards. The process of legitimization is often implied by a poet's phrasing. Lope's *descuido artificioso* points up the paradox, neatly encapsulating both the dilemma and the solution: the brushwork looks like carelessness or *descuido*, but in reality it is *artificioso*, full of artful awareness. The reference to Velázquez in *Al Pincel* as *diestro, cuanto ingenioso*, makes the same association of skill with intellectual talent, neither of which is accidental in producing a mancha. Carducho comes closest to spelling out the new justification when he refers to the *artificio* of the painter, continuing to say:

and if this deception is done with *prudence,* and with *measured,* luminous and colored perspective, so that *one achieves by this means what one seeks,* it is not less admirable, but rather much more admirable . . . [italics added].[114]

To the modern reader, the question of whether Spaniards linked the borrón with the Italianate *non finito* comes to mind. Of course the Italian tradition was by now familiar to the Spaniards. In addition, the *non finito* likewise involved issues of proximity or distance from the work of art. Although the potential relevance of the *non finito* cannot be ruled out, the terminology associated with that Italian idea does not always appear explicitly in Spanish discussions of the borrón.[115]

Titian

In virtually every reference to the borrón, Titian and Venice have been all but omnipresent, in implication if not in manifest statement. As the following passages make clear, Titian provided a ready pattern for the mythologizing of the artist as much as his work provided a model for brushwork. Indeed, his biographical model, as well as his arguably exemplary painterly techniques, eventually had its echoes in Spanish stories about Velázquez's life.

Carducho had described Titian as imitating the "bizarre and daring" manner that "afterwards all the Venetian School followed with such license." Such mentions of Titian are too frequent to inventory here, but it must be noted that the Spaniards perceived him as a deliberate revolutionary who redefined the art of painting, an artist of courage, daring, and originality. Coming ultimately from classical antiquity, and common coin since Vasari's treatment of Titian, the daring artist who breaks with his master was becoming yet another trope, and Titian's remaking of pictorial style is remarked by various Spanish writers, including Carducho, Gracián, and Fray Jerónimo de San José. An early Spanish rendition of what was to become the standardized pattern appears in Antonio Pérez's letter to Philip II:

> One day the ambassador Francisco de Vargas asked him [Titian] why he had turned to that style of painting . . .with broad brushstrokes, almost like careless borrones, . . . and not with the sweetness of the brushwork of the great painters of his time; Titian responded: "Sir, I wasn't sure that I could succeed at the delicacy and beauty of the brushwork of Michelangelo, Raphael, Correggio and Parmigianino, and even if I were to succeed, I would be considered less than they, or considered their imitator."[116]

In its free yet recognizable adaptation of the pattern, a later quotation from Fray Jerónimo in his *Genio de la Historia* of 1651 makes it clear that the rebellion of the ambitious student was a stock tale:

> Since Titian was tired of the ordinary mode of painting in a smooth and subtle way, he invented that other mode, so strange and intense, of painting with broad brushstrokes almost like random borrones, with which he achieved new glory, leaving . . . behind Michelangelo, Raphael, Correggio and Parmigianino . . . and as one who does not

condescend to walk on the ordinary road, he blazed a trail and made his entrance by means of mountain top and detours.[117]

Eventually this particular trope is applied to Spanish artists. In 1637 Gracián in his *Agudeza y Arte del Ingenio* tells of a *galante pintor,* unnamed but presumably Spanish:

> Without leaving the rules of art behind, the talented man knows how to leave the ordinary behind and find in the aging profession a new path towards eminence. Horace conceded the heroic to Virgil and Martial conceded the lyrical to Horace. Terence turned towards the comic, Persius towards the satyrical, all of them aspiring to pride of place within his genre. For spirited creativity never surrendered to facile imitation. The other courteous painter saw that Titian, Raphael and others had an advantage over him. Their fame was greater now that they were dead; he took advantage of his invincible creativity. When he took to painting flamboyantly, some reproved him for not painting in a soft and polished style, in which he could emulate Titian, and he replied politely that he would rather be first in that kind of coarseness than second in delicacy.[118]

The well-known quotation from Palomino on the young Velázquez clearly derives from this institutionalized legend:

> At that time everything our Velázquez did was in this vein [of *bodegones*], in order to set himself apart from all the others, and to follow a new route. Knowing that Titian, Alberti, Raphael, and others had an advantage over him and that their fame was greater now that they were dead [and] taking advantage of his inventive creativity he took to painting rustic subjects flamboyantly with strange lighting and colors. Some reproved him for not painting more serious subjects with softness and beauty, in emulation of Raphael of Urbino, and he replied politely, saying: that he would rather be first in that kind of coarseness than second in delicacy.[119]

Clearly this represents what Kris and Kurz have explained as the "urge to anchor the individual's achievement firmly in the dynastic succession," a process they refer to as "genealogization."[120] Kris and Kurz's observations on biographic mythology have considerable relevance to many of the phenomena discussed in this chapter. As they point out, Pliny had concerned himself with providing a genealogy for achievement in which innovation could be honored, but in which the master-pupil line of succession could also be established. In discussions of style, establishing the Venetian descent of Spanish painting was particularly important. Indeed, as was mentioned earlier, for many painters, the vaguest resemblance of their works to Venetian pictures was carefully catalogued. Navarrete el Mudo was habitually presented as Titian's most immediate Spanish disciple. Velázquez was more distant from Titian in time, but the link between Spain's foremost painter and Venice's foremost painter was nonetheless carefully forged. The Spanish writers' appropriation of the Venetian tradition is not surprising, for in a sense their ownership was real. After all, Charles V, Philip II (fig. 73), and Philip IV had amassed the greatest collection of Venetian canvases in Europe. Charles V had further incorporated Titian into the national tradition by knighting him. In view of this Spanish tendency to identify with Venice, it is hardly

surprising to hear Jusepe Martínez describe Venice's *caposcuola* as "*nuestro* gran Ticiano" [italics added], and the reader is justified in understanding the possessive to be more than rhetorical.[121] Just as Palomino's remarks on the use of pigment make earlier tendencies explicit, his lumping of "Venetians and Spaniards" together as a single entity clarifies the Spanish attitude of his own and the preceding eras. In his chapter on Velázquez, Palomino makes him the legitimate offspring not only of the great traditions of antiquity, but also of Veneto-Hispanic painting: "And lately the art of Velázquez shone forth with the energy of the Greeks, with the diligence of the Romans, and with the tenderness of the Venetians, and Spaniards."[122]

Although it had not always been expressed so clearly, the Spanish alignment with the Venetian school had existed for a long time, even among writers who claimed to support more Florentine ideals. In spite of his ostensible allegiance to Florence, Carducho mentioned Titian nearly as often as Michelangelo. Pacheco joined Carducho in celebrating Titian as painter par excellence, mentioning him only slightly less often than Michelangelo or Raphael. Paravicino found him the supreme painter in the collection of Philip IV, and his paintings apt examples of a theological point. Whenever convention required a painter, Titian was called into play. He became a character in one of Lope's comedies, *La Angélica*, and he shared that honor with only one other painter: Apelles. When Lope wished to claim Rubens's descent from a distinguished pictorial tradition, he called him "el nuevo Ticiano."[123]

Within the same poem, Lope describes Philip IV as the new Charles V, and the structural parallel between the two progenitors of heroes, Titian and Charles V, is hardly accidental.[124] Since the Spanish royal collections began to take shape with the advent of Charles V, and since the admiration of Charles V for the great Venetian became a Hapsburg tradition, it is not surprising that Titian came to be considered the paradigmatic painter. From the sixteenth- and seventeenth-century references to Titian and his followers, it is clear that the Venetian school of painting was perceived as something apart from other schools, an institution whose natural aristocracy had been validated by both patronage during Titian's lifetime and influence upon other painters after his death. For the Spaniards, Venetian painting became a creed, complete with a doctrine of colorido which claimed superior validity through its verisimilitude. Those initiated into the mysteries—those connoisseurs who possessed the sensitivity and experience to view a painting properly—could claim an ascendancy over ignorant onlookers and were to be rewarded with perceptions of uncommon versimilitude and beauty. If Venetian painting was a doctrine, the borrón was its particular emblem. A device capable of representing, by association, a complex conjunction of ideas about taste, illusionism, skill, and the privileged inheritance of Spanish painting, it came to represent, in miniature, many of the issues at stake in painting during Velázquez's lifetime. Thus to a seventeenth-century viewer, borrones like those in the *Surrender of Breda* (fig. 24 and colorpl. 1A) or *Las Meninas* (figs. 43, 44, and colorpl. 3A) probably triggered a relay of associations about discriminating viewers (from Charles V to Philip IV), about optical truth that overstepped conven-

tion, and about a painter's gifted manipulation of his art (with its associations of *facilidad*, dominion of aerial perspective, and Venetian naturalism). The associations illustrate the close and simultaneous interlinking of each idea to various other ideas, from connoisseurs to Charles V, and on to Titian and the Venetians, thus to *borrones*, which brought up the nearness or farness of pictures, and this idea of correct distance brings these connections full circle, for correct distance requires a connoisseur. As is evident from the written testimony, any single element of this consortium of concepts could generate a reference to any other element. When a seventeenth-century writer tried to shepherd the various ideas under one abstract concept, he generally fell back upon colorido.

MARTÍNEZ AND THE MERGING OF OPPOSITES

Ultimately Spanish aesthetic theory regarding disegno and colore does catch up with Velázquez's practice, although the known writings are not dated before the decade after his death. It is assumed, for example, that Jusepe Martínez wrote his *Discursos practicables* in the 1670s, but it was not published until 1866. Martínez was only two years younger than Velázquez and the two were on friendly terms. Certainly Martínez saw Velázquez at work, for he lent the latter his own studio to paint in when Velázquez was in Zaragoza in 1644.[125] As might be expected from a painter of Velázquez's generation, Martínez became the confident apologist for colorido, Titian, *borrones*, and paintings seen from afar. In expressing his views he eventually revised the dibujo versus color distinction drastically. Before attending to that serious change, however, it is worth noting several of Martínez's points about drawings on paper, Venice, loose brushwork, scale, and distance.

As remarked previously, Pacheco defended the disegno-derived tradition of making complete drawings on paper before putting brush to canvas: "I will not follow the degenerate advice, which permits the painter . . . to draw what he has thought up upon the canvas or panel with no further preparation."[126] Pacheco's theoretical orientation dictated that any discussion of dibujo necessarily called for an endorsement of Florentine disegno, with Michelangelesque preparatory drawings. Martínez, on the other hand, took the notion of dibujo and then within this Florentine category described a drawing procedure so coloristic that it would have seemed a travesty to Vasari. Martínez does not doubt that dibujo is fundamental. He puts his chapter, "*Del dibujo,*" first in the treatise, as Pacheco and Carducho had done. But he qualifies the chapter title, calling it "*Del dibujo y maneras de obrarlo con buena imitación.*" "Imitation," with its connection to naturalism and optical verisimilitude, was of course more usually placed in chapters on color, not dibujo. What follows is a procedure that can only be called Venetian. It may also be the sort of working method Velázquez used (see chapter 2, below). Martínez begins with a brief description of conventional drawing on paper with chalks. Once this formality is over, he says:

There is another way, which is characteristic only of masters, and it serves to record their intentions, and thus they are called drawings of [an] idea; which are the drawings that they do in very sketchy form to show their intention, and to choose what would be most appropriate to execute; and since they are not content with this information, they carry out a greater effort, which is to take the primed canvas, on which the chosen form shows itself to be more perfectly executed; and this is done in black and white in oil . . . and this alone is not enough, but to finish their work with perfection . . . they avail themselves afterwards of making drawings from life in order to insert them to suit the gestures and movements of the *historia* that they have made, removing and adding whatever might be necessary, for not everything is found merely by copying from life, . . . and thus it is necessary for said painter to retouch the work with his knowledge and skill, in order to get the work all correct.[127]

Certainly the Venetians seem to have created paintings with procedures like those Martínez describes: moving directly from a quick *pensiero* to the canvas, and then mixing sketches drawn on paper with sketches painted on the canvas, all the while "removing and adding" painted forms as the picture making proceeds. In his description of this loose procedure, Martínez has not dispensed with drawing on paper, but he has freed it from the structured rigors of disegno to make it the coloristic painter's friend. Martínez's chapter on dibujo echoes other Venetian influences, too. Although he advises the use of prints and drawings by great artists, he suggests not following them too closely, advising instead that the

most common means is to copy heads, made by great men, colored in a beautiful style and with great skill and resolution, and if one can, let it be in the Venetian style which is the loosest in brushwork, and most agreeable to the sight, as one sees by experience in the works of Titian, Paolo Veronese, Tintoretto and Bassano . . .[128]

The date of Martínez's manuscript is unknown, but the last year mentioned by him is 1673. In 1674 Boschini was to publish his *Breve instruzione,* which contains descriptions of the working procedures of Titian[129] and Tintoretto.[130] Even though Boschini's and Martínez's accounts bear a generic resemblance to each other in the free working methods they ascribe to master painters, the descriptions of neither author appear to derive simply from the other. The exact sources for this portion of Martínez's treatise are unknown. His ideas on disegno may well derive in part from various sixteenth-century Italian writers, but perhaps especially from authors such as Pino, who had earlier refused to limit the definition of drawing to mere linear outlining.[131] The sources for Boschini's treatise, beyond his reliance upon Pino and Dolce and his acknowledgment of information gained from other painters, are best left to students of Venetian art theory.[132] Even more fascinating than Martínez's Venetianizing *otro modo* of drawing is his inclusion of this free method within the section on dibujo. Boschini's *Breve instruzione* also devotes a section to disegno, but it is utterly different from Martínez's in tone and content. Martínez is serene in his conviction that free mixtures of drawing on paper with painting in oils legitimately belong in a chapter on dibujo. Boschini

shares Martínez's conviction about the importance of imitating natural vision, but by contrast his tone is defensive and polemical. He pleads that "painting should be soft, full of impasto and without [a] boundary,"[133] but he clearly is responding to Central Italian critics who would exclude such styles from the definition of good disegno. Compared with Martínez, Boschini is still reacting against the confining early definition of drawing.

This situation is all the more curious because it reverses the usual historical sequence of the development of ideas from Italy to Spain. It is an art historical axiom that Italy normally takes the lead in articulating new theoretical positions. Here, however, Martínez seemingly outstrips Boschini in his liberal redefinition of the foundation of good painting. But he does so with bland innocence, interweaving the separate components of disegno and colore as if he were unaware of their supposed antipathy. One can only conclude that a Spaniard like Martínez, for all his familiarity with Central Italian concepts, unquestioningly assumed that Venetian painting was part of the supreme achievement of the past century. Surrounded by royal and aristocratic collections of works by Titian, Tintoretto, Veronese, and Bassano, and secure in the knowledge that these canvases had enjoyed the high esteem of four great Hapsburg monarchs, Martínez may well have been unresponsive to the intense inter-Italian rivalries that could produce writing like Boschini's. In a way, it is this almost unconscious privileging of the Venetian tradition that gives Spanish theory its own oddly national flavor.

Before leaving Boschini, we must note a final irony in his own description of Venetian painting. As had been pointed out throughout this chapter, Spanish theorists repeatedly used the prestige of Venetian art to legitimize their own achievement. By claiming a stylistic and historical kinship between Venetian and Spanish pictures, writers could enhance the claim of their native product to being a liberal art and could specifically establish a theoretical pedigree for the production of an artist like Velázquez. But when Boschini published his *Carta del navegar pitoresco* in 1660, he reversed that situation. Instead of using Titian and Tintoretto to legitimize Velázquez, he used Velázquez to validate the Venetians. Boasting of the regard in which Titian's paintings were held by the Spanish Hapsburgs, he repeated a purported statement by the *gran sugesto* of Philip IV, Velázquez, as *un testimonio*:

> L'amava sti Pitori molto forte,
> Tician massimamente èl Tentoreto,
> Con vero cuor, con purità d'afeto[134]

[He loved the Painters very much, Titian most of all and Tintoretto, sincerely, with purity of affection.]

Boschini goes on to report a conversation that seems tailormade to his pro-Venetian propaganda. When Velázquez is in Rome on his second trip to Italy in 1650–51, Boschini records a question put to the Spanish painter:

Col dir: caro signor, per cortesia
Cosa diseu del nostro Rafael?
Se avé visto in Italia el bon él bel,
No guidicheu che questo el meglio sia?[135]

[Speak: dear sir, please what would you say about our Raphael? If you have seen the good and the beautiful in Italy, would you not judge that he is the best?]

To which Velázquez replies:

A Venezia se trova el bon él belo,
Mi dago el primo liogo a quel penelo;
Tician xe quel che porta la bandiera.[136]

[In Venice one finds the good and the beautiful, I give first place to that brush; Titian is the one who carries the banner.]

Boschini's motive in recording this supposed conversation requires no further comment here. In view of the enormous prestige of Venetian painting in Spain, as well as Velázquez's own avowed intention to acquire more Venetian pictures for Philip IV on this trip,[137] whether his statement is reported with absolute accuracy likewise need not be dwelt upon. For a Spaniard in Velázquez's century, the value of Venice was an article of aesthetic faith.

Returning to Martínez's description of otro modo for making a drawing, we note that, with such a coloristic procedure placed in the chapter entitled "Del dibujo," one can only wonder what will be left to discuss in the chapter called "Del colorido." Martínez's view of colorido is what he sees as the nucleus of that term: paintings seen from near versus far, as well as the role of the borrón. Over half the chapter is devoted to the conventionalized anecdote about the ignorant patron who was "amazed that the painter had improved the picture so much in so short a time," even though all the painter had done was to increase the viewing distance. Thus colorido becomes the summarizing category, as colorito had been in Italy, for the practices embodied by Titian, the Venetians, and probably Velázquez. Martínez mentions Titian by name in this chapter, saying that the "greatest masters have managed to make their works in imitation of the most beautiful . . . for example, in Titian . . . for all the other colorists have come out of this school."[138]

Obviously, by the 1670s the original definition of dibujo as a painting with clear outlines and smooth paint, preceded by elaborate preparatory drawings, had been eroded almost beyond recognition. The erosion was not sudden, and Martínez no doubt did not set out deliberately to subvert Vasari's definitions. The process of expanding color to absorb and transform dibujo was a gradual one. Carducho had repeated the Florentine endorsement of disegno with evident sincerity, but then a few pages later had held up a well-executed borrón as superior to "this other smooth, and

polished manner." Pacheco also had claimed to support Vasari's ideals, but he had admitted a personal preference for Dolce.[139] From the evidence of poems, plays, and sermons, it is clear that the current of literary interest flowed toward questions of verisimilitude and thus toward borrones. References to paintings to be seen up close, and thus presumably smoothly brushed, persisted; but as the years passed, references to such smooth paintings seem to occur only as an excuse to discuss their opposite.

The very definitions also evolved to accommodate changing taste. When Pacheco described a painting as *unido,* for example, he often meant that the brushstrokes were blended or smooth (cf. figs. 7, 8, 72). *Unidad,* with its long rhetorical association, was not a concept that anyone wanted to do without. So the definition was remodeled, until a painting that was unido was not a painting with smooth brushwork, but one with loose brushwork, on the ground that the borrones aided in the creation of a united composition. By the 1670s such overall unity was to Martínez a grander ambition than a unity of smooth facture. The polished Flemish fifteenth- and sixteenth-century panels known to Spaniards were often of smaller size, and Martínez assumed that they were made for close contemplation. Martínez frankly preferred the forensic canvas. In stating his position, he implicitly underscored the decisive importance of the Spanish patrons who had made Venetian painting the ideal decoration for their palaces and chapels,

> as is seen in the churches and sumptuous palaces, adorned with galleries and rooms of very great size, which have large paintings, so that one can enjoy the sweeping distances: the small things [when] placed beside these large ones, become petty and poor . . .[140]

The slow reversal of the meaning of dibujo, in fact, need not be seen as an instance of theory's following practice rather than prescribing it. Styles assuredly had changed long before Martínez wrote. But the comments of theorists and poets, instead of merely catching up with practice, seem to represent an accompanying activity, and a necessary one in view of painting's professed ambitions. Since Spaniards desired to make their native art a worthy descendant of antique painting and the art of the Italian Renaissance,[141] verbal maneuvering and rhetorical reconciliation were indispensable. Words could articulate concerns and specify genealogical connections that could not be enunciated with paint on canvas. To the Spaniards' keen regret, there were no antique paintings by Apelles or Zeuxis to juxtapose to texts by Pliny, Vitruvius, and Horace. They did, however, have those written texts, and to these antique authors, a long line of intervening books on art had already been added, especially in Italy in the sixteenth century. Not only did painters aspire to be the learned peers of poets, but antique traditions such as ekphrasis also encouraged the transformation of canvases into texts.[142] They were schooled in the belief that pictures could call for words and words could become involved with pictures, so the instinct for a dual practice of both the visual and the verbal must have had roots too deep to disregard. Verbalizing the borrón also would have helped to organize and facilitate perception of the painted pattern.

Pacheco's remarks on pigments, and sometimes his entire treatise, are indeed *report-age*. When he speaks in the first person of materials actually in use in Seville, he appears to provide a valid historical document that matches painters' practice closely. But simultaneously, and confusingly for the reader, he compiles and passes on a list of pigments used in Roman times but not in baroque Spain. In light of this encyclopedic procedure, one naturally wonders to what extent traditional debates over obsolete issues were also preserved in the theoretical sections of treatises. Such an archive would honor antique precedent, present the author as a *pictor doctus*, and acknowledge the conventions of the literary genre of treatise-writing. From the jumbled and contradictory opinions on technique expressed in the works of Pacheco, Carducho, and Martínez, one is inclined to believe that items such as disegno and colore were rehearsed partly as a formality—but only partly. Lineal descendants of the categories of perception spawned by the early debate had lived on and continued to shape and shade the seventeenth-century viewer's verbal discourse. The heat of the argument, in other words, had died away, but the words themselves endured. The once-polemical vocabulary had provided perceptual pigeonholes for organizing the viewer's experience, and that vocabulary was continually redefined and adapted to current discourse.

From this review of Spanish pigments in theory and practice, it is evident that past beliefs about "colors" helped determine which ones would be discussed enthusiastically as if used in the baroque present. Likewise, the desire to establish painting's status by chronicling its lines of historic succession affected which techniques would be described and which would be ignored. In the case of both pigments and techniques, the twentieth-century viewer may be surprised that the baroque viewer did not transcribe many things that one notices today. Leaving aside the question of our own unspoken biases, it seems important to note that the seventeenth-century viewer articulated his vision through the agency of mythologized dogma. Not only did writers acknowledge the inheritance of pigments and adapt biography itself to formula, but they guided visual perception itself by the critical repertoire of the past. Thus borrones could be noted thanks to intellectual ancestors such as Horace and Vasari. Of course an element like Titian's fabulous success with powerful patrons was a real and recent event. But there were precedents for wise patrons, too. In any event, Apelles, Alexander, Horace, Titian, and the Hapsburg monarchs would eventually be blended together in the machinery of mythmaking.

For all that the distinction over paintings seen from up close versus paintings seen from afar went back for more than a millennium, it seems that the problem of the borrón engaged the minds of seventeenth-century viewers as a living issue. The vital question was not whether to *manchar*—after all, that practice was all but universal by the time Spanish fussing over it was printed—but that discussion of it was nonetheless irresistible. The persistence of a critical tradition and the desire to claim the Venetians as progenitors for Spanish painting both must have operated. Yet one other cause is overlooked at the historian's peril: the actual sensory experience of a borrón. As any twentieth-century visitor to the Prado knows, Velázquez's paintings can be

optically persuasive to a degree that amazes the viewer. The "discovery" of the magic of Velázquez's brushwork is hardly original, but to an individual standing before the painting the sense of revelation is nonetheless genuine. The words that rise to describe it may be hackneyed, but the experience is always new.

Whatever the mixture of motives in Velázquez's time, references to free brushwork are widely disseminated through court literature and theoretical writing. A popular *refrán* indicates that the borrón-related issue of distance had penetrated even to circles outside the court: "I keep my distance from paintings and fights."[143] Such widespread familiarity seems to indicate that by the time Velázquez practiced his free brushwork, the borrón had long since been accepted in the minds of the more sophisticated. It is not possible to imagine Velázquez fretting over whether to use borrones in, say, the *Surrender of Breda* (fig. 24), or turning to a reading in Pacheco to help him solve his dilemma. One cannot even realistically expect to know whether the word borrón ever slipped from his lips. It is reasonable to suspect, however, that a contemporary courtier looking at either the *Surrender of Breda* or *Las Meninas* (fig. 44) might have pondered, as he positioned himself before the picture, his own nearness to or distance from those paradigmatic borrones.

2

VELAZQUEZ AND VENICE
A Provisional Comparison
of Techniques

*T*he motives for early claims that Velázquez resembled Titian were wonderfully complex, because statements linking Velázquez to Titian were infused with mythology and were motivated by national and professional aspirations. Indeed, throughout the Spanish chronicle of Titian's influence, it is difficult to separate spurious propaganda from truthful description. Yet, in spite of the problems posed by early reports, it would be foolish to discard them altogether or to assume that the techniques of Titian would have gone unnoticed by Velázquez.

Beginning with Pacheco's statement that Velázquez painted a portrait "with the manner of the great Titian,"[1] Velázquez's paintings have been compared with greater or lesser seriousness to those of the Venetian painters of the sixteenth century. In 1660 Boschini said of the Spanish painter: "He loved the Painters very much, Titian most of all, and Tintoretto."[2] In the 1670s Jusepe Martínez pointed out that Velázquez had a connoisseur's knowledge of Titian's works when he reported that copies by Sánchez Coello of paintings by Titian "passed for originals, and Diego Velázquez admitted it (which is no small testimony)."[3] In 1715–24 Palomino reported that Velázquez "was very fond of Venice, because it was the shop where such excellent artists had worked," and he said further that Velázquez had "tried to follow and imitate" Titian, Tintoretto, and Veronese.[4] In 1889 Justi remarked that the "study of the Venetian style of composition might apparently be surmised from the few great historical works Velázquez has left us."[5] And throughout the twentieth century, art historians have associated Velázquez's paintings with the Venetians. In 1976, for example, Pérez Sánchez continued to find Titian a foundation for Velázquez's style, declaring that "without the familiarity with and study of the Venetian painter, it would be hard to understand works like the *Rokeby Venus* or the *Mercury and Argus*. . . ."[6] As for evidence from the artist himself, certainly he rendered Titian that sincerest of tributes when he included the *Rape of Europa* (fig. 70) in the background of a major painting from the 1650s, *Las Hilanderas* (fig. 60).

In this chapter, then, we will put the relationship between Velázquez and the

Venetians to the modern test of technical examination in an effort to clarify the nature and extent of Venetian influence upon the seven paintings we examined. More specifically, we will compare Velázquez's techniques with the techniques of Titian and Tintoretto. Whether this way of comparing works by Velázquez and the Venetians—juxtaposing information from X-radiography, infrared photography, chemical analysis of pigments, and analysis of cross sections of paint—is at all suitable for testing their relationship is a question whose relevance may not be obvious until the end of the discussion when the results of the comparative examinations will be summarized.

Throughout the following discussion we will isolate the mechanics of Velázquez's masterpieces—pigments, grounds, imprimatura, underdrawings, pentimenti, glazes, and brushwork—for comparison with their physical counterparts in paintings by Titian and Tintoretto. But in order to create for the reader a structure within which to comprehend these details, we first give a general description of Velázquez's development into a painter whose works eventually resemble Venetian paintings.

Certainly, Velázquez does not appear on the Sevillian scene in 1617 as a full-blown Titianesque painter. Indeed, if the works produced in Velázquez's Sevillian technique had been the only surviving vestiges of his production, the word "Venice" might never have been mentioned.[7] The Venetians were famous for their opulent colors, but Velázquez's palette in this period is restricted. Earth tones predominate, with red, yellow, or brown ochres used in the broader areas and the brighter pigments used only sparingly. In technical terms, then, Velázquez's earliest works remain competent but unexceptional examples of European painting of the first quarter of the seventeenth century.

The *Surrender of Breda* (fig. 23) was painted in Madrid in 1634–35, and in this painting the lessons of Venice seem well learned. As has already been noted, Velázquez's fully Venetian technique appears only after his first Italian trip in 1629. Almost every aspect of this canvas offers a contrast with his early works. First of all, the painter has abandoned the dark brown ground seen in his Sevillian paintings for a nearly white ground. The sky in the *Surrender of Breda* was covered with a white lead ground; before beginning work on the figures in the lower part of the canvas, he covered it with a pale grayish-beige ground which also contains a substantial amount of lead white. The palette has not really expanded significantly, but Velázquez employs it in a way that favors more noticeable use of the bright, expensive colors such as azurite and red lake. Also, there is a sudden loosening of the tradition-bound rules that governed the making of the Sevillian works. In the *Surrender of Breda,* for example, an occasional underdrawing is unabashedly visible to the naked eye, as one can see on the cuff of Justinius's right hand (fig. 31).

Technically, this is one of Velázquez's most dazzling performances; it is his virtuosity of brush that immediately captures the viewer's attention. The freer brushwork

which was to become such a hallmark of Velázquez's technique, and which was so often compared to Titian's facture, is visible throughout this canvas. Lace and taffeta are stroked and dabbed onto the canvas in a way that creates patterns that are abstract when seen at close range (fig. 24). If one looks at the figure of the Dutch boy dressed in white, one sees that his elegant garment is fabricated from wet, abbreviated strokes (fig. 25, colorpl. 1A). Making no effort to hide the ground, Velázquez adds an astonishingly small number of touches in pale gray, charcoal gray, and white to create the effect of a fine collar. A telling contrast between Velázquez's Sevillian works and his mature works can be seen in the treatment of the hand silhouetted against the lower portion of the Dutch boy's white jacket. With daring economy, that hand is no more than a few dark strokes of underdrawing shaping the light grayish-beige imprimatura. In the early works, hands tended to be worked out in detail from the knuckles down to the fingernails. By contrast, in the *Surrender of Breda*, even the hand of a central character such as Justinus blurs away into a soft fuzziness.

In the *Surrender of Breda*, Velázquez is sophisticated in varying the degree of focus within the figure groups. The hand of the boy with the musket on his shoulder behind Spínola is blurred when compared with Justinus's hand. The faces of the Spaniards become progressively freer in brushwork as they recede from the foreground of the painting. Thus the face of the figure who stands immediately behind the yellow sleeve of the man holding the horse is painted with blended strokes, whereas the cheeks of the figure just behind him are indicated with thick strokes, probably of red and yellow ochre, sitting unblended side by side (fig. 24).

Velázquez's willingness to let his grounds and underdrawings show through in the *Surrender of Breda*, his free brushwork, and the decorative colors of the painting have always invited a comparison with Venetian paintings. It could be argued, of course, that these techniques, and especially the relative lack of finish in the brushwork, were really nothing more than Velázquez's response to the original location of this painting. It was to hang well above eye level in the Hall of Realms.[8] However, Velázquez's colleagues, who also painted for this location, did not display a similarly unfettered brushwork. From this date on, the greater freedom of technique appears frequently in Velázquez's portraits and religious paintings, whatever their intended setting.

One cannot look at *Las Hilanderas* (fig. 60), the *Rokeby Venus* (fig. 55), or the *Surrender of Breda* (fig. 23), without being reminded of Venetian color, light, and atmosphere. Yet a direct influence from a single Venetian painting to a single Velázquez painting has always been hard to demonstrate, especially when dealing with just these elements. To make the problem more amenable to research, scholars have turned away from such indefinable characteristics and looked instead for the influence of specific Venetian motifs, compositions, or poses in Velázquez's paintings.[9] Velázquez, however, was only rarely disposed to quote anyone verbatim, including the Venetians, and this second approach has yielded general resemblances (such as the relationship between Titian's portrait of *Philip II*, fig. 73, and Velázquez's *Philip IV Standing*, fig. 7) but few limb-for-limb borrowings.

At the start of this project, we wondered whether by concentrating on the mechanics of Velázquez's technique, upon the painterly procedures that made the paintings look Venetian, we might better comprehend the nature of his relationship to Venice, and certainly our comparisons may help to describe that problem better and to give some idea of its fascinating, and frustrating, complexity. Velázquez's free brushwork, pentimenti, glazes, and toned underpainting are all reminiscent, to some degree, of the techniques of Titian, Tintoretto, Veronese, and Bassano, and they seemed a good place to start the inquiry. But in trying to be specific about the degree and nature of influence, we found that the problem resists easy solution. All of the characteristics just listed are also present in many seventeenth-century pictures.[10] So by looking at those aspects of Velázquez's technique, the inquiry became more diffuse, not more focused. Moving to less visible considerations, such as painting materials as revealed by chemical tests, or paint layers as shown by cross sections, or hidden revisions as disclosed by infrared and X-radiography, we found that some details of Velázquez's technique are similar to details of Venetian technique and that some are different. Yet, deciding the real significance of these resemblances and contrasts is a very sticky point. Because it is this historical significance that eludes precise definition, it is well to review the historical facts about Velázquez's contact with Venetian painting, even though attempting to define the complicated historical record with technological data is a little like hoping that with a new high-tech hammer we could finally succeed in nailing currant jelly to the wall.

VELÁZQUEZ'S CONTACTS WITH VENETIAN PAINTING

In a sense, all techniques for European oil painting after the sixteenth century can be said to reflect Titian's masterful manipulation of paint. His technique is encyclopedic in the variety of methods of handling his medium, and rarely could a later artist make an absolutely original addition to his repertoire. This encyclopedic quality is one of the first stumbling blocks to determining significant influence. Titian's effect upon subsequent painting was so broad and pervasive that his relationship to any one individual painter seems obvious to the point of irrelevance. To confuse the issue, Titian's catalogue of effects was soon assimilated by a series of near-contemporaries and younger painters. From Venice, Titianesque maneuvers in paint spread through Europe. By the time the twelve-year-old Velázquez was legally apprenticed to Pacheco in 1611 (or to Herrera the Elder before Pacheco, if that long-standing rumor has any truth), painters both within Venice and within Spain had not only absorbed, but reinterpreted and personalized aspects of Titian's manner.

To complicate further the comparison between Velázquez and the Venetians, Velázquez and Titian and Tintoretto all tended to vary their procedures from painting to painting. Thus a comparison of a given Velázquez to a given Titian merely shows how each painter operated in that particular situation. Nonetheless, when one goes on to compare additional paintings, some general characteristics do emerge, and

we concentrate on these here, but it must be kept in mind that the Venetians, and Velázquez too, were quite capable of deviating from their own routines.

Titian's paintings were collected by the Hapsburgs with an enthusiasm bordering on obsession. At the same time, the Spanish monarchs also acquired paintings by Veronese, Tintoretto, and Bassano, who displayed techniques derived either directly from Titian or from the artistic ambience of Titian's Venice. To what extent actual paintings by the great Venetians were to be seen in the Seville of Velázquez's youth is uncertain. Whether Velázquez saw Titians or copies of Titians in Seville, he visited Madrid in 1622 and moved there for good in 1623 as painter to Philip IV. Thus by the time he painted the earliest work we examined from this period, the *Philip IV Standing* of about 1626 (fig. 7), he had been in contact with the royal collections with their rich Venetian holdings for several years.

In August of 1629 Velázquez made the first of two trips to Italy. He landed in Genoa, went on to Milan, and from there on to Venice. Palomino tells us that while in Venice Velázquez made drawings after Tintoretto's *Crucifixion*, and that he also copied Tintoretto's *Last Supper*. From Venice he went to Rome and Naples, and from there back to Madrid, arriving early in 1631.[11] Velázquez waited twenty years, until 1649, to return to Venice, where he arrived on April 21. His host there, the Spanish ambassador, the Marqués de la Fuente, arranged for him to see paintings in the city. Palomino tells us that he "saw many works by Titian, Tintoretto, and Paolo Veronese."[12] Velázquez was in Rome by May 29, 1649. He may have returned to Venice for an unknown length of time in 1651, and it was probably then that he purchased several Venetian paintings for the Spanish monarch. Martínez, Boschini, and Palomino all report that he sought or purchased works by Titian, Tintoretto, and Veronese.[13] As Harris points out, all but one of the Venetian pictures listed by Boschini and Palomino are among the canvases now in the Prado.[14] And according to Boschini, Velázquez is said to have remarked on his second Italian trip that Titian "carries the banner."

Yet the fact that Velázquez was likely to have seen as many paintings by Tintoretto, Veronese, or Bassano as by Titian himself makes it all but impossible to separate Titian's individual influence from the influence of the younger Venetians who both imitated him and were active during the period between Titian's death and Velázquez's lifetime. Our discussion, nevertheless, will be focused on the similarities and differences between, first, Velázquez and Titian and, then, Velázquez and Tintoretto. We separate the two sections because, in fact, the techniques of Titian and Tintoretto are so much alike that to discuss them together would blur the occasional sense of development of a particular technique from Titian to Tintoretto and then from Tintoretto to Velázquez. And we confine these sections to comparisons between Velázquez and Tintoretto and Titian, not because Veronese and Bassano are unimportant painters—indeed, they are major painters—but because there are relatively few studies on their work whereas exemplary studies of Titian and Tintoretto are readily available.[15]

TITIAN

A perennial difficulty in evaluating Velázquez's technical response to Titian is distinguishing affinity from influence. For example, Titian was famous for his pentimenti (fig. 69), and Pacheco comments on them in *El arte de la pintura*. Velázquez's early paintings, such as the *Portrait of Góngora* (fig. 58), also show painted revisions in radiographs.[16] Thus when we compare Velázquez's pentimenti with Titian's pentimenti, it is difficult to know whether Velázquez continued to make revisions in paint during his Madrid career merely because he had always done so or because Titian's example had spurred him into a more confident use of this technique. At the same time, the part Pacheco played in the formation of the young Velázquez's working method is equally unclear, because Pacheco used pentimenti far less often in his own paintings, and verbally he alternately inveighed against pentimenti while accepting them as a practice sanctioned by, of course, Titian.

Velázquez's pentimenti, in any case, have noticeable similarities to those of the Venetians, who also were famous for overturning the conventions of Central Italian procedures, which required preparatory drawings on paper to fix a composition. The pentimenti of Velázquez and the Venetians or, more precisely, their habit of drawing directly on the canvas suggest a more subtle rejection of Florentine conventions: that the artists, in fact, did not necessarily bother to make preliminary drawings on paper.

The passage from Martínez quoted in chapter 1 seems to confirm this notion. The Spanish theorist describes an *otro modo* of drawing that "only pertains to the most masterful painters." The otro modo requires that the artist compose directly on the canvas itself, availing himself of drawings on paper only as suits his immediate need for adjusting a figure in paint. According to the procedure described by Martínez, pentimenti would be made during the process of first creating the canvas, not later when the painter might have second thoughts. Throughout his career, Velázquez was present in the buildings where his works were hung, and he would have had ample opportunity to retouch them if he had wished. Whether Velázquez's revisions were indeed made years after executing a picture has long been disputed. According to one school of thought, "the artist, until his death, was in a sense his own curator: most of his paintings remained close at hand and he took full advantage of this fact to retouch them and sometimes make important changes."[17] From our analysis of cross sections taken from areas with pentimenti, we believe that Velázquez's revising layers were usually put on as he first painted, rather than applied later to a finished work.[18] If the theory about Velázquez's habitually fiddling with finished canvases long after they were painted were correct, one might find a layer of varnish trapped between the rejected form and the covering revision. We found no layer that we can associate with varnish in any cross section when the sections were examined under fluorescence. And although it is always possible that a trapped layer of varnish would be too thin to show up, and therefore conclusions from any sample should be drawn with care, it nevertheless seems significant that

among the numerous cross sections from seven paintings by Velázquez, trapped varnish was never discovered between paint layers.

The hasty, slight sketches in the Biblioteca Nacional, if they were in fact executed for the *Surrender of Breda* (figs. 62, 63) probably further fit Martínez's description of the masterful working method. These sketches appear to show how a drawing on paper could be both preliminary to painting on the canvas and a sketchpad used alongside the picture to work out changes to be made in the midst of painting.

We have only a handful of drawings seriously attributed to Velázquez. By what seems to be a historical coincidence, we also have relatively few drawings by Titian: less than fifty attributions have found general acceptance over the past forty years.[19] Students of Spanish and Venetian draughtsmanship have offered similar reasons for the relative paucity of drawings by both masters. From the time of Vasari the Venetians were not considered accomplished draughtsmen by Central Italian standards, and such early prejudice against painters who strayed beyond the confines of Florentine disegno may have caused Venetian drawings to be undervalued and hence not seriously collected.[20] It seems that Spanish drawings were likewise collected only sporadically, and the lack of a consistent tradition of great patrons for local drawings no doubt figured in the neglect of the Spaniards' graphic production. In both Venice and Spain, the drawings that do survive seem to have been kept, at least initially, by fellow painters as practical tools rather than preserved as works of art in their own right.[21]

Whatever the reason for the relatively meager supply of his drawings, it is clear that Titian did make preparatory drawings for his paintings.[22] Both quick sketches of isolated figures or groupings and drawings squared for transfer survive (fig. 65); documents also record that Titian sometimes submitted a preliminary drawing to a patron. More to the point, in spite of such survivals, we cannot follow the development of even a single painting through preparatory drawings.[23] The same can be said of Velázquez: we cannot reconstruct the making of any painting through drawings.

Even in a painting for which Titian might have made a sketch on paper, often the drawing was more a step on the way to an eventual arrangement than an inflexible blueprint. Some drawings for single figures suggest that Titian's interest was confined to postures rather than to compositions that locate the figures in space. Other sketches record generic poses for often-repeated figures, such as the Madonna, and such drawings may resemble a final pose in a painting without matching it. Study of Titian's working method in paint reveals a preparatory activity that helps understand his drawings' role in the creation of his paintings. X-radiographs indicate that he sometimes painted a figure in the nude first and later painted on the garments. If the first sketch on the canvas was open to revision by clothing, then one can assume that other elements copied from drawings on paper were amendable, too.

As has been noted elsewhere,[24] Velázquez also habitually revised as he painted. Among surviving drawings attributed to him,[25] all of which may be preparatory for paintings, some show poses that were changed in paint and some show a figure just as

it is in the final painting. The angel in *Christ after the Flagellation Contemplated by the Christian Soul,* for example, appears to have been changed little in its translation onto canvas (fig. 64).[26] In another case Velázquez perhaps used preparatory drawings, but as part of a process of revision in paint: the studies for the *Surrender of Breda* (figs. 62, 63). Here Velázquez may have sketched Spínola on paper once, painted him, then drawn on paper again before revising him.[27] But again, the relationship of that drawing to the final painting is less than certain, and the attribution of an oil sketch, the so-called *boceto* for the head of Apollo in the *Forge of Vulcan* (fig. 15) has been debated; neither were we able to examine it to compare it to the finished canvas.[28] In spite of this incomplete information, there nevertheless seem to be significant similarities between Velázquez's few drawings and his way of using them, and Titian's drawings and procedures.

Among the paintings themselves, a similarity often remarked between Velázquez and Titian is their shared use of glazes. But glazing was an old practice and was common enough by the seventeenth century in Spain that there is no reason to infer direct Venetian influence, for example, when we see that the table covered with red velvet in Velázquez's *Philip IV Standing* (fig. 7) is glazed. In the paintings we examined, we noticed that extending a translucent veil of dark paint over an underlying light paint is a characteristic that occurs early in Velázquez's career. In the *Philip IV Standing* from the 1620s, the red tablecloth got two light pinkish layers before receiving a red lake glaze. Later, in the *Surrender of Breda,* of 1634–35, Spínola's iridescent red silk sash (fig. 23) looks rather more Venetian than the flatter, more lifeless red tablecloth. But Spínola's sash is not made with a Titianesque glaze. As Newman points out in chapter 5, the effect of translucency is not obtained by drawing a veil of red over a light underpainting. Instead, Velázquez simply used a very thick layer of red lake, probably applied over the light gray ground; this ground was fairly light in tone already, which may have encouraged him to dispense with a light underpainting. But the glazed effect of the sash derives more from the play of light within one very thick layer of red lake than from the interaction of two layers of paint. In a glaze the red might have been applied less thickly in places, letting a light underpainting show through as a highlight. But Velázquez simply added a dab of white on top of, not underneath, the red. This simpler method of imitating the appearance of a glaze without working up from the underlying layers may owe something to Velázquez's observation of Tintoretto, as will be noted below.

Cross sections of paintings by Titian reveal that he gave his pictures a thin ground of white gesso. Sometimes Titian also provided his figures with a toned underpainting placed on top of one area of the gesso ground. Often, however, what seems to be a toned imprimatura is really no more than discolored glue that has soaked through from beneath the gesso.[29] In Velázquez's work, occasionally a colored ground occurs over a white or nearly white priming (as in the *Surrender of Breda*). But the traditional white gesso of Italian paintings, which Titian continued to employ, is not used by Velázquez, who in his mature work used the colored layers as the priming. In the

early *Philip IV Standing* (fig. 7), Velázquez did paint directly over the red ground, but he did not allow the ground to show through or model the form. The green background around the figure of the king is not an imprimatura covering the entire canvas. It does not extend beneath the king's figure or the table. Thus no effort was made to reconcile the background color with the undertones of figure and tablecloth, which were created out of red ochre.

Velázquez's way of relating the figure to the background in his later paintings does recall Titian, however. One of Titian's most characteristic procedures was to use a toned underpainting but to leave bare patches in which that underpainting was not covered up with any design. In Velázquez's works, sometimes the visible imprimatura has a descriptive function, as when it provides the base color for the trousers of Justinus of Nassau in the *Surrender of Breda*. Sometimes it is frankly shown as a naked patch, without literally describing anything, as in the passage below the elegant Dutch boy in white flowered silk who faces us (fig. 25). Such a practice, then, inevitably recalls Titian, though it was becoming common in Europe by the 1630s.

Titian was a revolutionary in many ways, and his pentimenti, free brushwork, and toned, daringly visible underpaintings were but a few of them. Cross sections reveal that he drew at any stage of making a painting, whether on top of the paint or beneath it.[30] Such practices subverted the Central Italian theory of confining any drawing to sketches on the panel or canvas beneath the paint, not on top of the paint. We suspect that Velázquez also drew on top of his paint. Although our cross sections were not taken from places likely to yield a drawing trapped between two layers of paint, infrared photographs of the *Rokeby Venus* (fig. 56) indicate that Velázquez mixed strokes of chalk or charcoal among the strands of Venus's painted chestnut hair.[31]

Sometimes fragments of underdrawings in chalk, charcoal, or paint applied with a fine brush on the canvas are visible to the naked eye and in infrared photographs, as on Justinus's white cuff in the *Surrender of Breda* (fig. 31), or around the frames of paintings, the door, and windows in *Las Meninas* (fig. 53). At other times one cannot be sure that underdrawings were used to lay out the painting at all, an uncertainty that one encounters in Titian's work, too.

Titian preferred coarsely woven, nubby canvases. Velázquez used both finely woven canvases and ones of a slightly coarser weave at different times of his career. Nevertheless, Velázquez never used canvases as coarsely textured as Titian's. He did, however, invent a fresh technique that recalls Titian's rough canvases. Velázquez sometimes had chunks of pigment in his thin, wet paint. In the *Surrender of Breda* (fig. 23), and the *Portrait of a Dwarf* (fig. 34) especially, these chunks protrude in scattered fashion from the surface of the canvas in some areas, but not in all. Some of the smaller bumps could be mistaken for nubs of canvas, but samples showed them to be lumps of pigments of many different colors. If Velázquez added palette scrapings to his paint, perhaps he did so in order to give his paint texture and to catch and fragment the play of light over the painting's surface. Whether this textured surface was in some way a response to Titian's surfaces is a matter of conjecture.

The similarities listed above are many, but there are differences, too. The cross sections we examined from Velázquez's paintings sometimes show multiple layers of paint, but in many instances the final forms were painted directly on top of the ground, without elaborate underpainting. Thus one notable difference between Titian's and Velázquez's paintings is that Titian produces many more layers of paint in creating a painting than Velázquez does. Titian's many layers sometimes result from overpainting one form with another. These are not always pentimenti in the sense of a change of mind. Sometimes, as in Ariadne's scarf in the *Bacchus and Ariadne* in the National Gallery, London (fig. 72), it is simply that Titian painted the sea first, then Ariadne's shoulder on top of the sea, then two layers of underpaint on top of her shoulder for her glazed scarf, then finally two layers of glazes.[32] Velázquez did not trouble to paint grass first and then to paint people on top of the grass. The exception we found within Velázquez's production is revealing. In the *Forge of Vulcan* (fig. 14), one of the Cyclops' loincloths was painted over nude flesh (colorpl. 4C). This indicates that Velázquez, because of his presumably scanty opportunity for painting the nude in Spain, found it necessary for accuracy to paint the entire anatomy before adding the small garment.

A more significant distinction results from the choice of pigments. Artists' palettes changed around the turn of the seventeenth century, as has been noted by Kühn.[33] Whether the change is due to new choices created in order to express new visual effects, or whether it reflects a scarcity of some sixteenth-century pigments is unclear. In any event, had Velázquez used Titian's pigments, his paintings would appear strikingly more Venetian. Examples from the *Surrender of Breda* make this point clear. Had the yellows been orpiment rather than lead-tin yellow, had the blues been ultramarine rather than azurite, had the oranges been red lead or realgar instead of iron oxide, then Velázquez's painting would have come closer to the chromatic brilliance of Titian's. One suspects, however, that even if Velázquez had had all those Venetian pigments at hand, he would have either rejected them or mixed them differently. As Plesters points out, Titian tended to use paints that were pure, highly saturated colors. In his *Bacchus and Ariadne* he did not dilute even the expensive ultramarine, but applied it in unadulterated form, mixed only with oil.[34] Samples of Velázquez's paints reveal fewer pure, bright colors. Even when he had a good grade of bright azurite, he added chalk or lead white to it.

TINTORETTO

Both to the naked eye and in his layering and working method, Velázquez's technique is somewhat closer to that of Tintoretto than to Titian's. The closer resemblance is not surprising, for Tintoretto was younger than Titian and had had time to revise and refine Titian's technique. Tintoretto, Titian, and Velázquez all made pentimenti as a frequent method for creating and revising directly on the canvas. All three incorporated the underlying layers into their revision, as Velázquez

did in his reworking of the red-cheeked boy among the Spanish soldiers in the *Surrender of Breda* (fig. 24).[35] Titian in his earlier works, however, might isolate the area to be repainted with opaque paint before doing the revision.[36]

According to Pacheco, Tintoretto was notorious for dispensing with preliminary drawings. When competing for a commission, he even presented a rapidly executed canvas, "painted with so much verve and spirit, that all marvelled."[37] In spite of the tale, today we have a good many more drawings by Tintoretto than by Titian.[38] In some respects drawings attributed to Velázquez, and his presumed use of them, resemble Tintoretto's sketches and procedures especially. Tintoretto drew an entire multifigured composition at least once, but more often he studied the figures singly (fig. 67). In the drawings (figs. 62, 63, 64) relating to *Christ after the Flagellation Contemplated by the Christian Soul* and the *Surrender of Breda* Velázquez did the same. Drawing figures separately was a traditional practice in the Renaissance, but in Florence and Rome the single figures were, at least in theory, also sketched in a drawing that rendered the entire composition. If Titian, and especially Tintoretto and Velázquez, habitually created poses in isolation, without a final drawing of the whole composition, then as a result they would often have to adjust figures to each other on the canvas, leaving pentimenti to testify to these reconciliations. Single-figure sketches also may record a redesigning of an already-painted figure, as may have happened in the study for Spínola in the *Surrender of Breda* (fig. 63), and thus may have been drawn during the painting of the canvas, not before it.

Tintoretto sometimes glazed, added an opaque layer, and then repeated the glaze and highlight, leaving a layer of red lake sandwiched between two opaque layers. The possible reasons for Tintoretto's many-layered compositions are discussed by Plesters and Lazzarini.[39] We did not find such complicated layering in Velázquez, though without more cross sections the technique cannot be ruled out. Velázquez resembles Tintoretto in his willingness to treat the ground or imprimatura as an underpainting and to glaze directly over it, finally highlighting it in white as he did in Spínola's sash.[40] From the inspection of the surface and the cross sections, it seemed that Velázquez reduced Tintoretto's technique, eliminating such repetitive layers in which a glazing pigment was buried beneath an opaque one.

Like Tintoretto, Velázquez varied his grounds from painting to painting. As noted before, Titian tended consistently to lay down a ground of white gesso. Tintoretto sometimes used a gesso ground, but at other times he worked on a ground made of black or white oil paint; sometimes he used a ground of white paint with particles of blue smalt mixed in, or a brown ground composed of ochre with multicolored pigment particles.[41] We are not aware of a black ground in a Velázquez, but his grounds nonetheless vary considerably, from white to bright reddish-brown to gray or brown. Again, Tintoretto and Velázquez were reducing Titian's procedure when they eliminated the traditional white gesso ground that had been used on panel paintings for generations and that Titian retained for his canvases.

Like both Titian and Tintoretto, Velázquez may or may not have produced a

detectable underdrawing. Though Titian might occasionally draw at any point in his working procedure, Tintoretto frequently drew freely on top of his paint,[42] as Veláz-quez did in the *Rokeby Venus*. Tintoretto's underdrawings could be executed either in chalk or charcoal, or with a brush. Velázquez also appears to have varied his medium, from chalk or charcoal in the *Rokeby Venus* to brush drawings in *Las Meninas*. Drawing freely on the primed canvas with a broad brush has been observed in Velázquez's *Portrait of a Young Man* in Munich[43] (fig. 59), and in Tintoretto's *Doge Alvise Mocenigo before the Redeemer* in the Metropolitan Museum (fig. 66). When Tintoretto used black grounds, he often made underdrawings in white lead. At other times he drew in red lake. Since Velázquez did not use black grounds, it is not surprising that radiographs of the seven paintings we studied reveal no white lead underdrawings. Red lake underdrawings would be harder to detect from radiographs or infrared photographs; nonetheless, we did not find any in cross sections.

Tintoretto's palette resembles Titian's, not Velázquez's. He uses orpiment, realgar, and malachite,[44] all colors not yet found in any painting by Velázquez.

CONCLUDING REMARKS

Velázquez's paintings do indeed resemble Titian's and Tintoretto's in certain broad aspects of technique. In revising directly on the canvas, Velázquez is equally like Titian and Tintoretto. In his use of single-figure drawings, he follows both, but it seems that Tintoretto drew single figures more often than Titian. When Velázquez chose black chalk for his medium in sketches, he followed the Venetian preference as demonstrated by the drawings of both Titian and Tintoretto. In his glazing proce-dures, he is closer to Tintoretto, though he could sometimes produce Titianesque glazes. Tintoretto preceded Velázquez in eliminating underpainting from a glaze when a lightish ground would serve the same purpose. In using a toned ground or underpainting freely and at times with considerable daring, Velázquez resembles both Titian and Tintoretto. In eliminating the white gesso ground beneath the toned layer, both Tintoretto and Velázquez depart from the tradition still maintained in Titian's otherwise innovative canvases. In freely drawing at any stage of making a painting, and in including detectable underdrawings or not, all three painters are close. In his pigment choices, however, Velázquez departs significantly from the pigments used by both Titian and Tintoretto.

The sheer number of similarities among these three painters suggests a measure of historical connection. That measure remains difficult to quantify, however, and its significance is uncertain. After all, most of the characteristics named above occur now and then in the work of many painters of Velázquez's era, and several of the similari-ties can be found almost universally in the works of painters of the seventeenth century. White gesso or chalk grounds, for example, disappear from the paintings of innumerable baroque masters; pigments likewise change all over Europe between the times of Titian, Tintoretto, and Velázquez. Along with superficial similarities of

facture, it is the frequency of the other technical similarities within Velázquez's oeuvre, as well as their deep assimilation into his working procedures, that makes his work resemble that of the the Venetians.

Yet even this observation about frequency demands refinement and qualification. As mentioned before, within Velázquez's production, his technique can vary considerably from painting to painting. Like Tintoretto, he takes Titian's inventions and reduces them; he also turns around and reduces Tintoretto's procedures. More will be said about this reductive tendency in a moment, but here what needs to be emphasized is the Venetian precedent of freedom and innovation in handling the oil medium. Velázquez's incorporation of Venetian techniques often seems not so much a copying as a free improvisation on Venetian inventions. If freedom and spontaneity can be learned, then perhaps Velázquez profited from the example of the great canvases by Titian and Tintoretto in the royal palaces. But neither Titian's nor Tintoretto's canvases, with their thick, frothy paint, taught Velázquez some of his most characteristic practices, such as his use of delicately diluted washes of paint. If a very general comment about Velázquez's relationship to Venice can be made at all, it is that he shared with the painters of that city a predilection for, or habit of, spontaneity in the fabrication of a canvas. Predilections can be inborn and habits can be learned, and Velázquez's readiness to respond to the Venetians' legacy may be a quality that defies more exact historical elucidation.

Nevertheless it does seem that Velázquez comes along and takes up where Tintoretto left off. Tintoretto had simplified some of Titian's procedures, and Velázquez simplified some of Tintoretto's. Insofar as Velázquez eliminated paint layers, making a less complicated structure of superimposed colors, he was very much the Spaniard. Cross sections of paintings by Zurbarán and Murillo show that they also rejected complex underlayers and painted quite directly, often obtaining their final effect in just one or two strata of color.[45] Whether this simplicity indicates that Spanish painting tended technically to derive from Italian and Flemish, and hence to be reductive, or whether it responds to an indigenous craft tradition, is an open question.

A more general comment about the utility of technical data for construing a historical relationship may be appropriate here at the end. In making a technical examination of a painting, one concentrates upon elements that are testable, such as pigments and layering. Part of our difficulty in devising a usable answer to the question of Velázquez's relation to Venice is that the data are hard and narrow but the question is soft and broad. Chemical testing of a pigment, however subjectively the site may be selected, at least gives credible hard evidence that a precise pigment is, say, azurite, and that it was layered in such and such a way. But the question of Venetian influence is itself indefinite and can be variously phrased. Partly because the issue is so difficult to define in researchable terms, one gladly recasts it into questions amenable to scientific analysis. But to rephrase the question is not necessarily to

answer it. To talk about influences in pure technique, as opposed to style or iconography or purpose, is confining. A brushstroke in isolation is a senseless thing, lacking any meaningful form. Brushstrokes and layers are common to all paintings, the universal phonemes out of which pictorial language is devised. Unless placed in the context of a painter's characteristic facture, subject matter, composition, palette, set of poses, and sense of space, the information about materials and structures is of limited relevance. The contrast between the appearance to the naked eye of the tablecloth in *Philip IV Standing* (fig. 7), which from a cross section alone could be a passage from a finely-stroked Venetian painting, and the sash on Spínola in the *Surrender of Breda* (fig. 23) is a good example of the limitations of cross sections. From the cross section, *Philip IV Standing* looks Venetian, whereas to the naked eye, it does only in the most general way (fig. 7). Spínola's sash in the *Surrender of Breda* (fig. 23) presents the opposite situation: from the cross section it does not look Venetian, but to the naked eye it does. Further examples could be added. We have noted earlier that Velázquez's protruding lumps of pigment in his otherwise smooth paints may record his effort to imitate Titian's coarse, nubby canvases. Nevertheless it is important to remember that Velázquez did not exploit this rougher texture in the same way Titian did. Titian liked to drag a half-dry brush over the bumpy canvas, depositing a scumble on the highest threads to create an almost frothy effect. Velázquez scumbled too, but his paint was frequently thinner and less assertive.

Velázquez refined Titian's and Tintoretto's brushwork in other ways. Without the fanfare of the multilayered glazing procedure, Velázquez could keep his paint thin and fluid, avoiding the pastier pigment so often used by Titian and his followers. In a passage from a painting by Titian, the paint is often thick-bodied, standing well off the surface of the canvas and almost inviting touch from the viewer who examines it. As in the case of the false illusion of glazed fabric in the *Surrender of Breda*, Velázquez's borrones represent supreme simplifications of the impasto technique. In the *Surrender of Breda* and most of all in *Las Meninas*, Velázquez worked with paint so thin that one would think the effect of impasto would be impossible to achieve. Because Velázquez was successful in fooling us into believing that thick slashing strokes are heaped onto his canvas to create Princess Margarita's notorious rosette in *Las Meninas* (fig. 43, colorpl. 3A), those familiar with the canvas from photographs may not realize the insubstantiality of the famous passage. One begins to appreciate that the rich pile of three-dimensional paint is an optical illusion when one sees the ground and underdrawing visible beneath. The blush of salmon on Margarita's white dress, which is either her pink shoulder ribbon reverberating on the white sleeve, or a reflection of the brilliant bow that decorates the wrist of the menina opposite, is likewise painted with the thinnest of washes: red lake suspended in a medium so liquid as to be almost a stain (colorpl. 1B). The mixture of ingredients explains the effect. Red lake is a sheer glazing pigment, here mixed with some calcium carbonate, which increases both the transparency and shimmering quality of the glaze. Chalk also gives pigment "tooth" or traction and thus makes a veil so delicate, and so runny,

manageable. In the rosette on Margarita's dress, the final illusion of impasto, of thick, freely loaded paint, dissolves into an almost flat pattern up close. With the gray ground still visible, the delicate cloud of red lake and the soft stipples of thin black are finished with a half-dozen tiny points of lead white, the only genuine impasto in the passage. Velázquez also knew how to exploit very thin paint in other areas, as when he let the liquid paint of God the Father's cloak in the *Coronation of the Virgin* (fig. 40) run to make the plump fold at the edge of the garment.

The princess's left shoulder in *Las Meninas* (fig. 43 and colorpl. 1B) is one of the more delicately stroked passages in the painting. The blacks are bone or charcoal, which are soft and, if diluted, translucent. The only touches of genuine impasto are over what is almost a watercolor. The variations in the tones of black give the illusion of paint that varies in thickness, in build-up off the surface of the canvas, but most of the optical effect is just a variation in the liquidity of the medium and the amount of white mixed in to give the viewer the subjective impression of variations of thickness.

If we stand back from the Velázquez and compare the entire painting with a painting by Titian, the cumulative effect of the many differences in the handling of paint invites general observations. In a late Titian, one's first impression is often of the materials that make up the painting: one sees the brilliant hue of a yellow drapery before one comprehends the form it describes. Or one may first perceive the thick, pasty strokes of impasto highlights that cry out to be recognized as paint, and only then are read as flesh. Even at a distance of some ten to twelve feet, the assertiveness of Titian's materials demands notice, at least to the eye of the modern viewer. In Velázquez by contrast, bright colors are more muted. In the *Surrender of Breda* or *Las Meninas,* even the pure reds are more diluted and are forced to obey their ambient light. In the scarlet suit of the midget at the far right of *Las Meninas,* the red does not declare its autonomous opulence in the way that a red may do in a Titian. And in *Las Meninas,* when viewed from a distance of ten to twelve feet, individual brushstrokes disappear and particular colors fade away. Nowhere is the viewer terribly conscious of the paint itself. It is hard to pin down the exact moment when the illusion ceases and the paint betrays itself as paint, as has been pointed out.[46] But still, the approaching viewer is tempted to draw ever closer in the belief that the fragile tissue of brush-strokes is no more than a thin veil and that the faces of the king and queen will eventually become recognizable in well-focused resolution.

The visual assessment with the naked eye is crucial. One demands, quite reason-ably, that a painting supposedly influenced by Venice have the outward and visible signs of being influenced—that it look Venetian. The Venetian look is partly pro-duced by surface handling of paint, partly by layering, and partly by materials. In his handling of paint, Velázquez's thin washes would produce a somewhat different picture regardless of how he layered them. Nevertheless, Velázquez could sometimes approximate a Venetian surface optically without duplicating it structurally, especially if the passage were viewed from a distance. This is interesting, and one is tempted to speculate that the deception was deliberate and thus was proof of a desire on his part

to make his pictures appear Venetian. In his actual layering, though, Velázquez is in fact no more Venetian than any seventeenth-century Spanish painter. Knowledge of his simpler structures is intriguing mainly because it indicates that Velázquez, as a Spaniard, worked more simply and economically than the Venetians, but that he often did so without sacrificing complexity of visual effect. In his use of pigments, Velázquez was clearly a man of his century. Awareness of the considerable difference between his palette and Titian's or Tintoretto's reminds the viewer of the importance of pigments in determining a final effect, and of the improbability of any seventeenth-century painting's looking more than vaguely—or partially or relatively—Venetian.

At the beginning of this chapter, we mentioned the danger that twentieth-century tests might produce an anachronistic picture of Velázquez's relationship to Venice. The picture provided by the chemical analyses of pigments, cross sections, radiographs, and infrared photographs seems to indicate that Velázquez's practices were Venetian in a rather disorganized, hit-or-miss way. Definitive evidence of consistent contact with specific procedures is missing, so, as befits skeptical moderns, we chose to decide that the tests of Velázquez's relationship to Venice did not show any absolutely conclusive indebtedness.

It seems, however, that the twentieth-century approach may fail to see the forest for the trees. The precision of modern analysis distorts the original issue of Venetian influence by phrasing it too tightly, and in this phrasing it misses the point of the early references to Velázquez as a Titianesque painter. The seventeenth century conceived of a painter's allegiance only in the broadest and grandest terms. Like so many issues in Velázquez's century, this one boiled down to a simple yet all-encompassing polarity. The world was divided into two camps. On one side were Michelangelo and the northern artists, who painted with crisp outlines and smooth brushstrokes. On the other side were Titian and the later Venetians. The fact that in a Spaniard's mind a few painters could shuttle back and forth across the chasm— Raphael, Coreggio, Parmigianino, and Bellini were placed on different sides by different writers—did not diminish local faith in the fact that the chasm existed. Martínez laid out the distinction with admirable clarity:

> Albert Dürer, Lucas van Leyden, Giovanni Bellini, with many others, worked in that very finished manner, and they carried that style to its limit, and won well-merited applause by following their talent and natural inclination. Titian, Bassano, Paolo Veronese, and Tintoretto went in the opposite direction, making their works so bold that it seems that with their works they canceled the applause for the others, because in their works a certain rapid execution was apparent, suitable for more grandiose achievement.[47]

So if we set aside our microscopes and look at the question as Velázquez's contemporaries looked at it, the answer is suddenly crystal clear. Of course Velázquez painted like a Venetian. He made borrones and pentimenti. He drew directly on the canvas. He was inconsistent when it came to making drawings on paper. He sought verisimili-

tude through the illusionistic manipulation of color and light. For all the dazzling variety of procedures exhibited by his different paintings, one cannot think of even one canvas in all his oeuvre that is closer to Dürer than to Titian.[48]

A Spanish painter of Velázquez's time would no doubt have been amazed at this chapter. Not that it would have surprised him that the question of Velázquez's artistic allegiance be asked, for that question was still a common pretext for discourse in the 1600s. What would have astonished him would have been our attention to Velázquez's many departures from Titian's technique. For to a Spaniard the very essence of the Titianesque style was its variety and unpredictability. Perhaps we should allow Jusepe Martínez to say a little more about the difference between the two manners, for he tells us that Velázquez's unfettered originality was exactly what made him Venetian:

> Titian, Bassano, Paolo Veronese, and Tintoretto went in the opposite direction, making their works so bold that it seems that with them they canceled the applause for the others, because in their works a certain rapid execution was apparent, suitable for more grandiose achievement. *This is not something one can study, for it is done only by means of a certain resolution that is born of a liberated soul. . .*[49] [emphasis added]

In chapter 1, it was pointed out that Spanish authors saw Titian as a prototypical rebel painter. It was also clear that when Palomino modeled part of Velázquez's biography on a Titianesque prototype he was, ironically to us, grounding Velázquez's originality in a convention. Technical comparison of Velázquez's paintings with Titian's and Tintoretto's reveals both persuasive similarities and compelling differences. Possibly the complex historical relationship implied by the analysis of the writings should be seen again in the analysis of the paintings. Velázquez, in other words, belonged to the Venetian tradition of innovation.

3

INTERPRETING COLOR

While examining Velázquez's works in 1980 we noticed areas in the paintings that were strangely dull and hard to make out. The dark skirt of the kneeling menina in *Las Meninas* or the lifeless black clothing worn by the men in portraits, for example, seemed incongruous when compared with the parts of those paintings that are light and bright. Chemical analysis shows that the kneeling menina's skirt (colorpl. 3B) was once a bright greenish blue (which is the characteristic color of azurite). Infrared photographs show that the taffeta, velvet, and satin suits worn by Velázquez's male sitters were far from drab. Colors are not all that have changed. Aging paint has also become more transparent, with the result that Velázquez's early ideas, of which he "repented" and which he painted out, are often visible to the naked eye as pentimenti. Questions raised by emerging pentimenti are, however, somewhat differ-ent from questions raised by mutating colors, because Velázquez's pentimenti usually underlie his figures and thus change his subject matter.[1] We have chosen, therefore, to confine our discussion here to color changes.

To the seasoned conservator, the color alterations we noticed in Velázquez's paint-ings are not startling. Many seventeenth-century pictures show similar changes, and some have experienced far more radical transformations. At first, it might seem that most alterations are trivial or irrelevant as far as modern readings of the paintings are concerned. Thus one's initial reaction to the fact that a Velázquez has gotten darker is that the change at most will nuance the modern onlooker's aesthetic enjoyment. In fact, it is precisely this complacent view of the issue that motivated the writing of this chapter. When we commented to colleagues that the hues and tones of Velázquez's paintings had changed over the years, the most frequent response was a clearing of the throat that heralds an effort to be tactful: "Did the original colors have symbolic meaning?" When we confessed that there was little evidence of color symbolism, the question would be put more baldly: "What difference does it really make?" And more often still, "Does the fact that a lady's skirt has changed from a green-tinged blue to a dark green in *Las Meninas* change the *meaning* of the painting?" The most disconcert-ing aspect of these exchanges was that we found ourselves without a confident reply. In spite of the uneasy feeling that a color change in *Las Meninas* ought to have some significance, we were at a loss as to how to situate that significance within recent

discourse on that complex painting. This uneasy feeling provided the impetus for a consideration of ideas about color in Velázquez's time.

Reviewing these seventeenth-century ideas makes it clear that color was indeed meaningful. But it was meaningful in a way difficult to articulate within the conventional rubric of art history. Indeed, hue was never easy to talk about, even before the invention of the academic discipline. Acknowledging that it is hard to come to terms rhetorically with a major component of seventeenth-century painting may only remind a viewer of the truism that a picture contains dimensions that are not amenable to verbal interpretation. But more important, it challenges the speaking viewer to construct new modes of perception and to develop a fresh repertoire of ideas to shape and give voice to these modes. Before embarking on such an ambitious task it seems wise to define the nature of color change in the Velázquezes.

First, however, it must be pointed out that our reconstruction of the original colors, more especially of original tones, is necessarily tentative, because chemical analysis is more reliable in demonstrating that a color must have changed than in specifying precisely what the original color was (see Appendix II). Thus one can state that the kneeling menina's nearly black skirt was once blue, but the exact tone, intensity, and value of that blue are more difficult to pin down. This lack of exactitude is regrettable, for, as will become apparent in the discussion, it was precisely an artist's ability to control subtle gradations of hue and tone that gave his works value in the eyes of his contemporaries. Nevertheless, we proceed on the assumption that it is better to be aware that we do not know exactly what the saturation or tone of every pigment was than to repeat the mistake of previous generations in assuming the image before our own eyes is the image Velázquez painted in 1628, 1634, or 1656. And, of course, one must also ask whether the spontaneous changes were intended by Velázquez. Although it seems unlikely that he knew his paintings would change as drastically as they have, that issue is complicated (see Appendix II).

TEMPUS PICTOR

We begin with an inventory of the major changes in hue in the six Velázquezes.

In *Philip IV Standing* (figs. 7 and 10) the losses of chromatic detail within the king's clothing are significant. As infrared photographs show, his garments were once alive with subtly orchestrated distinctions among black silks, velvets, and taffetas; buttons and rosettes further ornamented the king's suit. But a verbal inventory alone does not do justice to the original fineness of the stuffs or the verisimilitude of their rendering. Velázquez's brush once distinguished the shifting iridescences of the taffetas and velvets, and it delicately discriminated between these individual cloths by manipulating the degree of reflectance in each black, endowing it with the full implication of its appropriate weight and texture. If one relies upon normal photographs to assess the image as it now appears, one may still see a good deal of this textural splendor, because commercial and museum photographs are overexposed to

reclaim detail; furthermore, normal panchromatic black-and-white film is slightly sensitive to the infrared spectrum. To the museum visitor who actually sees the painting, however, Philip wears dull garments whose original magnificence can be only partially grasped.

In the *Forge of Vulcan* (figs. 14, 17), Apollo's once-green wreath is now distinctly blue, although the yellowed varnish that covers it partly restores the green tone. The loincloths of three of Vulcan's assistants have changed from comprehensible drapery to flat patches of dark paint. Very likely the browns that describe the walls and floor of Vulcan's forge have also darkened. But the pale flesh tones have remained comparatively light, and Apollo's gold robe has probably kept its brilliance. What once must have been a controlled distinction between bodies and their surrounding environment has been disrupted, making the figures stand out with unintended prominence. The dark areas behind Apollo and behind the assistant in the far background have turned almost black, ceasing to provide these figures with an orientation in atmospheric space.

The *Portrait of a Dwarf* (*El Primo Don Diego de Acedo*, figs. 34, 36) has seen darkening in the brown and black paints. Like the suit of Philip IV in the standing portrait, the sitter's black clothing was understated in color only. His sumptuous jacket, once a rich texture of cut velvet and silk (fig. 36), has turned into a less differentiated fabric that retains only the broad outlines of the pattern that once decorated it. It is hard to know whether the sky was always the dull grayish color visible now. Velázquez used smalt there, and, even when it is fresh, smalt comes in various intensities of blue. But bright smalt can dull or discolor to brownish gray. Thus, whether the day depicted was originally sunny or dreary cannot be answered by scientific data in isolation. Common sense suggests that no one would want to sit outside in such unpleasant weather, and therefore it is reasonable to assume that the smalt may have discolored. Certainly the mysterious dark brown strokes that have appeared in the sky cannot have been there originally; now they interfere with the sweeping landscape and contradict the illusion of spatial recession.

Las Meninas (figs. 42, 44) also has undergone tonal changes because of darkening paint. Fortunately, a sensitive and sympathetic cleaning of the painting in 1984 has restored some of its tonal balance.[2] Now many original touches of color show themselves still to be vivid. The *búcaro* of water offered to Princess Margarita is a brilliant red, as are the firelike touches on the sleeve and hands of the dwarf Maribárbola. Velázquez used a fine brush to lay on glittering highlights over Margarita's torso and hair, and he set them in sparkling contrast against the black that trims the neck of her gown. The hue of individual brushstrokes is still often intense: the orange pigment on Velázquez's palette is made up of a yellow, with a red that is mashed in but not mixed. This recent cleaning has brightened the picture considerably, but because of oils that have darkened spontaneously during the centuries after *Las Meninas* was painted, the floor behind Margarita, as well as the walls and ceiling, are still darker than they once were. Velázquez's fine suit, like Philip's suit or the dwarf's jacket, has

lost its elegant detailing (fig. 47). The dress of the kneeling menina, María Agustina Sarmiento, was once more colorful. Judging from pigment samples, it was originally a lighter blue-green. It is now a dark green (colorpl. 3B); the bright aqua color of the dwarf Maribárbola's dress has also dimmed and now appears a dark blue.

COLOR AND ICONOGRAPHY

Colors in the seventeenth century did sometimes have symbolic meaning, and, as information about color and tonal changes in old paintings becomes more readily available, research will also be necessary to decode their iconographic and iconological meanings.[3] But in this chapter, we will nowhere discuss color as symbolic iconography. Moreover, one of our purposes is to point out the aspects of a painting for which that kind of analysis is inappropriate.

Iconography is capable of providing an interpretation for a work of art that fulfills all the requirements of rhetoric. It provides clarity, structure, logical narrative development, and a sense of closure. But ultimately the system becomes the victim of its virtues. Iconography promises a quick fix for the difficulty of verbalizing a painting. Yet the promise is false because what vision itself offers is a synthesis of impressions, some of which are impossible to structure, narrate, or bring to a close. It is iconography's promise of completeness that makes it misleading, yet Panofsky's persuasiveness in encouraging viewers of art to focus on subject matter at the expense of form has meant that discussions of form have not been developed to the same level of sophistication that iconography has. Iconography, nevertheless, is problematic as a system for discussing color, because although Panofsky's desire to separate meaning from form has created a comprehensible academic structure, it is a distinction that fails to take into account the subtlety of the entanglement between subject matter and form.[4] That is, it is a distinction that underestimates the indeterminacy and irreducibility of the visual image itself.

The origins of this system can be traced at least to the Renaissance, when rhetoric and poetics were also faced with similar distinctions. Rhetoric, in addition to its oratorical mode, was a discipline defined by the use of language as art. In the fifteenth and sixteenth centuries, the standards of the art of discourse were readily extended to painting, so that by 1596 El Pinciano claimed the equivalence of poetry and painting, saying that both were comprised of plot and meter. For a painting the plot or *fábula* was the figure, whereas the *colores* were the meter. As far as El Pinciano was concerned, the fábula was the more important element.[5] If the fábula can be seen for a moment as sharing some common ground with Panofsky's subject matter, and if the meter can be seen as his form, then modern iconography, in spite of its innovative appearance when it was first introduced, was in fact deeply embedded in the linguistic structure of Western rhetoric. This connection to rhetoric is, in fact, part of the problem. When applied to paintings, rhetoric assumes a mutuality of language and vision. Although there is some common ground, this relationship is far from abso-

lutely reciprocal. Crucial aspects of vision—color, brushwork, light, texture, and space—are not easily verbalized.[6]

To return, then, to the query raised by colleagues about the menina's now-dismal skirt: Do the changes in color, tone, and texture discussed earlier matter to our understanding of the "meaning" of the painting? If this meaning refers to Panofsky's iconography, then the answer is "no," even though in Spain color often had meaning in the tight symbolic sense: for example, blue equaled heaven and also equaled the Virgin's robes. But if we use meaning as a liberal, fluid category, then clearly color participates in the production of meaning denied it by iconography. For example, color became implicated in politics in seventeenth-century Spain, when sumptuary laws prohibited the color blue or placed different price ceilings on objects of different colors. Our choice not to discuss color here in its traditional iconographic definition is due to the greater urgency of establishing that color's function in a painting was more fundamental and more crucial than that definition allows. If we relegate color to a merely symbolic function, then we subordinate color to the symbol it serves. Such a transaction would again empower the concept at the expense of the visual object, and, as a damaging corollary, would close off the capacity of color to generate a multiplicity of responses from a viewer.

Seen through the eyes of later art historians, it seems clear that art history often divides itself, even within a single book or article, into a fabulist camp versus a formalist one.[7] By pointing out the negative aspects of iconography, however, we in no way mean to say that traditional iconographic interpretations are invalid. In fact, iconography is indispensable to the thorough historical understanding of a painting. In recognition of that fact, we have tried to develop an approach to Velázquez's paintings that retains a discussion of subject matter but does not allow that subject matter to subordinate the formal elements of the image. In other words, we have tried to restore a balance between the discursive and the formal. In doing this, we deliberately soften and blur the traditionally sharp divisions between the two. And, by choosing to articulate the viewer's experience of both subject matter and form, we focus upon a "sensation of value" in which the various aspects of a painting merge into a synthetic perception.

When dealing with light, color, and form, one deals with aspects of a painting that transcend its own description. When discourse on painting was the province of the gentleman and poet, form was feted, and it is no accident that so many of the contemporary reports on Velázquez's paintings were written in verse. When in 1637 Manuel Gallegos says of *Joseph's Bloody Coat Brought to Jacob* that "Jacob groans in colors / and explains his sorrow in shades,"[8] he is indulging in a sort of ekphrasis for which poetry was ideally suited. Art history was conceived as another enterprise altogether. Positivist and rational in its aims, it adopted expository prose as its vehicle. It took as given that whatever is seeable is sayable. An essay demands a narrative development, not a recreation of sensory impressions. Art history also assumed that the "real" meaning of a painting could be established objectively. For all that

Panofsky's pre-iconographic description included "expressional" subject matter, and in spite of the fact that his *iconology* indeed recognized broad cultural "symptoms," the practical application of his theories has resulted in the disenfranchisement of form.[9] Subject matter answered art history's early need for an objective method by providing material that was easier to assess empirically than color. For all that writers in the early twentieth century also attempted a discourse that presented abstract art in terms of form and color, that attempt largely failed as a successful narrative.

The sensory dimension of a painting, that aspect that is more easily perceived than described, has quite logically become a casualty of the discursive discipline of art scholarship. Ignoring the immediate visual impact of *Las Meninas* has increased its fascination. Through scholarship, it has become a hermeneutic icon. Its self-reflexive character catches the structuralists' eye;[10] its curious play of glances and reflections invites philosophical musings;[11] its social content proves amenable to various readings;[12] its arguably accurate perspective challenges the mathematician;[13] its original site or sites offer further material for interpretation.[14]

One wonders what would happen if, in the interests of constructing a different category of perception, the emphasis upon "meaning" were to be changed. Instead of asking what a painting by Velázquez *meant* to the artist and the court, one might ask, "What about a painting by Velázquez *mattered* to the artist and the court?" This question allows us to discuss "meaning" in the sense of significance rather than in the sense of denotation. Such a rephrasing would still allow interpretation based upon subject matter, for unquestionably subject matter was a major concern for a viewer in Velázquez's time. For example, Palomino's first sentence in his description of *Las Meninas* tells us that the painting contains the portrait of "las señora Emperatriz. . .Doña Margarita María" (fig. 42).[15] The problem of the status of painting, which may well also have been part of the meaning, is equally clearly described by surviving writings and documents about painting in general. Without a doubt the subject of a picture mattered, and it mattered a great deal. But asking what mattered would permit the reintegration of subject matter and social history with the equally emphatic contemporary concern for verisimilitude, color, light, and the various material ingredients of a painting.

COLOR AND THE SEVENTEENTH-CENTURY VIEWER

Many of the points in the following review of color may seem to hark back to the formalism and aestheticism that had worn out their welcome by the closing decades of the twentieth century. The reasons for the demise of formalism were many and complex, but at least one of its fatal weaknesses was its indifference to the relationship among historical and social factors and the work of art. Now that social context is firmly established as crucial to the understanding of a painting, it seems advisable to turn attention again to form. Because after all, form—and here more specifically,

hue—had meaning in the sense of significance within the historical context, too. To the extent that the painting's general aesthetic eloquence was altered, a grisaille *Las Meninas* in 1656 would have proved a less seductive image to its seventeenth-century viewer. Similarly, one wonders whether forty-four years later, in 1700, Luca Giordano, that devotee of color and light, would have proclaimed *Las Meninas* the "Theology of Painting" if it had been done in monochrome.[16] To a Spaniard colorido meant optical naturalism and verisimilitude. Verisimilitude is extremely important in this regard, but first it is equally important to note that colorido also referred to the system of hues used by a painter: the reds, blues, yellows, and so forth. Beautiful hue as a desirable element in itself was discussed in the fifteenth and sixteenth centuries, and to judge from published comments, the delights of the rainbow had lost none of their fascination by Velázquez's time.

We begin by presenting some quotations that describe the importance of color in Velázquez's Spain, even though we believe that the reintegration of form into a discourse that already includes iconography and social history is a task requiring more than the excavation of documents that will testify to the importance of colorido in a given era. And, if one accepts the premise, as we do, that talk about paintings is always limited by preexisting cognitive categories, then ultimately we will have to develop a new way of organizing and articulating the perception of form. Completing such an ambitious undertaking lies beyond the limits of this book, but we try to make a case for beginning it. The categories of perception to be introduced in the coming pages are limited to approaches suggested by the examination techniques we used. Pigment analyses, which established that colors had changed, suggested seeking ways of understanding the seventeenth-century meanings of the original colors. Microscopic cross sections, which clarify the layering of Velázquez's paints, invited a discussion of the significance and relevance of craft traditions.

In the quotations which follow in the section on the concern for color and tone among artists and writers, no effort is made to trace the historical development of thinking about color, or to distinguish trope from living practice. Scholarly and scientific investigations of color theory and practice in Spain are still embryonic, and evidence to trace broad developments is as yet not available. Until more thorough research has been carried out, we suggest reviewing the evidence from the early seventeenth century to the early eighteenth, thus putting a broad bracket around Velázquez's career. It is true that in chapter 1 we found Pacheco's written list of *colores* or pigments of 1638 or 1644 to be only partially reliable, because he included in his list obsolete items. But by the time Palomino published his treatise in 1715–24, his list was more accurate for describing the pigments of Pacheco's day. With this in mind, the following hypothesis will be used to evaluate the attitudes of Velázquez's contemporaries regarding hue, tone, and chromatic verisimilitude. Anyone comparing Pacheco's list of pigments with Palomino's notices that some pigments were dropped by Palomino's time, whereas some stayed. The ones that stayed were, with the exception of indigo, pigments found in Velázquez's paintings. Borrowing this

principle, we limit the following quotations and summaries to expressions of beliefs that continued to find voice consistently in the literature from Pacheco's time through Palomino's; presumably such continuity will identify the general aesthetic assumptions that were current at Velázquez's time.

Surely a culture's visual habits would also find expression, however elliptical or indirect, in manifestations beyond artistic and literary circles, yet aspects such as the education of the public in general, theatrical costumes and the staging of plays, public festivals, exequies, and ephemera are poorly published.[17] Although we have not been able to look further into this area, we wish to acknowledge that such research would be useful.

One desirable area for future research into the seventeenth-century perception of color might be a review of the evidence about textiles. Fabrics, for example, had to receive dyes; investigation into guild regulations or commercial transactions might reveal how color was perceived, described, quantified, or valued. Certainly the society's response to texture in fabric differs from our own, at least to the extent that it found expression in sumptuary laws governing which classes could wear what cloths. Silk for public wear, for example, was occasionally legally prohibited to the lower classes,[18] although the prohibition was unevenly enforced. Visually, silk is distinguishable from cotton or wool by means of the reflectance of light off the surface and the relationship between that light and the saturation of the color. Proper reading of texture, light, and color was clearly an important ability for a Spanish citizen, and the exacerbated awareness of these qualities may have transferred itself to the viewing of paintings. To take a painted example outside the six canvases in the Prado, one wonders what effect this ability to read texture would have had in the viewing of the *Rokeby Venus* (fig. 55). Not only might the viewer have been quick to distinguish the heavy crimson curtain from the thinner dark sheets, but the silken expanse of female flesh might have aroused an association with a fabric that was desirable but forbidden, at least in law, to all save a few. Even the hazy sheen on the surface of the mirror would at least have called into play the capacity for discriminating among items endowed with different kinds of reflectance.

The Concern for Color and Tone among Artists and Writers

To readers familiar with sixteenth- and seventeenth-century theory, the following descriptions of color aesthetics will seem so obvious as to be unnecessary.[19] But in the context of the perception of hue in Velázquez's time, it seems wise to review the thinking about color between about 1600 and about 1724, and thus to identify what seem to have been enduring criteria for Spanish painting.

Pacheco at one point restored a painting falsely attributed to Pedro de Campaña. Looking over his comments again, one notes his concern to revive colors that had dulled. Speaking of the just-restored painting, he says: "I put back the blue of the mantle of Our Lady, the colors of the sky, which were faded. . . ."[20] Indeed the art of restoration was to Pacheco a restitution of brightness: "We will say a word about

restoring and brightening (*alegrar*) canvases, or old panels, in oil which have been darkened by smoke and varnish. . . . "[21] Apparently the intrinsic beauty of color could still be praised in the early seventeenth century, in spite of the fact that the arguments of the parangón had reminded painters that bright materials were less important than the skilled use of those materials. In the hands of a genial painter, the prudent manipulation of a lovely hue still recommended the nobility of the art. *Deus pictor*, that first artist of the world, had painted with color. Furthermore, as Pacheco pointed out triumphantly, color often told more about an object's identity than shape did, and color further provided *agrado* or agreeableness. So, as Pacheco retold the Biblical tale, when God created the world, "if all these things created were of just one color, they would not have the agreeableness and perfection that they show, with the variety and distinction of so many colors." At which point Pacheco turned to a verse by Pablo de Céspedes, which itemized the coloristic glory of the Creator's palette: the sky was adorned with "purplish tints," the peacock received wings and a tail that "Thou embroiderest with gold and a divine blend, where the pale pink lives, where the emerald green shines, and the vivid sapphire. . . . "[22]

Judging the extent to which this taste for sumptuous color endured unchanged throughout Velázquez's lifetime is difficult. Each generation must have had its own preferences for certain hues and tones. Yet for all that preferences for specific hues must have shifted, the general desire for a vivid color of some sort seems not to have changed in any way that was readily recorded in writing. In 1654, two years before Velázquez painted *Las Meninas*, a contract signed in Madrid for an altarpiece by Herrera the Younger stipulated that "all of said paintings are to be made up and finished with fine and bright colors."[23] In 1696, a generation after Velázquez's death, García Hidalgo still insisted that fully saturated color was a necessary ingredient in painting. Echoing Pacheco, García Hidalgo advised "that you should put on colors in a clean and beautiful way; and . . . you should leave it [the painting] finished, and well built up, with much color."[24]

The example of grisaille that we created was extreme enough to make it clear that color made a difference to the seventeenth-century onlooker. But what if the painting had had, in 1656, the same appearance it has now? It is not just that *Las Meninas* has grown noticeably darker. The impasto has also been flattened by lining. Though precise reconstruction is impossible, the surface presumably had delicately descriptive three-dimensional passages seen in unlined paintings of about the same time, such as the *Juan de Pareja* (fig. 57).[25] In *Las Meninas* the seams now stand out prominently, dividing the canvas arbitrarily into three meaningless panels and interfering with atmospheric perspective. To the viewer Velázquez's suit must have represented the ideal attire for the gentleman painter at ease in silks and velvets (fig. 45). The easy negligence that he shows in daring to paint in such exquisite garb would have recommended him, and his medium, to anyone familiar with the parangón and sensitive to the suggestion that the practitioner of the art of painting did not soil his hands while at work. María Agustina and Maribárbola would in all probability have

been dressed in shades of bright blue or aqua, not in the greenish-black they now wear, and the stuffs of their dresses would have been recognizably rendered to speak clearly of fashion, taste, and luxury. Certainly the careful reproduction of individual fabrics was insisted upon by early theorists, and Pacheco quotes Pino's demand that artists make recognizable "a suit of armor, a drapery of silk or linen, a scarlet separated from a green. . . . "[26] Well after Velázquez's death, García Hidalgo points out that beyond simply making silk discernible from wool, a painter must also get the specific type of silk fabric right: taffeta, for example, should be recognizable as such.[27] Palomino points out that colors should express linen versus wool and wool versus silk.[28]

The paintings on the walls in *Las Meninas* might have still been hazily brushed in, for infrared photos clarify them only up to a point (figs. 49, 50). But the ambient light would have been brighter, and the play of luminosities would have worked with the perspective to create a still more subtly evoked sense of that admired accomplishment, the duplication of real space.[29]

Color and Truth

When modern viewers attempt to imagine the aesthetics of the seventeenth century, it is all but impossible to comprehend the intensity and universality of the emphasis upon one criterion for pleasing the viewer: verisimilitude. Once again, time has probably rendered the scene in *Las Meninas* less optically persuasive than it was in 1656. The slow evolution away from sensory replication seems of little significance in the twentieth century, when abstraction has become an accepted mode of representation. But to the viewer of Velázquez's time, verisimilitude mattered. Nor was it just that verisimilitude was a manifestation of the artisan's skill. Likeness possessed absolute value. No one was quicker than Pacheco to point out that Aristotle had demanded that a work of art, either literary or visual, had to possess resemblance. And thus "painting is art, for it has nature itself as its objective, and as the rule of its works, always managing to imitate nature in the quantity, three-dimensionality and color of things. . . . "[30] Furthermore, the imitation of God's nature is the imitation of the Deity who made it: "Who could there be in the world who would not take pleasure in imitating Nature, and God himself, with the paintbrush, insofar as it is possible?"[31] A century later, Palomino still wrote in the same vein, defending deceptive illusionism on the grounds that Christ at Emmaus had deceived his apostles' sight and "*pretended to go farther away*" (emphasis added).[32] Tributes to Velázquez's paintings written during his lifetime praise his illusionistic effects almost without exception. Around 1625, Luis Vélez de Guevara claims that Velázquez's brush "robs truth, whether subtly or overtly, and simulates truth so well that in thee [the brush] ferocity is feared."[33] For Quevedo, the painter's brush is a "talented competitor with nature."[34] When in the 1660s Vaca de Alfaro praises Velázquez, he again refers to the imitative powers of his painting: "with skillful brush you instill a soul into each sketch, a breath into each likeness."[35]

Palomino emphasizes this illusionism especially, and he discusses its creation through the optical rendition of atmosphere. Indeed, Palomino finds the virtue of defining perspective and space by light to be well illustrated by *Las Meninas,* for he notes specifically that "between the figures there is atmosphere."[36] In the service of resemblance, color and perspective played interpenetrating parts. Pacheco said that "*colorido* [here in the sense of coloring] serves in place of the various tints with which nature paints, and with which all things are imitated."[37]

To establish color's theoretical prestige further, colors in a painting were likened to chords in a piece of music. They must be subtly adjusted to each other to produce harmony, and they must also diminish in intensity as they recede to produce atmospheric perspective. According to Martínez, the "colors on the canvas are for the eyes what strings of an instrument are for the ears, from which it follows that unison which is what makes the effort harmonious, is to be sought in colors through blending. . . ."[38] Palomino believes colors must be subtly varied to produce musiclike harmonies of thirds, fifths, and octaves; dark colors should recede according to this musical metaphor, dimming in progressive diminution for the background.[39] And Palomino perceives similar virtues in Velázquez's *Las Meninas* in the early years of the eighteenth century: José Nieto, silhouetted in the bright doorway, is a good likeness, "despite the distance, and decrease in the quantity of light."[40] Palomino again uses a musical metaphor to explain the proper gradation of colors for flesh, which should be toned down bit by bit "in the way that it decreases in music, entoning *la, so, fa, mi, re,*" and he ends with the statement that painting is the music of human sight.[41]

As Pacheco had already pointed out, color was capable of the most exquisite distinctions. For example, the painter was supposed to be able to tell us "two things: first, the color of the natural or artificial thing; second, the light from the sun, or from another light."[42] Thus the colors of the meninas' dresses or the clothes of the dwarfs and the princess, would have communicated not only the correct fabric and hue, but also the sunlight in which the group was painted and the diminution of intensity in each figure as it receded from the viewer. When García Hidalgo had said that a painter should be able to make taffeta different from other silks, he also advised that the painter should get the highlights on the taffeta right to record the time of day. Perhaps María Agustina Sarmiento's blue velvet was once not only carefully set apart from Isabel de Velasco's gray satin in *Las Meninas,* but the fall of light from the long windows to the right told the viewer, and especially the viewer familiar with Velázquez's studio, whether the picture reproduced a morning or an afternoon scene.

Still more extravagant demands were made upon the painter's skill. Quoting from Alberti, Pacheco pointed out that a painting should be executed "in accord with the place where the painting was to be hung."[43] This principle was still in operation when García Hidalgo elaborated the idea of painting with a specific place in mind:

> And also it is very important, that the Painter see, or know, the light in which his painting is to be hung, and how much higher, and how much farther away, because for a moderate light one has to paint with the colors that are strong, and bright, and the

darks should be strong too; and for bright light, or a brightly lighted place, all the colors should be soft, and well modulated, and controlled, and soft in execution; and for far away, the figures should be large and should seem proportionate and the brushstrokes for highlights, and the brushstrokes for darks, should be broad, because distance and height spoil and lessen them.[44]

The treatise published by Sanz Sanz gives the same advice, and that anonymous author alerts us to the fact that a *color fino* was by definition vivid and was reserved for the main figures.[45] Since Velázquez was in charge of hanging works in the royal palaces in his later years,[46] one can assume that he knew just where his major paintings would hang; he would have been able to calculate light and distance to suit the intended spot. In fact he seems to have done just that in the *Surrender of Breda* and *Las Meninas*.

The preceding discussion gives only the briefest summary of the copious literature on color and tone in painting in the seventeenth century. There was a daunting array of sensory data to be processed by the painter's and viewer's eyes: local color toned by ambient light, either natural or artificial; color which expressed a specific time of day; color placed in harmonious accord with neighboring hues; color dulled proportionately to convey atmospheric perspective; color adjusted to its intended location. Such delicate distinctions of color and of tone would surely be deformed by even the most superficial alteration in the artist's paint. To update the habitual metaphor of Velázquez's time, extreme distortions such as those now seen in María Agustina's murky green skirt, or in Velázquez's nearly flat black suit, must be as jarring to *Las Meninas*'s original palette as trumpets in a string quartet.

Palomino may have been recording ideas that were nearly contemporary to *Las Meninas* when he declared that the perfect painter would make paintings with beauty, softness, and three-dimensionality (*hermosura, suavidad, y relieve*) and such a painting would also have grace, sweetness, and melody (*gracia, dulzura,* and *melodía*).[47] When Palomino described *Las Meninas,* his opening paragraph said that Princess Margarita in the painting has grace, lifelikeness (*viveza*), and beauty. According to the treatise, beauty is defined as "knowing how to tune that pictorial instrument, in such a way, that the painted instrument is organized of different kinds of colors, some bright, some moderate, and others dark. . . ."[48] Palomino's aesthetics as voiced in the *Museo Pictórico* can be applied to *Las Meninas* in other ways, too:

> This beauty consists in the fact that the principal brushstroke of light should be in the center of the *historia* with the greatest splendor, and beauty of colors. . . . One should avoid that two colors touch, or that two equal lights (touch); which are what are called *unisonus* in music . . . Also it is a great help in this if from the center of light one goes along imperceptibly lessening the light towards the far edges . . .[49]

It would be simplistic to see the bright central Margarita, surrounded by personages in variegated colors—bright greenish blue, silver gray, deeper blue, scarlet—and

placed in a space that slowly recedes away from her, as a literal illustration of Palomino's directives. Yet the coincidence of the tonal organization of Palomino's criteria with Velázquez's painting, perhaps especially when still fresh and bright, does at least help explain the terms in which Palomino appreciated the work. Understanding Palomino's aesthetics and some of the ideas behind his praise for the picture also makes one aware that one can no longer imaginatively "walk on the floor" or read the soft recession of tones in the ceiling[50] as easily as Palomino could when the painting was young.

COLOR AS A CRITICAL PROBLEM TODAY

It seems clear that all this fuss over hue and tone establishes the importance of color. But importance is a crude quantity. In a serious consideration of Velázquez's paintings the importance of color must be defined more precisely. Lamenting the loss of the once delicate chromatic gradations may be justifiable, but it offers only limited benefits to the viewer who wants to make color a discussable topic. Simply compensating today's viewer with a careful verbal recreation of the original appearance of the painting is also unsatisfactory. Not only does the verbal surrogate overlook the fact that words and images are not reciprocal, much less synonymous, but such a surrogate bears a perilous resemblance to an aestheticizing discourse that is no longer satisfactory.

In *Art and Illusion*, Gombrich points out that artists and their viewers depend upon a preexisting mental scheme to make possible perception of a chaotic visual field. Painters and viewers must construct a model of any object in that visual field before they can recognize or represent it.[51] As Bryson refines Gombrich's argument, it is clear that the perception of reality is always historically determined; it is also clear that all societies " 'naturalise' the reality they have constructed,"[52] persuading themselves that this reality preexists their construction of it. In order to integrate a discussion of form into a social and historical account, we begin by attempting to reconstruct the social perception of color in the seventeenth century. The kind of information supplied by technical examination offers a place to start. In the next few pages we hypothesize that Velázquez's viewers possessed categories of perception now lost to us, and we combine documentary and technical evidence in an effort to rebuild those categories.

In discussions of Italian paintings, it has been pointed out that if St. Francis's blue cloak is painted with ultramarine, the contemporary viewer may realize that the saint is parting with something truly valuable when he discards it.[53] The point raised by Baxandall can be extended to works by Velázquez. After all, Velázquez's courtly audience knew something about the system of values associated with specific hues. Such values probably represented a loose but real consensus about what was excellent or important in a picture. One cannot however assume that all, or even most, Spanish

viewers recognized specific pigments in a painting by Velázquez. But in the era before the invention of modern synthetic pigments, certain colors, whether in pictures, clothing, jewels, or tapestries, were obtainable only by means of certain substances. If a pigment was expensive, like ultramarine, then the color associated with it probably also acquired a connotation of value, however subliminal. To give an example, the sky behind the *Dwarf* (fig. 34) is made of smalt, an inexpensive pigment. The sky in the *Surrender of Breda* (fig. 23) is made of azurite, a costly pigment. What difference did this make to the viewer in the second quarter of the seventeenth century? Smalt produces a violet blue that is quite different from the slightly acidic blue of azurite. The dwarf is merely a court functionary. Though he may have been of noble blood, he is not a personage of high rank.[54] Furthermore, his picture was probably painted to hang in the relatively private location of the Torre de la Parada, which was a hunting lodge for Philip IV and small groups of courtiers.[55] The *Surrender of Breda*, by contrast, was a major *historia* recording a great national victory, and it was painted for a grand public room which was the most important space in the Buen Retiro Palace.[56] In short, it was a painting in which the monarchy and its prestige were on display. Once one realizes the differences in value that separate these two paintings, one also realizes that the difference in the value of materials would have contributed to the total effect upon the viewer. In the *Surrender of Breda*, the brighter and more expensive shade of blue and that shade's superior status would have contributed to a response of awed admiration at so much material luxurience in the broad sky. Cross sections show that both the blue sky and the earth below overlie a layer of lead white mixed with chalk. Lead white, although not as expensive as azurite, was still considerably more luxurious than the materials used for most grounds in Spanish pictures. The decision to single out the *Surrender of Breda* as an exceptional painting was made from the start, and uniformly costly materials were used. By contrast, *Don Diego de Acedo* was underpainted with inexpensive brownish ochre, an unprocessed pigment dug out of the ground, mixed with only some lead white.

The modern viewer misses a good deal of the connotation of value attached to the colors of the *Coronation of the Virgin*. Among modern scholars, the painting has been rather little discussed, in spite of its size and its secure attribution to Velázquez. Its iconography and composition are not very original, and Velázquez made little effort to vary the traditional format he borrowed from Dürer and Rubens. But this is a picture of the Queen of Heaven painted for the Queen of Spain.[57] Here a veritable fortune was spent, at least as pigments go. The blues, purples, and reds are made of ultramarine, azurite, and fine red lake, three of the most expensive pigments in Spain during Velázquez's century. Ultramarine in particular is a rather unusual ingredient for a Spanish picture in Velázquez's generation, although it appears in several paintings by Velázquez. And these pigments were used in lavish abundance: over half of the total design area is occupied by them. Far from being a routine picture, the *Coronation* was a work on which no expense was spared. To a viewer schooled in the rank of hue, such chromatic extravagance surely excited reverence for both the sacred

event depicted and the depiction itself. Perhaps it is no accident that the traditional hues for God's, Christ's, and the Virgin's robes, that is, red and blue, are juxtaposed, combined, and recombined to create a spectrum of purplish tones. Among precious jewels, amethysts in seventeenth-century Spain reportedly had a value on a par with diamonds, a value beyond that of other colored stones.[58] If the appeal of the amethyst's color extended into simulacra of its shades in paint, then perhaps that extension further enhanced the *Coronation*'s effect. In any event, technique here reinforced any sense of lavishness. Mixing the precious pigments with an unusual amount of medium, Velázquez smoothed them over the canvas in liquid, swelling tints. In a voluptuous display of craft, he even loosened the edges of the color fields, letting them drip over each other in a celebratory squandering of money and paint.

Another aspect that is important to note is the relationship among pigments, craft traditions, and original location. As was pointed out in the review of the demands made upon a painter's talents, the artist was supposed to take the painting's destination into account when he selected his colors and calibrated his tones. As is pointed out in chapter 5, Velázquez conformed to European practice by covering his sized canvas with a colored ground. More specifically, in *Las Meninas* he mixed lead white with brown earth pigments and spread the then-pale mixture over the canvas (fig. 42). This provided the fundamental tone for the floor, walls, and ceiling of the huge room. It also showed through thinly painted areas in the paintings on the walls and served to model the figures. Not only does this unify the painting, but such limitation in the choice of the major pigment also contributes to the intimacy of the scene depicted. *Las Meninas* is tenderly crafted, and the soft tones of brown seem to emanate from the skins and garments that cover those tones. This sense of emanation reinforces the illusion of presence, of seeing real people standing just beyond our space.

This technique continues a time-honored craft tradition, but stratagems for changing the verisimilitude game have also been invented. In chapter 2 we noted that Velázquez's borrones are less assertive in their impasto than Venetian brushwork had been. This sense of tact in Velázquez's self-effacing materials also reinforces the deferential and subtle *vraisemblance* in *Las Meninas*. Brown has emphasized only recently that *Las Meninas* appears in the palace inventory of 1666 as hanging in the personal office of Philip IV (*pieza del despacho del verano*): "Despite its size, *Las Meninas* was regarded at the time of its creation as a private picture addressed to an audience of one, Philip IV."[59] As a picture with a particular relationship to a single viewer within a relatively small space, the bombastic brushstrokes of the Venetian technique and the splendid brilliance of color in a painting like the *Surrender of Breda* have been renounced.

While on the subject of craft traditions and their manipulation in the search for verisimilitude, we find it interesting to note the final phase in Velázquez's revision of that workshop trick called a glaze. In a Venetian picture like the *Rape of Europa* (fig. 70), Titian has provided an unforgettable expanse of red lake to describe the silk

drapery.[60] When first created, such handling of the centuries-old glazing technique must have been amazing in its resemblance to real stuffs. Its success was such that luxurious velvet or taffeta fabrics draped themselves conspicuously in the designs of European paintings for the next hundred years. Whenever a technique achieves the status of a cliché, it eventually becomes perceived as a man-made deception instead of a magical and mysterious reality. Then a new schema must be devised, and that new schema will at first not be perceived as a schema. When in *Las Meninas* Velázquez applied the red lake pigment, which had been sanctified within the Venetian glazing tradition, he used it differently. In the fragile veil of red lake that covers Margarita's left shoulder, he refuses to repeat the design of several thin layers of red over white that would have described a customary velvet bow (colorpl. 1B). Instead he devised a new formula: he simply floated an amorphous veil of lake over the shoulder without attaching it to any bow, ribbon or rosette. The viewer's sense is of a bright flash of color seen at a glance, a fragment of vision to be left behind by the restless eye. As is often the case with unfamiliar conventions, Velázquez's rupture of the craft tradition is perceived not as another formula but as a new and genuinely unmediated reality; this heightened sense of authenticity is produced by a dislocation of the previous tradition. Thus the viewer schooled in Venetian usage—and Philip IV was certainly such a viewer—would possess, whether knowingly or not, the necessary cognitive experience to put Velázquez's painted maneuver to appropriate use in the perception of *Las Meninas*.

To digress from *Las Meninas* for a moment, the necessity of particular cognitive skills for seeing a painting is explicitly acknowledged by the writers whose comments on the borrón are discussed in the chapter 1. In other words, there was some contemporary awareness that certain parts of a painting required categories of perception (such as proximity versus distance) that were learned, rather than natural. But not surprisingly, such explicit awareness of the conditions that make perception possible is the exception rather than the rule.

Finally, of course, it is important to point out the dangers in attempting to distinguish expensive pigments from cheap ones. Although it is true that expensive materials may indicate that a painting was either very political (*Surrender of Breda*) or very sacred (*Coronation of the Virgin*), such information has to be combined selectively with other data. For example, many of the pigments in *Las Meninas* were cheap. Brown earth pigments are overwhelmingly the most common ingredient. But presumably brown was chosen because in a painting that was to be visually consonant with its rather small space, the neutral tones needed to predominate, whereas the bright, expensive azurite, ultramarine, and red lake were effective in creating atmospheric resemblance only when used sparingly. The choice of brown ochre and umber, in other words, cannot be interpreted as indicating that *Las Meninas* was not an important picture. Understatement in this canvas, whether in brushwork or in pigments, seems to have been a deliberate strategy.

Plate 1A. *Surrender of Breda*, detail of Dutch youth

Plate 1B. *Las Meninas*, detail of Margarita's dress

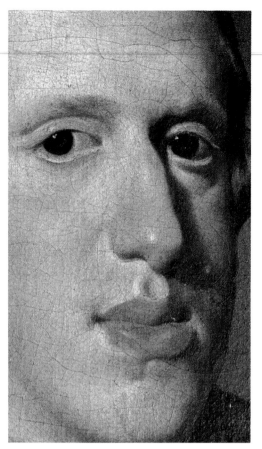

Plate 2A. *Bust of Philip IV*, detail of Philip's face. Actual width of area shown is approximately 10.4 cm.

Plate 2B. *Las Meninas*, detail of Margarita's face. Actual width of area shown is approximately 8 cm.

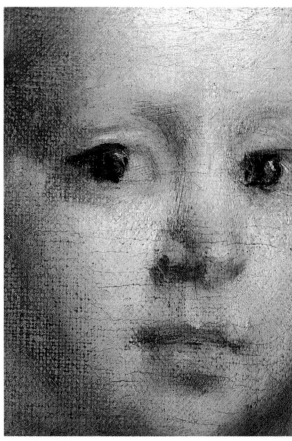

Plate 3A. *Las Meninas*, detail of Margarita's rosette

Plate 3B. *Las Meninas*, detail of the right edge of the skirt of the kneeling menina

A

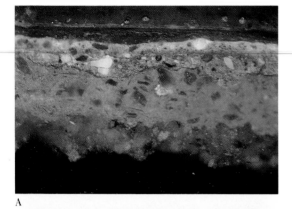

B

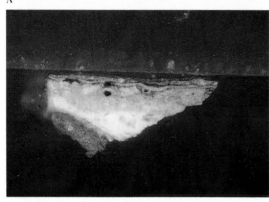

C

D

E

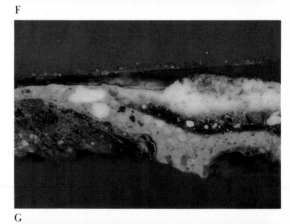

F

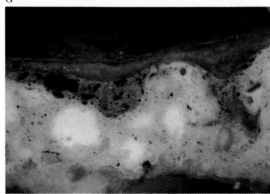

G

H

FABULISM, FORMALISM, AND SENSATION OF VALUE

We avoided any discussion of the symbolic iconography of color because such a discussion would have run counter to our commitment to developing a repertoire of ideas for interpreting form, and in particular to developing a repertoire for interpreting the aspects of form most readily studied by conservation science. Yet the preceding suggestions of ways to conceptualize form by discussing it in relation to materials and techniques are actually quite dangerous. They claim to discuss color solely on its own terms. In fact, of course, any such discussion has taken place in the alien medium of words. And the occasional citation of securely narratable elements like the chemical identity of a pigment or the documented site of a painting makes it clear that, in this case, formalism has appropriated a few fabulist strategies. We put forward no defense, for we are resigned to the idea that a degree of conceptualization

Plate 4A. *Bust of Philip IV*, cross section from red sash, left tacking edge (1183–4XS). Magnification: 138×. A thin red lake glaze appears over a pink layer of lead white and red lake. Below this are a gray layer (lead white and charcoal black) and the red earth ground which contains large translucent grains of quartz and mica(s). Medium-rich sizing below the ground contains some calcite and ochre.

Plate 4B. *Bust of Philip IV*, cross section from the background, upper edge (1183–2XS). Magnification: 138×. One or two thin grayish layers are separated from a somewhat thicker grayish brown layer by traces of a dark brownish layer. Below these layers are a thick white layer (predominantly lead white), a thin grayish brown layer, and the red earth ground.

Plate 4C. *The Forge of Vulcan*, cross section from loincloth of figure at the far right, canvas piece 1 (1171–17XS). Magnification: 138×. At top is a grayish green layer of lead white, bone black, azurite, ochre, and possibly some yellow lake. Below are a beige layer of lead white and brown earth or umber and a flesh-colored layer which contains scattered azurite grains. The gray ground contains lead white, some carbon black, and a few pale grains of smalt.

Plate 4D. *The Forge of Vulcan*, cross section from sky to left of Apollo's head, canvas piece 1 (1171–11XS). Magnification: 138×. Pale blue layer of lead white and smalt covers the orange-brown upper ground layer (lead white and red ochre). Underneath is the gray lower ground (predominantly lead white, with some carbon black particles).

Plate 4E. *The Forge of Vulcan*, cross section from sky in the strip of canvas at the far left side, canvas piece 4 (1171–9XS). Magnification: 138×. At the top is a thin glaze which contains some ultramarine blue, underlain by a gray layer which may contain a little smalt. Below is a thicker light gray layer of lead white with small scattered black particles; also present is a considerable amount of calcium carbonate (calcite) and some calcium-magnesium carbonate (dolomite). At the base of the section is the orange-red ground, underlain by residues of sizing.

Plate 4F. *Surrender of Breda*, cross section from foreground, near foot of soldier (1172–20XS). Magnification: 138×. One or two thin orange-gray paint layers overlie the ground which is made up of lead white and large, irregularly distributed chips of charcoal black.

Plate 4G. *The Dwarf*, cross section from the sky, right tacking edge (1201–3XS). Magnification: 69×. Pale blue layer overlies a white layer and a deeper blue layer; the blue pigment in these paint layers is smalt. Below is the warm brown upper ground (lead white, ochre, scattered grains of red lake) and the darker brown lower ground layer which predominantly consists of earth pigment with a little lead white.

Plate 4H. *Les Meninas*, cross section from upper background, right edge (1174–10XS). Magnification: 138×. Three gray to brown paint layers appear at the top, the thick middle one containing abundant chips of charcoal black. Below is the beige ground, which contains large clumps of lead white and some brown earth or umber. A medium-rich layer appears below the ground; this contains some calcite, black, and ochre.

67

is inevitable in any verbal discourse. It is to be hoped, however, that we have not entirely overcome that sense of discomfort that should accompany the written rehearsal of colorido.

Art historians sometimes speak of "decoding" a work of art. In so doing, they seek to recuperate the meaning intended by the artist in his time. The study of ideas about color in Velázquez's time, however, reminds one that many of the elements that mattered in a seventeenth-century painting, such as color and tone, were never encoded because they were not codifiable. Other formal elements are equally hard to transform into narrative content. As was pointed out in chapter 1, the borrón (figs. 24, 43, 44, and colorpls. 1B, 3A) was more than a mere tool for constructing subject matter. As a convention of picturing, it demanded to be seen as a sign. As a sign it expresses both the painter's concern for verisimilitude and his allegiance to Venice. Yet it seems unwise to convert brushwork too literally into a system of signs to be decoded. In many senses, what the borrón signified was, by its natural variety, beyond the reach of quick verbal commensurability. Perhaps one must be satisfied to note that the borrón had a certain perceived resonance and status among viewers at the Spanish court. This resonance and status again belong mainly to the realm of connotation and sensation.

In all fairness to our own era, it must be repeated that squeamishness about color is not a modern invention. In Velázquez's time, treatise writers who communicated through prose also had trouble legitimizing color. In their effort to validate color and verisimilitude theoretically, they habitually fell back upon the strategy of drawing analogies between color and items that were easier to codify, like mathematics. Thus color was compared to music, which in turn was validated by mathematics. Along these same lines, color was likened to meter in poetics. On the one hand, writers usually conceded color's importance up to a point: El Pinciano's treatise on poetics of 1596 already pointed out that sight is the most important sense and that "the main purpose of sight is color" (*"El principal objecto de la vista es el color"*).[61] Yet in the statement made earlier in this chapter El Pinciano also echoed ancient rules when he said that "the poem is a panel made up of figures and colors; and the story (*fábula*) is the figure, and the meter is the colors."[62] And with a confidence that was to be shared by writers in the twentieth century, he stated plainly, "The main thing is the *fábula*" (*"Lo principal es la fábula"*).[63] El Pinciano's *lo principal* is based on rules of rhetoric and poetics already venerable when he wrote. El Pinciano's meter, with its presumed appeal to the emotions rather than to the mind, was a slippery property and ill-suited to the linear development of the written word. At the end of the sixteenth century, subject matter was meaning and subject matter was privileged. Color as a legitimate intellectual entity was marginal.

We suggest that this hierarchy had shifted, at least momentarily, in Spain during the seventeenth century. All writers may not have shared Martínez's opinions, but his treatise clearly indicates that by the 1670s colorism was an immensely important element in painting. He still has one chapter on dibujo, but the concept of drawing

has been invaded and eroded by coloristic thinking.[64] The abundant literature on color in treatises, poems, plays, and letters establishes that El Pinciano's rules were too narrow to explicate the full significance of a coloristic painting within Velázquez's time. If instead of looking only where rhetoric tells us to look (at the fábula), one pauses to pay equal attention to what seventeenth-century Spanish viewers also noticed (the *colorido*), it is obvious that form mattered. Color and tone may have been rhetorically recalcitrant, but it does not follow that they were pictorially irrelevant.

Colors could have specific, encoded, symbolic meaning, but that kind of meaning is not what has been of concern in this chapter. Instead we have focused upon something more elusive: the seventeenth-century connotation of value associated with color. Since a connotation is less easily defined than a denotation, connotation may never achieve ascendancy in art historical interpretation. And value is itself difficult to narrate. But it is precisely this indeterminacy, this resistance to verbal authority that makes a connotation or sensation of value peculiarly necessary for penetrating some aspects of a painting.

If formalist elements in Velázquez's paintings can be reintegrated into the discussion of the painting's documented location, its iconography, and its patronage, then perhaps we can begin to reconstruct the sensation of value experienced by the seventeenth-century viewer. To the palace viewer who stood before the *Surrender of Breda* (fig. 23) in the Hall of Realms (the original location), the fact that the picture utilized a known system of poses to express both victory and magnanimity (iconography) would have contributed to the viewer's sensation of reverence. And the fact that this iconography signalled a major military victory by a major military power (patronage) would have evoked a sense of pride in the courtier and perturbation in the foreigner. The flagrant costliness of the grand azurite sky (materials) combined with the Spanish claim to the Venetianizing borrones (manipulation of craft tradition), the luminosity of the brightly-garbed soldiers (hue), and the subtle adjustments of focus and perspective (verisimilitude) would all have combined to create in the onlooker a sense of awe, admiration, envy, pleasure, or surprise—a sensation of value. Perhaps sensation is a more useful word than connotation, for it merges the visceral and visual as well as accomodating an awareness of symbol.[65]

Rhetoric seeks to divide and conquer, breaking poems or images down into their separate parts in order to analyze and subdue them. In doing this for a painting it has an impressive record of providing insight plus a welcome illusion of control. But in our effort to make color discussable without utterly denaturing it (as a restorer would say), we have preferred to try to reconstruct the vaguer sensation of value produced by materials and their virtuoso manipulation. Rhetoric dissects, but sensation—and vision—synthesize.

4

REMARKS ON THE PAINTINGS

*I*n the three previous chapters, discussion of the paintings has been confined to observations that related to specific questions. Thus the chemical analyses were discussed in chapter 1 because they illuminated a problem of theory and practice; selected pigment analyses, cross sections, infrared and X-radiograph examinations were discussed in chapter 2 when they were related to Venetian practices; color alterations in the paintings were considered in chapter 3 because these changes posed problems of interpretation. As we made our examinations, we of course noticed things that did not fit neatly into any of these chapters. Sometimes what we saw bore upon questions raised earlier in the Velázquez literature but not relevant to our own inquiry. In this chapter, then, we discuss various details that are interesting but that were secondary to the issues raised in the earlier chapters.

The following entries are compilations of information that is miscellaneous but, we hope, not altogether indiscriminate. They do not pretend to be consistent in format or in type of information presented. We were not able, for example, to measure all the paintings unframed, or to see all the edges of the canvases; the larger ones were nailed into their frames with old, square nails, and nothing short of a major conservation effort would have justified trying to take them out.

Philip IV Standing. ca. 1626. Prado 1182.
Figs. 7–13
Measured unframed: 198 cm at the left edge; 101.5 cm at the lower edge and 101.2 cm at the top edge.
The canvas has never been cut at the bottom edge, which shows scalloping and still has its tacking edge. It has, however, been cut at the right edge, where there is no scalloping and where one can see the cut through the paint layers. Philip's hat now continues around the right edge of the stretcher. The canvas may have been cut at the top, but perhaps not by much; a faint cusping is visible in places. A strip of wood nailed over the left edge to make the stretcher fit the frame covers that edge.
There are two paper tickets on the back, each in a different hand:

1) *Retrato de hombre / que entrega un memorial. / Belazques.*
2) *188. Es. . . . es es numero q.e / [. . . .]de el d[. . . .]de componerlo.*
The second inscription probably notes that 188 was the painting's number before
lining.

X-radiographs of the painting were made by the National Gallery, Stockholm, in
1960 (fig. 9). We took infrared photographs (fig. 10), examined the painting with the
infrared vidicon, and took pigment samples (see chapter 5). For a discussion, see the
next entry, *Bust of Philip IV.*

Bust of Philip IV. ca. 1626. Prado 1183.
Figs. 1–6, colorpls. 2A, 4A, 4B.
Measured unframed: 58 × 44.7 cm. The canvas has been cut down on all four
sides.
An X-radiograph of the painting was taken by the National Gallery of Sweden in
1960 (fig. 2). We took infrared photographs (fig. 3) and pigment samples (see
chapter 5 and colorpls. 4A, 4B).
Sometimes pentimenti respond handily to questions raised in earlier art historical
literature. Our infrared photographs did reveal two pentimenti in the *Bust of Philip
IV* that clarify that painting's relationship to the *Philip IV Standing.* Most students of
Velázquez agree that both canvases were executed in the 1620s. Opinion about the
precise date of each varies,[1] but our concern was less with problems of exact date than
with the relationship of the Prado pictures to each other. X-radiographs taken in 1960
and infrared photographs made by us revealed that beneath the standing portrait (fig.
7), the king assumed a different stance: his legs were farther apart, his hands were
placed at slightly different levels, and his cape swung more widely behind him. The
hat and table top were placed lower and the rungs of the table were clearly indicated.
Since its publication in the early 1960s, the X-radiograph of the Prado pointing (fig
9) has been the subject of some disagreement. It was first suggested that the X-
radiograph of the face showed that Velázquez initially painted the king with a pudgy
jaw: therefore the painter's revision to a smoother, more slender face was a significant
step in the creation of a more elegant version of the royal face.[2] It was further
suggested that beneath the Prado version lay Velazquez's first portrait of the king, the
painting mentioned by Pacheco as completed in 1623.[3]
The bust image, like the standing image, has been revised (figs. 1, 2). It is clear
that Philip's suit of armor once had a strap across the chest. In the area around the
head, the X-radiograph is hard to read. On the basis of stylistic analysis, López-Rey
had suggested that this bust portrait follows the standing portrait in the Prado.[4] On
the basis of information from infrared photographs, we agree. To his comments, we
would add that infrared photographs (figs. 3, 4) show two pentimenti in the bust
portrait that are not visible to the naked eye or in the X-radiographs: one on the collar
and one on the proper left shoulder. In this small image, the collar's edge at Philip's
proper left was once higher: originally it met the line that divides the king's upper lip

from his lower lip. In the _Philip IV Standing_ in the Prado (fig. 7) that collar edge again lines up with the meeting of the king's upper and lower lips. The pentimento on the shoulder of the bust portrait likewise mimics the border of the shoulder in the standing version.

In the _Philip IV Standing_, the higher collar and higher shoulder make sense, because the face of the king is seen from below. Similarly, because the standing king is turned more toward the front, he presents a broader chest. But in the bust, which would hang at eye level, the head of the king is closer to the viewer. Thus the king's collar in the bust version had to be lowered to accommodate the spectator's gaze (fig. 3). In narrowing the king's shoulders in the bust, Velazquez has also turned him slightly away. Considered together, these two pentimenti indicate that Velázquez took the standing portrait as his point of departure, and they also suggest that Velázquez himself revised the smaller canvas to make it work from a lower point of view. In other words, in the 1620s the canvas was already a bust portrait with a collar lowered to suit a face seen more or less on the viewer's level.[5]

Examination of the unframed painting indicates that it has been cut down on all four sides; no cusping or tacking edge is visible on any side. According to López-Rey, the canvas was lined in 1923.[6] Today one does not see the nailholes from an earlier tacking edge, so unless the restorer who lined the picture drove his nails through Velázquez's old holes, then he or she must have trimmed the painting again, cutting away at least the previous tacking edge.

Forge of Vulcan. 1630. Prado 1171.
Figs. 14–22, colorpls. 4C, 4D, 4E
Measured framed: 223 × 290 cm.

X-radiographs of Apollo's head were made by the National Gallery, Stockholm, in 1960. X-radiographs of the entire painting were made in collaboration with José María Cabrera and María del Carmen Garrido in 1980 (figs. 15, 16). We took infrared photographs (figs. 17, 18) and pigment samples (see chapter 5 and colorpls. 4C, 4D, 4E). We later worked on this painting with Cabrera and Garrido; Garrido took pigment samples and cross sections that have been published elsewhere.[7]

THE PROBLEM OF THE ORIGINAL DIMENSIONS

This painting is made up of four separate pieces of canvas, as is illustrated in figure 21. The central canvas (piece one) is the largest. On the left of it are two thin strips (pieces two and four). To the far right, a final strip (piece three) completes the canvas. Whether the strips on the sides of the central canvas were part of the original painting by Velázquez has long been uncertain. In order to evaluate this problem, we review evidence from cross sections, X-radiographs, examination with the naked eye, and inventories.

The Evidence from Cross Sections. As is discussed in chapter 5, the layer structure in the central canvas (fig. 21, piece one; colorpls. 4C, 4D) is different from that of the strips attached to the left and the right sides (pieces two, three and four, colorpl. 4E).[8] This difference in structure between the central canvas and the strips is not in itself proof that the strips were painted by someone other than Velázquez.

The Evidence from X-Radiographs. X-radiographs of the central canvas (piece one, fig. 15) show sweeping arcs that do not match any design in the painting. Such arcs appear also in other paintings, such as the _Surrender of Breda_ (fig. 26). Probably they result from the application of a ground rich in lead white, as is indicated by the cross sections (colorpls. 4C, 4D, 4E, 4F). Pacheco recommends using lead white to prepare a canvas.[9] Occasionally lead white was mixed with glue in old linings, as has been found in paintings by Rembrandt in the Metropolitan Museum,[10] but here we assume that the image in the X-radiograph was produced by the lead white in the painting's ground.

We doubt that lining materials explain these arcs. Although arcs appear in one other work by Velázquez in the Prado,[11] the dates of relinings and the identities of the restorers who carried them out are not known. Firmer evidence that the arcs do not record lining materials—and that the central canvas originally did not have strips added—is supplied by the fact that the arcs stop at the seam between pieces one and two. Short, finishing strokes are particularly evident in the area behind Apollo's left foot. If the arcs were the result of relining, and if the strips were part of the original canvas, the arcs should have carried over the seams into the strips. The short arcs suggest to us that the central canvas was prepared independently of the strips, and that the strips were not part of Velázquez's first design for the painting.

As is noted in chapter 5, the pigments in the strips are different from the pigments in the central canvas (piece one), and this difference of materials makes the strips respond to X-radiographs differently from the central piece. (The vertical line seen in the central canvas in the radiograph is not a seam, but perhaps is the mark of the canvas's being bent over the stretcher or the mark of the stretcher pressing forward from behind.)

This evidence suggests the following. The structure of the pigments indicates that the strips and central canvas are layered differently. The X-radiograph confirms that the ground on piece one, the central canvas, does not extend to the strips, pieces two, three, and four, because the strips have a different density and the arcs of white lead from the palette knife end at the left edge of piece one.

The Evidence from Examination of the Surface with the Naked Eye. Ordinarily the original edge of a canvas shows cusping, or a scalloped distortion of the weave that records the tension of the fabric where it was nailed to the stretcher. The central canvas (piece one) shows a scalloped edge in the X-radiograph at left and right, indicating that this piece was once attached to a stretcher without the added strips.

The strip on the right (piece three) also has cusping at its outer right edge, indicating that this edge is the original edge of that strip. It is difficult to judge the paint surface on piece three, because it is covered with discolored varnish and bloom, but any discrepancies between it and the central canvas are not obvious. The right edge of strip four shows no cusping or evidence of sewing; it appears simply to overlap strip two. Such a structure may indicate that strip four was added to the painting during lining, when it could have been adhered to both strip two and the lining canvas. The color and consistency of the paint changes on the far left strip, and is visibly different from strip two and the central strip, piece one. Strip two has cusping on its left edge, suggesting that it was once the terminus of the picture. Both strips two and three have unexplained vertical marks, as if they had been bent over a stretcher. The paint surface along strip two is rough, as if damaged by pressure of a frame or stretcher.

Thus, the central canvas (piece one) was once independently stretched, without side strips two, three, or four. Strips two and three appear to have been added first, without strip four, for both two and three have cusping on their outer edges. In color and consistency, they are similar to each other, different from strip four, and different from central piece one. Strip four, the present far left edge of the painting, shows no visible cusping at either its right or its left edge.[12]

The Evidence from Inventories. According to López-Rey, the painting was inventoried in the Royal Palace in 1716 with a width of *3 varas,* or about 251cm,[13] and it was given a number *570,* which appears at the lower left of piece one. He points out that in the inventories of 1772 and 1794, the width is given at an increased *3 ½ varas,* or about 292cm, which is close to the painting's present total width of 290cm. On the basis of these inventories, he concludes that the strips were added between 1716 and 1772.[14]

Conclusions about the Added Strips. No single piece of evidence, either technical or documentary, provides a conclusive answer to this problem when used in isolation. The structure as revealed by cross sections shows different layering in the strips when compared with the central canvas. X-radiographs suggest that the ground on the central canvas contains much more lead white than the grounds in the added strips, as is confirmed by the cross sections (see chapter 5).[15] Visual examination of cusping indicates that the central canvas originally was tacked to a stretcher, without the strips. It also indicates that strips two and three may once have been the outer edges of the painting. Possibly the painting was expanded in two stages: first by the addition of strips two and three, then finally by the addition of four. All this indicates that the central canvas, piece one, was originally conceived and executed without the strips.

Yet the evidence does not answer these questions: When was the painting expanded? Did Velázquez himself initiate or carry out the additions? Did he, for example, paint piece one in Italy and enlarge it when he returned to Madrid?[16] Or did a later restorer enlarge the picture? Here documents, combined with examination with the naked eye, are particularly helpful. The recorded dimensions in

inventories suggest that the additions of strips two and three were made in the eighteenth century. Strip four is of an uncertain date. But since strip four seems to have been added at a time when the canvas was being lined, it also probably dates from at least the eighteenth century. Possibly strip four was added to fill out a mismeasured frame, or possibly it was in fact included in the measurement of 1772, since early measurements are often approximate. Each category of evidence then points in the same direction: toward the canvas's having been expanded by someone other than Velázquez.

Along with all this technical and documentary information, a traditional stylistic assessment is relevant. As has long been observed, the _Forge of Vulcan_ in its expanded form is an airier, more diffuse composition. The Cyclops at the far right has more room, and Apollo receives greater emphasis with some empty space behind him. The enhanced spaciousness is itself characteristic of the taste of the eighteenth century. It is difficult to determine which factor was the prime motive for expanding Velázquez's picture: a need for a new frame or a wish to improve upon a painting perceived as too compact in pictorial space.

PENTIMENTI AND THE PROBLEM OF VELAZQUEZ'S SOURCES

One of the pentimenti is a classic example of a revision that demands discursive assessment, because it alters a pose.[17] Ovid provides the tale of Apollo's announcement to Vulcan of his wife's infidelity. In Velázquez's version, Vulcan stands to the right of Apollo, who informs the unfortunate husband of Venus's dalliance with Mars. The narrative moment is clear: Apollo's raised hand and parted lips express speech; Vulcan's sharply turned head, recoiling torso and furrowed brow convey surprise (fig. 14). Partially visible to the naked eye, but now best seen in infrared and X-radiographs (figs. 16, 18, 19, 20), is a different Vulcan. (In fact, it may represent two different Vulcans, because the head in the pentimento does not fit the body in the pentimento. Here we will limit discussion to the early version of the body as visible in the X-radiograph.) The original Vulcan stood erect, rather than pulling back from Apollo. His hammer rested quietly on the anvil, rather than being jerked into the air.

Did Velázquez change the message when he changed the pose? One interpretation of the first pose might suggest that it expressed a different moment in Ovid's story: Apollo has spoken, but Vulcan has not yet understood and stands unreacting. Such a moment, however, is nowhere mentioned in Ovid's text. A better explanation might be that the change from an erect torso to a curved torso is a revision of type and expression, not of moment. Part of Vulcan's iconography is that he was lamed in a fall from Olympus. In paintings that lameness was sometimes depicted and sometimes not. When Vulcan is shown lame, he often sits. But many artists preferred to depict Vulcan as a healthy, athletic nude who stands, and the pentimento suggests that Velázquez began with such a vigorous god. The exact posture of either of the two early images is not absolutely clear. The torso, however, is unquestionably strong and

straight. It seems that as he worked, Velázquez found a way to have a standing Vulcan behind the anvil, but still to imply that he was crippled. With an economic fusing of the Vulcans of image and literature, the artist arranged Vulcan's torso to express both lameness and emotional recoiling through the curvature of the spine. In the final version Vulcan's angled body, combined with his tilted head, succinctly conveys both emotional pain and physical damage to his left leg and, as a consequence, to his spine. Seen alongside the more neutral pose of the pentimento, the final pose makes it clear that Vulcan's characterization is important. To understand that Vulcan was surprised is simply to understand Ovid's tale. To understand that Vulcan was also vulnerable and in pain is to understand Velázquez's telling of that tale. The discovery of the pentimento may thus clarify the intended meaning, because it makes the viewer aware of the artist's concern to communicate the startled, hobbled cringing of the blacksmith god.

Surrender of Breda. 1634–35. Prado 1172.
Figs. 23–33.
Examined while framed: 307 × 367 cm.

The canvas may have its original tacking edge on all four sides, if the canvas edges sticking out under the frame belong to Velázquez's canvas and not to the canvas used in lining the picture. From examination with the naked eye, cusping is visible on all four edges of the painting.

X-radiographs were made by the National Gallery of Sweden in 1960 (figs. 26, 27). We took infrared photographs (figs. 28, 29, 31, 32), made an examination with the infrared vidicon (fig. 30), and took pigment samples (see chapter 5).

The painting has many pentimenti, mostly on the Spanish side (figs. 26, 27, 28, 29, 30, 32). Major changes include two extra men to the right of Spínola (figs. 26, 28), alterations of hats, legs, collars, and slight shiftings of poses. The lances on the Spanish side were lengthened. Spínola's horses's legs were respositioned. When the X-radiographs were exhibited at the time of the Velázquez exhibition in 1961, it was suggested that the area above the Spaniards that now contains the lances once had contained banners. White arcs echoing Spínola's horse's rump also led to suggestions that the horse had been moved.[18] In our opinion, the seeming banners and horse's rump could be irregularities in the application of white lead in the ground, left by strokes of a palette knife or large priming brush. The fact that the ground in this painting is rich in lead white probably also explains why the X-radiographs are so blurry and difficult to read. On the Dutch side, the feet and collar of the soldier who is closest to us, with his back turned, were shifted. Slight alterations in the contours of hats and in the Dutchmen's stances also occur (figs. 28, 32).

In 1979 McKim-Smith suggested that Spínola was first positioned in three-quarter view, that is, he was turned more toward the viewer than he is now; she also suggested that a drawing in the Biblioteca Nacional (figs. 62, 63) showed this first pose.[19] Our examinations did not provide evidence either to substantiate or to refute

that hypothesis. Additional evidence simply indicated that Spínola's pose was more difficult to decipher than she believed when only the X-radiograph was available. As a consequence of this uncertainty about the pose of Spínola, the relationship to the drawings in the Biblioteca Nacional has become correspondingly uncertain. The drawings may still be related to the creation of the *Surrender of Breda,* but there is nothing from further technical examinations to prove or disprove their relationship.

Velázquez's paint is thin in this painting, and at times he does not cover up his grayish ground. Thus his underdrawings are frequently visible to the naked eye. On the back of the collar of Justinus of Nassau, and on his left cuff (fig. 31), a thin dark outline is apparent. The underdrawings appear to be made with a fine brush.

In 1986 the Prado's restorers began cleaning this painting.

Portrait of a Dwarf (El Primo Don Diego de Acedo). Late 1630s. Prado 1201.
Figs. 34–39.
Measured unframed: 107 × 82.7 cm.

On the left and right the canvas still has a very narrow original tacking edge. On the lower edge about two centimeters of the original paint film is bent around the stretcher, but the original tacking edge is still visible. On the top edge, about three centimeters of original paint film is bent around the stretcher, serving as a tacking edge now. The original tacking edge is not visible.

X-radiographs were made in 1960 by the National Gallery of Sweden (fig. 35). We made infrared photographs (fig. 36) and took pigment samples (see chapter 5).

In the sky, dark, meaningless strokes can be seen (fig. 34). At the end of the nineteenth century, these strokes were interpreted to mean that the present background of mountains and sky "was painted probably over an interior."[20] On the basis of our examination, there is no indication of this interior. The reasons for the strokes remain uncertain: possibly they are the result of differential darkening in which the now dark strokes changed more than the surrounding color of the sky; possibly there was a covering layer for these strokes that has been abraded or become transparent. These brushstrokes cannot be called pentimenti in the original sense of the word, for they indicate no "repentence" of one form or replacement with another. The dark stray strokes disrupt the sense of recession in the sky above the faraway mountains, and one can at least assume that the original sky has changed. Bold, but less disfiguring variations in paint occur in the backgrounds of other pictures by Velázquez throughout his career, such as in the *Saint John the Evangelist* in the National Gallery, London, or the *Pedro de Barberana* in the Kimbell Museum, or the *Juan de Pareja* (fig. 57) in the Metropolitan Museum. Modern conservators and art historians have assumed that Velázquez wiped his brush on the background of his paintings, either to rid it of extra paint or to test a color meant to be used elsewhere. Other painters have produced what seem incontestably to be wipings, although usually these occur at the edges of the canvas, where they will either be less conspicuous or will be covered by a frame.[21] Guessing Velázquez's motivation is hard enough under any circumstances,

and since we have not been able even to approximate the original appearance of this painting, the original purpose of the dark strokes remains a matter of opinion. Velázquez could well be wiping his brush. At the same time, and with characteristic economy, he might be providing a subtle atmospheric or textural effect, provided that the strokes were originally less striking. Velázquez does occasionally use haphazardly patterned strokes to create a shadow, for example between the feet of the Cyclops seen from behind in the *Forge of Vulcan* (fig. 14). If Velázquez indeed put the stray strokes there—and at this point there is no reason to assume they are not his—one may at least believe that they were not as prominent when painted as they are now.

As was noted in chapter 3, whether the sky was once more blue is uncertain. Common sense would suggest that the dreary, lowering sky seen at present does not illustrate the sort of weather in which it would be agreeable to be outside. Such a commonsensical judgment suggests that the color of the sky has dulled either due to changing paints or to the loss of a glaze. Solid conclusions about the original appearance of the sky are not, however, possible here.

Brown has recently suggested that this is not the painting executed in 1644 at Fraga. He believes that this picture, Prado no. 1201, should be dated to about 1636–38.[22]

Las Meninas. ca. 1656. Prado 1174.
Figs. 42–50, 53–54.
Measured framed: 380 × 276 cm.
In 1960 the National Gallery of Sweden made X-radiographs of the figures only (fig. 46). We made infrared photographs of the entire canvas (figs. 47, 48, 49, 50, 53) and took pigment samples (see chapter 5). See Mena, 1984, for complete X-radiographs.

This painting has undergone changes in color and tone in several areas (see chapters 3 and 5).

X-radiographs suggest that Velázquez's pose may have been altered (fig. 45), and infrared photographs show that Princess Margarita's right hand has been shifted (figs. 47, 48). The paint is thin in the area around the princess, which makes it possible to see the pentimento with the naked eye when the painting is well lighted. Velázquez's pose was one of the hardest to clarify, because he was apparently dressed in a black suit in the first version, and a black suit was used again in the final version. Where his broad white collar seems to be present in the pentimento, one gets some sense of the angling of the shoulders in the rejected pose. In the final painting, Velázquez stands facing us, with his proper right shoulder turned slightly toward the left rear corner of the room. His face is presented frontally and is tipped very slightly to his left. We have tried to reconstruct the pose in the pentimento from X-radiographs and infrared photographs, yet because Velázquez's pose was difficult to ascertain, we offer the reconstruction only provisionally. From our examinations, it seems that Velázquez's torso originally turned in a different direction. Rather than facing the canvas as if actively painting on it, he seems to have turned to one side,

with his right shoulder toward the large stretcher that fills the left part of *Las Meninas*. The exact original posture of his hands and legs is not clear.

In view of the fact that recent interpretations of *Las Meninas* have stressed the importance of Velázquez's inclusion of himself alongside the royal family,[23] even a slight change in his pose might indicate a corresponding shift of meaning. Given the abundance of interpretations of Velázquez's role in the painting, it is tempting to assess the pentimento. If in the original pose Velázquez turned slightly from the canvas—the painter posing rather than the painter painting—then the rejection of that passive pose for the more active one we now see, in which the painter faces the canvas with his brush poised, could have done several things. It might have emphasized the painter's concrete action in painting, his *diseño exterior*. At the same time it could echo Carducho's dictum that *sólo el pincel con soberana cienca reducir la potencia al acto puede*.[24] Simultaneously the change could have documented Velázquez's real pictorial activity while in the approving presence of the royal family.

In the case of Princess Margarita, the original pose of her right hand is not revealed by the X-radiograph, but it is clear in the infrared photograph (fig. 48). As was mentioned in chapter 3, she could be either reaching for the *búcaro* or raising her hand in surprise at what she sees. Given the direction of her glance, it does seem more likely that the hand expresses surprise. Then the startled gesture could be related to the traditional suggestion that the king and queen, who are reflected in the mirror above the princess's head, have just arrived.

Some problems about what has previously been thought to lie beneath the other figures deserve comment. Writing around 1690, Félix da Costa described *Las Meninas*, then hanging in the palace, as showing Velázquez "in the act of painting with his glance upon the Empress (Princess Margarita), and putting his hand with the brush to the canvas. . . . "[25] We saw no indication that Velázquez's hand had actually been painting. Perhaps Costa's recollection was more a synthetic memory than a precise document. He also mentioned that the dog in the right foreground was "lying down obediently among these ladies [the meninas]."[26] In fact the dog is closest to the dwarf and midget.

In the 1960s, the only technical information available on *Las Meninas* was the set of partial X-radiographs made in 1960. In 1963 López-Rey interpreted those X-radiographs as showing that "Velázquez introduced changes in the poses of the various figures, notably his own."[27] In 1966 Kubler further elaborated the idea of changes in the painting's main characters. According to his reading, "the x-ray photographs reveal possibly five more persons, three of them women and two men."[28] He believed at least one figure would have been closer to Margarita, and one would have been closer to Velázquez. Both these hypotheses were reasonable when the X-radiographs were seen in isolation. Our examinations cannot provide a more definitive reading, but they do suggest both caution and some reasons for the confusion. Because the ground of this painting is rich in lead white, the X-radiograph is blurred and hard to read. From infrared and from tracings of the X-radiographs

made on clear plastic to then compare against the painting, we found no indication of the maids of honor taking other poses, or of anyone near Margarita or Velázquez. From what we could see, it seems unlikely that such activity did take place. The canvas is especially thinly painted in the area around Margarita's head and shoulders, and the grayish ground in that area shows through her hair and gown. From the X-radiograph the lead white in the ground seems unevenly distributed, creating ghosts like those seen in the X-radiograph of the *Surrender of Breda*. It seems unlikely that major pentimenti in such a thinly painted area would leave no trace in infrared or to the naked eye. This portion of the canvas shows the underdrawing of the door in infrared, and scattered fragments of that underdrawing are visible to the naked eye. The light area seen in the X-radiograph to the proper left of Margarita's head seems to us to be simply the underpainting of the sunlit doorway at Nieto's feet, not an extra personage or a different pose for Isabel de Velasco, the menina to Margarita's left.

Underdrawings of outlines of pictures, frames, stairs, windows, and shutters are occasionally visible in many areas of this thinly painted canvas (figs. 47, 48, 49, 50, 53). They appear to have been drawn with a brush in brown pigment, using a straight edge as a guide. As would be expected, this laying-in was not absolutely precise: sometimes the brown line strayed beyond its final boundaries, increasing the sketchlike quality of the image. Sometimes, as in the steps beneath Nieto's feet, Velázquez created the bright horizontal overhang of the treads without the linear underdrawing. At other times, as in some of the coffers on the door, he laid in the coffer with parallel lines, though most often these lines seem a shorthand symbol for those decorative little cubes, not a descriptive outline of the coffers as actually painted. In the language of underdrawings, perhaps the parallel lines cued the artist to the fact that coffers were planned, but left him free to determine the precise size and outline of each one (fig. 53).

5

VELAZQUEZ'S PAINTING MATERIALS

One of the principal purposes of our research was to shed some light on how the materials and methods Velázquez used in creating his paintings relate to the materials used by his contemporaries and those described in contemporary treatises. From six to twenty-two samples were taken in 1980 from each of six of the paintings included in this study (the two portraits of Philip IV, the *Forge of Vulcan*, the *Surrender of Breda, Portrait of a Dwarf,* and *Las Meninas*). Two samples were taken from the *Coronation on the Virgin,* including a color (purple) not present in the other six paintings. Since this time, additional work has been carried out on the *Forge of Vulcan,* which we will summarize here.[1] A more thorough technical study of all of these paintings as well as other Velázquez paintings would be of great value but could not be undertaken in the circumstances of this study. It is hoped that the following pages will provide glimpses into an aspect of this Spanish artist about which very little is known at present.

SAMPLING AND ANALYTICAL PROCEDURES

The samples from the paintings included scrapings of pigment and small chips, taken with a sharpened microneedle generally with the aid of a binocular microscope. The sizes of the chips range from less than 0.2 mm in many instances to about 1 mm in the cases of some samples from damaged edges; the scrapings are barely visible to the naked eye. Sampling sites are shown in figures 6, 13, 22, 33, 39, 41, 54. Microscope slides of all of the powdered samples were prepared and examined with a polarizing microscope to identify the number of pigments present in a given sample as well as their relative proportions. Many of the pigments in the samples were at least tentatively identified by the microscopic examination. Identification of major crystalline phases was in many cases confirmed by powder X-ray diffraction, and a scanning electron microscope or an electron beam microprobe with an attached energy-dispersive X-ray spectrometer was used to determine major and minor elements present in the samples. The chips of paint were mounted in epoxy resin, polished, and examined with a reflected light microscope; identification of materials in specific layers was confirmed by X-ray fluorescence analysis in the scanning electron micro-

scope or microprobe. In a few instances, some other tests were used, and these are noted below. Protein- and oil-specific stains were used on a few of the cross-sections to gain some idea of the medium or media with which the pigments were bound, augmented by simple microchemical tests.[2]

Although the number of samples was limited, the range of materials actually used in each of the paintings (with the exception of *Coronation of the Virgin*) is probably reasonably well represented by the analysis. A detailed summary of the analyses of the powdered samples and the cross-sections is given in appendix III.

SUPPORTS

All of the paintings in this study, and indeed all of the works attributed to Velázquez, are executed on canvas. Most of the paintings examined here were done on linen canvas, although the *Bust of Philip IV* is on a canvas made from hemp.[3] The *Bust of Philip IV* is on a canvas of about 9 threads/cm by 10 threads/cm, and *Philip IV Standing* 11/cm by 12/cm. The *Forge of Vulcan, Surrender of Breda, Coronation of the Virgin,* and *The Dwarf* are all painted on canvases of about 13–15/cm by 18–19/cm. The canvas of *Las Meninas* measures 12/cm by 12/cm. The canvas in all of the paintings is of a regular weave.[4]

BINDING MEDIA

For this study, binding media were only generally classified. Staining tests indicate that oil was the artist's principal medium in ground as well as paint layers. We cannot rule out the presence of other components (proteins or resins) in smaller amounts, and further research is in progress to search for such admixtures.

PIGMENTS

In Velázquez's lifetime, the number of materials available to painters was relatively limited. The pigments continued to include many natural minerals, such as azurite and lazurite (ultramarine blue), synthetic pigments with long histories such as lead white, and lakes manufactured from various natural organic coloring matters.

A statistical idea of the pigments most commonly used by European painters during the seventeenth century can be gained from the bar diagrams prepared by Hermann Kühn from hundreds of analyses carried out at the Doerner Institute in Munich.[5] The majority of paintings included in Kühn's analyses are northern European; there is comparatively little published information on the materials favored by Spanish or Italian artists in the same period. On the basis of Kühn's analyses, it does not seem that the pigments Velázquez used in his paintings differ much from those most commonly encountered in paintings by other European artists working at the

same general time. A summary of the pigments identified in the individual paintings included in this study is given in table 1. The pigments are discussed below by color.

Blues. Velázquez made use of all three of the principal blue pigments of his time. Azurite, which had been used as a pigment as early as the Old Kingdom in Egypt,[6] continued to be popular in the seventeenth century, and it was found in at least small quantities in all of the paintings but the _Bust of Philip IV_. The pigment was identified in blue drapery or clothing accessories in the _Forge of Vulcan, Surrender of Breda_, and _Las Meninas_. It also occurs in mixed greens (made from azurite and a yellow pigment) in the _Forge of Vulcan, Surrender of Breda_, and _Las Meninas_. Azurite is the blue pigment in the sky of _Surrender of Breda_.

Apparently not long before the sixteenth century,[7] blue verditer, chemically equivalent to azurite, was first manufactured, and this artificial pigment coexisted side by side with its more costly natural counterpart, azurite. Although blue verditer has been found in paintings of this period,[8] none was observed in the Velázquez samples.

One of the most expensive of pigments was natural ultramarine blue (whose color is due to the mineral lazurite), from the semiprecious stone lapis lazuli. During the seventeenth century, the pigment probably continued to come primarily from the same mines in present-day Afghanistan that had been its source from the time of its earliest use as a pigment before the Middle Ages.[9] Lazurite was only found in small quantities mixed with azurite in one of the attendant's costumes in _Las Meninas_ (sample 1174–1),* and mixed with red lake to create a purple color in the _Coronation of the Virgin_ (sample 1168–2); the pigment was also identified in the Virgin's cloak from that painting (sample 1168–1).

Smalt is a pale blue-colored potassium glass that was first used as a pigment in the sixteenth century.[10] Its composition can be rather variable, giving it a variety of hues, but it is always a pale pigment that lacks the intensity of lazurite and azurite. It owes its color to a small amount of cobalt. The ores used as the source of cobalt in smalt pigments were probably in most cases arsenides. Arsenic was usually found in the smalt samples when they were analyzed in the microprobe; iron and nickel, two elements that commonly occur in cobalt minerals, were also identified in a number of the samples. Smalt is the principal blue pigment in the skies of the _Forge of Vulcan_ and the _Dwarf_, and it occurs in small amounts mixed with azurite in a blue or blue-green passage in _Las Meninas_ (sample 1174–6).

Because of the cobalt it contains, smalt can be used as a siccative in oil paint to quicken the drying process. There is evidence that some painters have used smalt for this purpose, particularly paler varieties of the material that would have been of little use as a pigment.[11] Velázquez also may have made such use of smalt, for example in the passages of _Las Meninas_ mentioned above, where it seems to be present in too small a quantity to have had an effect on the color. Some smalt is present in the ground of the _Forge of Vulcan_, perhaps also as a drier.

*Sample numbers correspond to those in the tables in appendix III.

All three of these blue pigments—azurite, natural ultramarine blue, and smalt—
occur in *Las Meninas,* and Joyce Plesters has also found all three in the *Rokeby Venus.*[12]

Velázquez seems often to have added a small amount of blue to his flesh tones;
smalt was found in the flesh color in the *Dwarf* (sample 1201–5), azurite in the large
Philip IV portrait (sample 1182–4), and probably both in *Las Meninas* (sample 1174–
4).

Greens. From Kühn's studies,[13] the most important change in pigments preferred
by seventeenth-century artists over those used by earlier painters occurred with
greens. During the course of the seventeenth century, mixed green pigments became
increasingly popular. These appear most often to have been mixtures of azurite and
one or more of three yellow pigments—lead-tin yellow, yellow ochre, and yellow lake.
Verdigris, the only bright green pigment available at the time, continued to be used in
spite of criticism of some of its properties by treatise writers, although it was much
less popular than mixed greens. Verdigris has been identified in several paintings by
Velázquez's contemporary Murillo.[14]

The most thorough study of mixed green pigments has been carried out by
Marigene Butler on paintings by Jan Steen.[15] She found that Steen's mixed greens
generally consisted of calcium carbonate, often with lead white, two or three yellow
pigments, and one or more blue pigments; rarely, green earth was also used in the
mixtures. The combination of pigments used was probably determined by the tint
and translucency sought by the artist in a particular passage.

Green passages occur in the *Forge of Vulcan,* the *Surrender of Breda,* and *Las
Meninas.* In the wreath of Apollo in the *Forge of Vulcan* the color proved to be a
mixture of azurite, yellow lake, and possibly some yellow ochre. A similar mixture of
azurite and probably the two yellow pigments occurs in foliage in the *Surrender of
Breda.*

Lead-tin yellow, a very opaque pigment, would create a less translucent green than
would either of the other two yellow pigments. Calcite (calcium carbonate) is found
in appreciable quantities in some of the green samples; this pigment would have
affected the transparency of the mixture also. Lead-tin yellow and yellow lake are
brighter yellows than most yellow ochres and could have created a purer, less brown-
ish green. Considerations of the overall tint and transparency probably affected
Velázquez's choice of components, as Butler has pointed out in her research with
respect to Steen.

The yellow lake in the *Forge of Vulcan* seems to have faded, giving the leaves of the
wreath a distinctly bluish tint. This problem is also encountered in some Dutch
paintings of this period.[16] The greens from the Velázquez paintings which contain
yellow lake are always rich in calcium, suggesting that the lake may have been on a
calcite (chalk?) substrate; Pacheco's "ancorca" was probably such a lake.[17] Although
weld, a group of weedlike plants, was probably the principal source of yellow textile

dyes at this time,[18] recipes suggest that yellow lakes for use in paintings were most often made from unripened buckthorn berries.[19]

Malachite and green earth, two duller green mineral pigments both of which have long histories as painting materials,[20] have also been identified in seventeenth-century paintings, although only rarely. The former was was not found in any of the Velázquez samples, but a bluish-green variety of green earth was found in small quantities in two samples: in a dull greenish-gray loincloth of one of the cyclops of the *Forge of Vulcan* (sample 1171–7) and in foliage in the foreground of the *Surrender of Breda* (sample 1172–16).

Earth colors. The brown, red, and yellow ochres are among the earliest pigments ever used for painting, and they are quite common in European paintings of all periods. In Velázquez's paints, they are present in at least small amounts in virtually every color. They are the major pigments in brown-yellow passages in the *Dwarf, Las Meninas,* the *Bust of Philip IV,* and the *Surrender of Breda,* and red ochres are important in the grounds of several of the paintings as well as in orange and orange-red passages in the *Surrender of Breda.* In *Breda,* the pant leg of Spínola (sample 1172–7) and the boot of a figure at the left (sample 1172–11) consist primarily of ochre. Brown ochre or umber was found in a few samples.

The yellow and red ochres are colored by iron oxides, and often they contain other minerals such as clays, micas, quartz, and others, which reflect their particular geological source and method of preparation. Brown ochres and umbers contain in addition manganese oxide(s), which give them their darker color. Gypsum was found in samples from the foreground of *Surrender of Breda* (samples 1172–12, 13); it may have been associated with the earth pigment(s) used in these passages.

Reds. In addition to red ochre, the red pigments available in the seventeenth century were vermilion, red lead, and red lakes. Red lead seems to have been rarely used, although it is rather common in Rubens' paintings.[21]

Vermilion is the name normally used for the synthetic variety of cinnabar, naturally-occuring mercuric sulfide (HgS). Mines at Almaden, Spain, were a major early source of the mineral, but by the seventeenth century, much of the pigment may have been the synthetic variety manufactured by the Dutch (or dry) process.[22] Natural cinnabar and the synthetic variety manufactured by this process are chemically identical and cannot be readily differentiated microscopically. Vermilion is the major pigment in the red-hot sheet of metal in the *Forge of Vulcan* (sample 1171–6) and the red stocking of one of the attendants in *Las Meninas* (sample 1174–2). Vermilion also occurs in the flesh tones of several of the paintings.

The red lakes in Velázquez's time were probably made of one of four dyestuffs: kermes, brasil wood, madder, or cochineal.[23] Madder was extracted from the roots of the madder plant. Cochineal came from the cochineal insect, an insect that was discovered by the Spanish in Central America and introduced in Europe during the first half of the sixteenth century. Kermes, a dyestuff known since the time of Moses,

came from another insect which lived on the scarlet oak in Europe and Asia. Brasil wood came from the reddish-colored bark of a number of types of trees, and according to Daniel Thompson it may have been the most important red dyestuff for painting pigments during the Middle Ages.[24] All four of these materials were used as textile dyes, although by about 1600, kermes seems to have been little used.[25]

All of these dyestuffs were normally prepared as lakes for use as pigments; this involved precipitation of the colorant onto an inorganic base, which gave the organic color some body. Usually the dyestuff was brought into solution in water with a soluble aluminum salt, such as the naturally occuring sulfate alum. Addition of an alkali such as plant ashes caused aluminum to precipitate out as an amorphous hydroxide; as it precipitated out it carried along the dyestuff. The inorganic substrate does not act solely as a sponge that draws the dyestuff out of the solution: there is a kind of chemical reaction that takes place with the dyestuff. For a given dyestuff, the methods of preparation and the specific materials can affect the overall color of the resulting lake pigment.

Cochineal has been identified in Rembrandt paintings occasionally,[26] and one sample from the tacking edge of the *Bust of Philip IV* (sample 1183–5) was large enough to attempt an anaylsis by thin-layer chromatography;[27] this sample was tentatively identified as cochineal.

X-ray fluorescence analysis of cross sections and powder samples of red-lake-rich passages in the paintings suggested that the substrates of the lakes were sometimes (for example, sample 1182–1XS, from the standing portrait of Philip IV) the traditional amorphous aluminum hydroxide, and in others (for example, sample 1172–8 from the *Surrender of Breda*) apparently a potassium-aluminum-sulfur compound, probably an alumlike material. Red lake was found in all of the Velázquez paintings and is present in small amounts in many colors, including the flesh tones.

Although Venetian artists (particularly Titian) are often pointed out as an important influence on Velázquez's artistic development (see chapter 2), the Spanish artist rarely used glazes in the manner of the Venetians, who quite frequently used them to produce more saturated colors.[28] One of the few instances of such a glaze in the paintings considered in this study is the tablecloth at the right of the large Philip IV portrait, where a thin, nearly pure red lake glaze overlies a light pink layer (sample 1182–2XS), creating a very crimson color in much the same manner that Titian would have. More typical of Velázquez's use of red lake, however, are the red sash of Spínola in the *Surrender of Breda*, drapery in the *Coronation of the Virgin*, and shadows in Apollo's cloak in the *Forge of Vulcan*, where nearly pure red lake has been thickly applied; it is translucent, but has not been used as a glaze in either instance.

Yellow. In addition to yellow ochre, during Velázquez's lifetime the other major yellow pigment continued to be lead-tin yellow. This synthetic lead-tin oxide, which apparently was first used as pigment at about the turn of the fourteenth century, exists in two different crystal forms that are manufactured by somewhat different processes.

The more common by far, Pb_2SnO_4, has been called *lead-tin yellow I* by Kühn.[29] This pigment was found in the two Philip IV portraits (samples 1183–6, 7, and 1182–5), and the *Forge of Vulcan* (sample 1171–4). The compound is made by fusing together lead oxide and molten tin metal, and free tin oxide, which is a white compound of high refractive index, is often present in lead-tin yellows. Lighter shades contain more of the colorless tin oxide (SnO_2). Free tin oxide was identified in the samples of the pigment which were examined by X-ray diffraction.

Blacks and browns. Charcoal as well as bone blacks were found in most of the paintings, although in many instances the two were not distinguished during the analyses. An organic brown pigment, perhaps bituminous earth (Van Dyke brown, Kassel brown, Cologne earth, and others) may be present in small amounts in a sample from the *Surrender of Breda* (sample 1172–15).[30]

Whites. Lead white was found in nearly all of the samples. Most lead whites are actually a mixture of basic lead carbonate (equivalent to the mineral hydrocerussite, $Pb_3(CO_3)_2(OH)_2$) and neutral lead carbonate (cerussite, $PbCO_3$). The latter forms when carbonation is allowed to proceed too far during the manufacturing process. Its presence in lead white causes the overall properties of the pigment to be poorer, since the more basic carbonate (hydrocerussite) apparently forms a more satisfactory paint film as it dries.[31] By comparison of X-ray diffraction films of Velázquez samples with films taken of known physical mixtures of cerussite and hydrocerussite, the approximate amounts of the two compounds in a particular sample of lead white can be estimated.[32] Many of these estimates for the Velázquez samples are included in appendix III. Rather surprisingly, the neutral carbonate is present in substantial quantities (sometimes up to approximately 50 percent) in some samples, and it was always present to an extent of at least 20–40 percent in those samples that were analyzed by X-ray diffraction. Cerussite occurs in the range 20–40 percent in most of Rembrandt's lead whites,[33] and it may prove to be common in lead whites of this period as more analyses are published. Lead whites of this period usually contain traces of silver and copper, elements associated with the lead ores from which the pigment was made; both of these elements were detected in the lead white ground (sample 1172–3) of the *Surrender of Breda* by emission spectrography.

Most of the samples examined during this study contained a small amount of calcium carbonate (calcite). The amounts of this compound vary considerably from sample to sample, but rarely exceed approximately 10 percent in any sample. In an oil medium, calcite has little covering power because of its relatively low refractive indices. In seventeenth-century Holland, there were apparently two commercially available types of lead white. "Lootwit," the cheaper variety, contained about 25 percent chalk; "schulpwit," the more expensive variety, was pure lead white.[34] The former has been found in underlayers of Rembrandt's paintings,[35] where hiding power would have been less important. Velázquez's samples do not contain nearly the amount of calcite that Dutch "lootwit" does.

In a study of Chardin's paintings, Ross Merrill has described the properties that a small amount of calcium carbonate imparts to oil paint.[36] The translucency of the paint is increased, as noted above, and the consistency of the paint is thickened, yielding a pastier paint. Chardin definitely added calcium carbonate to his colors to alter these properties of his paints. It is possible that the calcite in the paint samples from the Velázquez paintings is also a deliberate addition in at least some instances. But a more systematic study of many additional samples will be necessary to resolve this point.

GROUNDS

The ground of a painting is a layer or series of layers which prepares the support (canvas, wood, et cetera) for the paint layers; it may also have an effect on the texture and color of the paint layers themselves.[37] Medieval and Renaissance grounds, in northern Europe as well as in Italy, were generally white, but during the course of the sixteenth century colored grounds became increasingly popular. In some instances, the ground may consist of only one layer, but oftentimes two or more layers are involved. The uppermost layer in a ground structure is often referred to as an "imprimatura" layer and may be used to alter the tone of the lower ground layer before painting.

By adjusting the thickness and translucency of the overlying paint, the color of the ground can be entirely covered or can be used to alter the color of the paint. A warm colored ground, for example, can contribute a warmth to overlying, somewhat transparent paint, although the effect may be quite subtle. As was the case with Velázquez in the later part of his career, the ground itself may be left uncovered in some areas, so that its color directly contributes to the final painted image.

In this section, the grounds found in the examined paintings are briefly discussed. It is not unusual for an artist to use different colors of grounds in different paintings, as is the case with Velázquez. It is also possible that the upper layer of the ground of a particular painting may have different colors in different areas; for example, there may be a different color in areas underlying the flesh tones of figures, the sky or elements of landscape, as well as other elements. This seems to be the case with the *Forge of Vulcan*.

The Two Early Portraits of Philip IV. Both of these portraits of the young Philip IV, dating from the 1620s, are painted on the same type of ground, a nearly pure orange-red ochre (samples 1183–4XS; 1182–2XS). This particular ochre contains abundant flakes of mica and small acicular (needlelike) crystals of the mineral rutile (TiO_2). Both of these materials would not be unexpected in a natural earth color. The ground has been applied relatively thickly on both canvases, in a single layer that is up to approximately 200 μm (0.2 mm) thick. In both paintings, staining tests carried out on cross sections suggest that the medium of the ground is mostly or entirely oil. In

some cross sections a medium-rich layer appears below the ochre ground (see pls. 4A, 4B). Staining tests indicate a protein in these areas, and it seems likely that they are residues of an animal glue sizing that was used to seal the canvas before the oil-based paint was applied. Some calcite seems to be present in this sizing layer. Canvas readily absorbs oil, and a glue sizing was frequently recommended in technical treatises to prevent this.

The red ochre ground seems to be a type Velázquez used during his early years in Madrid. The red ochre in these two paintings is unusual in overall composition and can probably be distinguished from red ochres from different geological sources.

The red ground in the Philip IV portraits has a kind of flow structure in most of the cross sections, due to alignment of the mica flakes more or less parallel to the canvas surface (pl. 4A).

In the bust portrait of Philip, a relatively thin grayish layer overlies the red ground in some cross sections; perhaps this is an intermediate (imprimatura) layer which was used to tone down the red color of the ground locally before Velázquez actually began the portrait. A sample from the neck, however, shows the flesh color directly painted on the ground. The X-radiograph shows an area in the background of much greater density that surrounds the king's head and ends rather abruptly near the edges of the canvas (fig. 2). A cross section of this area (sample 1183–2XS, pl. 4B) shows a nearly pure lead white layer immediately overlying the red ground and gray layer, a layer that is not present in the less radio-opaque areas of the background. Velázquez partly repainted this portrait, and the X-radiograph of the background implies a design change of some sort, but its specific meaning cannot be deciphered at the moment.

Hubert von Sonnenburg has analyzed the *Portrait of a Young Man* (fig. 59) of the later 1620s,[38] a portrait which is more sophisticated in technique than the two portraits of Philip IV. Interestingly, the light ground in this painting also consists, for the most part, of a red-brown ochre, which has been modified by a thin reddish-brown glaze and a gray layer in parts (which added coolness to the reddish ground). Unlike the earlier court portraits, where the ground has not contributed much to the final image, in the *Portrait of a Young Man* Velázquez has used the ground and intermediate layers to modulate the warmth and coolness of passages in the final visible image.

The Forge of Vulcan. The *Forge of Vulcan*, from Velázquez's first Italian trip, is painted on a single large piece of canvas, to which two narrow strips have been added at the left and one at the right. There is documentary evidence that these strips may very well have been eighteenth-century additions, as has been discussed in chapter 4. The X-radiographs of the painting, in which the added strips are only barely visible, indicate much greater density in the central canvas. Cross sections from the central canvas (piece 1) indicate that the ground is gray; it is up to approximately 100 µm thick and consists predominantly of lead white, with small amounts of charcoal black and calcite; gray translucent sherds were observed in several cross sections (1171–

17XS [pl. 4C], 1171–19XS), which X-ray fluorescence analysis showed to be smalt. This smalt is virtually colorless and was most likely added as a drier, or perhaps to give "tooth" to the ground paint. The initial lead white ground layer was perhaps applied with a palette knife, which would account for the broad, sweeping arcs visible in the radiographs of the central part of the painting (see fig. 15). A sample from Apollo's robe (1171–14XS) shows a single brownish-orange layer over the ground; a lighter layer used for highlights on the robe overlies the brownish-orange layer. The layer structures in some samples are more complicated. A cross section from the loincloth of the figure at the far right of piece 1 (1171–17XS, pl. 4C), which is greenish-gray in color, shows a pink layer over the ground, probably the flesh color of the figure's leg; a beige layer overlies this, perhaps also associated with the flesh color. The final layer is that used to paint the loincloth. A cross section from the sky of piece 1 (1171–11XS, pl. 4D) shows a thin (approximately 35–40 μm) pale orange-brown layer, which contains some lead white mixed with a brownish ochre, overlying the gray ground. It is overlain by a single layer of smalt and lead white, which represents the sky. This brownish-orange underpainting or upper ground layer seems only to be present in the sky. This layer, which is darker than the first ground layer, was probably used to tone down the sky. The figures themselves seem to have been painted directly on the lighter gray ground, which would have given them a higher key or tone.

The ground structure of the *Rokeby Venus,* which dates to about 1645–48, is interesting to compare with that of the *Forge of Vulcan.* The initial layer consists of lead white in an oil medium, followed by a red ochre layer. Velázquez used the red layer in every part of the canvas, except under the figure of Venus.[39]

The structure of the ground layer(s) is different in the added strips. The outer of the two strips at the left (piece 4) seems to have a thin orange-red ground (predominantly ochre, approximately 10–40 μm thick), overlain by a translucent gray layer, which consists of lead white, with some charcoal black and numerous angular fragments of calcite and occasionally dolomite (see samples 1171–20XS, 1171–1XS, 1171–9XS, pl. 4E).[40] This orange-red ground is underlain by a thin layer of lead white in one sample. Staining tests indicate that the medium of this layer is mostly or entirely oil, and the carbonate minerals would have made this intermediate gray layer translucent.

The cross section from the sky of the inner strip at the left (piece 2) again includes a brownish initial ground layer, followed by a translucent gray layer (1171–10XS). A sample of Apollo's robe from piece 2 (1171–13XS), however, does not include the lowermost ochre layer. Two samples from the strip added at the right (from the loincloth of the figure at the far right of piece 3, 1171–16XS) show a single gray ground layer. The outer strips are overexposed in the X-radiographs, which is a result of the fact that an initial lead white ground was not used in these outer strips.

The Surrender of Breda. Although we could not unframe this painting because of its size, the ground could be seen at the top of the painting where it was not covered

by the sky color. It is pale gray or nearly white. In cross sections the ground is up to about 300 μm thick; it consists predominantly of lead white, with a small amount of calcite and scattered angular fragments of charcoal black (pl. 4F). Some sections contain only a few such chips (as sample 1172–14XS, from the sky); others contain many. This is probably fortuitous and does not indicate that the ground was a darker gray in some areas than in others. The fragments of charcoal are sometimes quite large, up to 200 μm, giving a rather dramatic appearance to some of the cross sections (see sample (1172–19XS). One sample, from the brown-green ground plane (1172–17XS) shows a grayish beige layer overlying the ground; this is followed by a grayish layer and a blue-green layer. This blue-green layer is covered in part by a pale orange-brown layer, probably used to define a detail of the ground.

Portrait of a Dwarf (El Primo Don Diego de Acedo). Hubert von Sonnenburg, in a discussion of the Juan de Pareja portrait, has remarked that Velázquez preferred light, warm grounds.[41] Such grounds were used in the two later paintings included in this study.

In his portrait of the dwarf Diego de Acedo, there are two ground layers (sample 1201–3XS, pl. 4G). The lowermost ground layer is a pale brown color and consists predominantly of lead white, large clumps of which are readily visible in the cross section. This layer is colored by some brown ochre or umber. Following this is a second somewhat warmer layer, which in addition to the pigments of the lower layer, perhaps also contains some red ochre as well as a few red lake particles. The two layers together are nearly 200 μm (0.2 mm) thick.

Las Meninas. In this painting, the ground appears to be a warm gray beige color. In cross section, clumps of lead white are readily visible, with scattered black particles and some red ochre. The layer is approximately 80 μm (0.08 mm) thick. In a cross section from the lower left corner, this ground layer has been followed by a white layer; several thinner, darker layers complete the sequence. Beneath the ground in one cross section (sample 1174–10XS, pl. 4H) is a medium-rich layer that contains some calcite and scattered charcoal black particles, possibly a residue of sizing. It is similar in appearance to layers found in some of the other paintings we examined. Translucent glassy sherds appear in one cross section (sample 1174–9XS), possibly pale smalt used as a drier or to give tooth to the ground although the elements characteristic of this pigment were not detected by X-ray fluorescence analysis in the microprobe.

MATERIALS AND TECHNIQUE

The history of artists' materials often runs parallel to the history of styles; but there are many instances where an artist's style is very closely related to his or her understanding of the potentials of materials—pigments, media, support.

In seventeenth-century Europe, artists (or assistants in their workshops) continued

to grind their own pigments in their chosen media.[42] Pigments preground in media did not become available commercially until the beginning of the nineteenth century. Pigments themselves were purchased from merchants. Although certain pigments were more readily available in some regions than others, and although particular artists (or groups of artists) may have preferred to use certain of the available materials and not others, extensive analytical studies are required to sort out the importance of such factors, and these have not been carried out for many artists of this period.

Velázquez, like most other seventeenth-century painters, favored drying oils as his medium. The oil medium was possibly first used for paintings in the thirteenth century; at any rate, the earliest paintings carried out primarily in this medium date to the middle of that century.[43] The oil medium was perhaps first utilized because of its refractive index, which was higher than that of egg yolk, the favored medium of earlier easel painting. This meant that many pigments were more transparent and of deeper color (apparently less "mixed" with white) when mixed with oil. This was the possibility of most interest to the earliest oil painters, who perhaps were emulating the effects of stained glass or cloisonné enamel. Although considerably more sophisticated in their technical skills, the Van Eycks and their contemporaries created many of their colors with virtually the same pigments and techniques as the anonymous painters of thirteenth-century Norwegian altar frontals. The workshop tradition meant that traditional methods of preparing colors and creating certain passages in paintings survived with little change for long periods of time, and it is not surprising that successful ways of creating certain coloristic effects should survive, until perhaps a new pigment had been introduced or a certain material fell into disfavor because of its behavior or some other reason. Approximately two-hundred years after the Van Eycks, Velázquez and his contemporaries used many of the same pigments and created certain passages in the same manner as the Van Eycks.

Van Eyck and the so-called Flemish primitives frequently painted red draperies with a mixture of red lake and lead white; shadows were often built up from thick layers of nearly pure red lake.[44] Virtually the same method was used by Velázquez in the sash of Spínola in the *Surrender of Breda* and the drapery in the *Coronation of the Virgin*, although his method was more direct than that of the early Flemish artists (he usually used a single very thick brushstroke of lake rather than a series of many thinner layers).

In the medieval, Renaissance, and baroque periods, there was no purple or violet pigment available. Painters created this color, quite naturally, from a combination of red and blue pigments. The early Flemish painters frequently used a layer of red lake and lead white, covered with a thin layer of ultramarine blue. The one purple passage (from the *Coronation of the Virgin*) sampled in our study was created in exactly this same manner.

But other colors were created in different fashions during the seventeenth century. The Van Eycks frequently painted green passages with an underpainting of malachite or verdigris and lead white, followed by a glaze of *copper resinate* (created by heating

92

verdigris in a solution of oil and resin). It seems that Velázquez always used a mixture of azurite and a yellow pigment to create his greens, as did many other (and perhaps most) seventeenth-century painters.

Another important change occurred with blue pigments. Blue-colored glass, smalt, first became available in the sixteenth century, not long after cobalt ores (the source of its color) were discovered in Saxony. By the seventeenth century, smalt was a common pigment, although it could not replace azurite and natural ultramarine blue (lapis lazuli) where brighter blues were required. Lapis lazuli continued to be an expensive pigment, and artists usually used it sparingly. We rarely encountered this pigment in Velázquez's paintings, but it was used in considerable quantities in the *Coronation of the Virgin*. Perhaps it was stipulated (and paid for) by the person who commissioned the painting, as sometimes happened with this and other particularly valuable pigments.

Canvas is apparently the only support that Velázquez used. Fabric supports had been used for paintings as early as ancient Egypt and were occasionally used in the medieval period. But the support first became important when the oil medium came into use. Oil-based paints are more flexible than egg tempera paints and thus canvas was a more viable support for oil paintings than tempera paintings. Many seventeenth-century oil painters used both panels and canvas for easel paintings.

Like other painting media, drying oils have possibilities of manipulation which are unique. Titian was perhaps the first "master of the medium" from this technical point of view, but until the seventeenth century the full possibilities of the medium were not generally realized. Velázquez was one of the great seventeenth-century masters of the oil medium, and probably one of the greatest of its masters in all of art history. Greatly increased transparency and depth of color were the properties of pigments dispersed in an oil medium that were exploited by the earliest oil painters, but there are many other possibilities: oil paints could range from very lean and thin (much medium and comparatively little pigment) to thick and pasty (much pigment and little medium), which meant that they could be used as washes, almost like watercolors, and also as impastos to create a varied topography and texture on the surface of a painting. On a canvas support, the varying consistencies of different pigment and medium combinations could be used to create complex effects that utilized the texture of the fabric support also.

If one studies Velázquez's painting technique over his entire career, a development in his own understanding of the medium can be traced. His earliest paintings exploit few of the possibilities of the medium, while his later paintings are creations of an artist who fully understood oil as a painting medium.

VELAZQUEZ AND HIS TECHNIQUE

The structures of Velázquez's paintings are usually comparatively simple where no major compositional changes occur. Single layers of paint, usually modulated in tone

and hue, were used in many passages; lighter or darker strokes were brushed into the underlying paint, sometimes before it was dry, to create highlights or shadows, or to otherwise define forms. In the *Bust of Philip IV*, as in other early paintings, the paint seems to have been of a rather uniform fluid consistency, creating a smooth, almost enamellike surface (p. 2A). Although this small painting was done on a canvas nearly identical in thread count (about 12 threads/cm) to that of *Las Meninas*, the canvas texture is much more obvious in the latter painting, even though it is some thirty-five times as large as the portrait of Philip. The thick ground of the portrait effectively disguises the texture of its canvas. The bright red ochre ground, among the most colorful ever used by Velázquez, is little evident in the finished painting. Occasionally it shows at the edges of forms, for example where the outline of the figure meets the background, but otherwise it is completely covered.

We have little evidence of how Velázquez began his paintings or of how he sketched in his compositions. Passages in a number of his paintings suggest that he used thin black or brown paint to define forms over the ground. This "underpainting" may have been sketchy, indicating little more than outlines of figures and setting. This seems to have been the case over most if not all of Velázquez's career.

From the time of the portrait of Philip (early 1620s), Velázquez's style evolved in a way that can be described as a "dematerialization of form." The paintings included in our study represent scattered stages of this evolution. In the *Forge of Vulcan* and *Surrender of Breda*, both from the 1630s, the principal figures are still solidly constructed, if perhaps more thinly painted; they are firmly outlined and painted with relatively thick, fluid paint. But in both paintings, in subsidiary figures but most of all in the background and details of setting, there is a sketchiness not present in his earlier paintings. The landscape in the background of the *Surrender of Breda* is marvelously evocative, set out in a freer, economical fashion that strongly contrasts with the more labored treatment of the figures.

The portrait of a dwarf, from the 1640s, shows how Velázquez's way of handling faces and figures also became more economical. The weave of the fabric is evident everywhere in the painting, only entirely covered by the thick pasty paint used for final highlights.

In *Las Meninas*, Velázquez has applied his warm beige ground thinly, so that it does not hide the topography of the canvas threads to any extent. Large sweeping arcs in the x-radiographs are perhaps marks left by a large knife used to spread on the ground, which was rich in lead white. Passages of the background are very thinly painted. Ruled lines (in thin brown paint?), used by Velázquez to lay out the door and the floor in the lighted doorway, are visible, as are tick marks used to mark the positions of the panels in the door. These underpainted marks have been barely if at all covered. The colors of the floor and door are due as much to the beige ground as to overlying paint. Thin layers of black or brownish paint modify the ground color; highlights are laid in with thicker strokes. The lighter strokes, which are like scumbles, frequently catch only the tops of canvas threads; interstices show through

as darker spots, colored by the ground. The thickest paint in the background occurs in the highlighted door around the silhouette of the servant. Here pasty white paint completely covers the canvas threads and ground. The faces of the principal figures in *Las Meninas* emerge from the darkness. Although in Velázquez's earlier paintings shadows had nearly as much substance as highlights, in *Las Meninas* shadows are frequently created by the ground itself, sometimes partly covered with additional thin washes.

Margarita's softly lit face, which seems slightly out of focus, fades at its edges into the ground color—especially in the shadowed area at the left of her face (pl. 2B). The scumbled flesh paint partly covers the ground where the face begins to emerge from the shadow. Again the canvas weave is only completely covered in the highlighted areas—the cheeks, nose, and forehead, where pasty strokes of whiter paint were added as final touches. The outline of Margarita's hair is defined by the edges of thin brushstrokes of black or dark brown color that create the adjacent background. The hair itself is painted with darker or lighter strokes over the ground, which remains uncovered at times. The flower in Margarita's hair was created with thin varied strokes of reddish-brown, brown, and black on the beige ground, almost in a watercolor-like technique. The thickest paint in this detail of costume as well as over the entire surface is found in the sharp nervous squiggles of white, usually put in last to indicate where light caught decorations in the hair or costumes. These small dabs (usually about 0.5 cm or less in size) were rarely even partially covered with other strokes of paint.

The steely gray drapery of Margarita and some of the other figures was laid in with light gray paint which is fairly thin. The cool "silvery" tone of these passages is perhaps partially due to Rayleigh scattering or the "turbid medium effect"; this is the reason that distant mountains seen through haze appear bluish, and the same effect can be created with translucent layers of light paint over a dark ground. A number of painters have used this optical trick, which permits very subtle transitions between cooler and warmer tones to be created simply by altering the thickness of the overlying paint. Velázquez seems to have used brushes a little less than one centimeter wide to lay in these passages; the brushstrokes are visible criss-crossing even though the paint is thin. As the light gray underpainting grows thinner, the ground asserts itself, and in some shadows (for example, in Maribarbola's dress) the shadow is simply the beige color of the uncovered ground.

Where the center of Margarita's rosette was to be painted, Velázquez left a roughly circular patch of ground uncovered when he painted in the light gray drapery color (pl. 3A). The rosette was completed with dark gray and reddish washes, spots of black, and finally the typical thick, white dabs. Reddish washes at the top of the rossette cover some of the gray dress color.

Definition is given to the drapery by lighter and darker strokes; these were sometimes apparently painted into the wet underlying color and were laid in with brushes of about the same size as those used in the underpainting. When viewed up close,

there is an abstract quality to many of the details of *Las Meninas,* and one can well imagine that Velázquez did the painting with relatively long brushes, which would have allowed him to stand a certain distance away from his canvas. Although the brushes Velázquez has shown himself holding in *Les Meninas* are probably similar to those used in actually creating the painting, the palette he holds in his hand is probably too small for a large painting such as he is shown working on. Artists' self-portraits that include palettes are frequently a source of information about the artist's pigments, but the spots of paint on Velázquez's palette are limited in color range— white, several browns and blacks, probably orange and red earth colors, a possible dab of red lake and a spot of vermilion—and lack many of the pigments he commonly used in this and other paintings.

APPENDIX I
Glossary of Pigment Names

PIGMENTS MENTIONED BY PACHECO AND CARDUCHO

All the pigments Velázquez used in the seven paintings sampled were mentioned by Pacheco and/or Carducho. Both writers knew Velázquez personally, both were painters themselves, and both moved in the same circles, at least at times, as Velázquez. Thus this glossary is confined to pigment names mentioned by these two writers for painting in oils. In order to clarify the identity of the substances mentioned by Pacheco and Carducho, other sources will also be quoted at times. Comments by Nebrija at the beginning of the sixteenth century, by Felipe de Guevara at the end of the sixteenth, by Covarrubius in 1611, by the Portuguese Nunes in 1615, by the anonymous writer of the treatise published by Sanz Sanz (undated but probably from the mid-seventeenth century), by Garciá Hidalgo in 1693, and by Palomino in the early eighteenth century are thus quoted when necessary. References from painting contracts and *pragmáticas* are sometimes useful also.

As in most languages, Spanish pigment names are also color names. In reviewing early comments, we have tried to distinguish between references that indicate hue and references that indicate the source of the hue, but the remarks in the early literature are not always clear. Many other difficulties plague the following translations. Most twentieth-century Spanish dictionaries rely upon etymology to determine a pigment's identity. Such information is important, but here we have also paid attention to handling and storage instructions, as well as to the physical properties they imply. Conservators and chemists may find that our parenthetical remarks are unnecessary, but these remarks may make our reasoning clear to art historians.

By the end of the sixteenth century, painting and polychromy contracts usually ceased to specify pigments. This is unfortunate for our purposes, because some of the pigments whose identification is problematic, such as *espalto,* came into use just as specific mention of *colores* in contracts was ceasing. It would be helpful if we possessed a seventeenth-century contract specifying pigments and if we then also had analyses of pigments from the painting executed under that contract, but at this writing we have no such data. Because fifteenth- and sixteenth-century contracts not only specify pigments, but also sometimes describe them, we would like to have analyses of earlier paintings mentioned in contracts, too. But we do not now have such samples, nor do we have any guarantee that the meaning of pigment names remained unchanged over the centuries.

Examples of published occurrences of each pigment are limited to seventeenth-century Spanish paintings. Although El Greco lived into the early decades of the seventeenth century, we excluded paintings by him because he had learned his *colores* in sixteenth-century Italy.

We are grateful to Zahira Véliz and to R. D. Harley for their advice throughout the preparation of this glossary.

Albayalde (alvayalde). Lead white. Lead white is mentioned by all treatise writers. There seems to be no question about the meaning of the word, for its use is clear and reasonably consistent. Covarrubias (1977, p. 107) correctly translates the Latin *cerussa* as *albayalde*.

According to Pacheco, Carducho, García Hidalgo, and Palomino, lead white was used for whites and was often mixed with other colors; it was not used in fresco. It could darken upon exposure to air (Palomino, 1947, p. 93: because it came into contact with hydrogen sulfide in the air, causing formation of black lead sulfide). It was stored in water (Palomino, 1947, p. 490). It could be used to highlight drawings (a common use for lead white), although such use was unwise for it tended to discolor (Palomino, 1947, p. 529; because the pigment when used in drawings is not protected from the air as much as it usually is in an easel painting). It could be heated to make a yellow pigment (Palomino, 1947, p. 758). Palomino uses the word *génuli*, which we translate as a lead yellow, often lead-tin yellow; he omits any mention of tin, however, as is discussed under genuli. When heated, lead white gives off carbon dioxide and water, leaving behind lead monoxide, which is a yellow powder, massicot. According to several authors, further heating produced another oxide, Pb_3O_4, red lead (Covarrubias, 1977, p. 107; Palomino, 1947, pp. 758 and 1168; see *Azarcón*).

Writers mention *albayalde* frequently. Because it was such a common ingredient, they sometimes simply call it "blanco" when discussing pigments for oils. Pacheco mentions that he himself uses it (1956, vol. 2, pp. 75–76, 82, 83).

Published Occurrences: Lead white was identified in Velázquez's *Rokeby Venus* (Laurie, 1967, p. 150, and P. Hendy and A. S. Lucas, 1968, p. 262); in Zurbarán's *St. Margaret* (P. Hendy and A. S. Lucas, 1968, p. 262) in Coello's *St. Peter Alcántara* (Kühn, 1970, p. 28); in Murillo's *Young Beggar* (Hours and Rioux, 1978, p. 105); in Zurbarán's *Holy House of Nazareth* (Véliz, 1981, p. 278); in Velázquez's *Pedro de Barberana* (Jordan, 1981, pp. 378–79); in Murillo's *Two Boys Eating Melon and Grapes, Two Boys Eating a Pastry,* and *Boys Playing Dice* (von Sonnenburg, 1982, pp. 19–20); in Antolinez's *Immaculate Conception* (von Sonnenburg, 1982, pp. 19–20).

Albin (alvín). Hematite. In 1516 Nebrija's *Vocabulario* had designated *alvín* simply as *piedra conocida,* but he had given the Latin for hematite: *lapis sanguinarius* (1973, p. 21). Palomino's glossary described *albín* as a dark red derived from stones found in copper mines (1947, p. 1144). Hematite is ferric oxide, Fe_2O_3; this is the same compound that provides the color in red ochres, where it occurs in mixtures with other minerals, such as clays. Throughout Europe, hematite was used principally in fresco.

Albín is not mentioned frequently, nor is it greatly emphasized by any treatise writer. Pacheco does not say he uses it, but he does report (1956, vol. 2, p. 84) that "some" make draperies in oils with it. Carducho does not mention albín at all. García Hidalgo and Palomino do not mention it for oils.

Published Occurrences: None.

Almagra (almagre, almagro, almazarrón, tierra roja, tierra roxa). Red ochre. In general almagra and tierra roja seem to be interchangeable, though within some treatises individual authors imply distinctions. Almazarrón does not appear until the pragmática of 1680, as published in *Autoridades.*

Covarrubias, 1977, identifies *almagre* and *almagro* as "red earth." The treatise published by Sanz Sanz again refers to "*almagre, llamado comunmente de tierra roja*" (1978, p. 255). *Autoridades,* when publishing the pragmática of 1680, defines *almazarrón* as "*Lo mismo que*

por otro nombre llamamos almagra." Pacheco describes almagra as a red earth (1956, vol. 2, p. 17). He states that it is used in oil, tempera, and fresco (1956, vol. 2, pp. 17, 28, 51, 78). Carducho does not use the word almagra; in Italian style, he lists tierra roja (1979, pp. 381–82). García Hidalgo and Palomino mention both almagra with tierra roja, and Palomino defines them as synonyms. Palomino also mentions almazarrón as "red mud (*barro colorido*) or tierra roja, so common in all the provinces of the globe" (1947, p. 58).

Red ochre is a docile and reliable pigment that does not require extensive preparation, as is noted by Palomino (1947, p. 92). As Palomino also pointed out, it does not require a drier and should be stored in water (1947, pp. 99, 492); it can be heated to change color (1947, p. 58).

Red and brown ochres are distinct substances with different chemical compositions and different behavior. Red ochres consist of ferric oxide and other (usually colorless) minerals, such as clays or micas. Brown ochres usually contain yellow hydrated iron oxide and manganese oxides, with associated colorless minerals. It is hard to tell whether Spanish writers consistently distinguished between red and brown ochres. If our present hypothesis is correct, Pacheco's *barro que se usa en Sevilla* (1956, vol. 2, p. 75) was a dark brown, and possibly it was different from red earth. A variety of colored earth pigments were probably found occurring naturally in southern Spain. Zahira Véliz has pointed out to us that "a majority of Zurbarán's Andalusian paintings are on a mouse-brown ground, in contrast to his late Madrid works, which are on a reddish ground. Also Palomino describes a clay from Andalusia to which red is added to give it color and body. . . ." (letter of August 31, 1982; Palomino, 1947, p. 484). We have also noted that unpublished analyses of early paintings by Velázquez, done while still in Seville, reveal a brown ground, whereas his Madrid works (such as the early portraits of Philip IV) were painted on a red ground (letter from Joyce Plesters, December 8, 1975).

Perhaps because almagra was so common, it came to be a frequent color term and sometimes was also applied to other red pigments, such as albín. Most authors mention almagra and tierra roja frequently, but as one would expect with a dependable pigment, they do not give elaborate advice for using it. Pacheco mentions that he uses almagra (1956, vol. 2, p. 78).

Published Occurrences: Red ochre has been identified in Zurbarán's *St. Margaret* (P. Hendy and A. S. Lucas, 1968, p. 262); in Antolínez's *Immaculate Conception* (von Sonnenburg, 1982, pp. 19–20); in Velázquez's *Portrait of Camillo Massimi* (Harris and Lank, 1983, p. 415). Brown ochre has been identified in Murillo's *Boys Playing Dice* (von Sonnenburg, 1982, pp. 19–20).

Almazarron. See *Almagra.*

Ancorca (ancora, ancorza, oncorca, ancorque). Yellow glazing pigment. Véliz (1986, pp. 196–97) suggests that in Velázquez's time, ancorca was "an artificially prepared organic pigment." Certainly from the comments of Pacheco, Carducho, García Hidalgo and Palomino, it seems clear that ancorca and *ocre* (yellow iron oxide) were different. Véliz's broad and comprehensive perusal of Spanish sources lends credence to her argument that ancorca could be either organic or inorganic in source. Pacheco's statement that ancorca could not be stored in water, lacked body, and was used for washes (1956, vol. 2, pp. 29–30, 88) combined with Palomino's identification of ancorca as "*yeso mate, y tinta de gualda*" (1947, p. 1144), remind one of the organic pigments described by Harley (1982, pp. 107–14 especially).

Although ancorca is mentioned in most discussions of yellows, it is not advised quite as often as ocre or yellow ochre. Pacheco mentions that he himself uses ancorca (1956, vol. 2, p. 82).

Published Occurrences: None.

Añil (añir, índico). Indigo. Añil is mentioned by Pacheco, Carducho, García Hidalgo, and Palomino. The discussions of añil all fit the modern knowledge of indigo. It was a dark blue (García Hidalgo, 1965, p. 10v); it had little body (Pacheco, 1956, vol. 2, p. 30; because it is organic); it needed a drier (because it is organic); it came from India, and it was derived "from a certain juice of plants" (Palomino, 1947, p. 1155). Except for the discussions in García Hidalgo and Palomino, añil is not mentioned frequently.

Published Occurrences: None.

Azarcón (zarcón). Red lead. Azarcón is mentioned by Pacheco, Carducho, García Hidalgo, and Palomino. According to García Hidalgo (1965, p. 10v), and Palomino (1947, p. 758), it was made by heating lead white, which when heated breaks down and eventually oxidizes to red lead, Pb_3O_4. As mentioned by Pacheco (1956, vol. 2, pp. 73, 80–81, 83, 109–110, 123), García Hidalgo (1965, p. 11r), Palomino (1947, p. 1145, by implication), it was an excellent drier (because of its lead content). A contract of 1511 in Seville describes azarcón as a priming coat for ironwork (Seville, *Documentos*, 1935, vol. 8, p. 27; red lead is still used today as an anticorrosive for modern steel and iron). Pacheco mentions *azarcón de la tierra* for painting in tempera (vol. 2, p. 20); the meaning of this term is not clear.

In the sixteenth century, Felipe de Guevara confused massicot (yellow lead monoxide) and red lead by referring to both as azarcón. In 1611, Covarrubias confused the color of azarcón, believing it related to the Arabic word for blue. But he does point out that azarcón is derived from burnt lead (1977).

As in Italy, the term *minio* was applied both to red lead and to vermilion (see *Bermellón*). Pacheco mentions *azarcón* frequently as a drier. Carducho mentions it only once, and García Hidalgo only a few times, once as a drier.

Published Occurrences: A small quantity of red lead was found in Zurbarán's *St. Margaret* (P. Hendy and A. S. Lucas, 1968, p. 262), perhaps as a drier.

Azul, Cenizas de Azul. Azurite (and artificially produced copper carbonate?). Although it seems likely that *azul* and *cenizas de azul* were usually azurite, the many names for blues have not as yet been clarified, and the Spanish vocabulary distinguishing natural azurite, natural ultramarine, and artificial copper blues is not well understood. *Azul fino, azul de Santo Domingo, azul baxo,* and *cenizas de Sevilla* may have been used to describe blues that were different chemically, or they may have been used to distinguish different grades of a single pigment such as natural azurite. Because of its costliness, usually ultramarine was specifically designated as *azul ultramaro* or *ultramarino*, but, as in Italy, cenizas sometimes referred to an inferior grade of lapis lazuli. Palomino does, however, separate *cenizas de ultramaro*, which he calls "an inferior kind of ultramarine, third rate," from *cenizas azules*, which he calls "a beautiful blue, especially for illuminations and miniatures, and for painting in tempera" [all mediums in which azurite does not discolor] (1947, p. 1147).

Pacheco, Carducho, and Palomino all mention cenizas that appear to have many of the physical qualities of azurite. Cenizas has to be applied in several coats to produce a suitably intense blue and was difficult to spread (azurite is ordinarily ground coarse and gritty and consequently is difficult to spread). Pacheco deliberately set his azul apart from ultramarine (1956, vol. 2, p. 86), and Palomino also distinguished between cenizas de ultramaro and cenizas azules, citing the former as *"género inferior de ultramarino que llaman tercera suerte,"* and the latter as *"azul hermoso, especialmente para iluminaciones y miniaturas, y para pintar al temple"* (1947, p. 1147; the distinction among mediums for azurite is traditional to that

pigment; the yellowing and discoloration of aged oil mediums and varnishes causes azurite-containing paint films to become darker and darker, often nearly black). Although ultramarine also can lose its color in oil films, the problem is more severe and common with azurite. A 1522 Sevillian contract for polychromy requires that azul fino be painted in tempera (Seville, *Documentos,* 1935, vol. 8, p. 33).

Cenizas appear to have been available in different grades, which again suggests azurite. It is interesting to note that a *pragmática* of 1627 lists cenizas that have been graded numerically: *"Cada onza de cenizas más finas de Sevilla número 8"* (Viñas, 1968, p. 736). *Segundos* appear to have been second- or third-rate, although within that term, there were further distinctions of quality: *segundos finos* were used in "works of importance" in the lesser medium of *pintura de sargas* (tempera painting on sargas cloth; Pacheco, 1956, vol. 2, p. 20). In another passage, Pacheco emphasizes that "the blues should be of the best and thinnest color, of *cenizas,* avoiding *segundos* and coarse ones that are spread with difficulty" (1956, vol. 2, p. 87). *Segundos finos* are used as if synonymous with cenizas in the passage on pintura de sargas.

One is further tempted to designate cenizas as azurite by the use of "ashes" for azurite in the vocabulary of other languages: *cendres bleues* in French and *asch-blau* in Dutch.

The proper translations of *azul baxo* and *azul de costras* are not clear. The treatise published by Sanz Sanz regards them as synonymous: *"azul bajo llamado costras"* (1978, p. 252). But Véliz (1986, pp. 197–98, nn. 6, 7) points out that azul baxo is probably "a low grade of azurite," whereas azul de costras is more likely an artificial blue. A description by Palomino and Ruíz de la Iglesia in 1694 declares *"azul de costras,* that used to be used for skies, and mountains," to be obsolete: "today they are not used, because others of better quality have been discovered." This passage is especially hard to interpret because, along with *azul de costras,* Palomino and Ruíz de la Iglesia would condemn *"el almazarrón, o Almagre . . .* (Agulló y Cobo, 1959, p. 233), a pigment almost universally used and one endorsed by Palomino in *El Museo Pictórico* (1947, p. 1163 as tierra roja).

All authors mention azul and/or azul fino and/or cenizas. For Pacheco these pigments seem to be the most prevalent source of blues and, when mixed with yellow, of greens. Pacheco refers to azul with reverence, saying that "because this illustrious color has so much to offer and is so noble, it does not allow itself to be used by all" (1956, vol. 2, p. 87). For García Hidalgo, smalt and indigo were equally important sources of blue, as they were also for Palomino. Pacheco mentions that he himself uses cenizas (1956, vol. 2, pp. 82, 86).

Published Occurrences: Azurite has been identified in Velázquez's *Rokeby Venus* (Plesters, 1966, p. 75); in Zurbarán's *Holy House of Nazareth* (Véliz, 1981, p. 278); and in Murillo's *Two Boys Eating Melon and Grapes* (von Sonnenburg, 1982, pp. 19–20).

Barro de Sevilla. Earth pigment from Seville. For the distinction between red ochre and brown ochre, see *Almagra.*

Berdacho. See *Tierra verde.*

Bermellón. Vermilion. Pacheco, Carducho, and Palomino all distinguish between natural and artificial bermellón (red mercuric sulfide, which is found in nature as the mineral cinnabar, can be compounded artificially from mercury and sulfur; natural and artificial vermilion are at present very difficult to distinguish by microscopic examination). García Hidalgo advises bermellón for flesh tints and middle tints (1965, p. 10v). Palomino describes this pigment as a mixture of sulfur and mercury (1947, p. 1145). Pacheco comments that painters in his day use the artificial form (1956, vol. 2, p. 16; it could be covered with a red lake glaze so as to use the hue of both pigments, p. 83). Palomino notes that it should not be stored in water, for it loses oil

(1947, pp. 489–90). Palomino also points out that it should not be used for paintings exposed to open air, because it would turn dark (vermilion may darken unpredictably when exposed to sunlight; 1947, p. 581). Although Palomino's advice may reflect firsthand experience, it may also echo Vitruvius's discussion (book seven, chapter nine).

As in the case of red lead (see *azarcón*), there was some confusion among Spanish authors as to whether bermellón or azarcón was the same as the Latin *minium,* and bermellón is occasionally referred to as *minio.*

Most authors mention bermellón frequently and consider it a beautiful and valuable pigment. Felipe de Guevara (1788, p. 73) reported that vermilion is expensive (*preciosa*) and that *"Por esto ay ley que las den los Señores de las obras."* Pacheco mentions that he uses bermellón (Pacheco, 1956, vol. 2, pp. 78, 83–84).

Published Occurrences: Vermilion has been identified in Zurbarán's *St. Margaret* of 1630 (Gettens, Feller, and Chase, 1972, p. 64); in Zurbarán's *Holy House of Nazareth* (Véliz, 1981, p. 278); in Velázquez's *Pedro de Barberana* (Jordan, 1981, pp. 378–79); in Murillo's *Boys Playing Dice* and in Antolínez's *Immaculate Conception* (von Sonnenburg, 1982, pp. 19–20); in Velázquez's *Camillo Massimi* (Harris and Lank, 1983, p. 415).

Blanco. White. When writers simply advise *"blanco,"* they presumably mean lead white. See *Albayalde.*

Carbón. See *Negro de Carbón.*

Cardenillo. Verdigris. Pacheco (1956, vol. 2, p. 82) mentions cardenillo as a glaze (verdigris is a copper acetate which has a low refractive index and is therefore somewhat transparent in an oil medium). Pacheco (1956, vol. 2, p. 88) advises that it not be stored in water (because verdigris is slightly soluble). García Hidalgo (1965, p. 10v) and Palomino (1947, p. 492) describe it as a drier. According to Palomino (1947, p. 488), it could turn black (because of its copper content, which reacts with sulfur-containing gases in the air). Palomino (1947, p. 1147) also notes that it was made from corroded copper and vapors of vinegar. Palomino gave *verdete* as a synonym for cardenillo.

Pacheco and Carducho mention cardenillo infrequently. García Hidalgo and Palomino discuss it slightly more often, although Palomino does not recommend it unreservedly. Pacheco mentions his own use of it (1956, vol. 2, p. 82). Sixteenth-century contracts for polychromy often mention cardenillo, *al aseite con su barnis* ("in oil with its varnish"). Probably this indicates a green copper resinate type glaze; the oil and varnish might also seal off the verdigris and prevent discoloration (see Seville, *Documentos,* vol. 8, p. 24).

Published Occurrences: Verdigris has been identified in Coello's *St. Peter Alcántara* (Kühn, 1970, p. 28); in Murillo's *Two Boys Eating Pastry* and *Boys Playing Dice* (von Sonnenburg, 1982, pp. 19–20).

Carmín, Laca de Francia. Red lake. Although neither Pacheco nor Carducho describes the preparation of carmín in detail, Pacheco's recommendation of it as a glazing pigment (red lake is transparent), as an ingredient for purples (red lake was commonly mixed with blues, for example in Velázquez's *Coronation of the Virgin*), and as a pigment not used in fresco suggests that carmín is red lake. García Hidalgo (1965, p. 11r) says that with bone black it needs a drier. Pacheco also mentions *carmín de Indias,* and such a New World origin indicates that that particular source of red lake was probably cochineal (although according to Nunes, 1615, p. 56, *coconilha* was also imported from the Low Countries). Carducho confines carmín

de Indias to works in tempera and washes (1979, p. 382). Palomino (1947, p. 1147) distinguishes between ordinary carmín, which he defines as cochinilla mixed with white chalk (which makes it technically no longer a lake; cf. Harley, 1982, pp. 111–12) and *carmín fino*, which is *carmín de grana, o cochinilla y ajebe y alumbre* (grain, or cochineal, mixed with alum), which is a distinction made in other treatises listed by Palomino (see Baldinucci, 1809, vol. 2, p. 273, who mentions *lacca fine* with alum). The distinction is between a cheap pseudo lake and a costly true lake pigment. Carmín was also an occasional designation for reds in general.

Pacheco, Carducho, García Hidalgo, and Palomino mention carmín frequently, and it seems to have been the fundamental source of red for flesh and draperies. It seems to have been a valuable color, too: Felipe de Guevara (1788, p. 73) and Palomino (1947, p. 488) mention carmín as expensive and as sometimes paid for by the patron. Pacheco mentions his own use of carmín (1956, vol. 2, p. 83).

Published Occurrences: Red lake has been identified in Zurbarán's *Holy House of Nazareth* (Véliz, 1981, p. 278); in Velázquez's *Pedro de Barberana* (as alizarin; Jordan, 1981, pp. 378–79); in Murillo's *Two Boys Eating Melon and Grapes* and *Boys Playing Dice* (von Sonnenburg, 1982, pp. 19–20).

Carnemomia. See *Espalto*.

Cenizas de Azul. See *Azul*.

Cinabrio. See *Bermellón*.

Esmalte, Esmaltines. Smalt. Pacheco mentions smalt for glazes (1956, vol. 2, p. 87), as does García Hidalgo (1965, p. 10v; smalt is a cobalt pigment, a potassium glass of relatively low refractive index, and thus it is fairly transparent in oil films). Palomino defined it as "a blue color that is made of glass paste, or silversmith's smalt," (1947, p. 1152); he mentions smalt as a good drier (1947, p. 492) (because of its cobalt content). Carducho mentions both esmalte and esmaltines, as does the author of the treatise published by Sanz Sanz (1978, p. 252); neither explains the diminutive. Véliz suggests that esmaltines were a finely ground grade of smalt (letter, October 9, 1986). Harley adds that they were "a very pale colour" (letter, June 3, 1987).

Because of its lovely color, smalt was well appreciated, although it was not as expensive as ultramarine or azurite. Pablo de Céspedes had claimed that God chose "sovereign smalt" for the color of the sky (Pacheco, 1956, vol. 1, p. 28), and García Hidalgo mentioned smalt as a color in the same class with ultramarine and azurite. Whereas Pacheco had made azurite his workhorse blue, Palomino makes it clear that smalt has replaced azurite in his palette as the basic choice for blues in oil (1947, p. 99). Pacheco mentions his own use of smalt (1956, vol. 2, p. 85, 87).

Published Occurrences: Smalt has been identified in Velázquez's *Rokeby Venus* (Mühlethaler and Thissen, 1969, pp. 54–56; Plesters, 1966, p. 75, and Plesters, 1969, pp. 62–74); and in a painting by an anonymous Sevillian, *Adoration of the Shepherds* (Mühlethaler and Thissen, 1969, pp. 54–56; Plesters, 1966); in Antolínez's *Immaculate Conception* (Mühlethaler and Thissen, 1969, pp. 54–56; von Sonnenburg, 1982, pp. 19–20); in Murillo's *Young Beggar* (Hours and Rioux, 1978, p. 105); in Murillo's *Boys Playing Dice* (von Sonnenburg, 1982, pp. 19–20).

Espalto. A bituminous earth (Cologne earth, Van Dyck Brown) or asphaltum, or mummy. Pacheco, Carducho, García Hidalgo and Palomino all mention espalto. As was

pointed out by García Salinero (1968, p. 111), espalto was defined as synonymous with *betún* or bitumen by Juanelo Turriano around 1590. It seems, however, that the precise definition of espalto as a pigment name is more complicated. Certainly the word suggests that the pigment should be related to asphaltum or bituminous earths, which are complex mixtures of organic compounds, including hydrocarbons and oxygen, sulfur and/or nitrogen-containing materials. Espalto did not dry well (Palomino, 1947, p. 489), and Pacheco says it cannot be stored in water (1956, vol. 2, p. 88). Palomino defines espalto as "a dark, transparent and soft color, for glazes . . . ; which by another name they call *Carne momia.*" (1947, p. 1152). (Asphaltum, bituminous earths and mummy (carnemomia) can be used as glazes.)

If the Spanish distinguished between these various substances, their distinctions are not immediately clear today. Among seventeenth-century references there was some confusion about the origins of espalto and carnemomia, which are sometimes given as synonyms (Palomino, 1947, p. 1152). Bituminous earths are pigments largely made up of organic substances that are similar to lignite or brown coal; two of the best known sources were ground from Cologne and Kassel, hence the names Cologne earth and Kassel earth. Asphaltum occurs in regions of oil deposits. Literary sources indicate that Spaniards believed it to come mostly from an area in the Middle East.

Possibly espalto was applied to both asphaltum and bituminous earths. We tentatively identified an organic brown in some samples from one of the Velázquezes, but we could not define the pigment more precisely. We believe that the bituminous pigment we identified was part of Velázquez's original paint surface. Nevertheless it should be kept in mind that while Cologne earth was indeed used in the seventeenth century, it was also employed by restorers in the centuries after Velázquez's death. Vicente Poleró y Toledo, the nineteenth-century restorer of the collections now housed in the Prado, describes the general use of Cologne earth, though he does not mention applying it to a specific painting by Velázquez (Poleró y Toledo, 1972, pp. 101–36).

Velázquez's contemporary writers mention espalto, but they do not give it much emphasis. Pacheco mentions espalto in the first person (1956, vol. 2, p. 78).

Published Occurrences (of bituminous Cologne earth, asphaltum, or mummy): None.

Genuli (jenuli, xenuli, ganoli). A lead-containing yellow, perhaps lead-tin yellow or massicot. Harley provides a useful discussion of lead-based yellows, (1982, pp. 995–99). Véliz (1982, p. 56, n. 31) establishes genuli's identity by pointing out that Pacheco says it is not poisonous and thus is not sandarach or orpiment, and that it tends to dry quickly. Palomino (1947, p. 758) describes making genuli by heating lead which, if the recipe is complete, would actually produce yellow lead monoxide (massicot) rather than lead-tin yellow. Harley has noted that lead-tin yellow and massicot were sometimes confused in technical literature on pigments (1982, pp. 95–99). Conflating the ancient references with his eighteenth-century knowledge, Palomino also mistakenly gives *sandaraca* as the Latin for genuli (1947, p. 1154).

Although preparation of lead-based yellows usually merits a shorter discussion than preparation of orpiment, genuli crops up more frequently than orpiment in descriptions of the writers' own paintings and in their specific instructions about color mixtures. Pacheco mentions his own use of genuli (1956, vol. 2, p. 82).

Published Occurrences: Lead-tin yellow has been identified in Antolínez's *Immaculate Conception* (Kühn, 1968a, p. 26; von Sonnenburg, 1982, pp. 19–20); in Zurbarán's *Holy House of Nazareth* (and also massicot, Véliz, 1981, p. 278); in Murillo's *Two Boys Eating*

Melon and Grapes, Two Boys Eating a Pastry, and *Boys Playing Dice* (von Sonnenburg, 1982, pp. 19–20).

Grano (grana). See *Carmín.*

Hyeso (Hyesso). See *Yeso.*

Ieso. See *Yeso.*

Indico. See *Añil.*

Jalde (oropimente). Orpiment. At times jalde, like many pigments, lent its name to a certain shade of yellow. But in the language of painters, jalde was usually synonymous with orpiment, as Covarrubias, 1977, indicated. Pacheco (1956, vol. 2, pp. 80–81) gives jalde and oropimiente as synonyms, mentioning that the pigment cannot be combined with cardenillo or verdigris (because sulfides and copper are incompatible), that it can be heated to make orange (realgar, or sulfide of arsenic), and that it is poison. Jalde is mentioned for highlights in sixteenth-century contracts, and "orange of burnt *jalde*" is also mentioned (Seville, *Documentos*, vol. 8, p. 22).

In Pacheco's discussion of oil painting, he mentions jalde as used by others: "Some use *jalde* or *oropimente*" (1956, vol. 2, p. 80). In his discussion of egg tempera painting, however, he mentions his own use of jalde (1956, vol. 2, p. 22); Hidalgo Brinquis's analyses of the tempera paintings by Pacheco in the Casa de Pilatos in Seville indeed reveal orpiment (1978). Pacheco does not mention realgar, but Carducho lists jalde or oropimento or *rejalgar* as if the three were synonymous (1979, pp. 381). The two pigments are in fact quite similar chemically and usually occur together in nature, although they are distinctly different in color. García Hidalgo mentions neither jalde nor oropimente nor rejalgar; Palomino does not mention rejalgar. Pacheco and Palomino discuss the preparation of orpiment at length (Pacheco, 1956, vol. 2, pp. 80–81; Palomino, 1947, pp. 501–502).

Published Occurrences: None.

Jenuli. See *Genuli.*

Laca. See *Carmín.*

Minio. See *Azarcón* and *Bermellón.*

Negro. Black. As in the case of white, writers sometimes advise a black pigment without specifying its source. *Sombra*, which usually means umber (a brown pigment) can also be used to describe a black, as in *sombra de hueso* (bone black). See *Negro de carbón* and *Negro de hueso.*

Negro de Carbón. Charcoal black, vine black, lamp black, soot black, plant black. Carbon blacks are made by the partial burning of a variety of organic materials, such as oils, resins, or wood. Lamp or soot blacks can usually be distinguished microscopically from charcoal blacks. Negro de carbón seems to have referred to charcoal blacks for the most part, although the source of the pigment is not always specified. Palomino says that negro de carbón was made from burning oak, grapevines, nutshells, "and others" (1947, p. 1158), and he also says that it could not be stored in water (1947, p. 99). Carducho mentioned negro de carbón only in his discussion of fresco (1979, p. 383).

Pacheco distinguished *negro de humo* (lamp black or soot black) from negro de carbón, and he remarks on his own use of both of them (1956, vol. 2, p. 78). Carducho and Palomino also

mentioned negro de humo. García Hidalgo (1965, p. 10v) advised that negro de humo needed a drier.

Pacheco mentioned negro de carbón more often than other black pigments. Carducho does not mention it for oils (instead, he recommends negro de humo). Palomino and García Hidalgo mentioned it frequently and appeared to value it for its practicality. Pacheco mentioned his own use of negro de carbón (1956, vol. 2, p. 78).

Published Occurrences: Carbon black has been identified in Zurbarán's *Holy House of Nazareth* (Véliz, 1981, p. 278); in Murillo's *Boys Playing Dice* (von Sonnenburg, 1982, pp. 19–20); a carbon black has been identified in Velázquez's *Camillo Massimi* (Harris and Lank, 1983, p. 415).

Negro de Hueso (sombra de hueso, sombra de gueso). Bone Black. Pacheco and García Hidalgo mentioned bone black frequently for modeling flesh (bone black is about 90 percent calcium phosphate, and it is more transparent and has better working qualities than the soot or charcoal blacks, which are nearly 100 percent carbon). Bone black could be used in either oil or tempera (Carducho, 1979, pp. 381–82). Bone black needs a drier (García Hidalgo, 1965, p. 10v). According to Palomino, it was made from burnt bacon, deer antlers, or sheep's horns (1947, p. 1162).

Negro de hueso is not emphasized by any writer other than García Hidalgo. Pacheco mentions his own use of negro de hueso (1956, vol. 2, p. 78).

Published Occurrences: Bone black or carbon black was found in *Boys Playing Dice* by Murillo (von Sonnenburg, 1982, pp. 19–20); bone black was found in Velázquez's *Camillo Massimi* (Harris and Lank, 1983, p. 415).

Ocre. Yellow ochre. Pacheco (1956, vol. 2, p. 17) mentions ocre as yellow earth. According to Palomino (1947, p. 1158), it could be burnt, and he points out that it produces a red color (yellow ochre turns to red ochre by loss of hydration). Palomino (1947, p. 492) says that if ocre is not recently ground, it does not need a drier. Like almagra or red iron oxide, ocre was stable and occurred so commonly that often the term was simply a color name. Ocre is one of the more commonly mentioned pigments, and Palomino (1947, p. 581) praises it as "not fussy to work." Pacheco mentions his own use of ocre (1956, vol. 2, p. 78).

Published Occurrences: Yellow ochre was found in Zurbarán's *Holy House of Nazareth* (Véliz, 1981, p. 278); in Murillo's *Two Boys Eating Melon and Grapes* (as "yellowish-brown ochre") and in Antolínez's *Immaculate Conception* (von Sonnenburg, 1982, pp. 19–20).

Oncorca. See *Ancorca.*

Oropimente. See *Jalde.*

Rejalgar. See *Jalde.*

Sombra (sombra de Italia, sombra de Venecia). Umber. Pacheco describes sombra as useful for washes and modeling (1956, vol. 2, pp. 29–30, 78; a typical use of umber). He also remarks that it dries readily (1956, vol. 2, p. 88; because of its manganese content). Carducho (1979, pp. 381–82) advises sombra de Venecia for oil, fresco and tempera.

Sombra is mentioned frequently, though individual references are usually brief. Pacheco mentions his own use of sombra (1956, vol. 2, p. 78).

Published Occurrences: Umber has been found in Zurbarán's *Holy House of Nazareth* (Véliz, 1981, p. 278).

Sombra de Hueso. See *Negro de hueso.*

Tierra Roja. See *Almagra.*

Tierra Verde (verdeterra). Green earth. Tierra verde or verdeterra has low hiding power (does not completely cover what is beneath) and is mentioned for tempera, fresco, and oil (Pacheco, 1956, vol. 2, pp. 26, 33, 51; Palomino, 1947, p. 582). García Hidalgo (1965, p. 10v, in Fresco) and Palomino (1947, pp. 509, 582, and 1163) say that it is obtained from Verona (where a good quality of celadonite, one of the principal materials in green earths, is found).

Tierra verde is not discussed frequently. Palomino mentions *verdacho* as a kind of tierra but all writers consider verdacho to be slightly different from tierra verde. Verdacho seems to have been darker in color than tierra verde.

Published Occurrences: None.

Ultramarino (ultramaro). Ultramarine. There seems to be no question about the identification of this pigment, which is made from the stone lapis-lazuli. It is mentioned by Pacheco, Carducho, the writer of the treatise published by Sanz Sanz, García Hidalgo, and Palomino. All writers stress the beauty and/or costliness of ultramarine. The treatise published by Sanz Sanz advises that "*Hay otro azul de ultramaro, éste es carísimo y sólo para mantos de Nuestra Señora*" (1978, p. 255). Pacheco claims in one passage that it is not used in Spain (1956, vol. 2, p. 84) but recommends it based on his own use a couple of pages later (1956, vol. 2, p. 86).

Published Occurrences: Ultramarine has been identified in Velázquez's *Rokeby Venus* (Plesters, 1966, p. 75); in Antolínez's *Immaculate Conception* (von Sonnenburg, 1982, pp. 19–20; in Velázquez's *Camillo Massimi* (Harris and Lank, 1983, p. 415).

Verdacho (berdacho). See *Tierra verde.*

Verdemontaña. Malachite. Analyses published so far indicate that malachite was not used frequently in seventeenth-century Spanish painting. Perhaps its infrequent use explains the lack of specific instructions for working it in the treatises, and one is left to assume that the verdemontaña of Spain is the same as the "mountain green" of other countries, and hence is malachite. Pacheco, Carducho, García Hidalgo, and Palomino all mention it at least once, and most describe it as beautiful.

Published Occurrences: None.

Verdete. See *Cardenillo.*

Verdeterra. See *Tierra verde.*

Xenoli (xanoli). See *Genuli.*

Zarcón. See *Azarcón.*

APPENDIX II

Why Paintings Change and
Attitudes Toward These Changes

This appendix has been created to give art historians a brief overview of why and how a Velázquez painting changes. In general any element in a painting may change over time. Here, however, we have chosen to emphasize the elements in a painting that change relatively rapidly and drastically rather than the elements that remain stable for a longer period of time because these changing elements present significant challenges to anyone trying to interpret the work of art.

Because oil paintings contain organic materials (primarily binding media), they continue to evolve as the materials respond to air, heat, cold, dampness, dryness, and each other. Thus it is unlikely that any picture other than a recently created one looks today exactly as it did when it was painted. Both tempera and oil paintings contain materials that are inherently unstable, but because in this book we are concerned with the work of Velázquez, we focus upon oil paintings and limit discussion to the ingredients he and his contemporaries used. The following summary lists typical alterations.

HOW OILS AND VARNISHES CHANGE

Staining tests indicate that Velázquez used oil as his binding medium. That is, he mixed his colors or pigments with what was either walnut or linseed oil.[1] All drying oils tend to turn yellow with time.

Seventeenth-century paintings were usually coated with a natural resin varnish, which was sometimes mixed with oil. The short-term advantage of varnish is that it protects the painting from grime and intensifies the colors by scattering light evenly from the paint surface. The long-term disadvantage of this practice is that natural resin varnishes turn yellow or brown as they age. Of course this darkened varnish dims the colors and tones in the image. Nor are varnishes the only element that darkens: oils also turn more yellow or brown.

One might at least hope that all oils and varnishes in a painting would darken uniformly, thus keeping the original range of tones intact. A painting thus wishfully imagined would simply resemble a photograph printed a little darker. But such hopes are often destined for disappointment, because not all oils darken at the same rate. And even if all oils did darken at the same rate, the painting's original tonal range would not be preserved, because the effects of yellowing and darkening on different pigments are themselves different. For one thing, they vary according to the pigment's hue and refractive index. Obviously a yellow or orange, or even a red, would be less affected by yellowed medium, whereas a blue would be seriously altered. Painters realized this and therefore treatises frequently recommended walnut oil for whites and blues, for example, but linseed oil for other colors. If the various oils mixed with

the different pigments themselves darken at different rates, the tonal relationships intended by the painter will be further distorted.

HOW PIGMENTS CHANGE

To complicate matters, pigments—the raw colors—mixed with oils themselves alter optically at different rates. Some pigments change tone or color more rapidly and more radically, while others are affected only slightly. Smalt (blue),[2] azurite (blue),[3] and mixed greens made of blue and an unstable organic yellow[4] are prone to change color dramatically. Earth browns and organic blacks often darken and destroy passages of modeling. Red lakes can fade.[5]

As has been noted in chapters 3, 4, and 5, the same pigment does not always change in the same way in different paintings. The azurite in the sky in the _Surrender of Breda_, for example, has maintained a blue color, whereas the azurite in the skirt of the kneeling menina in _Las Meninas_ turned a dark green. Nor is it always certain what the original components of a particular paint were. We assume that Apollo's blue wreath in the _Forge of Vulcan_ was originally green. If the green was produced by mixing the blue with an organic yellow lake pigment, this pigment may have proved fugitive and disappeared; this missing ingredient may or may not be detectable by tests available today.

PENTIMENTI

Another spontaneous change that occurs differentially is the transparency of paint films. Oil paints become transparent at different rates. Many pigments have refractive indexes just slightly higher than that of fresh oil, and as the index of the dried oil more closely approaches the index of the pigment, the pigment becomes more "transparent" because less scattering of white light occurs at interfaces between materials of similar refractive indexes than at interfaces of material with different refractive indexes. There are some pigments that have quite high refractive indexes, such as vermilions. Thus an area of vermilion in a painting may be impervious to a pentimento for a longer period of time than an area painted in lead white within the same image. Short of covering up a pentimento with a restorer's brush, which is not a procedure that most conservators would advocate, it cannot be suppressed. Sometimes conservators or restorers remove varnish selectively, leaving some old varnish to veil an emerging pentimento.

CHANGES DUE TO RESTORATION

Further changes occur when individual paints resist abrasion differently. If a painting is cleaned with less than impeccable care—and most important old paintings have been cleaned repeatedly—an area of red lake, which is easily soluble, may be partly removed. A neighboring area of lead white, which is a sturdy pigment,[6] may remain intact. Thus what was once a white/red contrast may become white/pink or even white/white (if the red was underpainted with white) because of the difference in the way the pigments react to abrasion. Fortunately for Velázquez's paintings, the Prado Museum has long followed a conservative policy, and many of the paintings in that collection have suffered little, if any, damage from cleaning in modern times.

Velázquez's paintings, like many seventeenth-century oil paintings, were executed on a canvas support. In time any canvas, especially in a large work, stretches, sags, or rots. If it is

left unlined, the paint may flake off. It it is lined, the passages of impasto may be flattened, and the play of light over the surface, a play often as expressive as color or line, will be lost or distorted.[7]

Even this brief and selective review of alterations within a painting makes it clear that time changes the artist's creation, often irrevocably. Technology such as chemical analysis can suggest that a pigment has mutated or an oil darkened, but exactly *how much* it has changed and *how far* it has moved from the original design is difficult to say. Thus original appearance cannot be reconstructed with perfect certainty, even with the mind's eye. If we add to these changes, most of which spring from elements inherent in the materials Velázquez used, additional changes effected by expanding a painting's size (the *Forge of Vulcan* was widened, probably in the eighteenth century, by the addition of strips of canvas) or cutting it down (at an unknown date both portraits of Philip IV and the portrait of the dwarf were cut down, and it is uncertain whether a significant portion of the original image was lost in any of these three pictures), then the paintings whose alterations are merely spontaneous are lucky.

ATTITUDES TOWARD THESE CHANGES

People have known for a long time that paint darkens, but it has been only in the past several decades that conservation scientists have systematically made public chemical analyses that demonstrate how drastic that darkening can be and how much colors can change. Thus in 1889, Stevenson could state with confidence that the Velázquezes he knew "have changed very little; but as with all old pigment, a good light is necessary."[8] In the twentieth century, chemical sampling makes it clear that a good light is not always enough to turn back the clock: a bright blue drapery can turn brown or black, a green leaf can become blue, and dark draperies can turn flat black.[9]

THE ARTIST AS SEER

Did artists ever foresee that their paintings would change?[10] The argument has been made that painters, being the shrewd craftsmen they were, anticipated and approved some of the spontaneous changes that would take place in their works. If Velázquez planned for his pictures to alter themselves over time, then the changes we observe today may not be altogether unintended, and thus the point is worth investigating. Because conservators often try to return a painting to the state intended by the artist, and in so doing replace discolored varnishes, the artist's attitude toward such "restoration" has been one of the more hotly debated issues in nineteenth- and twentieth-century conservation.[11] Frequently the debate hinges on whether the artist wanted his aging picture to acquire a patina and whether he planned his colors with an eye to their appearance when they were eventually covered with yellowed varnish. Along these same lines, it has also been suggested that some artists may have applied toned varnishes to mellow too-bright colors from the start. Since many of these arguably original toned varnishes have long ago been removed, whether they were really ever there to begin with becomes one of the imponderables of conservation theory. From our review of early Spanish literature, we can contribute little to clarify the question of planned changes in patina. Pacheco is aware that varnish darkens and regrets that change, advising that the canvases be "placed in the sun for half a day" as a remedy. But he also mentions that colors should be painted light in portraiture to compensate for the fact that the paint will

darken.[12] What one finds more frequently in the treatises are comments about color changes in the paints themselves, but a general comment is first in order.

Judging from Pacheco's remarks on the stability of paint layers, we can infer that he thought of a painting's life only in the very short term. Pacheco was a painter as well as a writer, as were all the early authors cited here. Speaking of imprimatura for canvases, Pacheco advised "earth from Seville" mixed with linseed oil, counselling:

> This is the best imprimatura and the one I would always use, without further modifications (_invenciones_), because I see my six canvases in the cloister of the Merced preserved without cracking or coming up since 1600 when they were begun, which is sufficient for me to approve and affirm the safety of this preparation of earth.[13]

If Pacheco's _Arte de la pintura_ was indeed finished in 1638, or even if he added this advice just before his death in 1644, his test period of 38 to 44 years hardly satisfies us today, when a painting made in 1600 has already survived more than 375 years. And this issue leads back to the question of patina. If an artist wanted his works to darken, did he want them to continue to darken into infinity? Or did he have in mind only a limited degree of darkening? And can we assume that even the artist who mixed his own recipes could predict the rate of change in oil and resin with precision? The questions are empty, for whatever the artist's wish may have been, he never had the power to ensure its gratification. These issues are raised not in order to answer them, but to point out that firm answers are not readily available. Planned patina, like intended hue, tone, or surface, is yet another element that defies precise modern definition.

In the end, almost all Spanish writers acknowledge that colors will change. But the author-painters are optimistic. Whether it is Pacheco advising how to keep pinks from fading[14] or García Hidalgo warning that azurite can turn green or black,[15] or Palomino descrying "_colores falsos,_"[16] they are all confident that the painter can do battle with time and emerge victorious. It is simply a matter of knowledge and skill, of underpainting flighty lakes with sturdy vermilions,[17] of substituting walnut oil for linseed,[18] of exiling false colors from the palette and replacing them with true ones.[19] Such a positive outlook is hardly surprising in view of the brief future that the authors addressed. It takes a long look, far beyond thirty-eight or forty-four years, to produce a 1983 statement by a conservation scientist: "The fading of pigmented paints is ubiquitous. It is only a matter of time."[20]

APPENDIX III

Pigments Identified in the Samples
from the Velázquez Paintings

For each painting, the powdered paint samples and the cross sections are described separately. Sample numbers correspond to those shown in figures 6, 13, 22, 33, 39, 41, and 54.

Identification of the pigments in the powdered samples is based on polarizing microscopy, X-ray powder diffraction, and X-ray fluorescence analysis in a scanning electron microscope or electron beam microprobe. X-ray fluorescence analysis of small portions of the samples identified elements of atomic number 11 (sodium) and above. Individual pigment grains as small as a few micrometers can be analyzed by this technique. X-ray diffraction permits the identification of major and minor crystalline phases in a sample. This technique was used to estimate the relative amounts of cerussite and hydrocerussite in the lead whites in a number of samples. (In the samples thus analyzed, the approximate percentage of hydrocerussite by weight is given in parentheses following "lead white".)

The identifications given below are based on a combination of the three techniques. Occasionally, other techniques were also used, as have been noted in the text. For each powdered sample, pigments are listed in order of abundance, from most to least abundant. Pigments present in small quantities (perhaps only a grain or two in a given microscope slide) are given in parentheses. These minor phases were generally identified by microscopy only, and thus should be regarded as tentative.

Cross sections were examined by reflected light microscopy and by X-ray fluorescence in the scanning electron microscope or microprobe. Individual paint layers and particles within these layers can be analyzed at magnifications of up to one-hundred-thousand times with these instruments. Pigments in the layers were identified by a combination of their appearance in reflected light and the elemental analyses.

TABLE 1. SUMMARY OF PIGMENTS IDENTIFIED IN THE VELÁZQUEZ PAINTINGS

		Philip IV Standing	Bust of Philip IV	The Forge of Vulcan	Surrender of Breda	Coronation of the Virgin	The Dwarf	Las Meninas
No. of samples examined		6	10	20	22	2	7	10
Blue	Lapis lazuli	x						x
	Azurite			x	x	x	x	x
	Smalt			x			x	x
Green	Mixed greens		x	x				
Yellow	Lead-tin yellow	x		x	x			
Red	Vermilion or cinnabar	x	x	x			x	x
	Red lake(s)	x	x	x	x		x	x
Black	Charcoal and/or bone blacks	x	x	x	x		x	x
Purple	Mixed purple (lapis lazuli and red lake)					x		
Earth colors	Green earth			x	x			
	Umber/brown ochre			x	x		x	x
	Yellow ochre(s)	x	x	x	x		x	x
	Red ochre(s)	x	x	x	x		x	x
Brown	Organic brown (VanDyke brown?)				x			
White	Lead white	x	x	x	x	x	x	x

CORONATION OF THE VIRGIN (PRADO NO. 1168)

Sample No.	Description	Pigments
1168–1	Blue, Mary's robe	Lead white Lapis lazuli (Calcite)
1168–2	Purple, robe of saint at right	Red lake Lapis lazuli Lead white (H 40–60%) Calcite Gypsum

THE FORGE OF VULCAN (PRADO NO. 1171)

Sample No.	Description	Pigments
1171–3	Blue-green, shoelace of right shoe of Apollo (piece 1)	Azurite Yellow orchre Red lake Calcite (Lead white)
1171–4	Orange-brown, robe of Apollo near his right foot (piece 1)	Lead-tin yellow Tin oxide Lead white Calcite Red lake (Yellow ochre)
1171–5	Flesh color, left foot of man to right of Vulcan (piece 1)	Lead white Yellow ochre Calcite (Red lake) (Bone black) (Azurite) (Vermilion?)
1171–6	Red-orange, sheet of heated metal (piece 1)	Vermilion Lead white (Calcite) (Red lake)
1171–9	Blue-gray, sky from left-most added strip (piece 4)	Lead white Calcite Charcoal/bone black Smalt (Yellow-brown ochre) (Ultramarine blue)
1171–10	Blue, sky, second (inner) added strip at left side of painting (piece 2)	Lead white Smalt Ultramarine blue (Calcite) (Bone black) (Yellow ochre)
1171–11	Blue, sky, central piece of canvas, to left to Apollo's head (piece 1)	Smalt Lead white (Charcoal/bone black) (Yellow ochre) (Calcite)
1171–7	Greenish gray, loincloth of figure at far right (piece 1)	Charcoal/bone black Lead white Green earth Yellow ochre Calcite (Vermilion)
1171–12	Blue-green, leaf of Apollo's wreath (piece 1)	Azurite Yellow lake (on calcite substrate) Lead white Yellow ochre

FORGE OF VULCAN (PRADO NO. 1171)

Sample No.	Description	Layers
1171–1XS	Ground plane, left strip of canvas (piece 4)	(uppermost layer or layers missing) 3. Intermediate grayish layer (lead white, appreciable calcite, occasional dolomite, some black) 2. Orange-brown ground (red/brown ochre, some lead white?) 1. Whitish ground (lead white, some calcite, some ochre)
1171–2XS	Ground plane, inner strip of canvas at left (piece 2)	4. Thin black glaze (restoration?) 3. White layer (lead white, gypsum), possibly fill? 2. Thin orange ground (lead white, ochre) 1. White priming (lead white, traces of calcite and ochre)
1171–8XS	Loincloth of figure at far right (piece 1)	4. Black layer (bone black and some ochre) 3. Very thin greenish-gray layer 2. Tan-gray layer (lead white, ochre, some calcite) 1. Light gray layer (lead white, calcite, ochre) (Ground missing?)
1171–9XS	Sky, left strip of canvas (piece 4)	5. Thin medium-rich glaze (containing ultramarine blue) 4. Gray layer (lead white and possibly some smalt) 3. Light gray layer (lead white, black, abundant calcite and occasional dolomite) 2. Orange-red ground (red ochre, some lead white) 1. 'Sizing' (contains some calcite) and canvas
1171–10XS	Sky, inner strip of canvas at left (piece 2)	4+. Very thin layer or layers, containing some ultramarine blue 3. Pale blue-gray layer (lead white and smalt) 2. Gray layer (lead white, black, some calcite) 1. Trace of warm brown layer (ground?)
1171–11XS	Sky to left of Apollo's head (piece 1)	3. Pale blue layer (lead white and smalt) 2. Pale orange-brown ground layer (lead white and red ochre and/or umber) 1. Gray ground layer (lead white with some black)
1171–13XS	Apollo's robe, inner strip of canvas at left (piece 2)	5. Varnish 4. Brownish layer (calcite, lead white, red/brown ochre, rare red lake particles) 3. Grayish beige layer (lead white, calcite, ochre, carbon black) 2. Gray ground (lead white, calcite, ochre, charcoal black) 1. Sizing? (contains some pieces of calcite)
1171–14XS	Apollo's robe (piece 1)	4. Varnish 3. Discontinuous white layer 2. Brownish orange layer (lead white, ochres, occasional red lake particles) 1. Gray ground (lead white, carbon black)

1171–15XS Apollo's wreath
(piece 1)

3. Green layer (lead white, azurite, yellow lake)
2. Gray layer (lead white and smalt)
1. Gray ground (lead white, charcoal black, ochre, calcite)

1171–16XS Loincloth of figure at right, right added strip of canvas (piece 3)

4. Discontinuous gray layer
3. Brownish gray layer (calcite, lead white, ochre, bone black)
2. Gray ground (lead white, calcite, carbon black, ochre, occasional azurite particles)
1. Sizing? (contains some pieces of calcite and glass or quartz)

1171–17XS Loincloth of figure at right (piece 1)

5. Grayish green layer (lead white, calcite, bone black, azurite, ochre, possibly yellow lake)
4. Beige layer (lead white, brown ochre or umber)
3. Flesh colored layer (lead white, ochre, occasional azurite particles)
2. Gray ground (lead white, calcite, pale smalt, carbon black)
1. Sizing?

1171–18XS Foot of figure at right (piece 1)

2. Flesh colored layer (lead white, ochres, carbon black, red lake)
1. Gray ground (lead white, carbon black)

1171–19XS Loincloth of figure to right of Vulcan (piece 1)

5. Varnish
4. Yellow layer brushed into an underlying brownish yellow layer (lead white, yellow ochre)
3. Thin gray layer
2. Greenish-gray layer (lead white, calcite, azurite, ochre)
1. Gray ground (lead white, calcite, charcoal black, pale smalt)

1171–20XS Ground plane, left strip of canvas (piece 4)

6. Varnish
5. Gray layer (lead white, orange-brown ochre)
4. Thin dark layer (dirt or varnish?)
3. Gray layer (lead white, calcite, dolomite)
2. Thin orange-red ground (ochre)
1. Sizing? (contains some calcite)

THE SURRENDER OF BREDA (PRADO NO. 1172)

Sample No.	Description	Pigments
1172–1	White, ground from top edge	Lead white (H 40–60%) (Calcite)
1172–2	Blue, sky, top tacking edge	Lead white Azurite (Charcoal/bone black) (Red ochre) (Calcite)
1172–3	White, ground from top tacking edge	Lead white (H 60–80%) (Calcite)
1172–4	Green, vegetation, lower edge near right corner	Lead white Azurite Yellow lake (on calcite substrate?) (Yellow/red ochres) (Charcoal/bone black) (Calcite) (Vermilion)
1172–5	Blue-green, sash of boy dressed in white coat next to horse at the left	Azurite Lead white
1172–6	Brown, right pant leg of uniform of Dutch official with keys	Bone black Yellow-brown ochre Lead white Calcite (Red lake)
1172–7	Brick red, right pant leg of Spínola, near top of boot	Lead white Red/yellow ochres Charcoal/bone black Calcite (Red lake) (Azurite) (Pale smalt or glass?)
1172–8	Red, sash of Spinola	Red lake (on K/Al/S substrate?) (Yellow ochre) (Bone black) (Calcite)
1172–9	Yellow-brown, decoration at bottom of Spínola's red sash	Lead white (H 40–60%) Yellow ochre (Calcite) (Charcoal/bone black) (Azurite) (Red lake)
1172–10	White, collar of man at far right edge of painting	Lead white (Calcite) (Quartz?)
1172–11	Orange, top of left boot of turquise-dressed man at left	Lead white Yellow/red ochres (Calcite)

		(Quartz)
		(Charcoal/bone black)
1172–12	Brown, boot heel of beige-coated man at left facing away	Yellow ochre
		Charcoal/bone black
		Lead white (H 40–60%)
		Gypsum
		(Red-brown ochre)
		(Red lake)
		(Calcite)
1172–13	Brown, vegetation near foot of beige-coated figure at left facing away	Lead white (H 40–60%)
		Charcoal/bone black
		Brown ochre or umber
		Calcite
		Gypsum
		(Red lake)
		(Azurite)
1172–15	Black, mane of horse at left	Bone black
		(Organic brown?)
1172–16	Green, clump of vegetation below Spinola's right foot	Lead white
		Red/yellow ochres
		Calcite
		Green earth
		(Azurite)
		(Charcoal/bone black)

SURRENDER OF BREDA (PRADO NO. 1172)

Sample No.	Description	Layers
1172–14XS	Sky, near horizontal seam in canvas	2. Blue layer (lead white and azurite) 1. Nearly white ground (lead white, with some black and ochre perhaps intermixed)
1172–17XS	Brown-green ground, right edge	6. Varnish 5. Pale orange-brown layer (clay-rich ochre and gypsum) 4. Blue-green layer (lead-white, calcite, azurite, yellow ochre) 3. Gray layer, indistinctly separated from (4) 2. Gray-beige layer (lead-white, calcite, ochre) 1. Grayish ground (lead white, charcoal black)
1172–18XS	Reddish-brown pant leg, figure at left	6. Varnish 5. Discontinuous red-brown layer 4. Discontinuous light red-brown layer 3. Warm beige layer 2. Beige layer, slightly redder than (3), into which it merges 1. Grayish ground (lead white, charcoal black)
1172–19XS	Brown-green ground, near right edge	5. Varnish 4. Discontinuous orange-brown layer 3. Discontinuous grayish-brown layer 2. Discontinuous grayish-brown layer, slightly darker than (3) 1. Grayish ground (lead white, charcoal black)
1172–20XS	Ground plane, near boot of soldier at left	2. Orange-gray layer (possibly more than one layer of nearly the same color) 1. Gray ground (lead white, charcoal black)
1172–21XS	Horse's hoof, near right edge	3. Varnish 2. Gray layer, overlain by a slightly lighter warm brownish-gray layer with which it merges 1. Gray ground (lead white, charcoal black)
1172–22XS	Blue uniform of soldier at left	3. Blue layer (lead white, azurite, glass or quartz, clay) 2. Beige-gray layer (lead white, ochre, glass or quartz) 1. Gray ground (lead white, charcoal black)

LAS MENINAS (PRADO NO. 1174)

Sample No.	Description	Pigments
1174–1	Blue-green, dress of dwarf at right	Azurite Lead white Lapis lazuli Charcoal/bone black
1174–2	Red, left stocking of boy at far right	Lead white Vermilion Red lake (Calcite) (Charcoal/bone black)
1174–3	White, collar of boy at far right	Lead white (H 80%)
1174–4	Flesh color, left hand of boy at far right	Lead white (H 60–80%) (Charcoal/bone black) (Calcite) (Pale smalt or glass) (Red lake) (Vermilion) (Yellow ochre)
1174–5	Black, cuff of right sleeve of lady-in-waiting to left of Margarita	Lead white (H 60–80%) Charcoal/bone black (Calcite) (Azurite)
1174–6	Green-blue, dress of lady-in-waiting to left of Margarita	Lead white (H 60%) Azurite Yellow ochre Charcoal/bone black (Calcite) (Smalt)
1174–7	Light brown, stretcher support of Velázquez' canvas, near lower left corner	Lead white (H 40–60%) Yellow ochre Charcoal/bone black Calcite (Smalt) (Red ochre or vermilion?)
1174–8	Light brown, floor near lower left corner	Lead white Charcoal/bone black Yellow ochre Calcite (Red ochre)

LAS MENINAS (PRADO NO. 1174)

Sample No.	Description	Layers
1174–8XS	Ground plane, lower left corner	4. Pale pinkish-gray layer 3. Thin, discontinuous brownish-black layer 2. White layer, possibly overlain at points by a pale brown layer 1. Very pale warm gray ground layer (lead white, some scattered ochre and black)
1174–9XS	Velázquez's coat, above palette	3. Black layer 2. Beige ground layer (lead white, some ochre and calcite, possibly some glass or pale smalt?) 1. Sizing?
1174–10XS	Upper background, right edge	5. Brown layer (lead white, brown ochre or umber, red ochre?) 4. Gray layer (lead white, charcoal black) 3. Pale gray layer (lead white) 2. Beige ground (lead white, brown ochre or umber) 1. Sizing? (contains some calcite, bone black, and clay or ochre)

PHILIP IV, STANDING PORTRAIT (PRADO NO. 1182)

Sample No.	*Description*	*Pigments*
1182–4	Flesh color, Philip's proper right hand	Lead white (Yellow ochre) (Red lake) (Vermilion) (Azurite?) (Charcoal/bone black) (Calcite)
1182–5	Yellow, "Order of Golden Fleece" hanging from Philip's neck	Lead-tin yellow Tin oxide Lead white (Calcite)
1182–6	White, letter in Philip's proper right hand	Lead white (Calcite) (Red lake) (Charcoal/bone black) (Red/yellow ochre)

PHILIP IV, STANDING PORTRAIT (PRADO NO. 1182)

Sample No.	Description	Layers
1182–1XS	Red stripe on tablecloth, right tacking edge	4. Thin brownish layer 3. Deep translucent red layer (primarily red lake on Al substrate; some calcite) 2. Orange-red ground (red ochre) 1. Grayish sizing(?), containing calcite
1182–2XS	Red tablecloth, right tacking edge	5. Thin deep red lake glaze 4. Pinkish-gray layer (lead white, red lake, calcite, and ochre) 3. Light pink layer (lead white, red lake, and calcite) 2. Orange-red ground (red ochre) 1. Sizing
1182–3XS	Black hat, right tacking edge	4. and 3. Thin black layers, the uppermost present only at right side of cross-section 2. Orange-red ground (red ochre) 1. Sizing
1182–4XS	Philip's right hand	4. Flesh tone (lead white, red lake, and red ochre(?); a few blue and black particles) 3. Thin black layer 2. Thin dark brownish-gray layer 1. Light warm gray layer (lead white, scattered red lake, ochre, and blue particles), Philip's hand from earlier version? (ground missing)

BUST OF PHILIP IV (PRADO NO. 1183)

Sample No.	Description	Pigments
1183–1	Brown-black, upper layer from background, left edge near top of painting	Yellow-brown ochre (Lead white) (Calcite) (Red ochre) (Red lake) (Charcoal/bone black) (Azurite?)
1183–3	Red-orange ground, left tacking edge	Red ochre (Lead white) (Red lake) (Charcoal/bone black)
1183–4	Red sash, left tacking edge	Red lake Red ochre Charcoal/bone black (Lead white) (Yellow ochre)
1183–5		TLC: probably cochineal
1183–6	Brown-yellow, armor of Philip's proper right arm	Lead-tin yellow Tin oxide Calcite (Lead white) (Charcoal/bone black)
1183–7	Pale yellow, highlight on armor on Philip's proper right arm	Lead-tin yellow Calcite Lead white (Yellow ochre?)

BUST OF PHILIP IV (PRADO NO. 1183)

Sample No.	Description	Layers
1183–2XS	Background, upper edge	6. One or two thin grayish layers, separated occasionally by dark brown lines 5. Traces of thin dark brownish layer 4. Pale brownish-gray layer (lead white, calcite, and ochre) 3. White layer (primarily lead white) 2. Thin grayish-brown layer 1. Orange-red ground (red ochre)
1183–3XS	Background, left tacking edge	3. Grayish-brown layer (lead white, black, some calcite and ochre) 2. Orange-red ground (red ochre) 1. Medium-rich sizing(?), containing some calcite
1183–4XS	Red sash, left tacking edge	5. Thin red lake glaze 4. Pink layer (lead white and red lake, possibly on a K/Al/S substrate) 3. Gray layer (lead white, black, and calcite) 2. Orange-red ground (red ochre), overlain by traces(?) of a very thin dark red-brown layer 1. Grayish sizing(?), containing some calcite and ochre
1183–8XS	Background, right tacking edge	5. Varnish 4. Dark gray layer (lead white, charcoal black) 3. Slightly lighter gray layer (lead white, charcoal black) 2. Orange-red ground (red ochre) 1. Trace of grayish sizing?
1183–9XS	Red sash, Philip's chest	5. Thin red glaze (red lake on Al/S-containing substrate) 4. Pink layer (lead white, red lake, calcite) 3. White layer (predominantly lead white) 2. Orange-red ground (red ochre) 1. Trace of grayish sizing?
1183–10XS	Red sash, left tacking edge	5. Trace of thin brown and/or varnish 4. Red layer (red lake in matrix of lead white) 3. Fine-grained brown-black layer, with scattered red lake particles 2. Orange-red ground (red ochre) 1. Grayish sizing (?), containing some calcite and charcoal black
1183–11XS	Flesh tone, Philip's neck	3. White layer (primarily lead white), representing flesh color of upper image 2. Pink layer (lead white with scattered red and black particles), overlain by traces of a thin line of varnish (?) or dirt; represents flesh color of earlier image 1. Orange-red ground (red ochre)

THE DWARF (PRADO NO. 1201)

Sample No.	Description	Pigments
1201–1	Brown-yellow, from ground, right edge near lower corner	Lead white Brown ochre or umber Charcoal/bone black Calcite Quartz
1201–2	White, page of book, right tacking edge	Lead white (H 40–60%) Calcite Charcoal/bone black (Red lake) (Yellow ochre) (Pale smalt or glass?)
1201–3	Blue, sky, right edge	Lead white Smalt (Calcite) (Red lake) (Azurite) (Red/yellow ochres)
1201–4	Blue, sky near top edge, right of center	Smalt Lead white Charcoal/bone black (Red lake) (Red ochre) (Calcite)
1201–5	Flesh color, right ear of dwarf	Lead white (H 40–60%) Smalt Red lake Bone black Vermilion Calcite
1201–6	Blue-gray sky, near left edge	Smalt Charcoal/bone black Lead white (Azurite)
1201–7	Blue, sky, left tacking edge	Lead white Smalt (Red ochre or vermilion) (Yellow/brown ochre) (Charcoal/bone black)

THE DWARF (PRADO NO. 1201)

Sample No.	*Description*	*Layers*
1201–3XS	Sky, right tacking edge	5. Pale blue layer (smalt and lead white)
		4. White layer (predominantly lead white)
		3. Blue layer (smalt and lead white)
		2. Warm pale pinkish-brown upper ground layer (lead white, some ochre, some red lake)
		1. Pale brown lower ground layer (lead white, some ochre or umber)

SUMMARY OF INFRARED PROCEDURES
USED AT THE PRADO MUSEUM

*T*he infrared examination of these paintings was limited to near infrared photography with conventional equipment and materials. To achieve the highest possible image quality, the photographs were made with an 8″ × 10″ format Deardorf camera equipped with a 12″ Ilex f:6.3 lens. The film used was Eastman Kodak High Speed Infrared Type 4143. The film, boxed in its original containers, was packed into the steel tanks in which it was eventually processed to avoid the possibility of inadvertent X-ray fogging at airports. The film was kept frozen until the day of departure to minimize possible environmental fogging. The film was transported to Spain, along with the rest of the photographic equipment. A darkroom to process the film was generously provided by the Prado.

The photographs were made through a Wratten 87C filter whose transmission starts at about 800 nanometers. Since the film has a useful sensitivity which extends to about 900 nanometers, the combination of film/filter used indicates that the photographic response in the infrared records is limited to a wavelength band extending from 800 to 900 nanometers. Therefore, "crosstalk" between photographic effects due to visible light and those created purely by near infrared radiation was reduced to negligible proportions.

Exposure was originally determined by trial, but after the initial test the level of infrared was duplicated from day to day by setting up the lights to achieve the same incident infrared reading as had been established for the test with a Gossen Luna Pro light meter, the photocell of which had been covered with an 87C filter material. Thus, although the setups varied somewhat, it was possible by this means to reproduce absolute infrared intensity and to ensure that a standardized exposure would yield good negatives without further trials.

The lighting was usually provided by four Osram 500 watt photoflood lights, which were generally located about 12 to 15 feet from each corner of the painting. This level of tungsten lighting provided sufficient illumination to make proper exposures at an aperture of f:16 and a time of 4 seconds. When photographing details the lights were moved as close as 8 feet from the surface and the exposure was adjusted accordingly.

Because there was an inherent shift in focus due to imaging by infrared radiation, to ensure that the negatives would be sharp, the position of the camera back was moved away from the lens approximately 0.5 percent of the distance between the lens

and the film after visual focus was judged accurate. Since the adjustment in lens-to-film distance could not be precisely controlled, apertures of f:16 and f:22 were consistently used to ensure extended depth-of-field, thus minimizing the need for precision in the focus adjustment step.

The processing of the film was done in deep steel tanks capable of handling six sheets of film at a time. To produce negatives with slightly higher than normal contrast, and with low stain while still retaining a high level of acutance, the developer used was Agfa Rodinal at a dilution of 1:25 at 20°C for a processing time of fourteen minutes with intermittent agitation at one minute intervals. To insure uniformity of processing, the developer was used only once and discarded. Since Rodinal is a liquid concentrate, mixing of fresh developer solution for each processing run was not a problem. Further processing steps were standard.

In summary, the basic procedures used were those described in the Eastman Kodak pamphlet number M–28, entitled "Applied Infrared Photography," 1977 edition, 1981 printing, Library of Congress Catalogue number 81–65754, which covers the theory and applications of the technique.

Andrew Davidhazy

NOTES

INTRODUCTION

1. For reproductions of the radiographs made by the Swedish team see López-Rey, 1963.
2. This radiograph was made by María del Carmen Garrido and José María Cabrera. It is discussed in Garrido, Cabrera, McKim-Smith, and Newman, 1983.

CHAPTER 1: WRITING AND PAINTING

1. Ideas in this chapter appeared in Garrido, Cabrera, McKim-Smith, and Newman, 1983. For *El Arte de la Pintura* by Francisco Pacheco (Seville, 1649), see the edition by Sánchez Cantón (Madrid, 1956). For *Diálogos de la pintura* by Vincencio Carducho (Madrid, 1633), see Calvo Serraller (Madrid, 1979). For *El Museo Pictórico y Escala Optica* by Antonio de Palomino de Castro y Velasco (Madrid, 1715–24) see the Aguilar edition (Madrid, 1947). Recent studies relevant to the material contained in this chapter are: Fernando García Salinero, *Léxico de alarifes* (Madrid, 1968); Juan Antonio Gaya Nuño, *Historia de la crítica de arte en España* (Madrid, 1975), pp. 33–58, 91–138; F.J. León Telló and M. M. V. Sanz Sanz, *La teoría española en la pintura en el siglo XVIII; el tratado de Palomino* (Valencia, 1979); Francisco Calvo Serraller, *Teoría de la Pintura del Siglo de Oro* (Madrid, 1981). General information on Spanish treatises can be found in the Spanish edition of Julius Schlosser, *La literatura artística* (Madrid, 1976), tr. and ed. by A. Bonet Correa, who adds bibliography on each writer.
2. See Lee, 1967; Blunt, 1940; Baxandall, 1971; Summers, 1981.
3. See Lee, 1967; Summers, 1981; Rosand, 1970; Rosand, 1982b.
4. *Philip IV Standing* (no. 1182); *Bust of Philip IV* (no. 1183); *Forge of Vulcan* (no. 1171); *Surrender of Breda* (no. 1172); *Portrait of a Dwarf (El Primo Don Diego de Acedo,* no. 1201); *Las Meninas* (no. 1174); *Coronation of the Virgin* (no. 1168).
5. Isolated samples from paintings executed during the seventeenth century have been published as part of broader studies. In these samples the following pigments have been identified. For *whites,* lead white; for *reds and oranges,* red lake ("madder," alizarin, or of unspecified origin), red ochre, vermilion; for *yellows,* lead-tin yellow, massicot, yellow ochre, raw Sienna; for *blues,* ultramarine, azurite, smalt; for *greens,* verdigris, mixed green of azurite and lead-tin yellow; for *blacks,* bone black and carbon black; for *browns,* brown ochre, umber. The studies summarized here are: Laurie, 1967, p. 150 (lead white in Velázquez's *Rokeby Venus*); Plesters, 1966, p. 75 (ultramarine, azurite and smalt in the *Rokeby Venus*); Kühn, "Lead-tin yellow," 1968a, p. 26 (lead-tin yellow in the *Immaculate Conception* by Antolínez); P. Hendy and A. S. Lucas, 1968, p. 262 (ochre, lead white, and red lead in the *St. Margaret* by Zurbarán, and lead white in the *Rokeby Venus* by Velázquez); Mühlethaler and Thissen, 1969, pp. 54–56 (smalt in the *Adoration of the Shepherds* by an anonymous Sevillian painter of the seventeenth century, in the *Rokeby Venus* by Velázquez, and in the *Immaculate Conception* by Antolínez); Plesters, 1969, pp. 62–74 (smalt in the *Adoration of the Shepherds* by an anonymous Sevillian painter of the seventeenth century and in the *Rokeby Venus* by Velázquez); Kühn, 1970, p. 28 (verdigris and lead white in *St. Peter Alcántara* by Coello); Gettens, Feller, and Chase, 1972, p. 64 (vermilion in *St. Margaret* by Zurbarán); Hours and Rioux, 1978, p. 105 (iron oxide, smalt, and lead white in the *Young Beggar* by Murillo); Véliz, 1981, p. 278 (lead white, carbon black, azurite, vermilion, madder, red lake, lead-tin yellow, massicot, raw Sienna, yellow ochre, and umber in the *Holy House of Nazareth* by Zurbarán); Jordan, 1981, pp. 378–79

(vermilion, alizarin, lead white in *Pedro de Barberana* by Velázquez); von Sonnenburg, 1982, pp. 19–20 (azurite, lead white, lead-tin yellow, yellowish-brown ochre, red lake in *Two Boys Eating Melon and Grapes* by Murillo; verdigris, lead-tin yellow, lead white in *Two Boys Eating a Pastry* by Murillo; smalt, lead white, carbon black or bone black, red lake, vermilion, carbon black, lead-tin yellow, verdigris, and brown ochre in *Boys Playing Dice* by Murillo; ultramarine, smalt, lead white, yellow ochre, lead-tin yellow, red ochre, and vermilion in the *Immaculate Conception* by Antolínez); Harris and Lank, 1983, p. 415 (calcium sulphate, red ochre, carbon black, ultramarine, bone black, and vermilion in *Camillo Massimi* by Velázquez). We have not included our own work with Garrido, 1983; nor that published by Mena, 1984 nor Garrido, 1986.

6. Hidalgo Brinquis, 1978. We are grateful for her generosity in sharing her unpublished material.

7. Studies of additional paintings in the Prado were carried out from 1984–86 in collaboration with María del Carmen Garrido; these studies will be published by the Prado Museum.

8. Von Sonnenburg, 1982.

9. We would like to thank Barbara Miller of the Analytical Laboratory of the National Gallery in Washington for having made available her unpublished analysis of the *Girl and Her Duenna* by Murillo.

10. Véliz, 1981.

11. We did not find verdigris or malachite in the paintings we analyzed. Possibly verdigris will be found in future analyses of paintings by Velázquez, for Pacheco mentions using it himself, although he has reservations about it (1956, vol. 2, p. 82). In the second half of the seventeenth century, verdigris was used by Murillo and Coello (see n. 5). Malachite and red lead have been found in paintings by El Greco, but one must keep in mind that El Greco learned his colors in Italy in the sixteenth century. Malachite was found in the polychromed drapery of the *Virgin of las Angustias* by Juan de Juni (see Recchiuto, 1972, p. 13). Gettens and FitzHugh, 1974, pp. 2–23, did not find malachite in any Spanish painting.

12. The *terminus ante quem* of 1644 is established by the painting's appearance in the inventory of Queen Isabella, who died in that year; see Pérez Sánchez, 1965, p. 114. For recent research involving the *Coronation of the Virgin*, see Gérard, 1983, p. 283. We are grateful to Steven N. Orso for pointing out the relevance of Gérard's work and for discussing his own research, later published in 1984.

13. See Brown, 1986, pp. 275–77. His stylistic sense is acute, though whether Don Diego in Prado 1201 is "*rebestido de Philosopho*" is uncertain.

14. See McKim-Smith, 1979.

15. Menéndez y Pelayo, 1940; Sánchez Cantón (in Pacheco, vol. 1, 1956, pp. vii–xxxvi); Brown, 1978, pp. 21–83; and Calvo Serraller (in Carducho, 1979), discuss the treatises' debt to earlier works. Hidalgo Brinquis, 1978, pp. 14–28, also emphasizes Pacheco's debt to previous literature.

16. We translate Pacheco's *albayalde* as lead white; *almagra* or *barro de Sevilla* as red and brownish-gray ochre; *bermellón* as vermilion; *carmín* as red lake; *ancorca* as yellow lake; *genuli* as lead-tin yellow; *ocre* as yellow ochre; *cenizas* as azurite; *esmalte* as smalt; *ultramarino* or *ultramaro* as ultramarine; *negro de carbón* and *negro de humo* as carbon black; *negro de hueso* as bone black; *sombra* as umber; *espalto* as Van Dyck brown. For our reasoning on these translations, see Appendix I.

In the past, scholars have tended to assume that Pacheco's list of colors would be found in his son-in-law's paintings. See, for example, Baticle, 1961, pp. 115–16.

17. We translate Carducho's *albayalde* as white lead; *almagra* or *tierra roja* as red ochre; *bermellón mineral y artificial* as vermilion; *carmín de Florencia de pelotilla* as red lake; *ancona* as yellow lake; *jenuli* as lead-tin yellow; *ocre* as yellow ochre; *azul cenizas de Sevilla* as azurite; *esmalte* and *esmaltines* as smalt; *azul ultramarino* as ultramarine; *negro de humo* as carbon black; *negro de hueso negro* as bone black; *sombra de Venecia* as umber; *espalto* as Van Dyck brown. For our reasoning on these translations, see Appendix I.

18. Pacheco, 1956, vol. 2, pp. 80–81, discusses orpiment. On pages 81–82, he describes lead-tin yellow (*genuli*).

19. Hidalgo Brinquis, 1978.

20. Von Sonnenburg, 1982; Véliz, 1981, p. 278. A small quantity of red lead was found in the ground

of *St. Margaret* by Zurbarán (Hendy and Lucas, 1968, p. 262). Pacheco advises using red lead as a drier; probably Zurbarán used it as a siccative, not as a pigment.

21. Theophilus, 1963, book III, chapter 21.

22. See Menéndez y Pelayo, 1940, vol. 2, pp. 384–87; Brown, 1978.

23. Carducho, 1979, p. 284: "El Escultor alega el valor de la material que obra . . . la Minerva de oro y marfil de Fidias . . . el Pintor se preciará del poco valor de la materia, como es un poco de angeo, y unas tierras, y unos pocos de azeites, blasón de su científica operacion tan intelectiva, e ingeniosa, que bastó por si a dar tan grande valor a sus obras . . . " See Pacheco, 1956, vol. 1, pp. 48, 449–50, and vol. 2, p. 107; Palomino, 1947, p. 500. Antonio de León, in his "Por la pintura, y su exemción de pagar alcavala," (in Carducho, *Diálogos*, 1633 edition, p. 173) says the "value of Painting, and its excellence, does not consist in the material, but in the form."

24. Palomino, 1947, p. 479: "algunas veces de ébano o brasil, pero éstas dos últimas sólo son para príncipes, y caballeros, o personas muy curiosas, que se precian de esmerarse en lo más primoroso de todos los recados del pintar."

25. Palomino, 1947, p. 500: "aquella tinta, que hiciere mejor el efecto, que se pretende, ésa será la mas legítima, y verdadera, aunque sea hecha con polvo de la calle."

26. See Menéndez y Pelayo, 1940, vol. 2, p. 402, and Gállego, 1976. Other essays on the subject include Curtius, 1953, pp. 559–83, Lafuente Ferrari, 1944; Kubler, 1965; Kahr, 1976; Volk, 1978; Brown, 1978, pp. 87–110; Calvo Serraller (in Carducho, 1979); Gaya Nuño, 1975; León Telló and Sanz Sanz, 1979; Calvo Serraller, 1981; Martín González, 1984, pp. 195–268.

27. Gutiérrez de los Ríos, 1600, pp. 15–16, 22: "Razón, reglas y estudio;" "una recopilación, y congregado de preceptos, y reglas, esperimentadas, que ordenadamente encaminan a algún fin y uso bueno." See also Juan de Butrón, 1626, who declares, under "ARTE" in his index, that "consta de principios ciertos."

28. Gutiérrez, 1600, p. 22.

29. Pacheco, 1956, vol. 2, p. 17. In his translation of Vitruvius, Miguel de Urrea comments on *almagre* when he describes the colors of *ocre;* see his book VII, chapter VII (Vitruvius 1582).

30. Pacheco, 1956, vol. 2, p. 36.

31. Carducho, 1979, p. 178.

32. Pacheco, 1956, vol. 1, p. 28. According to Francisco de Holanda, God also created lead white at the moment that he said, "Let there be light;" see de Holanda, 1921, p. 19: "Ansí, que dijo Dios, 'Hágase la luz' y el albayalde para esta obra fue hecho."

33. Pliny, *Historia Naturalis*, book XXXV and XXXVII. Vitruvius, book VII, chapters 7–14.

34. Pliny, *Historia Naturalis*, book XXXVII.

35. Pacheco, 1956, vol. 2, p. 17.

36. Pacheco, 1956, vol. 2, p. 17.

37. Pacheco, 1956, vol. 2, p. 18.

38. Guevara, 1788, p. 89: ". . . que se puede creer ser la verde tierra, que al presente usan."

39. See Calvo Serraller (in Carducho, 1979), for a discussion of Carducho's supposed adult trip to Italy.

40. Vasari, 1966, vol. 1, pp. 35–36.

41. Pacheco, 1956, vol. 2, pp. 75–76.

42. Pacheco, 1956, vol. 2, pp. 68–69; Pliny, *Historia Naturalis*, book XXV; Felipe de Guevara, 1788, p. 60, implies that encaustic is not used in Spanish painting when he says "Sería bueno atinase hoy a éste género, que podría servir para muchos usos."

43. Pacheco, 1956, vol. 2, p. 84: "ni se usa en España ni tienen los pintores della caudal para usarlo." "Caudal" can also mean "money."

44. Pacheco, 1956, vol. 2, p. 86: "Los azules bañados no los apruebo, si no es con ultramarino."

45. Cennino, 1932, p. 34: "colore nobile, bello, perfettissimo, oltre a tucti i colori."

46. Pacheco, 1956, vol. 2, pp. 84–87.

47. Pacheco, 1956, vol. 2, pp. 83–84.

48. Pacheco, 1956, vol. 2, p. 20: "works of lesser importance."

49. Pacheco, 1956, vol. 2, p. 80: "Suelen algunos valerse de jalde u oropimente para los amarillos finos a olio."

50. Pacheco, 1956, vol. 2, p. 82: "Yo gasto genuli (por buena suerte) que dexa atrás el color del mejor jalde en viveza y hermosura venciéndole en seguridad."

51. In Pacheco, 1956, vol. 2, *albayalde* or lead white is mentioned in the first person on pages 75–76, 79, 92, 82; *almagra* or *tierra roja* on page 78; *bermellón* or vermilion on pages 78, 83–84; *carmín* or red lake on page 83; *ancorca* or yellow lake on page 82; *genuli* or lead-tin yellow on page 82; *ocre* or yellow ochre on page 78; *azul* (*cenizas*) or azurite on pages 82, 86–87; *esmalte* or smalt on page 85; *ultramarino* on page 86; *negro de carbón* or *negro de humo* or carbon black on page 78; *negro de hueso* or bone black on page 78; *sombra* or umber on page 78; *espalto* or Van Dyck brown on page 78. Pacheco appears to mention indigo in the first person on page 17; in reality he is not describing his own practice, but is quoting from Pablo de Céspedes's statement, but the 1956 edition of Pacheco omits the quotation marks. For the text of Pablo de Céspedes's statement, see Ceán Bermúdez, 1800, vol. 5, p. 347. Verdigris is mentioned by Pacheco in the first person on page 82.

52. Kühn, 1970, p. 28; von Sonnenburg, 1982, p. 19.

53. Pacheco, 1956, vol. 2, pp. 74–75.

54. Véliz, 1981, p. 278; von Sonnenburg, 1982, p. 19.

55. Here we use *flamenco* in the sense of the Spanish of Velázquez's day, which described both the northern and southern Netherlands. Von Sonnenburg, 1982, p. 20, points out this resemblance between Spanish pigments and Netherlandish pigments.

56. De Vries, Tóth-Ubbens, and Froentjes, 1978, pp. 216–17. Gettens and FitzHugh, 1974, did not find malachite among baroque paintings from northern Europe. See n. 11.

57. B. B. Johnson, 1974, pp. 18–35.

58. De Vries, Tóth-Ubbens, and Froentjes, 1978, p. 215.

59. Another northern artist, Vermeer, like Velázquez, does use yellow lake; he is unlike Velázquez in using indigo and verdigris, and in not using Van Dyck brown. Kühn, 1968b, pp. 177–202.

60. Kühn, 1970. De Wild, 1929, had found a similar distribution of pigments to that reported by Kühn: De Wild did not find orpiment (pp. 55–56); he found indigo only in paintings by Pot and Hals (p. 31), but he did not find red lead (pp. 69–70). He pointed out the use of calcite (pp. 42–45) and of white grounds (pp. 42–50).

61. The literature on Rubens's pigments is summarized in Feller, 1973, pp. 54–74. Another recent study reports results similar to those described by Feller: Fisher, 1980–81.

62. Velázquez used a white ground in the *Surrender of Breda*. He also used one in the *Rokeby Venus*, as was noted by Laurie, 1949, pp. 121–24, and Hendy and Lucas, 1968, p. 262, no. 13; see also McKim-Smith, 1979. Netherlandish pictures are sometimes done on white grounds, or on double grounds combining a white layer with a colored layer. For Rubens, see G. Martin, 1970, appendix II, comments by Plesters, 1970, pp. 289–90; Feller, 1973, pp. 55–56; Coremans, 1948, pp. 257–61; Fisher, 1980–81, pp. 21–38. For the relationship between Rubens and Velázquez, see Salas, 1977; Pérez Sánchez, 1977, pp. 86–109. For the grounds of Rembrandt and Jan Davidsz de Heem, see Kühn, 1965, pp. 189–201; for the grounds of Vermeer, see Kühn, 1968b, pp. 177, 181, 195, 198, 202. Cross sections of the structure of the lower part of the *Surrender of Breda* show that that section seems to be a double ground of brown over white.

63. Pacheco's text makes it clear that he knew many humanists and their books. See Brown's excellent essay on Pacheco's academy, 1978, pp. 21–43. For the influence of antique traditions upon Italian art theory, see Alpers, 1960.

64. Palomino, 1947, pp. 488–89, 502–03.

65. In 1983 the *Coronation of the Virgin* was cleaned by Alfredo Piñeiro Garay. In 1984 *Las Meninas* was cleaned by John Brealey of the Metropolitan Museum of Art; see Mena Marqués, 1984.

66. Palomino, 1947, p. 496: "fácil, porque la color corre con más suavidad; y magisterioso, porque se maneja más libremente . . . y se deja golpear, y cargar cuanto se quiere, quedando jugoso, y lustroso . . . "

67. Palomino, 1947, p. 922.

68. See note 62.

69. McKim-Smith, 1979.

70. See Rosand's illuminating discussion, 1982b, pp. 1–39. For other discussions of the meaning of Titian's facture, see Rosand, 1971–72; Rosand, 1975; Rosand, 1981.

71. See Enrique Vaca de Alfaro, *Lyra de Melpómene,* Córdoba, 1666, quoted in *Varia velazqueña,* 1960, p. 37.

72. See figs. 2–5, 9–12, 15–20, 26–32, 35–38, 46–48.

73. Pérez Sánchez, 1976.

74. Pacheco, 1956, vol. 2, p. 154: "pintado con la manera del gran Ticiano y (si es lícito hablar así) no inferior a sus cabezas."

75. To complicate the relationship to Titian further, we also know that Mazo copied paintings by Titian so well that Palomino (1947, p. 962) says that in Italy his copies could pass for originals.

Perhaps due to Titian's and Velázquez's examples, pentimenti eventually were sufficiently accepted in practice to become something of a hallmark among Spanish painters who came within Velázquez's magical orbit. What was idiosyncratic in the master became orthodox in the imitator, and Velázquez's followers, such as Mazo, seem to have made creating pentimenti a fixed procedure. Mazo sometimes makes pentimenti even when copying an existing canvas, as when he plays with the profile of Marsyas in his *Apollo and Marsyas* after Jordaens (shown through infrared photographs made by Davidhazy in 1980, now in the archives of the Prado Museum).

76. Vargas's observation was published in 1881 by Crowe and Cavalcaselle, 1881, vol. 2, p. 329: "tan grandes como unas varillas de abedul." Shop rumors must have circulated in Spain, because the size of Titian's brush was commented on by more than one author; see note 77.

77. Cited in Menéndez y Pelayo, 1940, vol. 2, p. 203: "inventó aquel otro tan extraño, y subido de pintar a golpes de pincel grosero." The commentary of Fray Jerónimo is a variant of Antonio Pérez's observation, Carta XXXI, I, in Ribadeneyra, vol. 13, p. 515, quoted in Sánchez Cantón, 1941, vol. 5, p. 372.

78. Palomino, 1947, p. 913: "pintó con astas largas, y cor la manera valiente del gran Ticiano."

79. Vasari, *Le vite,* 1568, vol. 3, p. 815: "da presso non si possono vedere, e da lontano appariscono perfette." See also the discussion in Gombrich, 1972a, pp. 191–202.

80. Palomino, 1947, p. 905: "de cerca no se comprendía, y de lejos es un milagro."

81. Horace, *Ars Poetica,* lines 361–62: "Ut pictura poesis: erit quae, si propius stes, / te capiat magis, et quaedam, si longis abstes." Gombrich, 1972a, pp. 191–202, also notes that Palomino's comment derives from Vasari's, as does Harris, 1982a.

82. Baxandall, 1971, chapter 2.

83. Grassi, 1973, pp. 110–11, also notes this association.

84. Francisco de Quevedo died in 1645. His poem *Al Pincel* was unpublished at his death. In 1648 González de Salas published *El Parnaso español,* which was to have works from the nine divisions, corresponding to the nine muses, into which Quevedo had divided his poetry. Because of lack of space, the 1648 edition published poems to only six muses. Poems to the three remaining muses were not published until 1670, when Quevedo's nephew, Pedro Aldrete Quevedo Villegas, published them in an edition entitled *Las Tres musas últimas castellanas.* See Crosby, 1981, pp. 9–13, 521–23. Blecua, 1969, vol. 2, p. 403, notes to lines 85–90, points out that the passage referring to Velázquez is part of a variant version (*C*) of the autograph *El Pincel,* which is poem 205 in Blecua's anthology. The problem of attribution is extremely complex, and Blecua's own words explain it best: "La transmisión de este poema es una de las más curiosas y desconcertantes. El sobrino de Quevedo publicó, en primer lugar, una versión coherente, pero primitiva, como se verá, y después con el epígrafe *En alabanza de la pintura de algunos pintores españoles,* un fragmento que comienza en el verso 83 hasta el final, pero con la adición de numerosos versos que faltan en todos los demás textos. Los mss. presentan el poema ya reelaborado, pero B mantiene todas en lecciones coincidentes con C y D, que en algun caso han desaparecido ya en A. . . . " (p. 400, poema 205). Blecua regards the passage referring to Velázquez as "un embrión," a

rudimentary sketch or draft (p. 401). The version containing the verses quoted here was published in 1670 in *Las Tres musas últimas castellanas*, Madrid.

In the version now considered by Crosby and by Blecua to be the definitive reading of these lines in Quevedo's final poem (Blecua, 1969, vol. 2, pp. 403–04; Crosby, 1981, p. 529), lines 85 ff. substitute "Richi" [Rizi] for "Velázquez" and make other changes, eliminating the reference to *manchas, verdad en él*, and so forth. We are indebted to Leah Lerner of Fordham University for pointing out the attribution problem and referring us to the research of Blecua and Crosby.

85. Blecua, 1969, vol. 2, pp. 403–04, notes to lines 85–90. In its choice of words, Quevedo's silva touches upon more than just the *manchas distantes*, for it reveals the poet's familiarity with the full vocabulary of coloristic discourse. Quevedo's wording (*lo mórbido*, the manchas, the naturalistic rendering that was *verdad en él*, and the *relieve*) recalls not only Vasari's single remark about Titian's brushstrokes appearing perfect from a distance, but also that theorist's attention to *morbidezza, macchiar, cose vive e naturale, relievo*, and so forth within Titian's works. Of course the author of the silva need not have actually read Vasari to have mastered the vocabulary of colore. By the third decade of the seventeenth century in Spain that vocabularly was well disseminated, and such coloristic tags crop up continually in a variety of authors.

86. Uztarroz, *Obelisco histórico i honorario que la Imperial Ciudad de Zaragoza erigió a la inmortal memoria del Serenísimo Senor, Don Balthasar Carlos de Austria*, Zaragoza, 1646, pp. 108–09, quoted in Carducho, 1979, pp. 262–63, note 683: " . . . el primor consiste en pocas pinzeladas, obrar mucho, no porque las pocas, no cuesten, sino que se executen, con liberalidad, que el estudio parezca acaso, i no afectación. Este modo galantísimo haze oi famoso, Diego Velázquez . . . pues con sútil destreza, en pocas golpes, muestra quanto puedo el Arte, el desahogo, i la execución pronta."

87. *Vocabulario*, as quoted in Socrate, 1966, p. 27.

88. Covarrubias, 1611, 230 B 15: "la señal de tinta que cae sobre lo que se escrive, y por alusión lo mal hecho que escurece lo de más bueno que en un hombre puede aver."

89. *Biblioteca de autores españoles*, vol. 3, 1876, p. 117b: "Cómo Lazaro pleiteó contra su mujer;" "me aconsejaban como quien tan íntimo suyo, sácase las manchas y quítase el borrón de mi honra tornando por ella."

90. See Brown, 1982, p. 147, note 137; and Pérez Martín, 1961.

91. Pacheco, 1956, vol. 2, p. 79.

92. Pacheco, 1956, vol. 1, p. 14: "No es arte la que acaso llega a su efeto."

93. Lope de Vega, *La corona merecida*, 1923, pp. 111–12. We are grateful to Willard F. King for her advice on editions of this play.

94. Sigüenza, 1909, vol. 2, p. 563a: "que como las havía dado tanta fuerça para que relavassen de lexos, no serían tan apazibles mirándose de cerca."

95. Sigüenza, 1909, vol. 2, pp. 549 a–b: "En estos quatro lienços me parece a mi que siguió Juan Fernández su proprio natural y se dexó llevar del ingenio nativo, que se vee en labrar muy hermoso y acabado, para que se pudiese llegar a los ojos y gozar quan de cerca quisiessen, proprio gusto de los Españoles en la pintura. Parecióle no era éste camino de valientes y lo que el avía visto en Italia. . . . y ansí en los demás quadros no acabó tanto y puso más cuidado en dar fuerç a y relievo a lo que hazía imitando más la manera del Ticiano."

96. Carducho, 1979, pp. 261–63: "después con borrones hizo cosa admirables, y por este modo de bizarro y osado pintó después toda la Escuela Veneciana con tante licencia, que algunas pinturas de cerca apenas se dan a conocer, si bien apartandose a distancia conveniente se descubre con agradable vista el arte del que la hizo: y si este disfraz se haze con prudencia, y con la perspectiva cantitativa, luminosa, y colorida, tal, que se consiga por este medio lo que se pretende, no es de menor estimación, sino de mucho más que esotro lamido, y acabado . . . "

97. Carducho, 1979, p. 264. To make his exposition symmetrical, he specifies a few paragraphs later that *Pintura para de cerca* should work its colors *con unión y dulzura* (whereas *pintura para distancia* could have *colores desunidos*).

98. Carducho, 1979, p. 237: "Dibujo, entiende . . . es la perfección del Arte."

99. Carducho, 1979, pp. 245–49, 261–67.

100. Pacheco, 1956, vol. 1, p. 361: "Es alma y vida. . . . "

101. Pacheco, 1956, vol. 1, p. 478: "que la mayor parte de los pintores siguen lo contrario de lo que yo apruebo, y que lo que está en uso de tantos . . . tiene fuerza de ley."

102. Pacheco, 1956, vol. 1, p. 478: "la pintura a borrones, hecha para de lexos . . . tiene mayor fuerza y relievo que la acabada y suave."

103. Pacheco, 1956, vol. 1, pp. 479–80: "el que labra puede dar a su pintura toda la fuerza que quisiere, como se ve en las pinturas de Leonardo de Vinci, de Rafael de Urbino, que son acabadísimas."

104. Pacheco, 1956, vol. 1, p. 478: "Tambien ponen otra fortísima, que parece imposible impugnarla, con el exemplo de Ticiano . . . pues se tiene por adagio cuando la pintura no es acabada, llamarla 'borrones de Ticiano.' "

105. Pacheco, 1956, vol. 1, p. 480: "Esta parte tuvo Ticiano, como tan grande artífice, y sus borrones no se toman en el sentido que suenan, que mejor se dirían golpes dados en el lugar que conviene, con gran destreza."

106. Pacheco, 1956, vol. 1, p. 480: "Y adviértase, que sus mejores y más estimadas pinturas (que yo he visto en El Pardo y Escorial) son las más acabadas . . . "

107. Pacheco, 1956, vol. 1, p. 485. See the very useful article by Trimpi, 1973. We are grateful to Joy Thornton for pointing out the article. Pacheco, 1956, vol. 1, p. 485: "que hay poesías que son para de lexos, para oidas de paso y no consideradas; y otras, que el mayor exámen las engrandece más, por tener en sí mucho bueno que considerar; de manera que la pintura hecha para de cerca, porque sus partes sufren mayor prueba, es aquí más alabada del poeta, y comparada a la buena poesía con mucha razón."

108. Carducho, 1979, p. 266: "y esta pintura hecha por este modo, el indocto en el Arte, y poco esperimentado, le parecerá los perfiles, y proporciones llenos de sobreguesos, y desconcertados músculos, y el colorido lleno de borrones, y colores mal colocadas, y descompuestas, sin proporción ni arte: y así reparando en estas pinturas, y en sus efectos, ¿quien no conocerá, que las que están hechas con este docto artificio merecen más superior estimación que las otras, que con sólos perceptos comunes se hazen?"

109. Martínez, 1866, pp. 25–26: "Señor mío, no esperaba yo de sus manos obra tan basta, y poco concluida, pues todo es borrones. V. trate de ponerla en la perfección que yo esperaba"; "quedó maravillado de que la mejorara tanto en tan poco tiempo: los discípulos del tal maestro se le rieron mucho sabiendo no había retocada cosa alguna." For Vasari's comments on the art of Luca della Robbia, and for the relationship of Vasari's story to the more ancient tale of Phidias and Alcamenes, see Gombrich, 1972a, pp. 191–92.

110. Lope de Vega, *Silva*, in Carducho, 1979, p. 256.

111. Paravicino, 1640, folio 161: "Porque hablando del mundo, que en pluma del Apóstol 2 Cor. 7, es una pintura no más. *Praeterit figura huius mundi*. Ser la luz dél, no es ser solo la luz para que se vea, sino para que se mire, y con que se pueda juzgar. Que en las pinturas, saben los que desta cultura adolescen, que importa el mirarla a su luz, no solo para juzgarla, sino aun para verla. Pues no mirada a su luz una tabla de Ticiano, no es más que una batalla de borrones, un golpe de arreboles mal asombrados. Y vista a la luz que se pintó, es una admirable y valiente unión de colores, una animosa pintura, que aun sobre autos de vista de los ojos, pone pleytos a la verdad. *Ego sum lux mundi*, pues dize Jesu Christo desta pintura del mundo."

112. Blecua, 1969, vol. 1, pp. 403–04, notes to lines 85–90. See notes 84 and 85.

113. Uztarroz (1646), quoted in Carducho, 1979, pp. 262–63: see note 86.

114. Carducho, 1979, pp. 262–63. "y si este disfraz se haze con *prudencia*, y con la perspectiva *cantitativa*, luminosa, y colorida, tal, que se consiga por este medio lo que se pretende, no es de menor estimación, sino de mucho más que esotro lamido, y acabado" [italics added].

115. For the *non finito*, see Brunius, 1967; Schulz, 1975.

116. Carta LXXI in *Epistolario Español*, vol. 1, *Biblioteca de Autores Españoles*, vol 13, 1850, p. 519, "Preguntábale un día el embajador Francisco de Vargas por qué había dado en aquella manera de pintar . . . de golpes de pincel groseros, casi como borrones al descuido . . . y no con la dulzura del

pincel de los raros de su tiempo; respondió el Ticiano: Señor, yo desconfié de llegar a la delicadeza y primor del pincel de Micael Angelo, Urbino, Coreggio y Parmesano, y que cuando bien llegase, sería estimado tras ellos, o tenido por imitador dellos . . . "

117. Jerónimo de San José, 1768, p. 83: "Cansado el Ticiano del ordinario mode de pintar a lo dulce y sútil, inventó aquel otro tan estraño, y subido de pintar a golpes de pincel grosero, casi como borrones al descuydo, con que alcanzó gloria dejando con la suya a Micael Angelo, Urbino, Coregio y Parmesano . . . pero este como quien no se digna de andar por el camino ordinario, hizo senda y entrada por cumbres y desvíos." Vegue y Goldoni, 1928, discusses Gracián's statement in "Un lugar común en la Historia del Arte Español," in *Temas*, 1928, 129–32, where he points out that the anonymous painter has been assumed to be, alternatively, Navarrete el Mudo or Velázquez.

118. Gracián, *El Héroe* (1637), in *Biblioteca de Autores Españoles*, vol. 229, 1969, p. 254: "Sin salir del arte, sabe el ingenio salir de lo ordinario y hallar en la encanecida profesión nuevo paso para le eminencia. Cedióle Horacio lo heroico a Virgilio, y Marcial lo lírico a Horacio. Dió por lo cómico Terencio, por lo satírico Persio, aspirando todos a la unfanía de primeros en su género. Que el alentado capricho nunca se rindió a la fácil imitación. Vió el otro galante pintor que le habían cogido la delantera el Ticiano, Rafael y otros. Estaba más viva la fama cuando muertos ellos; valióse de su invencible inventiva. Dió en pintar a lo valentón, objectáronle algunos el no pintar a lo suave y pulido, en que podía emular al Ticiano, y satisfizo galantemente que quería más ser primero en aquella grosería que segundo en la delicadeza."

119. Palomino, 1947, p. 893: "A este tono eran todas las cosas, que hacía en aquel tiempo nuestro Velázquez, por diferenciarse de todos, y seguir nuevo rumbo; conociéndo que le habían cogido el barlovento Ticiano, Alberto, Rafael, y otros, y que estaba más viva la fama, cuando muertos ellos; valiéndose de su caprichosa inventiva, dando en pintar cosas rústicas a lo valentón, con luces, y colores estraños. Objectáronle algunos el no pintar con suavidad y hermosura asuntos de más seriedad, en que podía emular a Rafael de Urbino, y satisfizo galantemente diciendo: Que más quería ser primero en aquella grosería que segundo en la delicadeza." Vegue y Goldoni, 1928, pp. 129–32, discusses Palomino's statement in this context.

120. Kris and Kurz, 1979, p. 20.

121. Martínez, 1866, p. 94.

122. Palomino, 1947, p. 894. "Y últimamente lució el arte de Velázquez con la energía de los griegos, con la diligencia de los romanos, y con la ternura de los venecianos, y españoles."

123. "Al cuadro y retrato de su Magestad que hizo Pedro Pablo de Rubens, pintor excelentísimo" (1628). See Sánchez Cantón, 1923–41, vol. 5, p. 415. See also de Armas, 1978.

124. Brown, 1978, pp. 93–94, discusses Apelles and Alexander, Titian, Philip IV, and Velázquez.

125. Martínez, 1866, p. 132.

126. Pacheco, 1956, vol. 2, p. 2. "No seguiré el consejo licencioso, el cual permite al pintor . . . debuxar lo que ha pensado en el lienzo, o tabla, sin más prevención."

127. Martínez, 1866, pp. 3–4: "Hay otro modo, que sólo pertenece a los maestros, y es para tener memoria de sus intenciones, y así los llaman dibujo de idea; que son los que hacen muy abreviados para mostrar su intención, y elegir lo que más conviene se ejecute; y no contentos con sola esta inteligencia, ponen otro mayor trabajo, que es tomar un lienzo aparejado, en donde lo elegido se manifiesta más perfectamente ejecutado; y esto se hace de blanco y negro al óleo . . . y no solamente esto basta, sino el consumar su obra con perfección . . . valiéndose después de hacer dibujos del natural para colocarlos según las acciones y movimientos de la historia que tiene fabricada, quitando y añadiendo en lo que hubiere necessidad, que meramente no se halla en el natural . . . y así es necesario al dicho pintor que con su estidio y práctica lo corrija para poner en obra toda corrección."

In advising the painter to mix drawing and painting all in one continuous process, Martínez may be recording his own transformation of the description given by Vasari of the Venetian working method versus what Vasari sees as the ideal working method, which was to include drawings on paper. Martínez may be conflating what Vasari saw as two distinctly different ways to proceed. See Vasari on Titian and Giorgione, 1568, vol. 3, p. 1806.

128. Martínez, 1866, pp. 5–6: "El medio más principal es copiar cabezas hechas de grandes

hombres, coloreadas de manera hermosa y grande destreza y resolución, y si se puede, sea de manera veneciana que el la más suelta, y más amable a la vista como se vé por experiencia en las obras de Tiziano, Pablo Veronés, Tintoretto y Bassano . . . "

129. Boschini, 1966a, pp. 711–12.

130. Boschini, 1966a, pp. 730–32.

131. Grassi, 1973, p. 53.

132. Grassi, 1973, pp. 50–53; Puppi, 1974, pp. 405–37.

133. Boschini, 1966a, p. 748: "la Pittura vuole esser rappresentata tenera, pastosa e senza terminazione. . ."

134. Boschini, 1966b, p. 77.

135. Boschini, 1966b, p. 78.

136. Boschini, 1966b, p. 79.

137. Martínez, 1866, pp. 118–19, reported that Velázquez on his second trip to Italy sought for Philip IV paintings by Titian, Veronese, Bassano, Raphael, and Parmigianino. Palomino, 1947, pp. 910–11, also discussed Velázquez's acquisition of Venetian paintings for the king.

138. Martinez, 1866, pp. 23–24: "Los más maestros han procurado hacer sus obras imitadas a lo más hermoso . . . por ejemplo, en Tiziano . . . que todos los demás coloristas han salido de esta escuela."

139. Pacheco, 1956, vol. 1, p. 258. Pacheco refers to the *Aretino* (Dolce, 1968).

140. Martínez, 1866, p. 27: "como se ve en los templos y palacios suntuosos, adornados de galerías y piezas de mucha grandeza, que están con cuadros grandes, de modo que se pueden gozar de dilatadas distancias: las cosas pequeñas puestas al lado de estas grandes, quedan mezquinas y pobres . . . "

141. We are indebted to Sally Gross for her perceptive discussion of the nationalistic ambitions of the Spaniards ("A Second Look. Nationalism in Art Treatises from the Golden Age of Spain," *Rutgers Art Review*, 5 [1984]: 9–27).

142. See the discussion by Rosand, 1971–72.

143. Correas, 1924: "*La pintura y la pelea desde lejos me la otea.*"

CHAPTER 2: VELÁZQUEZ AND VENICE

1. Pacheco, 1956, vol. 2, p. 154: "pintado con la manera del gran Ticiano."

2. Boschini, 1966b, p. 77: "L'amava sti Pitori molto forte, Tician massimamente el Tentoreto."

3. Martínez, 1866, p. 127: "pasaron por originales, y así lo confesó Diego Velázquez (que no es pequeño testimonio)." Velázquez appears to have enjoyed a reputation at court for his connoisseurship; see Pérez Sánchez, 1961.

4. In the full passage in Palomino, 1947, p. 911, he says that Velázquez, "Pasó a Padua, y de allí a Venecia, a cuya república era muy aficionado, por ser la oficina donde se han labrado tan excelentes artifices. Vió muchas obras de Ticiano, de Tintoreto, de Paulo Veronés, que son los autores, a quien procuró seguir, e imitar desde el año de 1629, que estuvo en Venecia la primera vez."

5. Justi, 1889, p. 155.

6. Pérez Sánchez, 1976, p. 156: "Sin el conocimiento y el estudio del pintor veneciano dificilmente se comprenden obras como la *Venus del Espijo* o el *Mercurio y Argos* . . . " Other twentieth-century articles on Velázquez's technique also note the Venetian influence: see Baticle, 1961.

7. This period will be discussed more fully in the forthcoming Prado publication.

8. See Brown and Elliott, 1980, for a discussion of the Hall of Realms.

9. See, for example, Pérez Sánchez, 1976; Angulo, 1947.

10. Lauts, 1956, pp. 76–79, discusses Titian's influence upon Carracci, Poussin, Rubens, Velázquez, and Rembrandt. For a more detailed study of Titian's influence upon Rubens, see Held, 1982a, pp. 283–339.

11. Pacheco, 1956, vol. 1, pp. 158–59; Palomino, 1947, pp. 900–02. See also Harris, 1982a, pp. 15–17 and 75–85; López-Rey, 1963, pp. 45–47. Norris, 1932, believed that a small painting in Madrid's Academia was Velázquez's copy of Tintoretto's *Last Supper*. That view has not met with universal acceptance, although Gudiol, 1974, p. 126 and no. 65, accepts Norris's attribution.

12. Palomino, 1947, p. 911: "Vió muchas obras de Ticiano, de Tintoreto, de Paulo Veronés." Martínez, 1866, p. 118, preceded Palomino in reporting that Velázquez went to Italy to acquire paintings for Philip IV. According to Martínez, Velázquez promised to seek "los mejores cuadros que se hallan de Tiziano, Pablo Veronés, Basan, Rafael de Urbino, del Parmesano."

13. Boschini, 1966b, p. 78; Palomino, 1947, pp. 910–11. See also Harris, 1982a, pp. 25–29 and 141–54; López-Rey, 1963, pp. 94–102. See also Pita Andrade, 1960.

14. Harris, 1982a, p. 29.

15. We have relied especially upon Plesters and Lazzarini, 1976; Lucas and Plesters, 1978; and Plesters, 1980a. See also Hours, 1976; Garberi, 1977; Hood and Hope, 1977; Mucchi, 1977; and Gould, 1978. One must also consider the fact that Velázquez was trained in Seville at a moment when styles were changing, and many Venetian-inspired practices were becoming common even among painters who may or may not have seen a Venetian painting. Oil was the most popular medium in Spain by the end of the sixteenth century, and by 1611 Titianesque practices had been diffused and absorbed among the painters in many Spanish cities.

16. See López-Rey, 1963, no. 496, p. 292; López-Rey, 1979, p. 235, plate 236.

17. Mayer, 1940, pp. 9–10. Other writers made similar statements: according to Lafuente Ferrari, Velázquez was "continually retouching his pictures even years afterwards, when his study of them demanded modifications to improve the silhouette or the composition" (1943, p. 14). López-Rey, 1963, p. 86, took the opposing point of view: "It is also known that he had a penchant for retouching his own works, which often show *pentimenti*, but there is no clear indication that such changes were not generally made in what he regarded as the course of execution—which very likely was a long time, given the overlapping of royal commissions for paintings, his other duties at the Court, and what seems to have been his own sense of leisure." See also n. 18.

18. Again, the generalization does not apply universally to Velázquez's oeuvre. It has been argued that in at least one case Velázquez did rework a painting years after its initial creation (*Man with a Globe*, Rouen, see "Notes sur les radiographies," 1964).

19. Oberhuber, 1976, p. 15.

20. Tietze and Tietze-Conrat, 1970, p. 35; Oberhuber, 1976, pp. 15–16.

21. Oberhuber, 1976, p. 16.

22. See Tietze and Tietze-Conrat, 1970; Rearick, 1976; Oberhuber, 1976.

23. Rosand and Muraro, 1976, p. 10. For development seen in pentimenti, see Lank, 1982.

24. See McKim-Smith, 1979 and 1980.

25. McKim-Smith, 1979; López-Rey, 1979; Harris, 1982a; Brown, 1986.

26. See McKim-Smith, 1979 and 1980.

27. See McKim-Smith, 1980; see also chapter 4.

28. See López-Rey, 1963, no. 69; 1979, no. 45.

29. Lucas and Plesters, 1978, p. 38. We are indebted to Joyce Plesters for information on the fact that discolored glue in Titian's works often darkens the painting and gives the appearance to the naked eye of a toned imprimatura. For a gesso ground mixed with colors in Velázquez, see Harris and Lank, 1983.

30. Lucas and Plesters, 1978, p. 39.

31. Joyce Plesters kindly pointed this out to McKim-Smith in 1977. See McKim-Smith, 1979, p. 601. Laurie, 1949, pp. 121–24 had noted the lead white ground in the painting.

32. Lucas and Plesters, 1978, p. 43.

33. Kühn, 1970, "Terminal Dates."

34. Lucas and Plesters, 1978, pp. 44–45.

35. See chapter 4.

36. Plesters, 1980a, p. 40.

37. Pacheco, 1956, vol. 2, p. 11: "pintado con tanta valentía y espíritu, que todos quedaron admirados . . . "

38. Rossi, 1975; Tietze and Tietze-Conrat, 1970.

39. Plesters and Lazzarini, 1976, pp. 24–25.

40. For Tintoretto, see Plesters, 1980a, pp. 35–38.

41. Plesters, 1980a, pp. 38–39; Plesters and Lazzarini, 1976, p. 25.

42. Plesters and Lazzarini, 1976, p. 15.

43. Von Sonnenburg, 1982.

44. Plesters and Lazzarini, 1976, p. 16; Plesters, 1980a, p. 34.

45. Véliz, 1981; we are grateful to Barbara Miller of the National Gallery of Art in Washington, D.C., for information on unpublished analyses of Murillo, and to María del Carmen Garrido of the Prado Museum for information on unpublished analyses of paintings by Murillo and Zurbarán.

46. Clark, 1972, pp. 36–37, points out a different but related phenomenon: the difficulty of pointing out the exact moment at which the forms become perceived as brushstrokes.

47. Martínez, 1866, p. 70: "Alberto Durero, Luca de Holanda, Juan Belino, con otros muchos, obraron por aquel camino tan acabado, que pusieron en el último confín aquella manera y consiguieron aplauso merecido siguiendo su genio e inclinación. Tiziano, Bassano, Pablo Veronés y Tintoretto dieron por la contraria, haciendo sus obras tan resolutas, que parece negaron con ellas el aplauso de los otros, por verse en sus obras una cierta expedición, apta a mayor grandeza."

48. We are indebted to David Cast for his perceptive comments on this chapter and in particular for his pointing out the historical bias in our critical enterprise as we originally conceived it.

49. Martínez, 1866, p. 70–71: "Esto no se estudia, sólo lo hace cierta resolución que nace del ánimo generoso . . ."

CHAPTER 3: INTERPRETING COLOR

1. The forthcoming publication by the Prado Museum will publish X-radiographs and examinations with the infrared vidicon that will reveal pentimenti in other Velázquezes. See also chapter 4.

2. The cleaning of *Las Meninas* was carried out by John Brealey of the Metropolitan Museum in the late spring of 1984. Losses were painted in by Rocío and María Teresa Dávila of the Prado Museum, and the painting was varnished by Brealey. The paintings on the back wall of the room depicted in *Las Meninas* may always have been brushed in hazily, for infrared photographs and cleaning clarify them only very slightly (see figs. 50, 51). For a discussion of these paintings within the painting, see Orso, 1978, pp. 212–32; Orso, 1982; Gállego, 1984.

3. Cultural information about color meanings could help especially in reconstructing the early colors of *Las Meninas*. From the proportion of azurite particles to yellow ochre particles in María Agustina's skirt, it seems that the color was originally a blue with a greenish tinge. But it is not impossible that it was more truly green. Given the present state of knowledge, one is reduced to noting, from published contemporary remarks, that blue seems to have been slightly more admired than green. Pacheco calls blue a "color grave" (1956, vol. 2, p. 197). Covarrubias (1611), 657 B 20, defines *grave* as "en una significación vale autoridad y calidad, como persona grave." In 1627, Garcia de Salcedo Coronel admiringly described the eyes of the Count-Duke of Olivares in Velázquez's portrait as expressing "sweet command, feared *gravedad;*" see "El retrato del excmo. Sr. D. Gasper de Guzmán . . ." as quoted in *Varia velazqueña*, 1960, p. 18. Treatises on both blue and green were written. See Manuel Fernández Villarreal (1608–52): "Color verde, a la divina Celia," in Pedro Matheo, *Historia de la Prosperidad infeliz de Felipa de Catanea*, Madrid, 1736, pp. 177–246. This treatise is apparently a reply to a treatise extolling the color blue by the Portuguese Doctor Fernando Alvares Brandón: "Color azul."

It is also possible to consider the colors of seventeenth-century clothing fabrics. A gown of emerald green velvet is housed in the Colegio del Arte Mayor de la Seda en Barcelona; blue velvet cape trains of about 1645 are also known. We are grateful to Lydia Dufour of the Hispanic Society of America, who kindly placed at our disposal the Society's notebooks, compiled by Ruth M. Anderson, on costume in seventeenth-century Spain.

4. Panofsky, 1962, p. 3. Other statements by Panofsky create similar distinctions: "To perceive the relation of signification is to separate the *idea* of the concept to be expressed from the *means of expression* (emphasis added), 1955, p. 5. Or "Man's signs and structures are records because, or rather insofar as, they express *ideas* separated from, yet realized by, the *process of signalling* and building: these records

have therefore the quality of emerging from the stream of time, and it is precisely in this respect that they are studied by the humanist" (emphasis added), 1955, p. 5b. See also the discussion of iconography by Kubler, 1963, pp. 127–29, and by Gombrich, 1972b, "Introduction."

5. López Pinciano, 1596, p. 280.

6. Baxandall, 1985, pp. 1–11, has discussed the problematic relationship between an image and its discussion.

7. Flax, 1984, discusses the history of "fabulist" versus "formulist" criticism in the eighteenth and nineteenth centuries. His article offers penetrating analysis not only of this particular polarity but also of the fact that our "modes of organizing experience . . . determine in advance the nature of the phenomena that the discipline will observe" (p. 2).

8. Manuel Gallegos, "Silva topográfica," quoted in *Varia velazqueña*, 1960, vol. 2, p. 31: "el Patriarca Iacob gime en colores; / y explicando en matizes sus dolores."

9. Kubler, 1963, pp. 127–28 discusses the fact that in "iconology the word takes precedence over the image."

10. Foucault, 1973, pp. 3–16.

11. Searle, 1980; Snyder and Cohen, 1980.

12. Kahr, 1976; Brown, 1978, pp. 87–110; Gállego, 1984b, part 2, chap. 3.

13. Steinberg, 1981; Snyder and Cohen, 1980; for others, see Brown, 1978, pp. 87–90.

14. Brown, 1986, chap. 4; Orso, 1986; Moffitt, 1983b.

15. Palomino, 1947, p. 920.

16. Palomino, 1947, pp. 921–22.

17. Interest in these topics has of course increased in recent decades, as evidenced by Lleó Cañal, 1975 and 1979, and the manuscript on royal exequies by Orso, which is currently in press. Pioneering work in the investigation of broad cultural symptoms elsewhere in Europe has been done by Baxandall, 1972 and 1980. Baxandall's work should serve as both a stimulus and a model to other investigations that seek to achieve breadth and subtlety without sacrificing accuracy. Another sophisticated and stimulating example of an interpretation that situated the visual products of a society within a general social and historical context is Alpers, 1983a, a ground-breaking interpretation of painting in northern Europe. Alpers's contribution is especially relevant to anyone interested in the influences upon the visual culture of Spain; in spite of political disruptions between Spain and her northern possessions, quantities of northern images continued to be imported into Spain.

18. Hume, 1896, pp. 212–54. Bennassar, 1967, pp. 457–66. We thank Richard Kagan for advice.

19. For color theory in Italy in the fifteenth and sixteenth centuries, see Barasch, 1978; Rosand, 1975.

20. Pacheco, 1956, vol. 2. p. 175: "restituí el azul del manto de Nuestra Señora, los colores del cielo, que estaban gastados . . . "

21. Pacheco, 1956, vol. 2, p. 88: "diremos una palabra en razón de restituir y alegrar los lienzos, o tablas antiguas, a olio oscurecidas con el humo y barniz . . . " In volume 2, p. 88, Pacheco's 1956 editor read *"alegrar"* as a misspelling of *"arreglar,"* to repair. Either reading is possible, but *alegrar*, to brighten, seems more likely since Pacheco is discussing works that are "oscurecidas con el humo y barniz."

22. Pacheco, 1956, vol. 1, p. 28: "se adorna el cielo de purpúreas tintas . . . / Al ufano pavón, alas y falda / de oro bordaste y de matiz divino, / do vive rosicler, do la esmeralda / reluce y el zafiro alegre y fino.

23. Caturla, 1978, p. 51.

24. García Hidalgo, 1965, p. 10r: "que metan los colores limpios, y hermosos; y . . . lo dexen concluido, y bien empastado con mucho color."

25. We are grateful to John Brealey for pointing out the condition of this unlined painting and the visual function of the impasto.

26. Pacheco, 1956, vol. 1, p. 86: "conocer una armadura, un ropaje de seda o lino, un carmesí separado de un verde . . . "

27. García Hidalgo, 1965, p. 10v. Pacheco, 1956, vol. 1, pp. 98–99, discusses *changeant* fabrics, as does Palomino, 1947, p. 506.

28. Palomino, 1947, p. 501.

29. The importance of duplication of space in perspective is pointed out by Brown, 1978, p. 96.

30. Pacheco, 1956, vol. 1, p. 14: "la pintura es arte, pues tiene por exemplar objetivo, y por reglas de sus obras, a la mesma naturaleza, procurando siempre imitarla en la cantidad, relievo y color de las cosas . . . "

31. Pacheco 1956, vol. 1, p. 15: "¿quién habrá en la mundo que no tome gusto de imitar con el pincel a la Naturaleza y al mesmo Dios en cuanto es posible?"

32. Palomino, 1947, p. 66 (Luke 24) The passage is worth quoting at length, for it tries to reconcile illusion and truth: "y así, dice el texto sagrado, hablando de Cristo, nuestro Bien, cuando se encontró con sus discípulos en camino de Emáus: que fingió ir más lejos; donde se halla calificado, que el fingir, no es mentir . . . ; sino a manera de una ingeniosa metáfora; cuya arcana inteligencia reservó a los sagrados expositores."

33. Vélez de Guevara, "Soneto . . . a un retrato. . . . " 1625(?), as quoted in *Varia velazqueña*, 1960, vol. 2, p. 15: "Pincel, que a lo apacible, y a lo fuerte / les robas la verdad, tan bien fingida / que la ferocidad en tí es temida."

34. Blecua, in Quevedo 1969, vol. 1, pp. 403–04, notes to lines 85–90.

35. Enrique Vaca de Alfaro, "A D. Diego de Sylva, y Velázquez . . . " (1660–66), quoted in *Varia velazqueña*, 1960, vol. 2, p. 36: "con diestro Pinzel imprimes / un alma en cada bosquejo, / un aliento en cada efigie."

36. Palomino, 1947, pp. 118–19: To quote the entire passage: "Y si la luz, considerada filosóficamente, es la razón formal con que se actúa la potencia pasiva; . . . y ultimamente, si considerada, segun matemática, es la actualidad del diáfano; este es el principalísimo constitutivo de la Pintura; pues el romper, y desmentir la superficie, fingiendo ambiente puro, y diáfano entre las figuras, y términos, que se expresen, . . . es el mayor empeño de esta facultad, . . . " Page 921: "entre las figuras hay ambiente."

37. Pacheco, 1956, vol. 1, p. 258: "El colorido sirve en vez de las varias tintas con que pinta la naturaleza, y se imitan todas las cosas."

38. Martínez, 1866, p. 23: "Son los colores en el lienzo para los ojos lo que las cuerdas en la instrumento para el oído, de donde la unión, que es la que hace armonioso el intento, se ha de solicitar en los colores con el temple."

39. Palomino, 1947, p. 510.

40. Palomino, 1947, p. 921: To quote the passage more fully, "A el lado izquierdo del espejo está una puerta abierta, que sale a una escalera, en la cual está José Nieto, Aposentador de la Reina, muy parecido, no obstante la distancia, y degradación de cantidad, y luz, en que le supone."

41. Palomino, 1947, p. 494: "y las demás vayan bajando, a la manera que lo hace en la música, entonando *la, sol, fa, mi, re* . . . "

42. Pacheco, 1956, vol. 1, pp. 22–23: "con los colores declara el pintor dos cosas, la primera el color de lo natural o artificial: la otra la luz del sol, o de otra luz."

43. Pacheco, 1956, vol. 2, p. 9: "y sea muy conforme y apropósito a la parte donde se hubiere de colocar nuestro cuadro." He is quoting from Alberti's *De pictura*, book III. For a discussion of the original hanging of *Las Meninas* see Brown, 1986, p. 259 and n. 63.

44. García Hidalgo, 1965, p. 12r: "Y también es muy importante, que el Pintor vea, ò sepa, à la luz que ha de estar su pintura, y à la distancia de alto, y de lejos, porque para luz templada se ha de pintar con claros fuertes, y destemplados, y que los obscuros sean fuertes tambien; y para luz clara, ò puesto claro, todo suave, y bien templado de colores, y corregido, y suave en lo executado; y para lejos grandes las figuras, y que parezcan proporcionadas, y fuertes los golpes de claros, y obscuros, porque los pierde y templa la distancia, y la altura." See also Palomino, 1947, p. 635.

45. According to the writer: "que las cosas, mientras más cercanas, se pinten con colores más vivos y encendidos para que semejen más a las cosas naturales, y como se fueren alejando se han de ir pintando con colores menos fuertes [*sic*], digo con medias tintas, de modo que vayan pareciendo menos coloridas y formadas" (Sanz Sanz, 1978, p. 257). We are grateful to Zahira Véliz for informing us that in the original manuscript the thirty-sixth word in this passage is "finos," and not "fuertes" as transcribed by

Sanz Sanz. The author of this treatise also equates "fino" with bright, as when he says that high skies should be "más azul y de color más fino y vivo" (Sanz Sanz, 1978, p. 76).

46. For Velázquez's activities in arranging works in the palaces of the king, see Brown and Elliott, 1980; Harris, 1982; Brown, 1986, pp. 107–29, 253–64.

47. Palomino, 1947, p. 630.

48. Palomino, 1947, p. 631: "saber templar de suerte aquel instrumento pictórico, organizado de diferentes especies de colores, sobresalientes unos, y templados, o bajos otros . . . "

49. Palomino, 1947, p. 631: "Consiste, pues esta belleza, en que el golpe principal de la luz . . . esté en el centro de la historia con el mayor esplendor, y hermosura de colores, que le competa . . . se ha de huir, que se encuentren dos colores, ni dos claros iguales; que son lo que la música llaman *unisonus*. . . . También ayuda mucho a ésto, el que insensiblemente desde aquel centro de luz, se vaya rebajando hacia los extremos del cuadro."

50. Palomino, 1947, p. 921: To quote more fully, "El pavimento es liso, y con tal perspectiva, que parece se puede caminar por el; y en el techo se descubre la misma cantidad."

51. Gombrich, 1972a, pp. 63–90.

52. Bryson, 1983, p. 14.

53. Baxandall, 1972, p. 11.

54. See Brown, 1986, pp. 274–77.

55. For this hunting lodge, see Alpers, 1971.

56. Brown and Elliott, 1980, discuss the hall and its function.

57. See Gérard, 1983, p. 283, and Pérez Sánchez, 1965, p. 114; see the fine essay by Orso, 1984.

58. Muller, 1972, p. 135.

59. Brown, 1986, p. 259.

60. Impressive velvet draperies were of course also executed in oil by Flemish painters such as Jan van Eyck in the fifteenth century. Velázquez would have known the numerous Flemish paintings in the royal collection, although his more immediate influence would come from the sixteenth-century Venetians.

61. López Pinciano, 1596, pp. 16–17.

62. López Pinciano, 1596, pp. 216: "el poema es una tabla formada de figuras y colores; y que la fábula es la figura, y el metro los colores."

63. López Pinciano, 1596, p. 280.

64. Martínez, 1866, pp. 1–7. This pro-coloristic attitude in Spain contrasts interestingly with the attitudes of the French in the latter half of the seventeenth century. See Bryson, 1981, pp. 59–61.

65. For a fuller discussion of the issues in this chapter, see the forthcoming article by McKim-Smith, "Materials, Mentality and Meaning in *siglo de oro* Spain."

CHAPTER 4: REMARKS ON THE PAINTINGS

1. Harris, 1982a, suggests a date of ca. 1626 for both. López-Rey, 1979, dates the final images of both pictures to about 1628. Gudiol, 1974, suggests ca. 1625 for both the standing and bust portraits. López-Rey, 1963, dates the *Philip IV Standing* to 1623, with revisions made in 1626–28; he dates the *Bust of Philip IV* to 1626–28. López-Rey, 1963, pp. 209–10, summarizes the earlier arguments of dating for both the paintings.

2. First suggested by López-Rey in 1963. The pose seen in the pentimenti has also been related to the painting of Philip IV in the Metropolitan Museum. See López-Rey, 1963 and 1979.

3. López-Rey, 1963, p. 210. Harris (1982a, p. 62) referred to López-Rey's hypothesis about the 1623 portrait as "disputable."

4. López-Rey, 1963, p. 209, no. 237.

5. Harris, 1970, pp. 368, 371, discusses the bust portrait of Philip, noting that it "was perhaps also a bust or half-length" because it may have resembled the lost bust portrait of Olivares by Velázquez.

6. López-Rey, 1963, p. 209, no. 237.

7. See Garrido, Cabrera, McKim-Smith, and Newman, 1983. We are grateful to Dr. Garrido and

Dr. Cabrera for their collaboration and advice throughout the examination of this painting. Their cooperation in sharing information on the materials used in the picture has been of great value. We are also indebted to María José Alonso for her aid in X-radiographing the picture.

8. Garrido's examination revealed that the canvas in two and four were the same. See Garrido, Cabrera, McKim-Smith, and Newman, 1983, p. 93, table 1.

9. Pacheco, 1956, vol. 2, pp. 75–76.

10. We are indebted to Maryan Wynn Ainsworth of the Metropolitan Museum of Art for information on the occurrence of lead white in the lining adhesive of paintings by Rembrandt.

11. See, for example, the X-radiograph of the *Surrender of Breda,* fig. 26.

12. According to analyses of the canvas carried out by Garrido, the weave of the linen canvas in central piece one is only slightly different from the weave of the linen canvases in strips two and three; strips two and three have about the same weave. Strip four is not linen, but is hemp of a markedly different weave. See Garrido, Cabrera, McKim-Smith, and Newman, 1983, p. 93, table 1.

13. One *vara* is about 83.59 cm.

14. López-Rey, 1979, p. 291.

15. Lead white in grounds occurs in the central canvases of the *Forge of Vulcan* and in the *Surrender of Breda,* as well as in the *Portrait of a Dwarf* and *Las Meninas* (see chapter 5). X-radiographs of other Velázquezes suggest lead white also: in *Pedro de Barberana* in the Kimbell museum.

16. Due to a printer's error, the 1983 article by Garrido, Cabrera, McKim-Smith, and Newman contained an erroneous paragraph that did not describe our findings and which should have been eliminated before publication. The paragraph occurs on page 86, column 1, paragraph 4: "La similar estructura . . ." As we make clear in this book, it is unlikely that any of the lateral strips (two, three, or four) were added by Velázquez.

17. A version of the following discussion, "Problems of Meaning in Velázquez," was presented in 1981 at the annual meeting of the College Art Association in San Francisco in a session on "Technique and Meaning in Painting," chaired by Charles S. Rhyne. We are grateful to Professor Rhyne for his continuing interest in the issues discussed here. Previous studies of the sources for poses in the *Forge* also include Tolnay, 1961; Angulo Iñiguez, 1947; Soria, 1955; and Sebastián, 1983.

18. López-Rey, 1963, p. 149; 1979, p. 368.

19. McKim-Smith, 1979, p. 591; 1980.

20. Stevenson, 1899, p. 154.

21. See, for example, El Greco's *San Bernardino,* Toledo, Museo del Greco, which has a bottom edge covered with wipings of different colors; reproduced *El Greco of Toledo,* 1982, p. 202, plate 53.

22. Brown, 1986, pp. 274–77. Gudiol (1974) had earlier suggested a date of about 1638.

23. See Kahr, 1976; Brown, 1978, pp. 87–110; Volk, 1978; Moffitt, "Velázquez in the Alcázar," 1983b; Brown, 1986, pp. 256–61; Campo y Francés, 1978.

24. Tolnay, 1949, suggests that Velázquez's image reflects the sixteenth-century distinction between *disegno interno* and *disegno externo.* Jordan, 1974, pp. 20–21 makes a related suggestion, pointing out that Velázquez's poised brush is similar to Vicencio Carducho's poised brush over a *tabla rasa* on the endpage of his *Diálogos de la pintura* of 1633. Jordan indicates that this motif may refer to the powers of the artist or prophet. Moffitt, "Velázquez in the Alcázar," 1983b, provides a similar interpretation.

25. Costa, 1967, p. 458.

26. Costa, 1967, p. 458.

27. López-Rey, 1963, p. 204.

28. Kubler, 1966, p. 213.

CHAPTER 5: VELÁZQUEZ'S PAINTING MATERIALS

1. For *The Forge of Vulcan,* see Garrido, Cabrera, McKim-Smith, and Newman, 1983.

2. The lipid-specific Sudan Black *B* was used for oils, following the method given in Johnson and

Packard, 1971. Coomassie Brilliant Blue G–250 in a saturated distilled water solution was used for proteins. A microchemical test for oil was also used on some samples (see H. Kühn, "A Study of the Pigments and the Grounds Used by Jan Vermeer," 1968b, p. 173.)

3. Identification of fiber types was carried out by Maria del Carmen Garrido of the Prado Museum.

4. For an interesting discussion of weave and fabric types used elsewhere in Europe during this period, see Vanderlip de Carbonnel, 1980.

5. Kühn, "Terminal Dates for Paintings Derived from Pigment Analysis," 1973.

6. Gettens and FitzHugh, 1966.

7. Harley, 1982, pp. 49f.

8. For example in Rubens's "Deborah Kip, Wife of Sir Balthasar Gerbier and Her Children" (Feller, 1973) and in two Jan Steen paintings (Butler, 1982/1983).

9. Plesters, 1966.

10. Mühlethaler and Thissen, 1969.

11. Plesters, "Possible Causes of Blanching involving Changes in Pigments or Interaction of Pigment and Medium," 1980b.

12. Plesters, 1966.

13. Kühn, "Terminal Dates for Paintings Derived from Pigment Analysis," 1973.

14. Von Sonnenburg, 1982.

15. Butler, 1982/1983.

16. Plesters, "Possible Causes of Blanching involving Changes in Pigments or Interaction of Pigment and Medium," 1980b.

17. Pacheco, vol. 2, pp. 29–30.

18. Hofenk-deGraaff, 1978.

19. See Harley, 1982, pp. 107 ff.

20. For malachite, see Gettens and FitzHugh, 1974. For green earth, see Grissom, 1986.

21. Feller, 1973.

22. Gettens, Feller, and Chase, 1972.

23. Harley, 1982, pp. 131 ff.

24. Thompson, 1956, pp. 120 ff.

25. Hofenk-deGraaff, 1975.

26. See, for example, Brown and Plesters, 1977.

27. The method used is that given in Masschelein-Kleiner, 1967.

28. Lucas and Plesters, 1978.

29. Kühn, "Lead-Tin Yellow," 1968a.

30. The identification was tentatively made on the basis of solubility tests described in Plesters, 1955–56.

31. Keisch, 1971.

32. For comparative purposes, the lines corresponding to d-spacings of 3.27 Å (hydrocerussite) and 3.50 Å (cerussite) were used (see Keisch, 1971). In the microscope slides, cerussite appears as granular particles displaying high-order interference colors and high refractive index relative to the common mounting media (its lowest index is 1.80). The grains are usually 10–20 μm in size and are irregularly scattered through the finer-grained hydrocerussite.

33. DeVries et al., 1978, Appendixes I and II, pp. 206–18.

34. Ibid., p. 212.

35. Ibid. See also Wetering, Groen, and Mosk, 1976.

36. Merrill, 1981.

37. Hendy and Lucas, 1968.

38. Von Sonnenburg, 1982.

39. Laurie, 1967, p. 150.

40. Also present in the sky in these added strips is a thin upper glaze of ultramarine blue, apparently the synthetic variety, which was invented about 1830.

41. Von Sonnenburg, 1971.

42. For an interesting discussion of artists' workshops during this period, see Bleeke-Byrne, 1984.

43. Plahter, Skaug, and Plahter, 1974.

44. For the painting technique of Van Eyck and his contemporaries, see: Coremans, Gettens, and Thissen, 1952; Coremans, 1952; and Coremans, 1954.

APPENDIX II: WHY PAINTINGS CHANGE

1. For information on the results of analyses of Velázquez's binding media with gas chromatography, see the Prado's forthcoming technical study of Velázquez's paintings.

2. See Mühlethaler and Thissen, 1969, for a general discussion of smalt. On discoloration, see Plesters, 1969, and Plesters, "Possible Causes of Blanching," 1980b, p. 62.

3. Gettens and FitzHugh, 1966, provide a general discussion of azurite.

4. On "fading yellow," see Plesters, "Possible Causes of Blanching," 1980b, pp. 61–62.

5. Johnston-Feller, Feller, Bailie, and Curran, 1984.

6. On the sturdiness of lead white, see Gettens, Kühn, and Chase, 1967, p. 127.

7. John Brealey has made a number of enlightening comments on the loss of what he terms "low-relief sculpture." Velázquez painted no known works on wood, but he did make miniatures on metal. See López-Rey, 1963, pp. 334–35. A recent note on Velázquez as miniaturist is provided by Priscilla F. Muller, 1978.

8. Stevenson, 1899, pp. 21–22. Occasionally artists did note dramatic changes in paintings, as when Hogarth declared, "When colours change at all it must be . . . that one changes darker, another lighter, one quite to a different colour, whilst another, as ultramarine, will keep its natural brightness even in the fire. Therefore how is it possible that such different materials, ever variously changing . . . should accidentally coincide with the artist's intention. . . ." (Hogarth, 1955, p. 130). Until recently, most twentieth-century scholars regarded Hogarth's opinion as overstated. Gombrich, 1962, says, "Hogarth may well have exaggerated the chemical changes to which pigments are subject."

9. For a general discussion of changes in works of art, see Guillerme, 1964, and Marijnissen, 1967.

10. Artists in Velázquez's time no doubt expected that their works might eventually be tampered with by collectors. Drawings were often inscribed or stamped by purchasers; paintings were frequently cut down to fit a particular spot or frame.

11. It has been noted, for example, that both Andrea Sacchi and Carlo Maratti may have painted their colors deliberately light on the assumption that the hues would become dark with time. See Francis H. Dowley, "Carlo Maratti, Carlo Fontana, and the Baptismal Chapel in Saint Peter's," *Art Bulletin* 47 (1965): 57–81; some important comments are registered in the footnotes to those pages. Sheldon Keck's excellent address to the American Institute for Conservation (Baltimore, May 1983) summarized the main points of past controversies from the seventeenth century to the present day: "Picture Cleaning Controversies, Past and Present", published 1984. Keck supplied bibliography on the history of conservation, and we gratefully acknowledge his advice. The best-known twentieth-century debate in English was rehearsed on the pages of the *Burlington Magazine* in 1962–63. Articles from this debate are: "The National Gallery Cleaning Controversy," 1962, pp. 49–50; Gombrich, 1962, pp. 51–55; Kurz, 1962, pp. 56–59; Rees-Jones, 1962, pp. 60–62; Mahon, 1962, pp. 460–70; Thomson, 1962, pp. 499–500; Gombrich, 1963, pp. 90–93; Kurz, 1963, pp. 94–97; Rees-Jones, 1963, pp. 97–98; P. L. Jones, 1963, pp. 98–103. A recent German article continued the theoretical discussion: Brachert, 1983, pp. 83–95. A still more recent essay invited further controversy: Sewell, 1984, pp. 24–25.

12. Pacheco, 1956, vol. 2, p. 150: "Templará el pintor sus colores algo más claras que el natural, porque casi siempre oscurecen." He advises placing canvases "al sol medio día" in vol. 2, p. 88.

13. Pacheco, 1956, vol. 2, p. 76: "Esta es la mejor emprimación y la que yo usaría siempre, sin más invenciones, porque veo conservados mis seis lienzos del claustro de la Merced, sin haber hecho quiebra

ni señal de saltar desde el año de 1600 que se comenzaron, que me basta para aprobar la seguridad deste aparejo de barro."

14. Pacheco 1956, vol. 2, p. 83.
15. García Hidalgo, 1965, p. 10v.
16. Palomino, 1947, pp. 488–89.
17. Pacheco, 1956, vol. 2, p. 83.
18. García Hidalgo, 1965, p. 10v.
19. Palomino, 1947, pp. 488–89.
20. Johnston-Feller, Feller, Bailie, and Curran, 1984, p. 114.

BIBLIOGRAPHY

Agulló y Cobo, Mercedes. 1959. "Noticias de Arte en una información inédita de Palomino y Ruíz de la Iglesia," *Archivo Español de Arte* 32:229–46.

Allende-Salazar, Juan, ed. 1925. *Velázquez. Des Meisters Gemälde (Klassiker der Kunst,* vol. 6) 4th ed., Stuttgart.

Alpers, Svetlana. 1960. "*Ekphrasis* and Aesthetic Attitudes in Vasari's *Lives,*" *Journal of the Warburg and Courtauld Institutes* 23:190–215.

———. 1971. *The Decoration of the Torre de la Parada.* Corpus Rubenianum Ludwig Burchard. vol. 9. London and New York.

———. 1983a. *The Art of Describing.* Chicago.

———. 1983b. "Interpretation without Representation, or the Viewing of *Las Meninas,*" *Representations* 1:31–42.

Angulo Iñiguez, Diego. 1947. *Velázquez. Como compuso sus principales cuadros.* Seville.

———. 1960. "La Fábula de Vulcano, Venus y Marte y 'La Fragua' de Velázquez," *Archivo Español de Arte* 33:149–81.

Armas, Frederick A. De. 1978. "Lope de Vega and Titian," *Comparative Literature* 30 (4):338–52.

Autoridades. 1726. *Diccionario de Autoridades (Diccionario de la lengua española).* Madrid.

Baldinucci, F. 1809. *Vocabolario Toscano dell'arte del disegno.* Florence (Milan, 1681).

Baldwin, Carl B. 1974. "Art and the Law. Property Right vs. Moral Right," *Art in America* (Sept.–Oct.): 34.

Barasch, Moshe. 1978. *Light and Color in the Italian Renaissance Theory of Art.* New York.

Barthes, Roland. 1977. *Elements of Semiology.* New York.

Baticle, Jeannine. 1961. "Les procedés techniques de Velásquez," *Jardin des Arts:12–19.*

Bauschatz, Cathleen M. 1980. "Montaigne's Conception of Reading. . . ," in S. R. Suleiman and I. Crosman, eds., *The Reader in the Text,* pp. 264–91. Princeton.

Baxandall, Michael. 1971. *Giotto and the Orators.* Oxford.

———. 1972. *Painting and Experience in Fifteenth-Century Italy.* Oxford.

———. 1985. *Patterns of Intention. On the Historical Explanation of Pictures.* New Haven and London.

Bennassar, Bartolomé. 1967. *Valladolid au siècle d'or. Une Ville de Castille et sa campagne au XVIe siècle.* Paris.

Beruete y Moret, Aureliano de. 1898. *Velázquez.* Paris.

———. 1922. "La paleta de Velázquez," *Conferencia lei da en la inauguración del Curso de 1920–21 de la sección de artes plásticas del Ateneo de Madrid.* Madrid.

Biblioteca de Autores Españoles. 1850. vol. 13. See *Epistolario Español.*

———. 1876. vol. 3. See *Lazarillo de Tormes* (Antwerp, 1553).

———. 1969. vol. 229. See Gracián, 1969.

Blecua, José Manuel, ed. 1969. See Quevedo, 1969.

Bleeke-Byrne, Gabriele. 1984. "The Education of the Painter in the Workshop," in *Children*

of Mercury. The Education of Artists in the Sixteenth and Seventeenth Centuries, pp. 28–39. Providence, Rhode Island.

Blunt, Anthony. 1940. *Artistic Theory in Italy, 1450–1600.* Oxford.

Boschini, Marco. 1966a. *Breve Instruzione,* preface to *Le Ricche Minere della Pittura Veneziana,* in *La Carta del Navegar pitoresco* (Venice, 1674), pp. 703–56. Anna Pallucchini, ed. Venice.

———. 1966b. *La Carta del Navegar pitoresco* (Venice, 1660), pp. 1–692. Anna Pallucchini, ed. Venice.

Brachert, Thomas. 1983. "Restaurierung als Interpretation," *Maltechnik/Restauro* 2:83–95.

Brommelle, Norman and Perry Smith. 1976. *Conservation and Restoration of Pictorial Art.* London.

Brown, Christopher and Joyce Plesters. 1977. "Rembrandt's portrait of Hendrickje Stoffels," *Apollo* 106(188):286–91.

Brown, Jonathan. 1978. *Images and Ideas in Seventeenth-Century Spanish Painting.* Princeton.

———. 1982. "El Greco and Toledo," see *El Greco of Toledo.*

———. 1986. *Velázquez: Painter and Courtier.* New Haven and London.

Brown, Jonathan and J. H. Elliott. 1980. *A Palace for a King.* New Haven and London.

Brunius, T. 1967. "Michaelangelo's non finito," *Contributions to the History and Theory of Art.* (*Figura,* n.s. no. 6), pp. 29–67.

Bryson, Norman. 1981. *Word and Image.* Cambridge.

———. 1983. *Vision and Painting.* New Haven.

Butler, Marigene H. 1982/83. "Appendix. An Investigation of the Technique and Materials Used by Jan Steen," *Philadelphia Museum of Art Bulletin* 78:44–61.

Butrón, Juan de. 1626. *Discursos apologéticos en que se defiende la ingenuidad del arte de la pintura.* Madrid.

Calvo Serraller, Francisco, ed. 1981. *Teoría de la Pintura del Siglo de Oro.* Madrid.

Camón Aznar, José. 1964. *Velázquez.* 2 vols. Madrid.

Campo y Francés, Angel del. 1978. *La magía de Las Meninas. Una iconología velazqueña.* Madrid.

Carducho, Vincencio. 1979. *Diálogos de la pintura* (Madrid, 1633). Francisco Calvo Serraller, ed. Madrid.

Cast, David. 1981. *The Calumny of Apelles.* New Haven.

Caturla, María Luisa. 1978. "La verdadera fecha del retablo madrileno de San Hermengildo," *Actas del XXIII Congreso Internacional de Historia de Arte (1973),* vol. 3, pp. 49–55. Granada.

Ceán Bermúdez, Juan Agustín. 1800. *Diccionario histórico de los . . . bellas artes en España.* 6 vols. Madrid.

Cennino d'Andrea Cennini. 1932. *Il libro dell 'arte* (c. 1390). D. Thompson, ed. New Haven.

Clark, Kenneth. 1972. *Looking at Pictures.* London.

Cormans, P. B. 1948. "The Recent Cleaning of Rubens' *Chapeau de Paille,*" *Burlington Magazine* 90:257–61.

———. 1952. "La technique des 'Primitifs Flamands,' I," *Studies in Conservation* 1:1–2.

———. 1954. "La technique des 'Primitifs Flamands,' III," *Studies in Conservation* 1:145–61.

Cormans, P. B., R. J. Gettens, and J. Thissen. 1952. "La technique des 'Primitifs Flamands,' II," *Studies in Conservation* 1:3–26.

Correas, G. 1924. *Vocabulario de refranes y frases proverbiales. . . .* Madrid.

Costa, Felix da. 1967. *The Antiquity of the Art of Painting* (*Antiguidade da Arte da Pintura*). George Kubler, tr. and ed. New Haven.

Covarrubias Orozco, Sebastián de. 1977. *Tesoro de la Lengua Castellana o Española* (1611). Madrid: Ediciones Turner.

Crosby, James O., ed. 1981. See Quevedo. 1981.

Crowe, J. A., and G. V. Cavalcaselle. 1881. *The Life and Times of Titian.* vol. 1. London.

Curtius, E. R. 1953. "Calderón's Theory of Art and the *Artes Liberales,*" in *European Literature and the Latin Middle Ages,* pp. 559–83. Willard R. Trask, ed. Princeton.

Damisch, Hubert. 1975. "Semiotics and Iconography," *Semiotics and Iconography,* no. 1. Lisse.

DeVries, A. B., Magdi Tóth-Ubbens, and W. Froentjes. 1978. *Rembrandt in the Mauritshuis.* Alphen aan den Rijn.

Diez del Corral, Luis. 1979. *Velázquez, la monarquía e Italia.* Madrid.

Dolce, Lodovico. 1968. *Diálogo della pittura* (Venice, 1557), in Mark W. Roskill, ed., *Dolce's Aretino and Venetian Art Theory of the Cinquecento.* New York.

Dowley, Francis H. 1965. "Carlo Maratti, Carlo Fontana, and the Baptismal Chapel in Saint Peter's," *Art Bulletin* 47:57–81.

El Greco of Toledo. 1982. (Washington, D.C., National Gallery of Art, July 2–September 6).

Emmens, J. A. 1961. "Les Ménines de Velasquez. Miroir des Princes pour Philippe IV," *Nederlands Kunsthistorisch Jaarboek* 12:51–79.

Epistolario Español. 1850. *Biblioteca de Autores Españoles.* vol. 13. Madrid.

Feller, R. L. 1967. "Studies on the Darkening of Vermilion by Light," *Report and Studies in the History of Art* (National Gallery of Art), pp. 99–111. Washington, D.C.

———. 1973. "Rubens's *The Gerbier Family:* Technical Examination of the Pigments and Paint Layers," *Studies in the History of Art* (National Gallery of Art), pp. 54–74. Washington, D.C.

Fisher, Sarah L. 1980–81. "*The Finding of Erichthonius:* Examination and Treatment," *Oberlin College Bulletin* 38 (1):21–37.

FitzHugh, Elizabeth West, and R. J. Gettens. 1974. See Gettens and FitzHugh. 1974.

Flax, N. 1984. "Fiction Wars of Art," *Representations* 7 (Summer, 1984):1–25.

Foucault, Michel. 1973. "Las Meninas," in *Les Mots et les choses* (Paris, 1966). tr., in *The Order of Things: An Archaeology of the Human Sciences.* New York.

Gállego, Julián. 1976. *El pintor de artesano a artista.* Granada.

———. 1984a. *El cuadro dentro del cuadro.* Madrid.

———. 1984b. *Visión y símbolos en la pintura española del Siglo de Oro.* Madrid.

Garberi, Mercedes. 1977. "Tiziano: I ritratti," in *Omaggio a Tiziano: la cultura milanese nell'età di Carlo V,* pp. 11–38. Milan.

García Hidalgo, José. 1965. *Principios para estudiar el nobilisimo, y real arte de la pintura . . .* (1693). A. Rodríguez Moñino, ed. Madrid.

García Salinero, Fernando. 1968. *Léxico de alarifes.* Madrid.

Garrido, María del Carmen, José María Cabrera, Gridley McKim-Smith, and Richard M. Newman. 1983. "La Fragua de Vulcano. Estudio técnico y algunas consideraciones sobre los materiales y métodos del XVII," *Boletín del Museo del Prado* 4 (11):79–95.

Garrido, María del Carmen, María Teresa Dávila and Rocío Dávila. 1986. "Las hilanderas: estudio técnico y restauración," *Boletín del Museo del Prado* 7(21):145–65.

Gaya Nuño, Juan Antonio. 1975. *Historia de la crítica de arte en España.* Madrid.

Gérard, Véronique. 1983. "Los sitios de devoción en el Alcázar de Madrid: capilla y oratorios," *Archivo Español de Arte* 56:275–84.

Gettens, R. J., R. L. Feller, and W. T. Chase. 1972. "Vermilion and Cinnabar," *Studies in Conservation* 17:45–69.

———, and Elizabeth West FitzHugh. 1966. "Azurite and Blue Verditer," *Studies in Conservation* 11:54–61.

———, and Elizabeth West FitzHugh. 1974. "Malachite and Green Verditer," *Studies in Conservation* 19:2–23.

———, Helmut Kühn and W. T. Chase. 1967. "Lead White," *Studies in Conservation* 12:125–39.

———, and George L. Stout. 1966. *Painting Materials. A Short Encyclopedia.* New York.

Gombrich, E. H. 1962. "Dark Varnishes: Variations on a Theme from Pliny," *Burlington Magazine* 104:51–55.

———. 1963. "Controversial Methods and Methods of Controversy," *Burlington Magazine* 105:90–93.

———. 1972a. *Art and Illusion.* New York.

———. 1972b. "Introduction: Aims and Limits of Iconology," in *Symbolic Images. Studies in the Art of the Renaissance,* pp. 1–25. London.

Gould, Cecil. 1978. "An X-ray of Tintoretto's 'Milky Way,' " *Arte veneta* 32:211–13.

Gracián, Baltasar. 1969. *El Heroe* (Madrid, 1637). In *Biblioteca de Autores Españoles.* vol. 229. Madrid.

Grassi, Luigi. 1973. *Teorici e storia della critica d'arte (L'età moderna: il seicento).* Rome.

Grissom, Carol A. 1986. "Green Earth," in R. L. Feller, ed., *Artists' Pigments. A Handbook of Their History and Characteristics,* pp. 141–67. Cambridge and Washington.

Gross, Sally. 1984. "A Second Look. Nationalism in Art Treatises from the Golden Age in Spain," *Rutgers Art Review* 5:9–27.

Gudiol, José. 1974. *Velázquez.* New York (Barcelona, 1973).

Guevara, Felipe de. 1788. *Comentarios de la pintura* (XVI century). Madrid.

Guillerme, Jacques. 1964. *L'atelier du temps.* Paris.

Gutiérrez de los Ríos, Gaspar. 1600. *Noticia general para la estimación de las artes.* Madrid.

Harley, Rosamund. 1982. *Artists' Pigments ca. 1600–1835.* London.

Harris, Enriqueta. 1970. "Cassiano dal Pozzo on Diego Velázquez," *Burlington Magazine* 122:364–73.

———. 1982a. *Velázquez.* Ithaca, New York.

———. 1982b. "Velázquez as Connoisseur," *Burlington Magazine* 124:436–40.

Harris, Enriqueta, and Herbert Lank. 1983. "The Cleaning of Velázquez's Portrait of Camillo Massimi," *Burlington Magazine* 125:410–15.

Held, Julius S. 1982. "Rubens and Titian," in David Rosand, ed., *Titian. His World and His Legacy,* pp. 283–399. New York.

Hendy, P., and A. S. Lucas. 1968. "Les préparations des peintures," *Museum* 21(4):245–76.

Herrero García, M. 1943. *Contribución de la literatura a la historia del arte.*

Hidalgo Brinquis, María del Carmen. 1978. "La pintura al temple en Francisco Pacheco," Memoria de licenciatura, Universidad Complutense. Madrid.

Hiler, H. 1969. *Notes on the Technique of Painting.* New York (London, 1934).

Hirsch, E. D., Jr. 1967. *Validity in Interpretation.* New Haven.

Hofenck-de Graff, J. H. 1975. " 'Woven Bouquet': Dyestuff-Analysis on a group of Northern Dutch Flowered Tablecloths and Tapestries of the 17th century," *Preprints,* ICOM Committee for Conservation, 4th Triennial Meeting, Venice, October 3.

———. 1978. "The analysis of flavonoids in natural yellow dyestuffs occurring in ancient textiles," *Preprints,* ICOM Committee for Conservation, 5th Triennial Meeting, Venice, September 4.

Hogarth, William. 1955. *The Analysis of Beauty* (London, 1753). Joseph Burke, ed. Oxford.

Holanda, Francisco de. 1921. *De la pintura antigua* (1548; tr. by Manuel Denis in 1563). Madrid

Hood, William, and Charles Hope. 1977. "Titian's Vatican Altarpiece and the Pictures Underneath," *Art Bulletin* 59:534–52.

Horace. *Ars Poetica.* Loeb Classical Library. 1926.

Hours, Madeleine. 1976. "Contribution à l'étude de quelques oeuvres du Titien," *Laboratoire de recherche des musées de France, Annales,* pp. 7–31.

———, and Jean Paul Rioux. 1978. "Observations techniques sur la matière picturale de Murillo et Goya," *Actas del XXIII Congreso Internacional de Historia del Arte (1973),* vol. 3, pp. 105–06. Granada.

Hume, Martin. 1896. *The Year After the Armada, and Other Historical Studies.* New York.

Johnson, B. B. 1974. "Examination and Treatment of Rembrandt's *Raising of Lazarus,*" *Los Angeles County Museum of Art Bulletin* 20(2):18–35.

Johnson, M., and E. Packard. 1971. "Methods used for the identification of binding media in Italian paintings of the fifteenth and sixteenth centuries," *Studies in Conservation* 16:145–64.

Johnston-Feller, Ruth, Robert L. Feller, Catherine W. Bailie, and Mary Curren. 1984. "The Kinetics of Fading: Opaque Paint Films Pigmented with Alizarin Lake and Titanium Dioxide," *Journal of the American Institute for Conservation* 23(2):114–29.

Jones, P.L. 1963. "Scientism and the Art of Picture Cleaning," *Burlington Magazine* 105:98–103.

Jordan, William B. 1974. *The Meadows Museum.* Dallas.

———. 1981. "Velázquez's *Portrait of Don Pedro de Barberana,*" *Apollo* 114 (December):378–79.

Justi, Carl. 1889. *Diego Velázquez and His Times.* London.

Kahr, Madlyn Millner. 1976. *Velázquez. The Art of Painting.* New York.

Keck, Sheldon. 1984. "Some Picture Cleaning Controversies: Past and Present," *Journal of the American Institute for Conservation* 23(2):73–87.

Keisch, B. 1971. "X-Ray Diffraction and the Composition of Lead White," *Studies in the History of Art* (National Gallery of Art), pp. 121–33. Washington, D.C.

Kris, Ernst, and Otto Kurz. 1979. *Legend, Myth and Magic in the Image of the Artist.* New Haven.

Kubler, George. 1963. *The Shape of Time.* New Haven.

———. 1965. "Vicente Carducho's Allegories of Painting," *Art Bulletin* 47:439–45.

———. 1966. "Three Remarks on the *Meninas,*" *Art Bulletin* 48:212–14.

Kühn, Hermann. 1965. "Untersuchen zu den Malgründen Rembrandts," *Jahrbuch der Staatlichen Kunstsammlungen in Baden-Württemberg* 2:189–210.

———. 1968a. "Lead-tin yellow," *Studies in Conservation* 13:7–33.

———. 1968b. "A Study of the Pigments and the Grounds Used by Jan Vermeer," *Report and Studies in the History of Art* (National Gallery of Art), pp. 155–202. Washington, D.C.

———. 1970. "Verdigris and Copper Resinate," *Studies in Conservation* 15:12–36.

———. 1973. "Terminal Dates for Paintings Derived from Pigment Analysis," *Application of Science in Examination of Works of Art* (Museum of Fine Arts), pp. 199–205. Boston.

Kurella, Annette, and Irmgard Strauss. 1983. "Lapislazuli und natürliches Ultramarin," *Maltechnik/Restauro* 1:34–54.

Kurz, Otto. 1962. "Varnishes, Tinted Varnishes and Patina," *Burlington Magazine* 104:56–59.

———. 1963. "Time the Painter," *Burlington Magazine* 105:94–97.

Lafuente Ferrari, E. 1943. *Velázquez*. London.

———. 1944. "Borrascas de la pintura y triunfo de su excelencia. Nuevos datos para la historia del pleito de la ingenuidad del arte de la pintura," *Archivo Español de Arte* 17:77–103.

Lank, Herbert. 1982. "Titian's 'Perseus and Andromeda': restoration and technique," *Burlington Magazine* 124:400–06.

Laurie, A. P. 1949. *The Technique of the Great Painters*. London.

———. 1967. *The Painter's Methods and Materials*. New York.

Lauts, Jan. 1956. "Venetian Painting in the 16th Century and its European Resonance," in *Venezia e l'Europa. Atti del XVIII Congresso Internazionale di storia dell'Arte*, pp. 70–80. Venice.

Lazarillo de Tormes. (Antwerp, 1553). In *Biblioteca de Autores Españoles*, vol. 3. Madrid.

Lee, R. W. 1967. *Ut pictura Poesis. The Humanistic Theory of Painting*. New York.

León Tello, F. J., and M. M. V. Sanz Sanz. 1979. *La teoría española en la pintura en el siglo XVIII: el tratado de Palomino*. Valencia.

Lleó Cañal, Vicente. 1975. *Arte y espectáculo: la fiesta del Corpus Christi en Sevilla en los siglos XVI y XVIII*. Seville.

———. 1979. *Nueva Roma: mitología y humanismo en el renacimiento sevillano*. Seville.

Lomazzo, Giampaolo. 1584. *Trattato dell'Arte della Pittura. . . .* Milan.

Lope de Vega. 1923. *La corona merecida* (1603). Jose F. Montesinos, ed. (*Teatro antiguo español*. vol. 5). Madrid.

López Pinciano, Alonso. 1596. *Philosophia antiqua poética*. Madrid.

López-Rey, José. 1960. "Pincelada e imagen en Velázquez," in *Varia velazqueña*, vol. 1, pp. 200–06. Madrid.

———. 1963. *Velázquez. A Catalogue Raisonné of His Oeuvre*. London.

———. 1972. "An Unpublished Velázquez: *A Knight of Calatrava*," *Gazette des Beaux-Arts* 80:61–70.

———. 1979. *Velázquez. The Artist as a Maker*. Lausanne.

Lucas, Arthur and Joyce Plesters, 1978. "Titian's *Bacchus and Ariadne*," *National Gallery Technical Bulletin* 2:25–47.

Mahon, Denis. 1962. "Miscellanea for the Cleaning Controversy," *Burlington Magazine* 104:460–70.

Marijnissen, R.H. 1967. *Dégradation, conservation et restauration de l'oeuvre d'Art*. 2 vols. Brussels.

Martin, Gregory. 1970. *The Flemish School, circa 1600–circa 1900*. London.

Martín González, Juan José. 1984. *El artista en la sociedad española del siglo XVII*. Madrid.

Martínez, Jusepe. 1866. *Discursos practicables del nobilísima arte de la pintura* (c. 1673). Valentín Carderera, ed. Madrid.

Masschelein-Kleiner, L. 1967. "Microanalysis of Hydroxyquinones in Red Lakes," *Mikrochimica Acta* 6:1080–85.

Mayer, August L. 1940. *Velázquez*. Paris.

McKim-Smith, Gridley. 1979. "On Velázquez's Working Method," *Art Bulletin* 61:589–603.

———. 1980. "The Problem of Velázquez's Drawings," *Master Drawings* 18:3–24.

Meiss, Millard. 1945. "Light as Form and Symbol in some Fifteenth-century Paintings," *Art Bulletin* 27:175–81.

Mena Marqués, Manuela. 1984. "La restauración de *Las Meninas* de Velázquez," *Boletín del Museo del Prado* 5(14):87–107.

Menéndez y Pelayo, M. 1940. *Historia de las ideas estéticas en España*. 5 vols. Madrid.

Menéndez Pidal, Gonzalo, and Diego Angulo Iñiguez. 1965. " 'Las Hilanderas,' de Velázquez, radiografías y fotografías en infrarrojo," *Archivo Español de Arte* 38:1–12.

Merrill, Ross. 1981. "A Step toward Revising our Perception of Chardin," *Preprints of the American Institute for Conservation*. Philadelphia, 27–31 May, pp. 123–28.

Moffitt, John F. 1983a. "Velázquez's 'Forge of Vulcan,' the Cuckold, the Poet and the Painter," *Pantheon* 41:322–26.

———. 1983b. "Velázquez in the Alcázar Palace in 1656: the Meaning of the *Mise-en-Scène* of *Las Meninas*," *Art History* 6:271–300.

Mucchi, Ludovico. 1977. "Radiografie di opere di Tiziano," *Arte veneta* 31:297–304.

Mühlethaler, B., and J. Thissen. 1969. "Smalt," *Studies in Conservation* 14:47–61.

Muller, Jeffrey M. 1982. "Rubens's Theory and Practice of the Imitation of Art," *Art Bulletin* 64:229–47.

Muller, Priscilla E. 1972. *Jewels in Spain, 1500–1800*. New York.

———. 1978. "Maino, Crayer, Velázquez and a Miniature of Philip IV," *Art Bulletin* 60:87–89.

"The National Gallery Cleaning Controversy," (editorial). 1962. *Burlington Magazine* 104:49–50.

Nebrija, Elio Antonio de. 1973. *Vocabulario de Romance en Latín*. Transcripción de la edición revisada por el autor (Seville, 1516), con una introducción de Gerald J. MacDonald. Madrid.

Newman, Richard M., and Gridley McKim-Smith. 1982. "Observations on the Materials and Painting Techniques of Diego Velázquez," *Preprints of the American Institute for Conservation*. Milwaukee, Wisconsin, 26–30 May, pp. 133–40.

Norris, C. 1932. "Velázquez and Tintoretto," *Burlington Magazine* 60:156–58.

"Notes sur les radiografies de deux tableaux appartenant aux Musées de Pau et du Rouen." 1964. *Revue du Louvre, Supplement*, no. 9, pp. 50–53.

Nunes, Felipe. 1986. *Arts of poetry, and of painting and symmetry, with principles of perspective* (Lisbon, 1615). See Véliz, 1986.

Oberhuber, Konrad. 1976. *Disegni di Tiziano e della sua cerchia*. Venice.

Orso, Steven Norgaard. 1978. "In the Presence of the 'Planet King': Studies in Art and Decoration at the Court of Philip IV of Spain." Ph.D. diss. Princeton University.

———. 1982. "A Lesson Learned: *Las Meninas* and the State Portraits of Juan Carreño de Miranda," *Record of the Art Museum* (Princeton University) 41(2):24–34.

———. 1984. "On the origin of Velázquez's *Coronation of the Virgin*," *Source. Notes in the History of Art* 4(1):36–40.

———. 1986. *Philip IV and the Decoration of the Alcázar of Madrid*. Princeton.

Pacheco, Francisco. 1956. *Arte de la pintura* (Seville, 1649). F. J. Sánchez Cantón, ed., 2 vols. Madrid.

Palomino de Castro y Velasco, Antonio de. 1947. *El Museo Pictórico y Escala Optica* (Madrid, 1715–24). Aguilar, ed. Madrid.

Panofsky, Erwin. 1955. *Meaning in the Visual Arts*. Garden City, New York.

———. 1962. *Studies in Iconology. Humanistic Themes in the Art of the Renaissance* (Oxford, 1939). New York.

Paravicino, Hortensio Félix. 1640. *Oraciones evangélicas que en las Festividades de Christo Nuestro Señor y su Santissima Madre, predicó el Muy Reverendo Padre Maestro Fray Hortensio Félix Paravicino* (Madrid, 1638). Madrid.

Pérez Martín, M. J. 1961. *Margarita de Austria, Reina de España*. Madrid.

Pérez Sánchez, Alfonso E. 1961. "Una referencia a Velázquez en la obra de Baldinucci," *Archivo Español de Arte* 34:89–90.

———. 1965. "Más sobre Borgianni y Nardi," *Archivo Español de Arte* 38:105–14.

———. 1976. "Presencia de Tiziano en la España del Siglo de Oro," *Goya* 135:140–59.

———. 1977. "Rubens y la pintura barroca española," *Goya* 140–41:86–109.

Pita Andrade, Jose M. 1960. "El itinerario de Velázquez en su segundo viaje a Italia," *Goya* 37–8:151–52.

Plahter, Leif Einar, Erling Skaug, and Una Plahter. 1974. *Gothic Painted Altar Frontals from the Church of Tingelstad*. Oslo.

Plesters, Joyce. 1955–56. "Cross Sections and Chemical Analysis of Paint Samples," *Studies in Conservation* 3:110–32.

———. 1966. "Ultramarine Blue, Natural and Artificial," *Studies in Conservation* 11:62–91.

———. 1968. "Photomicrographs of Cross-sections of Paint and Ground Samples," *Museum* 21:257–65.

———. 1969. "A Preliminary Note on the Incidence of Discoloration of Smalt in Oil Media," *Studies in Conservation* 14:62–74.

———. 1970. "The Grounds for Pictures by or Associated with Rubens," Appendix II, pp. 289–90, in G. Martin, *The Flemish School, circa 1600–circa 1900*. London.

———, and Lorenzo Lazzarini. 1976. "Preliminary Observations on the Technique and Materials of Tintoretto," in Norman Brommelle and Perry Smith, eds., *Conservation and Restoration of Pictorial Art*. London.

———. 1980a. "Tintoretto's Paintings in the National Gallery II," *National Gallery Technical Bulletin* 4:32–47.

———. 1980b. "Possible Causes of Blanching Involving Changes in Pigments or Interaction of Pigment and Medium," *National Gallery Technical Bulletin* 4:61–63.

Pliny. *Historia Naturalis*. Loeb Classical Library. 10 vols. 1938–62.

Podro, Michael. 1982. *The Critical Historians of Art*. New Haven.

Poleró y Toledo, V. "Arte de la restauración (1855)," *Informes y trabajos del Instituto de Conservación y Restauración* 12:101–36.

Quevedo, Francisco de. 1969. *Obra poética*. José Manuel Blecua, ed., 4 vols. Madrid.

———. 1981. *Poesía varia*. James O. Crosby, ed. Madrid.

Rearick, W. R. 1976. *Tiziano e il disegno veneziano del suo tempo*. A. M. Petrioli Tofani, tr. Florence (Gabinetto Disegni e Stampe degli Uffizi).

Recchiuto, Alberto. 1972. "La Virgen de las Angustias de Juan de Juni. Estudio para su conservación y restauración," *Informes y trabajos del Instituto de Conservación y Restauración* 12:5–22.

Rees-Jones, Stephen. 1962. "Science and the Art of Picture Cleaning," *Burlington Magazine* 104:60–62.

———. 1963. "The Cleaning Controversy: Further Comments," *Burlington Magazine* 105:97–98.

Ridolfi, Carlo. 1648. *Le maraviglie dell' arte*. 2 vols. Venice.

Riederer, J. 1968. "Die Smalte," *Deutsche Farben-Zeitschrift* 9:386–95.

Rosand, David. 1970. "The Crisis of the Venetian Renaissance Tradition," *L'Arte* n.s. 3(11–12): 5–53.

———. 1971–72. "Ut Pictor Poeta: Meaning in Titian's *Poesie*," *New Literary History* 3:527–46.

———. 1975. "Titian's Light as Form and Symbol," *Art Bulletin* 57:58–64.

————. 1981. "Titian and the Eloquence of the Brush," *Artibus et Historiae* 3:85–96.

————, ed. 1982a. *Titian. His World and His Legacy.* New York.

————. 1982b. "Titian and the Critical Tradition," in Rosand, ed., *Titian. His World and His Legacy*, pp. 1–39. New York.

————, and Michelangelo Muraro. 1976. *Titian and the Venetian Woodcut.* Washington.

Rossi, Paola. 1975. *I disegni di Jacopo Tintoretto.* Florence.

Salas, Xavier de. 1977. *Rubens y Velázquez*, in *Studia Rubenniana*, vol. 2 (Museo del Prado). Madrid.

San José, Jerónimo de. 1768. *Genio de la Historia* (Madrid, 1651). Madrid.

Sánchez Cantón, F. J. 1923–41. *Fuentes literarias para la historia del arte español.* 5 vols. Madrid.

Sanz Sanz, M. M. V. 1978. "Un tratado de pintura anónimo y manuscrito del siglo XVII," *Revista de Ideas Estéticas* 143:251–75.

Schlosser, Julius. 1976. *La literatura artística.* A. Bonet Correa, tr. Madrid.

Schulz, Juergen. 1975. "Michelangelo's Unfinished Works," *Art Bulletin* 57:366–73.

Searle, John R. 1980. "*Las Meninas* and the Paradoxes of Pictorial Representation," *Critical Inquiry* 6:477–88.

Sebastián, Santiago. 1983. "Lectura iconográfico-iconológica de 'La Fragua de Vulcano,' " *Traza y Baza* 8:20–27.

Seville, Universidad. 1927–46. *Documentos para la historia del arte en Andalucía.* Seville, Facultad de Filosofià y Letras.

Sewell, Brian. 1984. "The Flaying of Solomon," *Art and Antiques*, April, pp. 23–25.

Sigüenza, Padre. 1909. *Historia de la Orden de San Jerónimo* (1600–05). vol. 2. Madrid.

Snyder, Joel, and Ted Cohen. 1980. "Critical Response. Reflexions on *Las Meninas:* Paradox Lost," *Critical Inquiry* 7(2):429–47.

Socrate, Mario. 1966. "Borrón e pittura 'di macchia' nella cultura letteraria del *siglo de oro*," *Studi di letteratura spagnola* (Facoltà di Magistero, Università di Roma), pp. 25–70. Rome.

Soehner, Halldor von. 1965. "*Las Meninas*," *Münchner Jahrbuch der Bildenden Kunst* 16:149–64.

Sonnenburg, Hubert von. 1971. "The Technique and Conservation of the Portrait," *Metropolitan Museum of Art Bulletin* 29(2):476–79.

————. 1982. "Zür Maltechnik Murillos," *Maltechnik/Restauro* 88(1):15–34.

Soria, Martin S. 1955. "*La Fragua de Vulcano*, de Velázquez," *Archivo Español de Arte* 28:142–45.

Spencer, John. 1957. "Ut Rhetorica Pictura," *Journal of the Warburg and Courtauld Institutes* 20:26–44.

Steinberg, Leo. 1981. "Velázquez's *Las Meninas*," *October* 19:45–54.

Stevenson, R. A. M. 1899. *Velasquez.* London.

Summers, David. 1981. *Michelangelo and the Language of Art.* Princeton.

Theophilus. 1963. *On Divers Arts: The Treatise of Theophilus* (*Diversarum artium schedula*). John G. Hawthorne and Cyril Stanley Smith, trs. Chicago.

Thomson, Garry. 1962. "Notes on 'Science and the Art of Picture Cleaning,' " *Burlington Magazine* 104:499–500.

Thompson, D. V. 1956. *The Materials and Techniques of Medieval Painting.* New York.

Tietze, Hans, and Erica Tietze-Conrat. 1970. *The Drawings of the Venetian Painters in the 15th and 16th Centuries.* New York.

Tolnay, Charles de. 1949. "*Las Hilanderas* and *Las Meninas.* An Interpretation," *Gazette des Beaux-Arts* 35:21–38.

———. 1961. "Las pinturas mitológicas de Velázquez," *Archivo Español de Arte* 34:31–45.

Trapier, Elizabeth du Gue. 1948. *Velázquez.* New York.

Trimpi, Wesley. 1973. "Meaning of Horace's *Ut Pictura Poesis*," *Journal of the Warburg and Courtauld Institutes* 36:1–34.

Vanderlip de Carbonnel, K. 1980. "A Study of French Painting Canvases," *Journal of the American Institute for Conservation* 20:3–20.

Varia velazqueña. 1960. *Homenaje a Velázquez en el III centenario de su muerte 1660–1960.* 2 vols. Madrid.

Vasari, Giorgio. 1568. *Le vite de' piu eccellenti pittori, scultori, ed architettori.* 3 vols. Florence.

———. 1966. *Le vite de' piu eccellenti pittori, scultori, ed architettori* (1550 and 1568). vol. 1. R. Bettarini, ed. Verona.

———. 1811. *Le vite* (1550 and 1568) ed. Milan.

Vegue y Goldoni, A. 1928. *Temas de arte y literatura.* Madrid.

Véliz, Zahira. 1981. "A Painter's Technique: Zurbarán's *Holy House of Nazareth*," *Bulletin of the Cleveland Museum of Art* 68(8):270–85.

———. 1982. "Francisco Pacheco's Comments on Painting in Oil," *Studies in Conservation,* 27(2):49–57.

———, ed. and tr. 1986. *Artists' Techniques in Golden Age Spain: Six Treatises in Translation.* New York.

Viñas, Carmelo. 1968. "Cuadro económico-social de la España de 1627–8," *Anuario de Historia Económica y Social* 1:715–72.

Vitruvius. *De architectura, dividido en diez libros* (*De architectura libris decem*). Miguel de Urrea, ed. Alcalá de Henares, 1582.

Volk, Mary Crawford. 1978. "On Velázquez and the Liberal Arts," *Art Bulletin* 60:69–86.

Wetering, E. van de, C. M. Groen, and J. A. Mosk. 1976. "Summary report on the results of the technical examination of Rembrandt's Night watch," *Bulletin van het Rijksmuseum* 24:69–98.

Wild, A. M. de. 1929. *The Scientific Examination of Pictures. An Investigation of the Pigments Used by the Dutch and Flemish Masters from the Brothers Van Eyck to the Middle of the 19th Century.* London.

INDEX

Photographic Acknowledgments

Photographs have been supplied by the owners of the works reproduced, except for the following:

Archivo Mas: 62, 63, 64.

Andersen-Bergdoll: 4, 5, 11, 12, 19, 20, 33, 37, 38, 39, 55.

Davidhazy: 3, 10, 15, 17, 18, 28, 29, 30, 31, 32, 36, 47, 48, 49, 50, 53.

Ma: 21.

McKim-Smith: Colorplates 1A, 1B, 3A, 3B.

Newman: Colorplates 2A, 2B, 4A–H.

Photograph by Museo del Prado, numbering by Newman: 6, 13, 22, 33, 39, 41, 56.

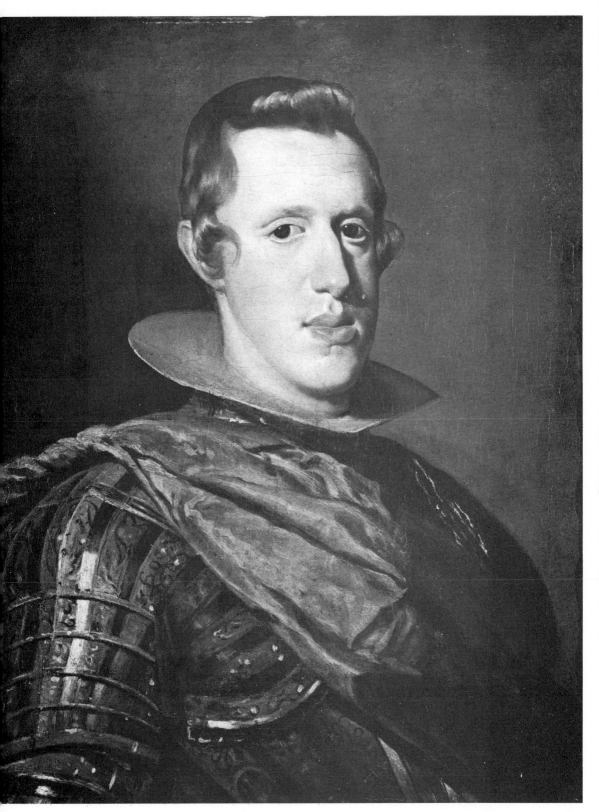

1. *Bust of Philip IV*, Madrid, Museo del Prado

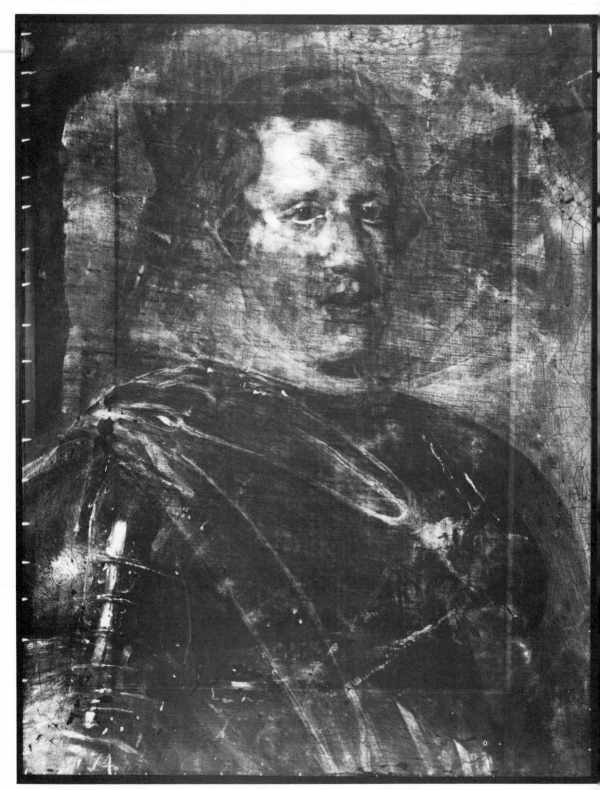

2. *Bust of Philip IV*, X-radiograph

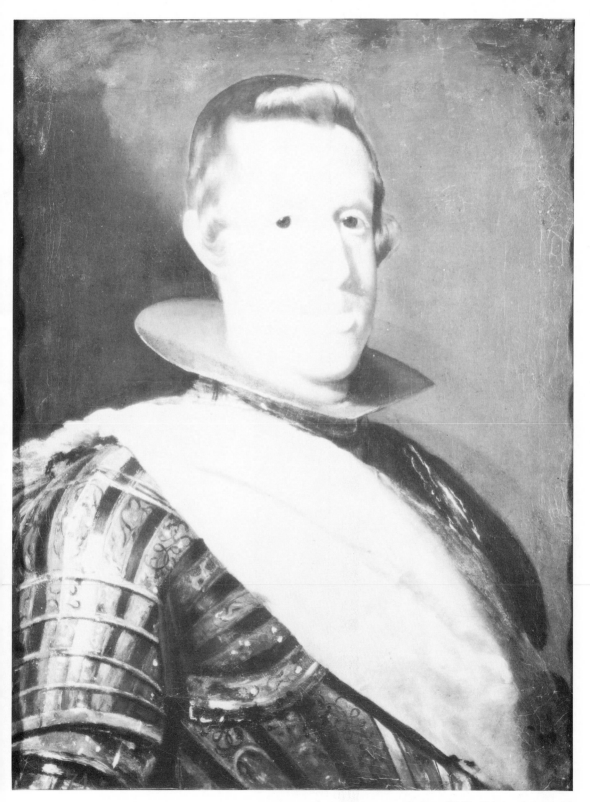

3. *Bust of Philip IV*, infrared photograph

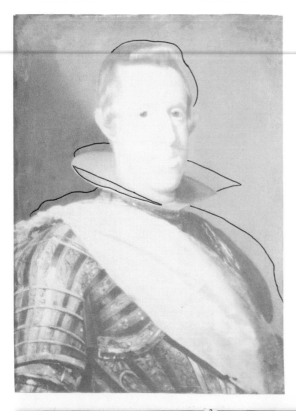

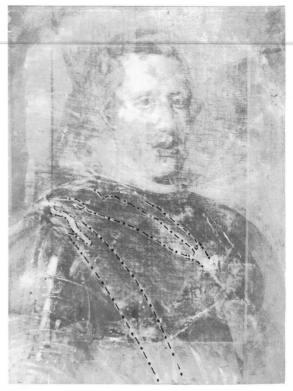

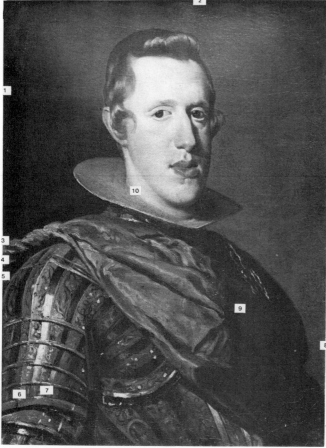

4. *Bust of Philip IV*, drawing showing pentimenti visible in infrared photograph

5. *Bust of Philip IV*, drawing showing pentimenti visible in X-radiograph

6. *Bust of Philip IV*, sampling sites

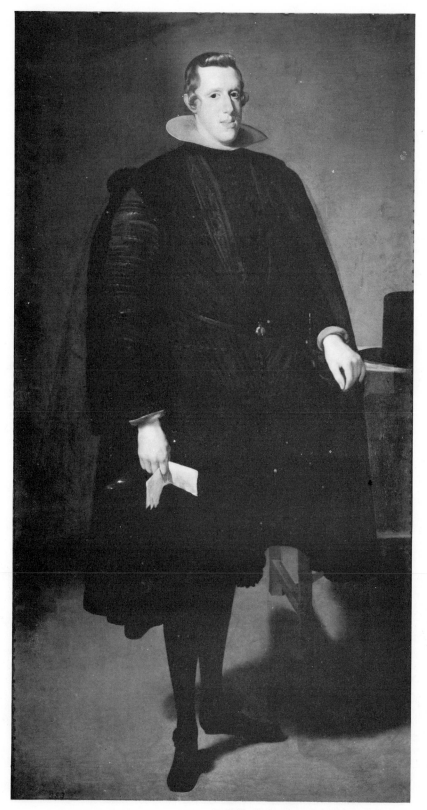

7. *Philip IV Standing*, Madrid, Museo del Prado

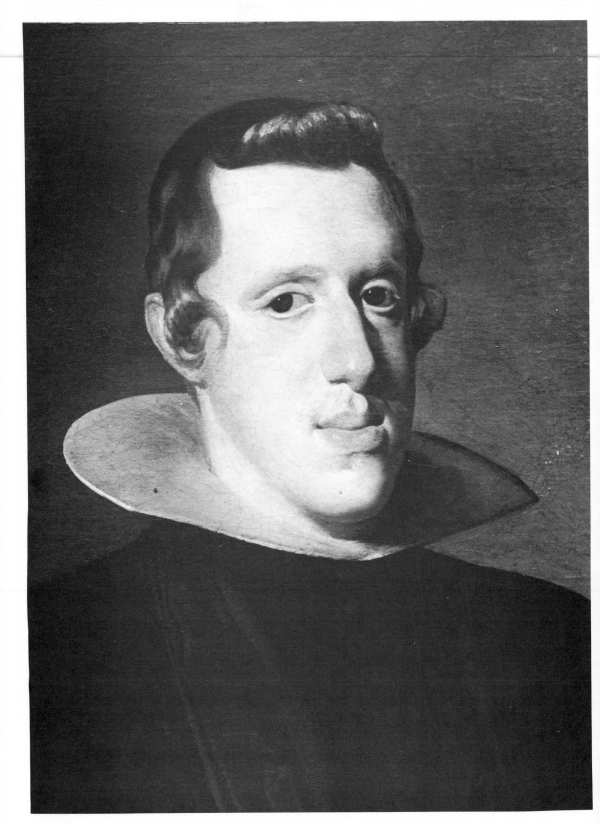

8. *Philip IV Standing*, detail

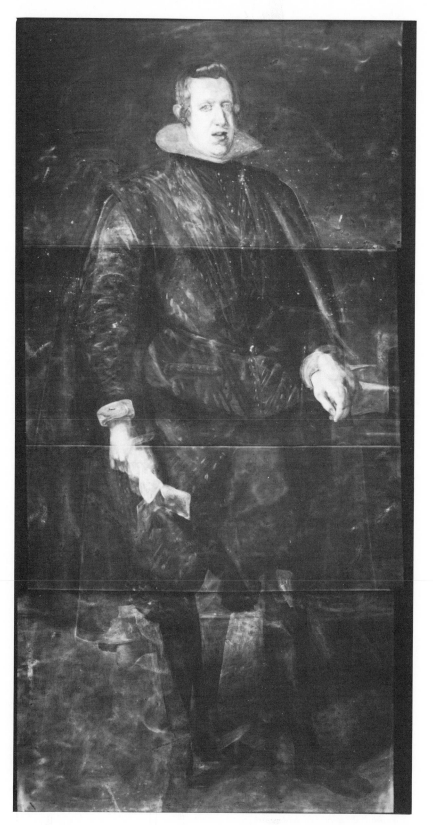

9. *Philip IV Standing,* X-radiograph

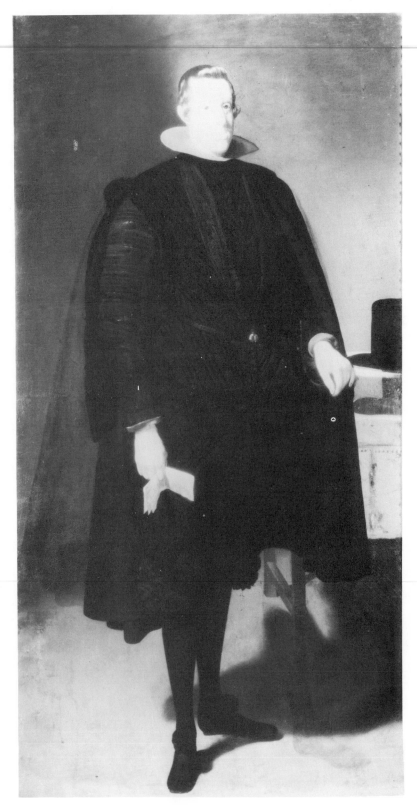

10. *Philip IV Standing*, infrared photograph

11. *Philip IV Standing*, drawing showing pentimenti visible in infrared photograph

12. *Philip IV Standing*, drawing showing pentimenti visible in X-radiograph

13. *Philip IV Standing*, sampling sites

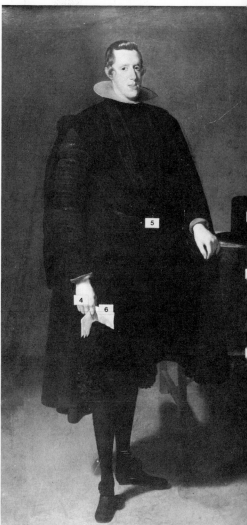

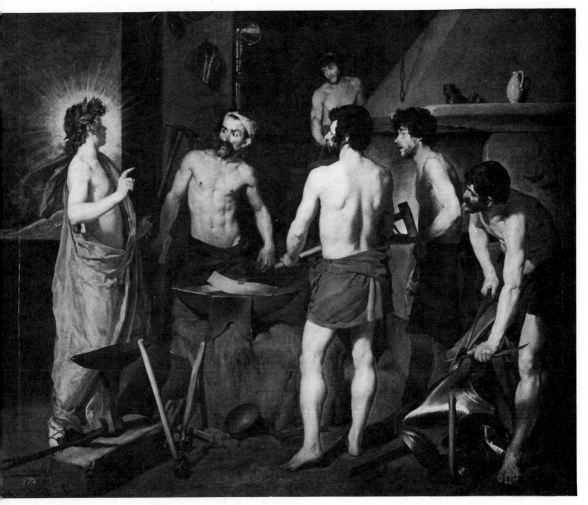

14. *Forge of Vulcan*, Madrid, Museo del Prado

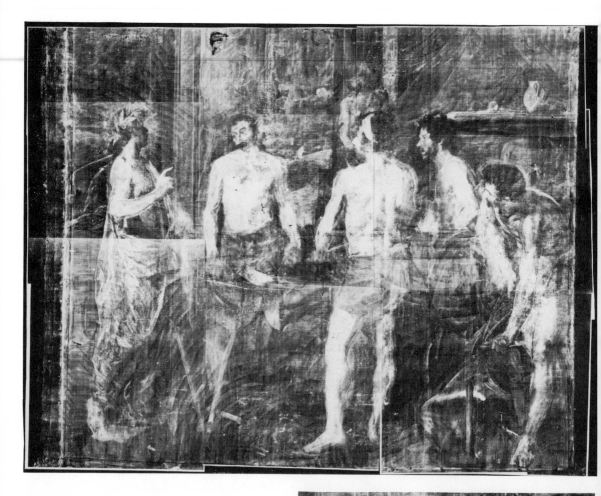

15. *Forge of Vulcan*, X-radiograph

16. *Forge of Vulcan*, detail of Vulcan, X-radiograph

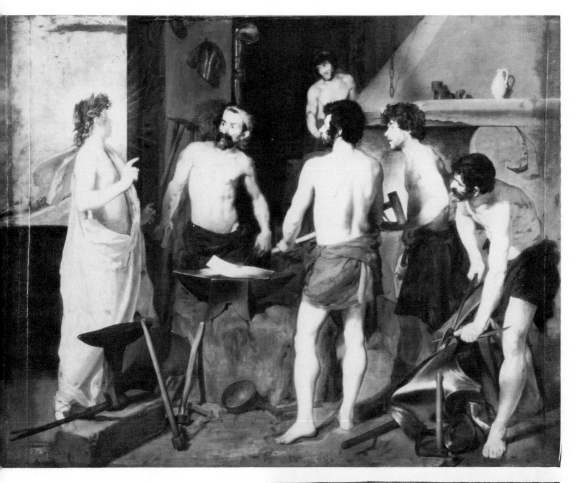

Forge of Vulcan, infrared photograph

Forge of Vulcan, detail of Vulcan, infrared photograph

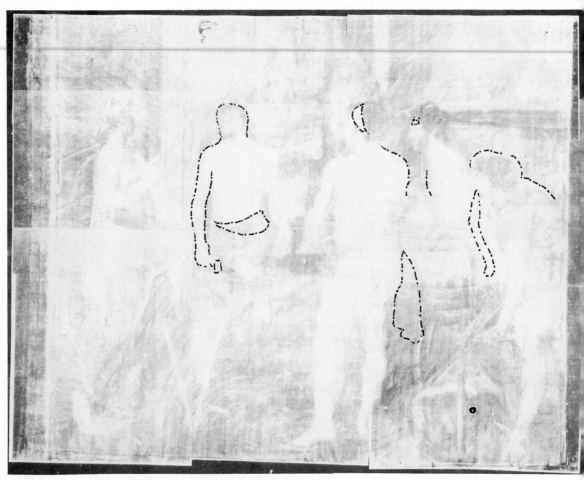

19. *Forge of Vulcan*, drawing showing pentimenti visible in X-radiograph

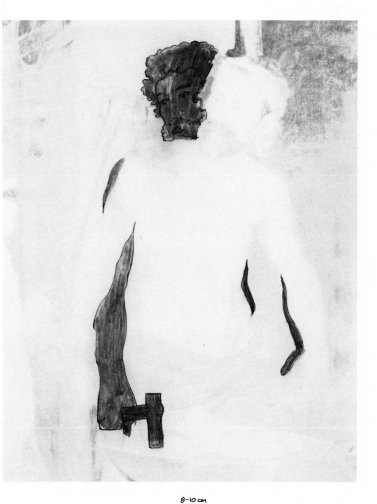

20. *Forge of Vulcan*, composite drawing of
pentimenti in figure of Vulcan visible in
infrared photographs and X-radiographs

21. *Forge of Vulcan*, drawing of pieced canvas

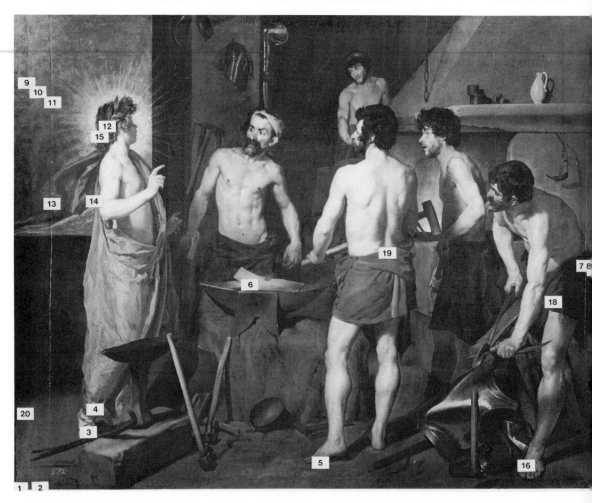

22. *Forge of Vulcan*, sampling sites

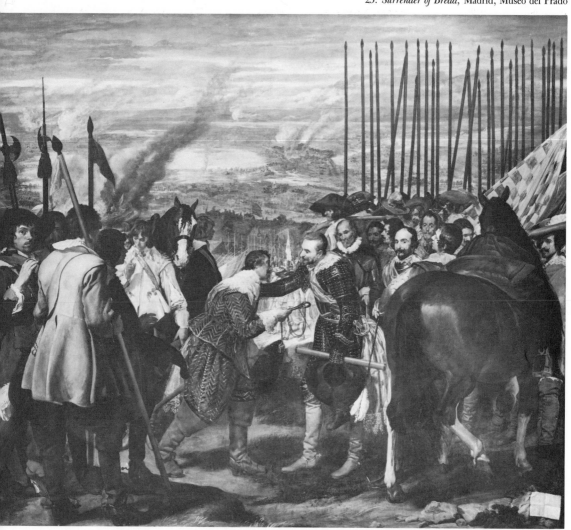

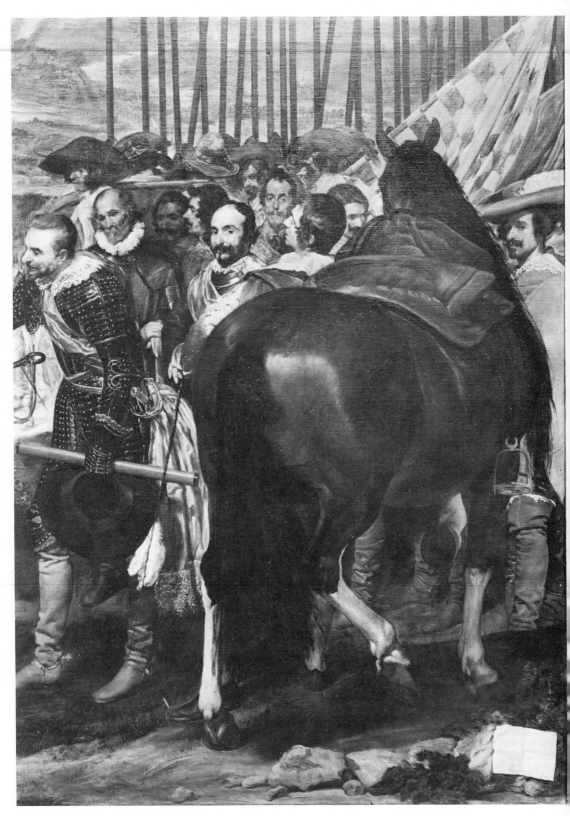

24. *Surrender of Breda*, detail of Spanish side

25. *Surrender of Breda*, detail of Dutch side

26. *Surrender of Breda*, X-radiograph

27. *Surrender of Breda,* detail of Spínola, X-radiograph

28. *Surrender of Breda,* infrared photograph

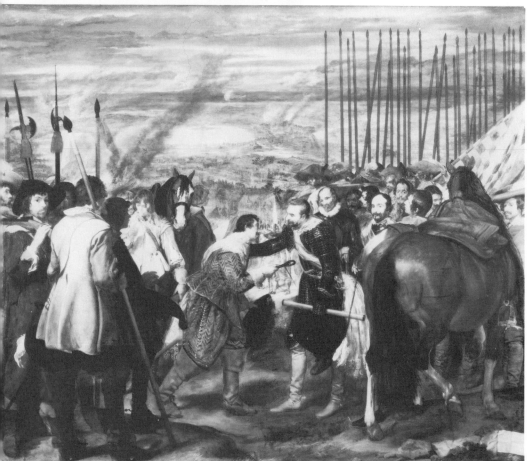

29. *Surrender of Breda*, detail of Spanish side, infrared photograph

30. *Surrender of Breda*, detail, Spaniard, photograph from infrared vidicon monitor

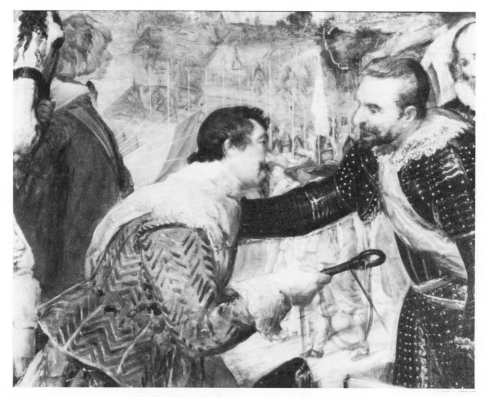

31. *Surrender of Breda*, detail, Justinus of Nassau and Spínola, infrared photograph

32. *Surrender of Breda*, detail of Dutch soldier, infrared photograph

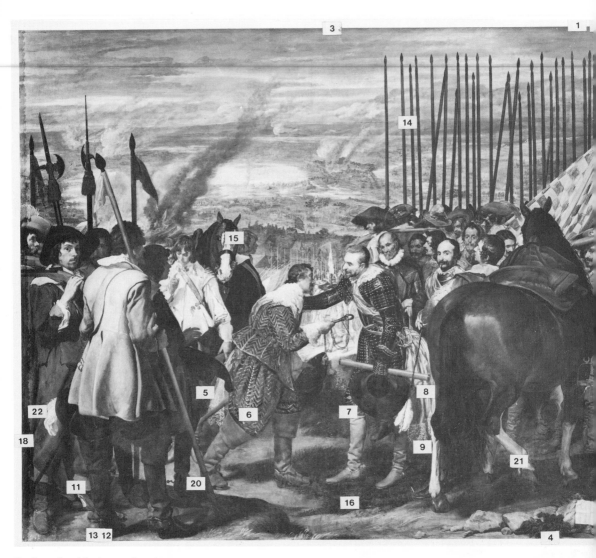

33. *Surrender of Breda*, sampling sites

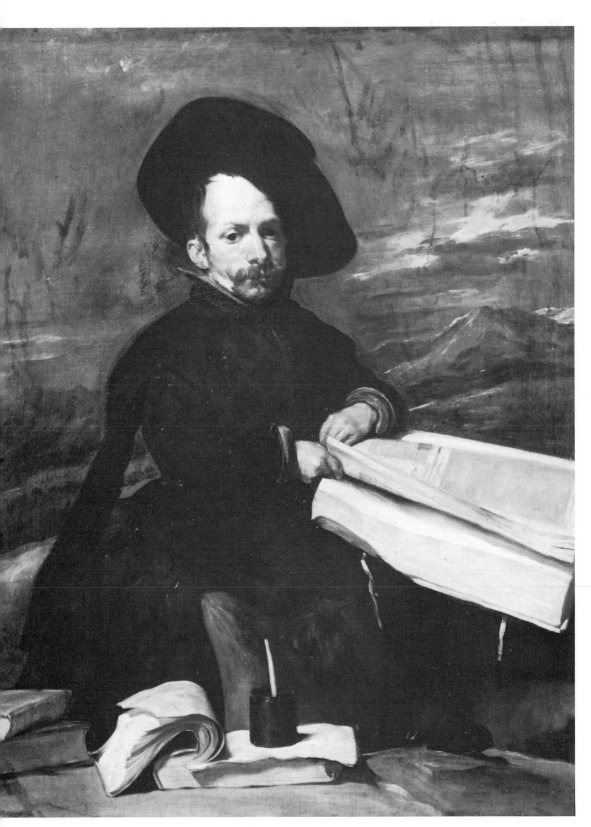

34. *Portrait of a Dwarf* (*El Primo Don Diego de Acedo*), Madrid, Museo del Prado

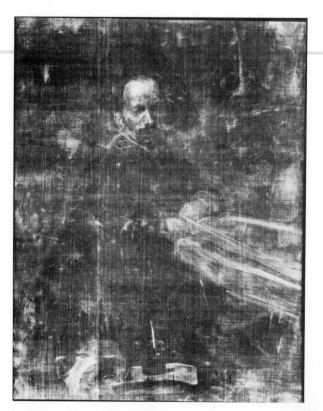

35. *Portrait of a Dwarf,* X-radiograph

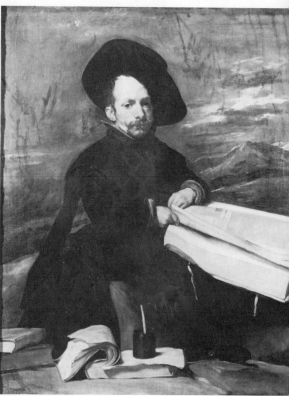

36. *Portrait of a Dwarf,* infrared photograph

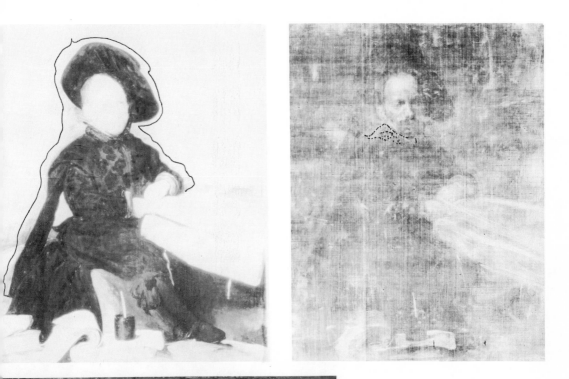

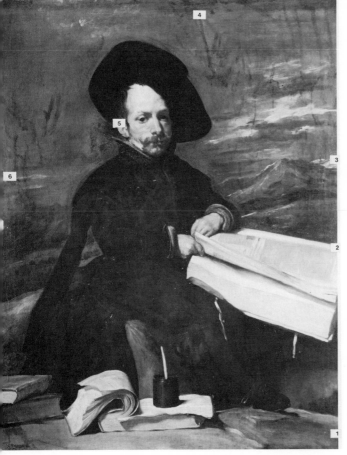

37. *Portrait of a Dwarf,* drawing of pentimenti visible in infrared photograph

38. *Portrait of a Dwarf,* drawing of pentimenti visible in X-radiograph

39. *Portrait of a Dwarf,* sampling sites

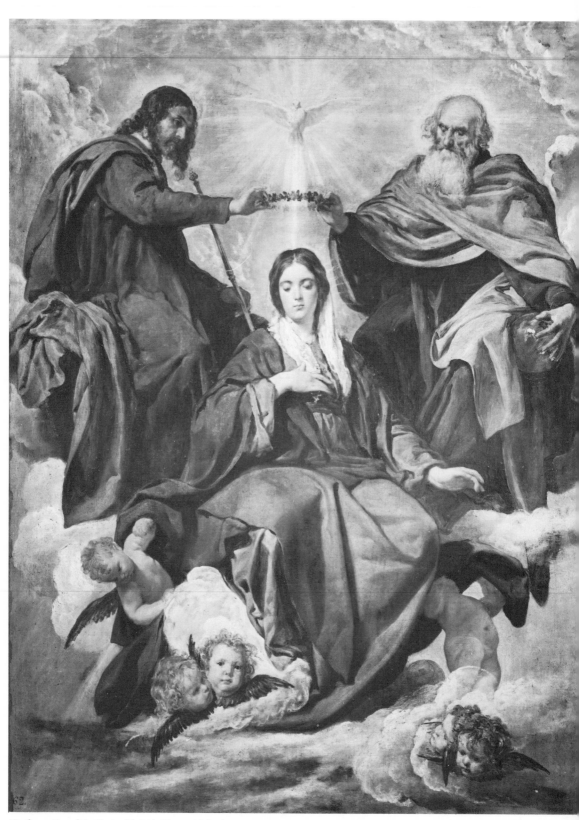

40. *Coronation of the Virgin*, Madrid, Museo del Prado

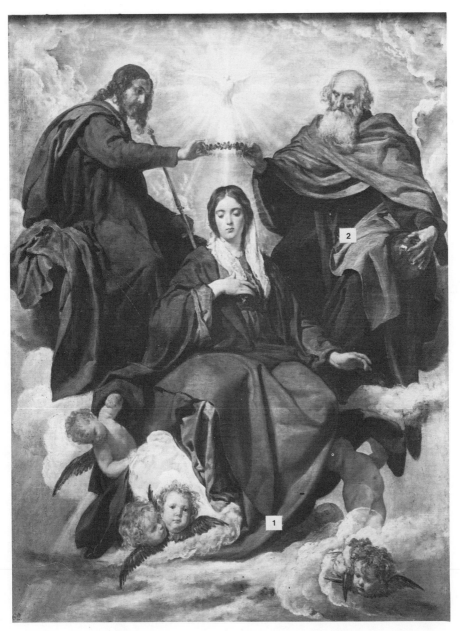

41. *Coronation of the Virgin*, sampling sites

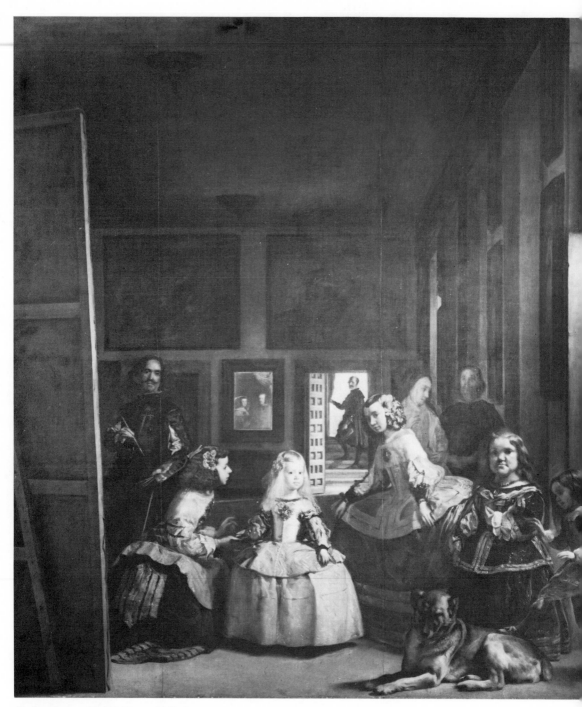

42. *Las Meninas*, Madrid, Museo del Prado

43. *Las Meninas,* detail of Margarita

44. *Las Meninas,* detail of kneeling menina

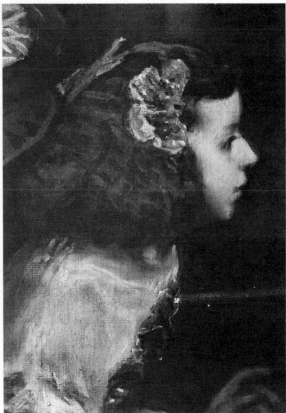

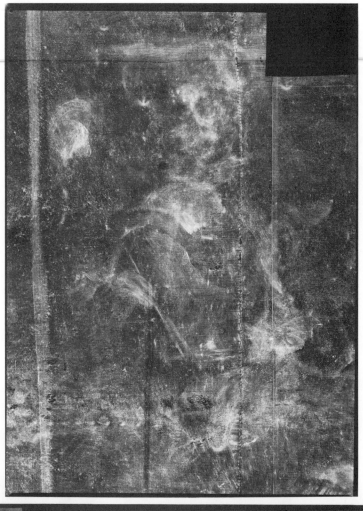

45. *Las Meninas*, detail of Velázquez, X-radiograph

46. *Las Meninas*, X-radiograph

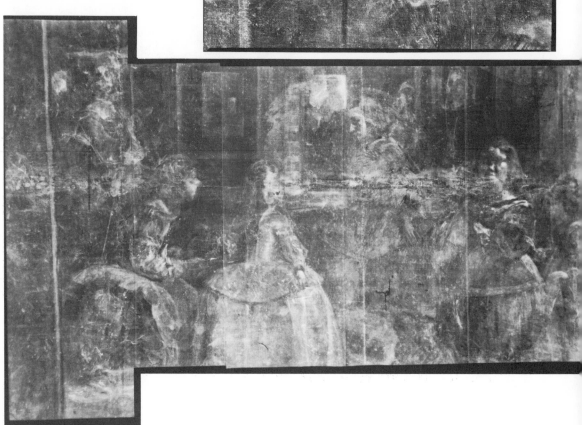

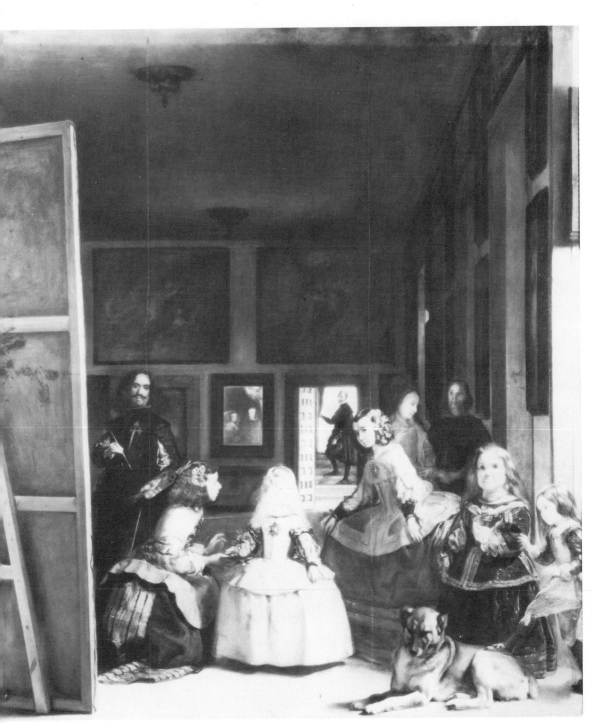

47. *Las Meninas*, infrared photograph

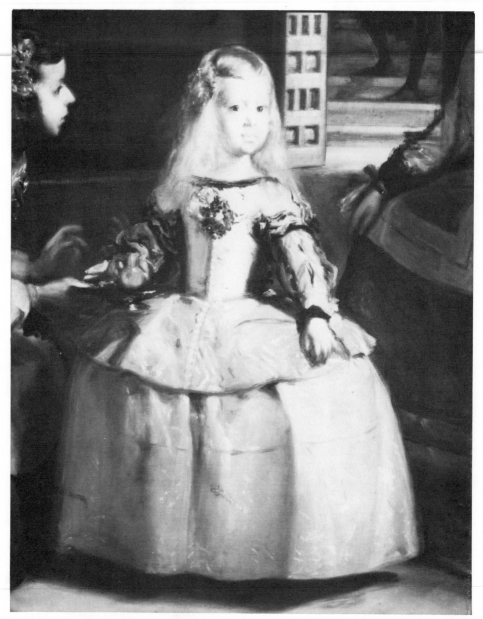

48. *Las Meninas*, detail of Margarita, infrared photograph

49. *Las Meninas*, detail of back wall at left, infrared photograph

50. *Las Meninas*, detail of back wall at right, infrared photograph

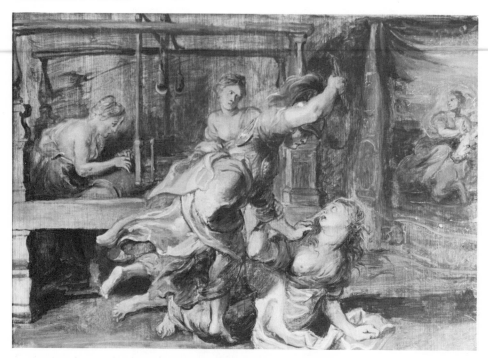

51. Peter Paul Rubens, *Pallas and Arachne*, Richmond, Virginia Museum of Fine Arts

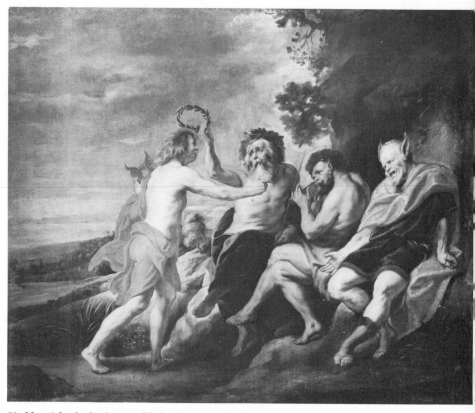

52. Mazo (after Jordaen's copy of Rubens), *Contest of Apollo and Pan*, Madrid, Museo del Prado

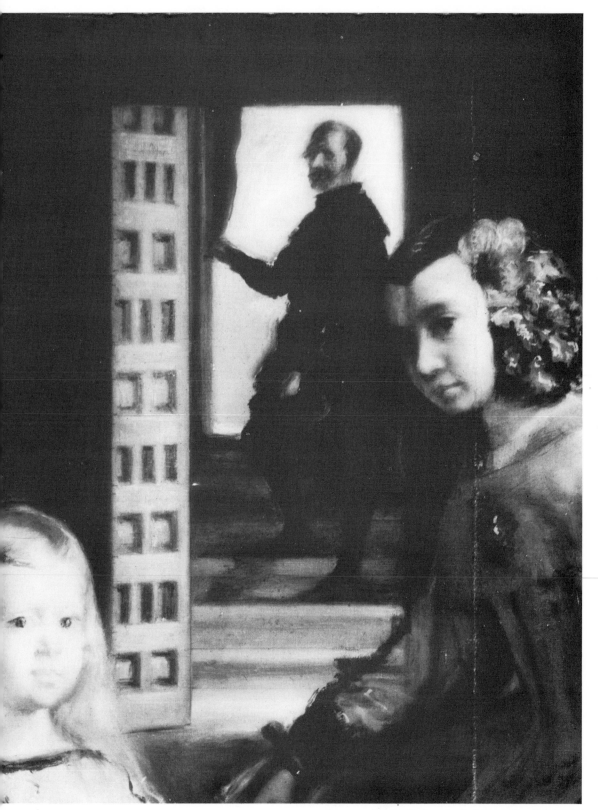

53. *Las Meninas*, detail of door, infrared photograph

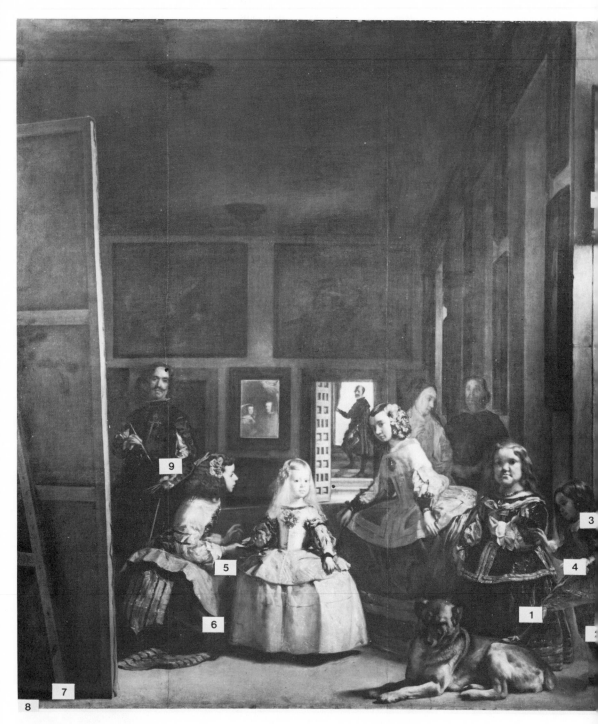

54. *Las Meninas,* sampling sites

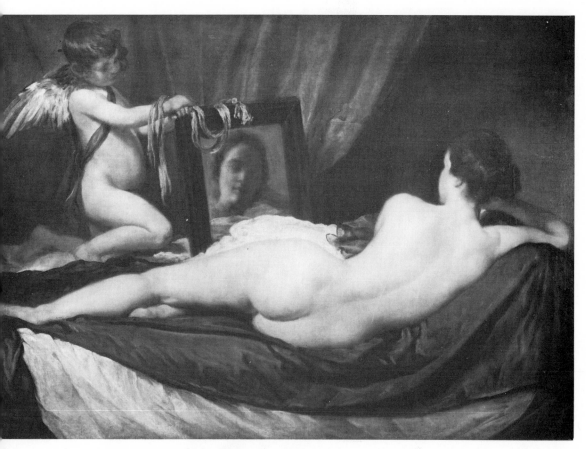

55. *Venus at Her Mirror* (*Rokeby Venus*). Reproduced by courtesy of the Trustees, The National Gallery, London

56. *Venus at Her Mirror* (*Rokeby Venus*), detail of infrared photograph. Reproduced by courtesy of
the Trustees, The National Gallery, London

57. *Juan de Pareja*, New York, Metropolitan Museum

58. *Portrait of Góngora*, Boston, Museum of Fine Arts

59. *Portrait of a Young Man*, Munich, Alte Pinakothek

60. *Las Hilanderas* (*The Fable of Arachne*), Madrid,
Museo del Prado

61. *Christ after the Flagellation Contemplated by the Christian Soul.* Reproduced by courtesy of the Trustees, The National Gallery, London

62. *Spínola in Three-Quarter View*, recto, Madrid, Biblioteca Nacional

63. *Spínola in Profile*, verso, Madrid, Biblioteca Nacional

64. *Angel*, formerly Gijón, Instituto Jovellanos

65. Titian, *Sacrifice of Isaac*, Paris, École nationale supérieure des Beaux-Arts

66. Tintoretto, *Doge Alvise Mocenigo before the Redeemer*. New York, The Metropolitan Museum of Art, John Stewart Kennedy Fund, 1910 (10.206)

67. Tintoretto, Study for a figure from the *Last Supper*. By courtesy of the Board of Trustees of the Victoria and Albert Museum

68. Titian, *Entombment*, Madrid, Museo del Prado

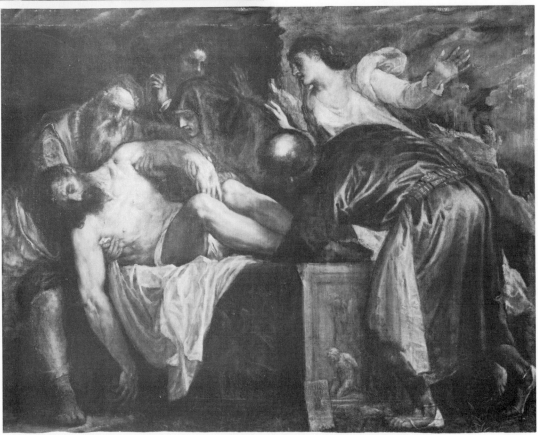

69. Titian, *Entombment*, detail

70. Titian, *Rape of Europa*, Boston, Isabella Stewart Gardner Museum

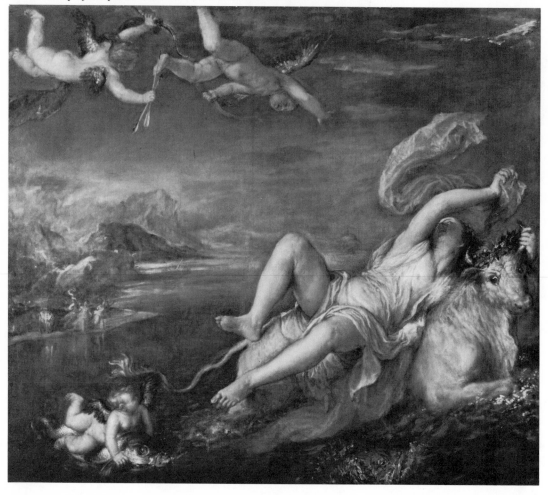

71. Titian, *Rape of Europa*, detail

72. Titian, *Bacchus and Ariadne*. Reproduced by courtesy of the Trustees, The National Gallery, London

73. Titian, *Philip II*, Madrid, Museo del Prado